THE ART OF WALTER SIMONSON

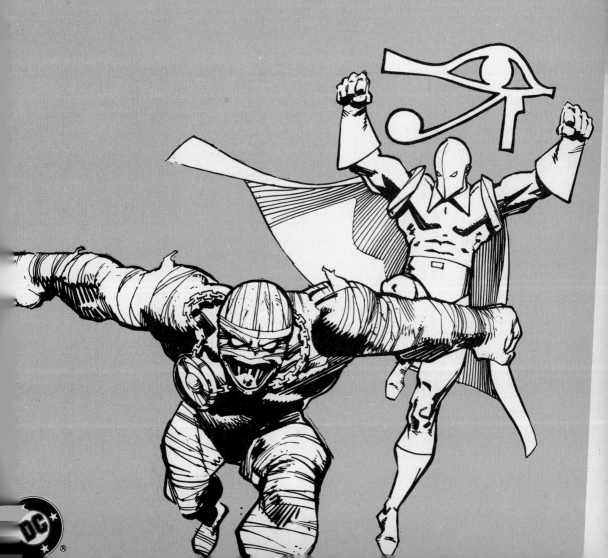

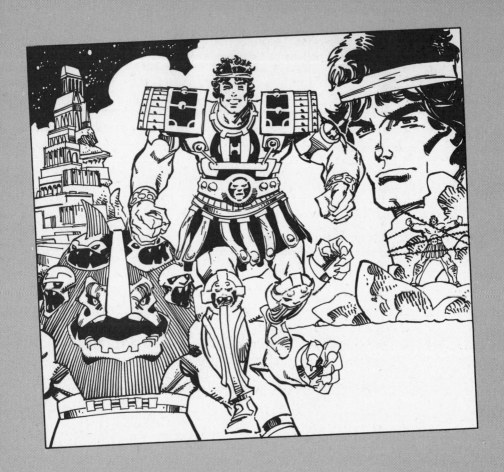

THE ART OF WALTER SIMONSON

Published by DC Comics Inc.

DC Comics Inc., 666 Fifth Ave., New York, NY 10103
A Warner Communications Company Ⓦ
Printed in Canada. First Printing.

Cover painting by Walter Simonson;
Publication design by Janice Walker.

JENETTE KAHN President & Publisher; DICK GIORDANO VP-Editorial; RICHARD BRUNING, MARK WAID Co-Editors; RICHARD BRUNING Design Director; TERRI CUNNINGHAM Managing Editor; BOB ROZAKIS Production Director; PAUL LEVITZ Executive VP; JOE ORLANDO VP–Creative Director; BRUCE BRISTOW VP–Sales & Marketing; MATT RAGONE Circulation Director; TOM BALLOU Advertising Director; PAT CALDON Controller

TABLE OF CONTENTS

ABOUT WALT.

By Howard Chaykin

So, first: Walter calls me to tell me that DC is going to collect all of his shorter pieces, as well as some of his other stuff, into a trade paperback. I'm delighted — there's some great work there — and of course I say "if you're interested, I'll write you an intro-duction." He says "great," we chat some more — then promptly put the subject aside.

So, second: I — Comicdom's favorite (I checked) Jew from the future — call Mark Waid, co-editor of the collection, and ask when this introduction of mine is due. "Three weeks ago . . ." he says. I become contrite — honestly — [terrifyingly — Mark] and promise to have it to him tomorrow.

That was three weeks ago.

So, finally: I came to the real-ization that I had a couple of choices. I could simply replace "Walt Whitman" with "Walt Simonson" in Allen Ginsberg's poem "A Supermarket in Califor-nia." You know — "What thoughts I have of you tonight, Walt Simon-son, for I walked down the side-streets . . ." You get the picture — and hope that Waid had never read it. Or I could tell a little truth.

In the November / December '88 issue of PRINT Magazine, devoted exclusively to the current comics scene, Arlen Schumer writes, "Walt(er) Simonson was

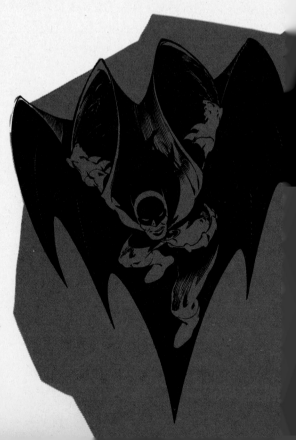

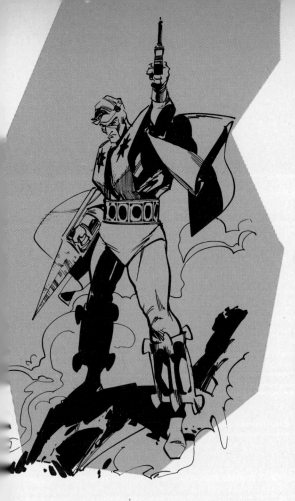

one of the first artists to introduce an unorthodox drawing style to mainstream comics . . . ". I take issue only with the qualifier. Simonson was the absolute first, because he had, even then, a specific vision — a point of view — which clearly and uniquely defined his work.

Oddly, I've known other cross-discipline men — guys who did comics and something entirely else — in my time: Jeff Jones and surgeon Bill Stillwell come to mind. But no one, until Walter came along, brought any of that outside discipline into play! It was Walter's gift that in its earliest, most formative stages, he was able to impose on his work a scientist's order and a researcher's logic.

Which is not to say that Walter's work is cold — or calculated. Rather, it is vigorous and confident, his people redolent with a sense of self, and his universe often seen from an odd and occasionally bizarre perspective. The story in which Thor, god of thunder, turns into a frog for several issues, for example.

All of which brings me around to some of the aforementioned little truths. Walter's work has always had a downright peculiar, sort of wonky, weird quality — a sensibility that both discomfits and relaxes — all of which is directly traceable to his own very personal perspective.

At any rate — back in what I and many of my peers consider the

real and true Golden Age of Com-
ics—you know, the Glory Days
when you could hope to have a
coherent conversation with Neal
Adams and our lives were directly
affected by two guys named
Carmine and Sol—there floated a
theory, to wit: The weirder the
guy—cosmic bullshit, long hair,
dope, and weird clothes—the
straighter and more banal the
work.

Trust me on this—I had a
coherent conversation with Neal
Adams about it. Now, I won't
name names—regardless of
what you may hear and contrary
to what you may think, I'm not
that kind of guy. And, for the
record, in those days (the early
seventies) we were a longhaired,
weird-looking loutish lot. (When,
at age 19, I worked as go-fer for
Gil Kane, he was reticent to send
me to deliver his work, fearing my
appearance would reflect badly
on him.)

Anyway, there we were—a
bunch of young white guys sitting
around scratching. Some of us
ate together, some of us worked
together—some of us lived
together—but most of all, all of us
spent far too much damned time
in the coffee room at DC Comics,
then located at 909 Third Avenue.

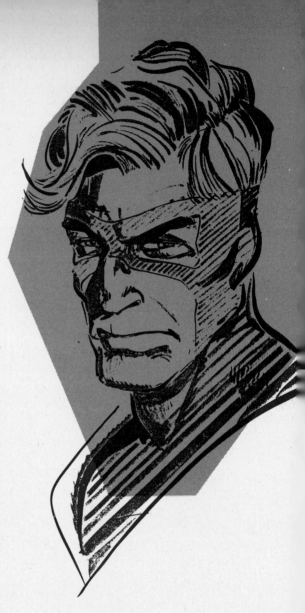

One fine day in August of '72,
we were sitting around dis-
cussing our futures. Back in those
days, the "paper shortage" was
on everybody's lips—and most
of us with half a brain figured
comics were due for oblivion by
the early eighties.

Suddenly, unaccompanied by any dramatic pause or anything, Michael Kaluta entered the room, in his hand a sheaf of samples. Following in Michael's tracks was a guy who looked like he'd been pencilled by Cliff Sterrett—and inked by Rayburn Van Buren. Kaluta displayed an unusual enthusiasm for someone so predatorily cool and introduced us to the fellow in question.

His name, ladies and gentlemen, was Walter Miller Simonson.

His stuff was the most stylistically complete and consistent work of any of our generation at the time. Period. While most of us were still struggling with drawing problems, Simonson had a grasp of drawing systems, his academic underpinning serving him in extraordinary stead. Exclamation point. That's a big gulp—and I'll try to explain it, if not justify myself.

I know I'm jaundiced—but I liked the atmosphere of enthusiasms in the industry better then. There was some really exciting new stuff around coming after a long boring period. Wrightson had an uncanny ability to create, in ink, a genuinely threatening sensuous anatomy of fear. Kaluta had an extraordinary gift in his portrayals of ancient enchantment. Even Buckler had a polish and finish that was hard to beat.

— All talented men—and there were many more.

But Simonson, in his earliest works, from the **Star Slammers**—*a black-and-white narrative prepared and printed as promotion for the World Science Fiction Convention*—to his first few pieces for DC and Gold Key, displayed a grasp of mature graphic ideas that most of us would come to only years later. Some of the guys never got it at all.

So, like I say, there we were. A bunch of guys executing often banal attempts to elevate our fantasy lives to the level of pulp fiction . . . and Walter comes along. He has the same sensibilities, but he's got one crazy vocabulary to lay out his trip. There were guys in the business who prefigured a number of Walter's approaches—Krigstein and Holdaway, among others—but it was Simonson who brought it all together with a brisk graphic flair for motion and action.

Walter was the first man of his generation—a generation whose influences were bookended by Harvey Kurtzman and Al Feldstein on one side, and Stan Lee and Jack Kirby on the other—to create a viable, believable, internalized world based on his own designed approach to the drawing. That world seemed to continue its existence outide the context of the border/frame.

All this internal verisimilitude was enhanced by a wonderful consistency of craft. Which, side-windingly, returns us to one of the topics at hand—the ratio of weird artist: banal stuff. Walter's

stuff was among the oddest. His grounding in graphics left him unsatisfied by "realism." Yet, almost to confirm the exact inverse of the equation—Walter Simonson is the comics answer to Andy Hardy.

To further quote the PRINT article, "[Simonson's] line was looser, sketchier, more graphic. His lettering of sound effects had a typographic feel . . ." Damned right. What Schumer hints at— but doesn't come out and say—is that Simonson liberated a lot of thinking. Unlike a lot of academics, he was freed by his education and let it carry him into fun territory.

And yet, to the audience at large, he remained largely unknown. It wasn't until the early eighties, with his freewheeling, off-the-wall reworking of Lee and Kirby's Thor, for Marvel Comics, that Walter received the attention he had long deserved.

It's wonderful to see these earlier stories in print. Walter's aesthetic judgment was and is so sharp. A number of these stories may seem a bit rough-hewn, but boy, do they breathe with life— particularly the one where I'm the main character.

One of the nice things about writing these introductions is the chance you get to say something nice about someone before they're dead. The problem, however, arises when the guy you're writing about is someone with whom you're in frequent contact.

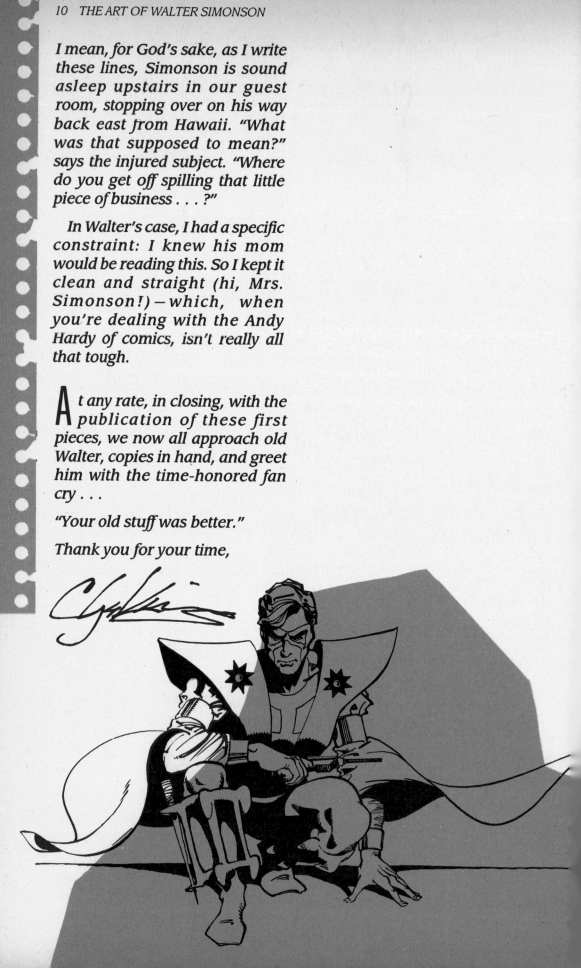

I mean, for God's sake, as I write these lines, Simonson is sound asleep upstairs in our guest room, stopping over on his way back east from Hawaii. "What was that supposed to mean?" says the injured subject. "Where do you get off spilling that little piece of business . . . ?"

In Walter's case, I had a specific constraint: I knew his mom would be reading this. So I kept it clean and straight (hi, Mrs. Simonson!) — which, when you're dealing with the Andy Hardy of comics, isn't really all that tough.

A t any rate, in closing, with the publication of these first pieces, we now all approach old Walter, copies in hand, and greet him with the time-honored fan cry . . .

"Your old stuff was better."

Thank you for your time,

SIMONSON THE STORYTELLER

C*omics don't have to be a collaborative medium. There's an excellent argument that the very best comics are those in which both art and writing are done by one individual. Be that as it may, for any number of reasons, the great majority of comics are done as a collaboration. The stories in this collection are cases in point. But why bring that up in a book called* The Art of Walter Simonson?

Because no small part of the art presented here demonstrates Walt's great ability as a collaborator.

Along with being an accomplished draftsman and artistic stylist, Walt is a storyteller. He doesn't just illustrate the writing — he writes with the pictures and page layouts he does. Even when working from a full script (as opposed to breaking the story down from a writer's plot), Walter finds ways to augment and amplify the material beyond the written word, but almost always (hey, the guy's human; he's slipped up maybe once or twice) to their advantage.

As a writer who has worked with Walter many times, and as I'm sure most of those represented here would agree, he never sleepwalks through a job. He takes it the extra mile and makes you (the writer) look better in the process. Because of his own total involvement in the story, Walt raises your own involvement in the material. Whenever I've worked with him, I've felt his effort and enthusiasm has drawn more out of me; my own contribution becomes greater because of his.

If there's a down side in all this from my point of view, it's that Walt is such a good storytelling artist that he eventually became a good writer as well. The days when he collaborates with another writer are fewer and farther between. Which makes this collection something special: the chance to see a major artistic stylist matching and melding his talent with a variety of interesting comics writers and using these collaborations to develop and vary his art approach over the course of a decade.

—ARCHIE GOODWIN

BATMAN

This story was the first work I did for DC Comics after completing the Manhunter strip that ran in the back of DETECTIVE COMICS in the early 1970s. I had done a couple of jobs for Atlas Comics and returned to DC, enjoying a healthy raise in pay. But I'm afraid I was a disappointment to them.

There had been a trend in the late 1960s toward a long-eared, graceful Batman, dating back to Neal Adams's first work on the character. And since I'd already drawn such a Batman in the Manhunter strip, I wanted to try something else.

I had also discovered the work of artist Jose Ortiz and loved it. The Manhunter work, especially near the end, was very cleanly drawn. I dug into this story trying to bring to it the kind of blacks and nervous lines Ortiz used.

So DC ended up getting a short-eared, scratchy, tank-like Batman with a jaw that could crack nuts. I don't think it was exactly what they were looking for. But they were good sports about it and ran it anyway.

The only change I had to make on the job was to alter the expression on Batman's face on the splash page. I had originally given Bats a grin, feeling (as I still do) that a grin in the wrong place is more frightening than a snarl. My editor didn't see it that way and had me change it. That's the way the job was printed, but I got the last laugh when I redrew the grin after I got the original back!

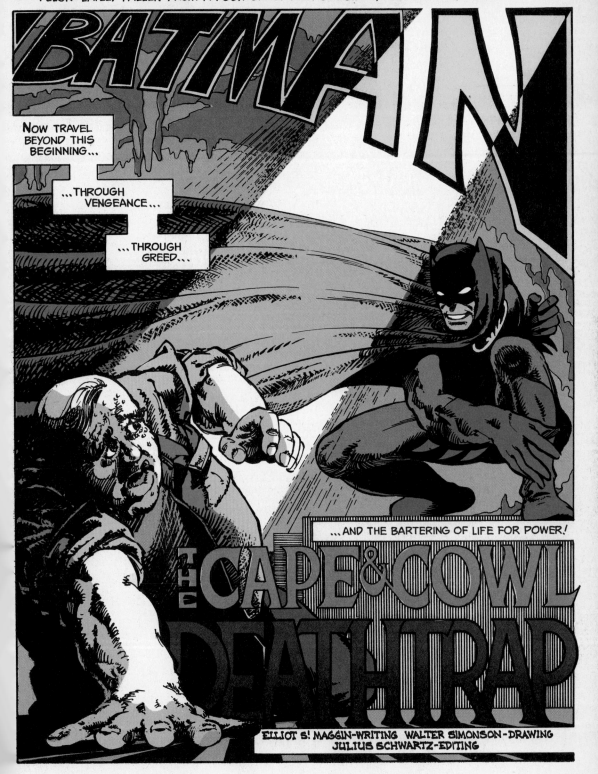

OKAY, YOU'VE GOT ME COLD ON THE BRIBE TO *JUDGE ARNELL* AND THE GRAND JURY...

...BUT I KNOW *NOTHING* ABOUT SENATOR LOCKSLEY-- I SWEAR!

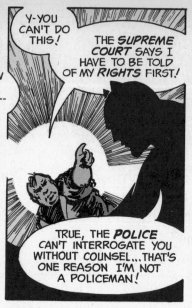

Y-YOU CAN'T DO THIS!

THE *SUPREME COURT* SAYS I HAVE TO BE TOLD OF MY *RIGHTS* FIRST!

TRUE, THE *POLICE* CAN'T INTERROGATE YOU WITHOUT COUNSEL...THAT'S ONE REASON I'M NOT A POLICEMAN!

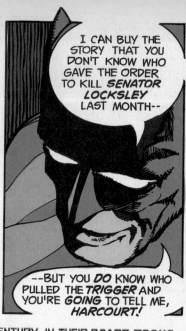

I CAN BUY THE STORY THAT YOU DON'T KNOW WHO GAVE THE ORDER TO KILL *SENATOR LOCKSLEY* LAST MONTH--

--BUT YOU *DO* KNOW WHO PULLED THE *TRIGGER* AND YOU'RE *GOING* TO TELL ME, *HARCOURT!*

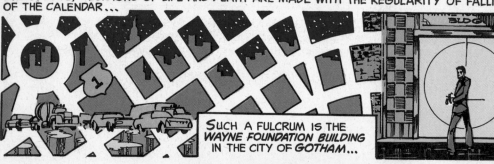

GREAT CITIES ARE THE FULCRUMS OF HISTORY IN THE TWENTIETH CENTURY. IN THEIR BOARD ROOMS AND BYWAYS, DECISIONS OF LIFE AND DEATH ARE MADE WITH THE REGULARITY OF FALLING LEAVES OF THE CALENDAR...

SUCH A FULCRUM IS THE *WAYNE FOUNDATION BUILDING* IN THE CITY OF *GOTHAM...*

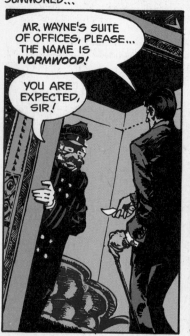

...WHERE ONE *JEREMY WORMWOOD* --FINANCIER, SOCIALITE, AND FREE-LANCE ASSASSIN-- HAS BEEN SUMMONED...

MR. WAYNE'S SUITE OF OFFICES, PLEASE... THE NAME IS *WORMWOOD!*

YOU ARE EXPECTED, SIR!

WHOOSHH!

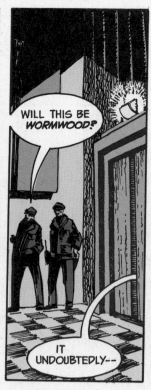

WILL THIS BE *WORMWOOD?*

IT UNDOUBTEDLY--

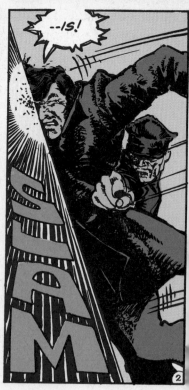

--IS!

WHAM

2

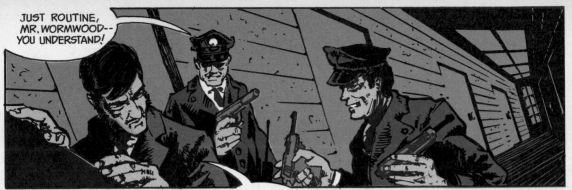

JUST ROUTINE, MR. WORMWOOD-- YOU UNDERSTAND!

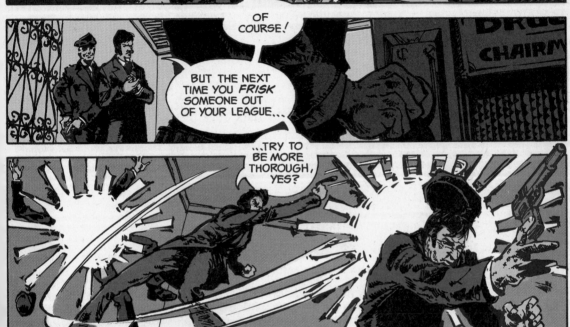

OF COURSE!

BUT THE NEXT TIME YOU *FRISK* SOMEONE OUT OF YOUR LEAGUE...

...TRY TO BE MORE THOROUGH, YES?

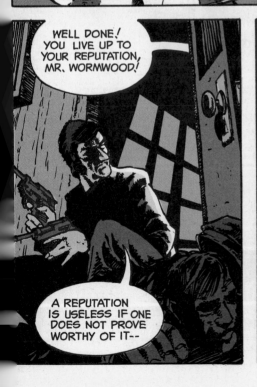

WELL DONE! YOU LIVE UP TO YOUR REPUTATION, MR. WORMWOOD!

A REPUTATION IS USELESS IF ONE DOES NOT PROVE WORTHY OF IT--

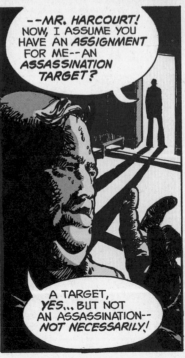

--MR. HARCOURT! NOW, I ASSUME YOU HAVE AN *ASSIGNMENT* FOR ME--AN *ASSASSINATION TARGET?*

A TARGET, YES... BUT NOT AN ASSASSINATION-- *NOT NECESSARILY!*

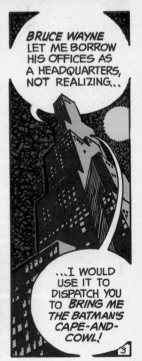

BRUCE WAYNE LET ME BORROW HIS OFFICES AS A HEADQUARTERS, NOT REALIZING...

...I WOULD USE IT TO DISPATCH YOU TO *BRING ME THE BATMAN'S CAPE-AND-COWL!*

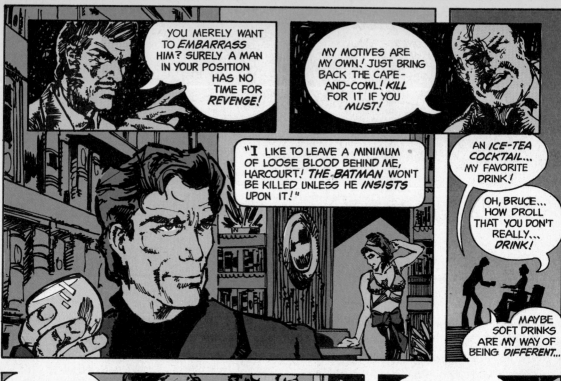

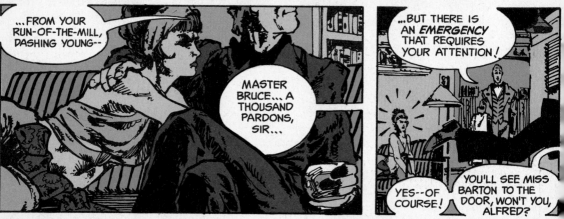

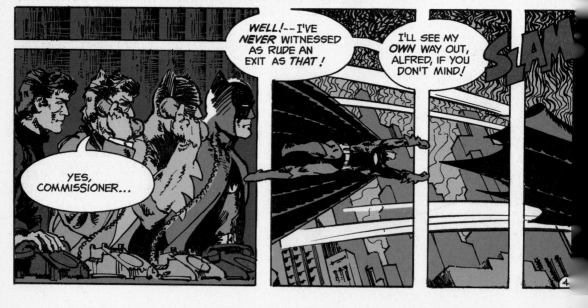

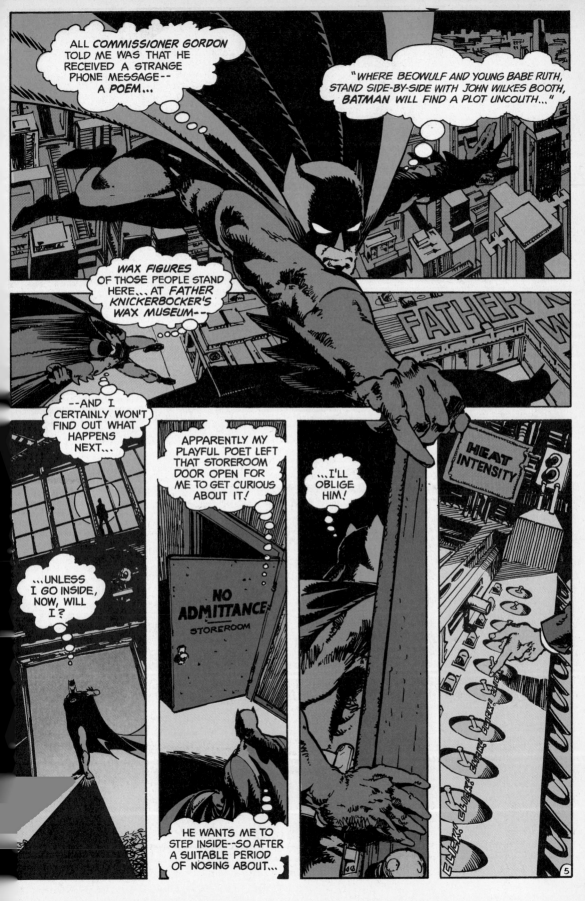

WELCOME TO MY HUMBLE LITTLE DEATH-TRAP, *BATMAN!*

YOU'LL NOTICE THAT YOU ARE NOW COMPLETELY LOCKED INTO THIS *STEEL-REINFORCED ROOM...*

...AND THAT A PANEL IS SLIDING AWAY ON THE CEILING TO EXPOSE A *10,000-WATT RED-HOT BULB...*

...WHICH WILL GROW UNBEARABLY HOTTER--*ORANGE* TO *YELLOW*...TO *BLUE* TO *WHITE-HOT*...UNLESS YOU COMPLY WITH MY SIMPLE REQUEST!

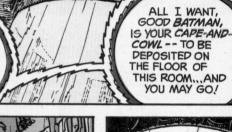

ALL I WANT, GOOD *BATMAN*, IS YOUR *CAPE-AND-COWL* -- TO BE DEPOSITED ON THE FLOOR OF THIS ROOM...AND YOU MAY GO!

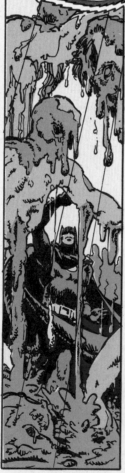

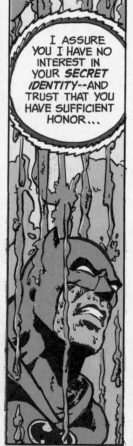

I ASSURE YOU I HAVE NO INTEREST IN YOUR *SECRET IDENTITY*--AND TRUST THAT YOU HAVE SUFFICIENT HONOR...

...NOT TO TRY TO *APPREHEND* ME WHEN I FREE YOU, AS I AGREE NOT TO LOOK AT YOUR UNMASKED FACE!

WHAT IS YOUR ANSWER-- YOUR *CAPE*...OR YOUR *LIFE?*

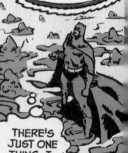

THERE'S JUST ONE THING I CAN DO NOW...

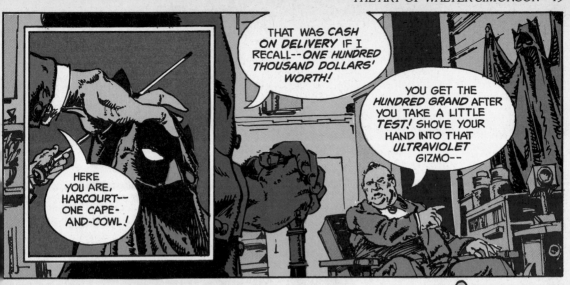
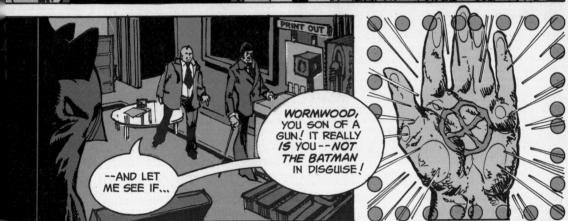
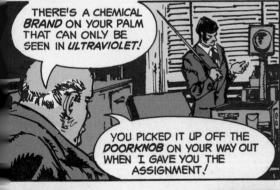
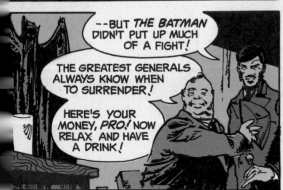
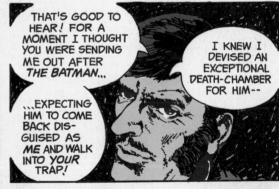
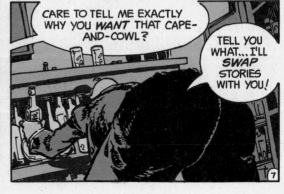

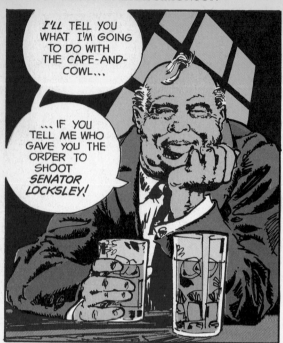

I'LL TELL YOU WHAT I'M GOING TO DO WITH THE CAPE-AND-COWL...

...IF YOU TELL ME WHO GAVE YOU THE ORDER TO SHOOT SENATOR LOCKSLEY!

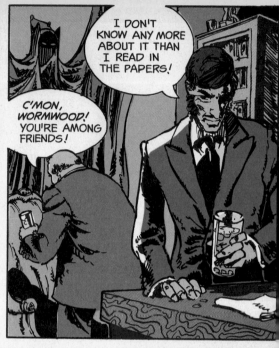

I DON'T KNOW ANY MORE ABOUT IT THAN I READ IN THE PAPERS!

C'MON, WORMWOOD! YOU'RE AMONG FRIENDS!

NEWS TRAVELS FAST IN THE UNDERGROUND! EVERYONE KNOWS YOU PULLED OFF THE ASSASSINATION!

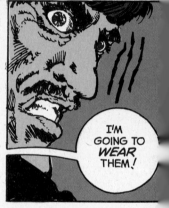

I'M GOING TO WEAR THEM!

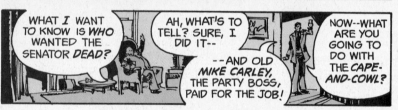

WHAT I WANT TO KNOW IS WHO WANTED THE SENATOR DEAD?

AH, WHAT'S TO TELL? SURE, I DID IT--

--AND OLD MIKE CARLEY, THE PARTY BOSS, PAID FOR THE JOB!

NOW--WHAT ARE YOU GOING TO DO WITH THE CAPE-AND-COWL?

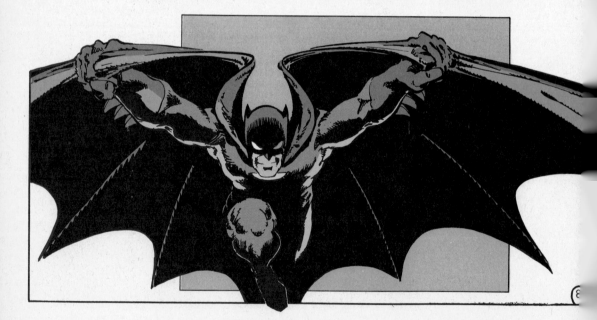

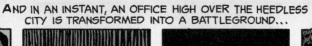

AND IN AN INSTANT, AN OFFICE HIGH OVER THE HEEDLESS CITY IS TRANSFORMED INTO A BATTLEGROUND...

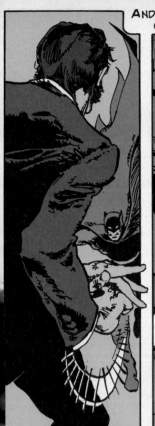 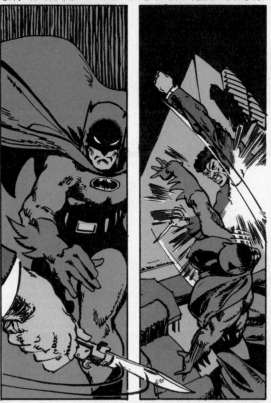 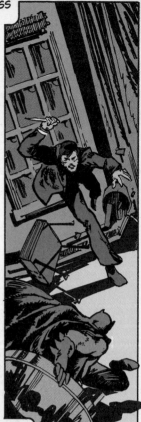

... FOR A MERCENARY KILLER WHOSE EVERY MOVE WARNS OF TREACHERY... AND A *BATMAN* WHOSE ONLY ALLY IS *JUSTICE*...

 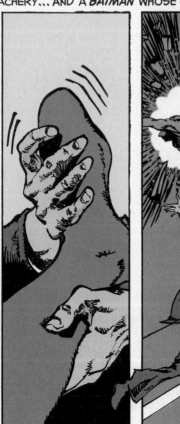 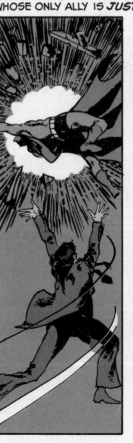 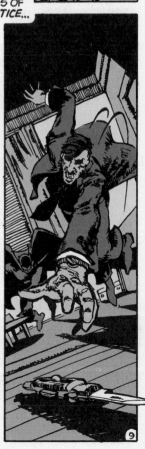

BEWARE
THIS AVENGING
CREATURE OF THE NIGHT!
THOSE WITH REASON TO
FEAR HIM ARE DESTROYED
BY THEIR FEAR...THOSE
WHO DO NOT FEAR
HIM ARE FOOLS!

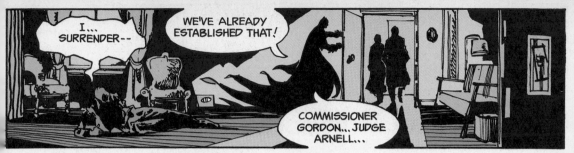

I... SURRENDER--

WE'VE ALREADY ESTABLISHED THAT!

COMMISSIONER GORDON... JUDGE ARNELL...

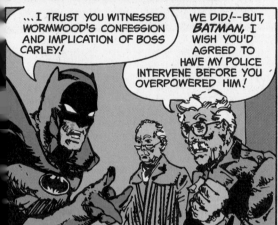

...I TRUST YOU WITNESSED WORMWOOD'S CONFESSION AND IMPLICATION OF BOSS CARLEY!

WE DID!--BUT, BATMAN, I WISH YOU'D AGREED TO HAVE MY POLICE INTERVENE BEFORE YOU OVERPOWERED HIM!

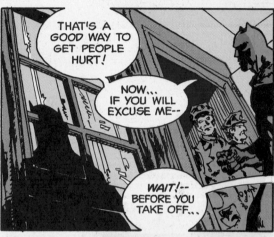

THAT'S A GOOD WAY TO GET PEOPLE HURT!

NOW... IF YOU WILL EXCUSE ME--

WAIT!-- BEFORE YOU TAKE OFF...

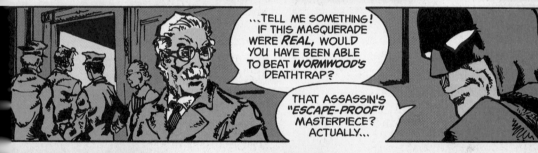

...TELL ME SOMETHING! IF THIS MASQUERADE WERE REAL, WOULD YOU HAVE BEEN ABLE TO BEAT WORMWOOD'S DEATHTRAP?

THAT ASSASSIN'S "ESCAPE-PROOF" MASTERPIECE? ACTUALLY...

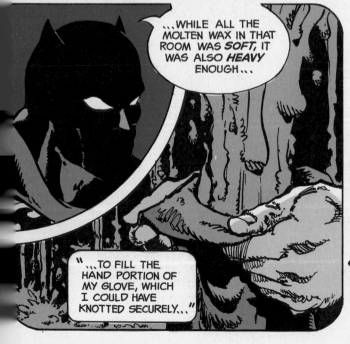

...WHILE ALL THE MOLTEN WAX IN THAT ROOM WAS SOFT, IT WAS ALSO HEAVY ENOUGH...

"...TO FILL THE HAND PORTION OF MY GLOVE, WHICH I COULD HAVE KNOTTED SECURELY..."

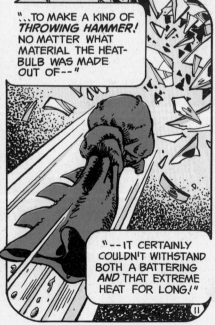

"..TO MAKE A KIND OF THROWING HAMMER! NO MATTER WHAT MATERIAL THE HEAT-BULB WAS MADE OUT OF--"

"--IT CERTAINLY COULDN'T WITHSTAND BOTH A BATTERING AND THAT EXTREME HEAT FOR LONG!"

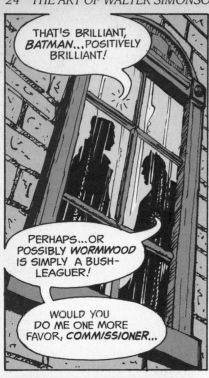

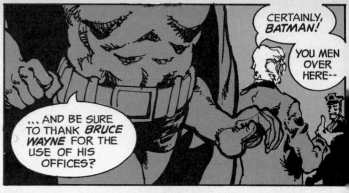

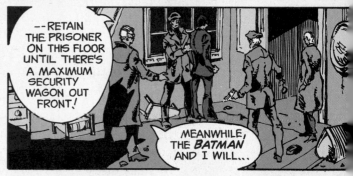

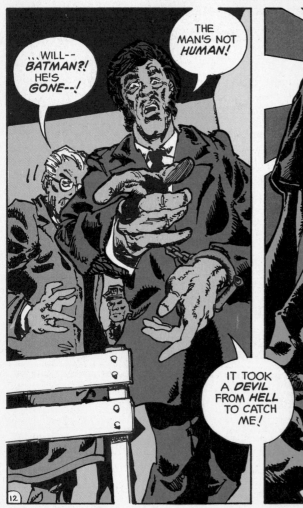

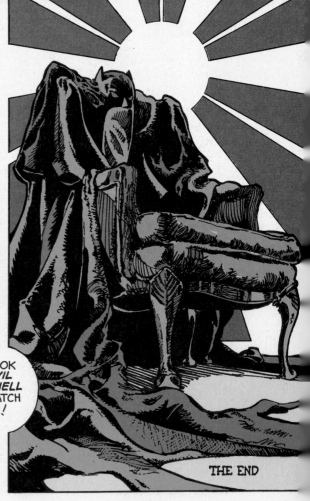

THE END

DOCTOR FATE

Writer Marty Pasko and I were both Dr. Fate fans and got the chance to do the first full-length adventure the character had ever had, for DC's new FIRST ISSUE SPECIAL title. But about the time I was halfway through drawing the book, DC shortened their books by two pages! There we were, merrily plugging along when, suddenly, our story was two pages shorter than our plot!

So we had to perform some instant corrective surgery (Inza rather miraculously discovered the mummy's real name) in order to trim the tale to publishable length, but the story doesn't seem damaged in retrospect.

The Nelsons also demonstrated their exceptional taste in cars by driving a Cord. That was done partly in homage to Alex Toth, who had done a brilliant Cord job a few years earlier for DC'S HOT WHEELS. It was a spectacular job that drove all of us young turks crazy at the time. Toth made it look so easy!

I'm not sure I've forgiven him yet.

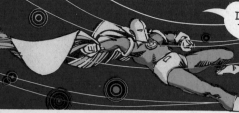

FROM A COLD AND LONELY TOWER WITHOUT WINDOWS OR DOORS STREAKS A FIGURE CLOAKED IN SPARKLING DARKNESS, GLIDING HIGH ABOVE WITCH-HAUNTED *SALEM*...

I DRAW *NEARER* TO THE PLACE THE CRYSTAL SHOWED -- *NEARER* TO THE *BATTLE* YET TO COME!

IT HAS BEEN *DESTINED* SINCE TIME BEYOND TIME -- AND *STILL* THE MORTAL MAN WITHIN ME... *SHUDDERS!*

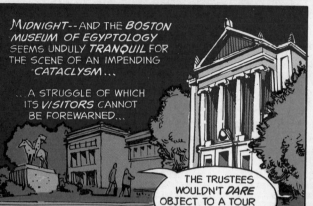

MIDNIGHT -- AND THE *BOSTON MUSEUM* OF *EGYPTOLOGY* SEEMS UNDULY *TRANQUIL* FOR THE SCENE OF AN IMPENDING *CATACLYSM*...

..A STRUGGLE OF WHICH ITS *VISITORS* CANNOT BE FOREWARNED...

THE TRUSTEES WOULDN'T *DARE* OBJECT TO A TOUR AT THIS HOUR...

...NOT FOR SO *DISTINGUISHED* A GUEST AS YOURSELF, *DR. MAGILL.*

⸮ AHEM ⸮ THANK YOU, ANDERSON. AWFULLY *GOOD* OF YOU.

NONSENSE, DOCTOR. I COULDN'T LET YOU LEAVE BOSTON WITHOUT SEEING OUR LATEST *ACQUISITIONS!*

OUR LAST EGYPTIAN DIG UNCOVERED SEVERAL RELICS FROM A RELIGIOUS *CULT* OF THE MIDDLE KINGDOM -- DATING FROM AROUND *2025 B.C.* ...

KREEK!

EH--? OF ALL THE CHILDISH *GAMES*--!

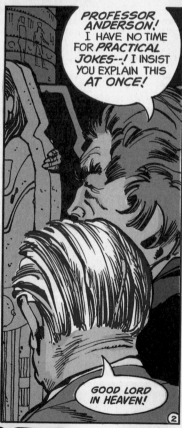

PROFESSOR *ANDERSON!* I HAVE NO TIME FOR *PRACTICAL JOKES*--! I INSIST YOU EXPLAIN THIS *AT ONCE!*

GOOD LORD IN HEAVEN!

ARRGGGG...!

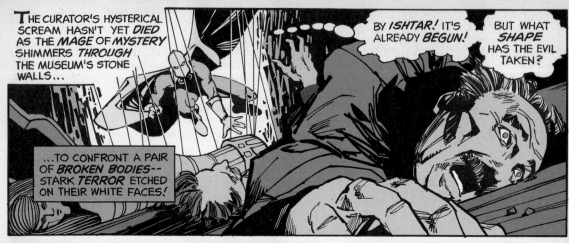

THE CURATOR'S HYSTERICAL SCREAM HASN'T YET *DIED* AS THE *MAGE* OF *MYSTERY* SHIMMERS *THROUGH* THE MUSEUM'S STONE WALLS...

BY *ISHTAR!* IT'S ALREADY *BEGUN!*

BUT WHAT *SHAPE* HAS THE EVIL TAKEN?

...TO CONFRONT A PAIR OF *BROKEN BODIES*-- STARK *TERROR* ETCHED ON THEIR WHITE FACES!

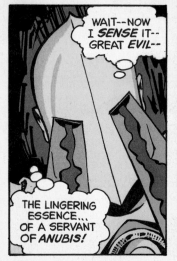

WAIT--NOW I *SENSE* IT-- GREAT *EVIL*--

THE LINGERING ESSENCE... OF A SERVANT OF *ANUBIS!*

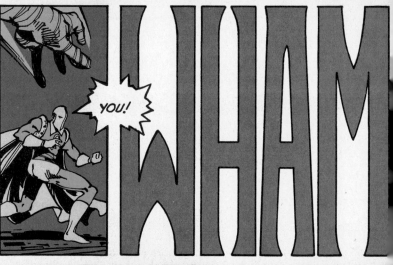

YOU!

WHAM

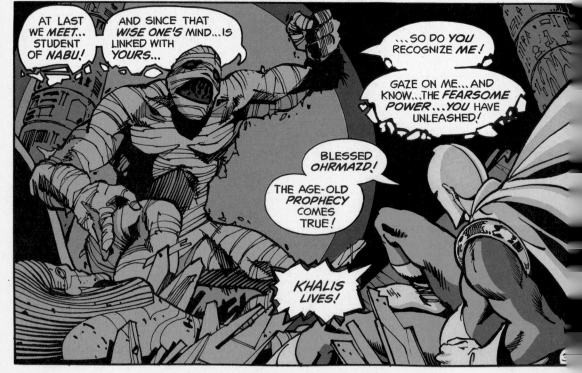

AT LAST WE *MEET*... STUDENT OF *NABU!*

AND SINCE THAT *WISE ONE'S* MIND...IS LINKED WITH YOURS...

...SO DO *YOU* RECOGNIZE *ME!*

GAZE ON ME...AND KNOW...THE *FEARSOME POWER*...YOU HAVE UNLEASHED!

BLESSED *OHRMAZD!*

THE AGE-OLD *PROPHECY* COMES TRUE!

KHALIS LIVES!

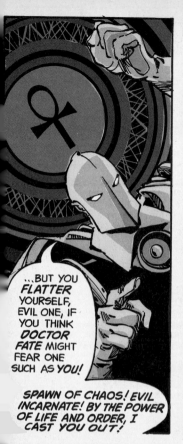

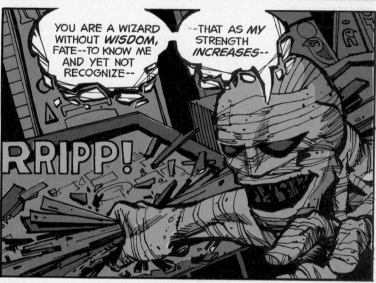

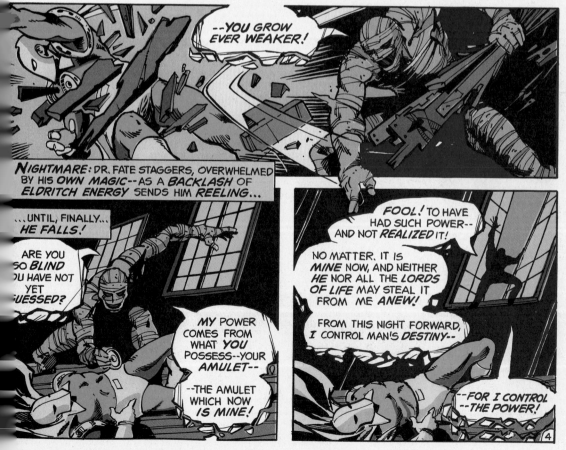

HOURS PASS AS THE MYSTIC LIES MOTIONLESS, LOCKED IN A DEATHLIKE *SLEEP*...

...UNTIL AT LAST A FINGER OF *SUNLIGHT* SLOWLY PRODS HIM BACK TO *CONSCIOUS-NESS*... AND HE DISCOVERS HIS AMULET... *GONE!*

HEAR ME, O GREAT *KA*-- LORD OF THE ETHEREAL PLANE! GRANT ME *COMMUNION* WITH *KHALIS*--SO THAT MY MIND MAY BE *MERGED* WITH HIS--! IT'S *FUTILE!* ARMED WITH THE AMULET OF *NABU*, KHALIS NOW HAS THE POWER TO BLOT OUT MY *PSYCHIC-PROBE*--TO RESIST ANY ASTRAL *INTERFERENCE!*

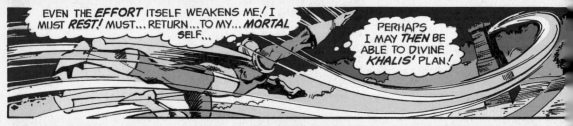

EVEN THE *EFFORT* ITSELF WEAKENS ME! I MUST *REST!* MUST...RETURN...TO MY...*MORTAL* SELF...

PERHAPS I MAY *THEN* BE ABLE TO DIVINE *KHALIS'* PLAN!

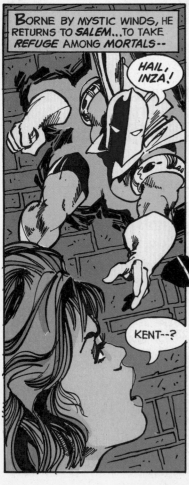

BORNE BY MYSTIC WINDS, HE RETURNS TO *SALEM*...TO TAKE *REFUGE* AMONG *MORTALS*--

HAIL, INZA!

KENT--?

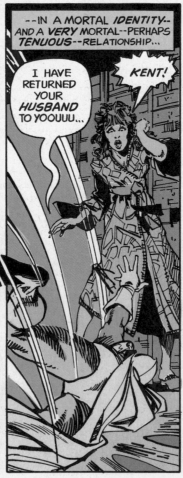

--IN A MORTAL *IDENTITY*-- AND A *VERY* MORTAL--PERHAPS *TENUOUS*--RELATIONSHIP...

I HAVE RETURNED YOUR *HUSBAND* TO YOOUUU...

KENT!

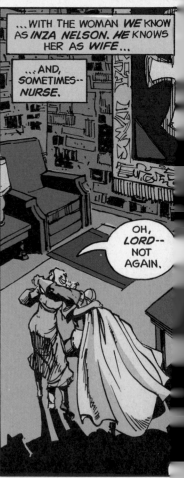

...WITH THE WOMAN *WE* KNOW AS *INZA NELSON. HE* KNOWS HER AS *WIFE*...

...AND, SOMETIMES-- *NURSE.*

OH, *LORD*-- NOT AGAIN.

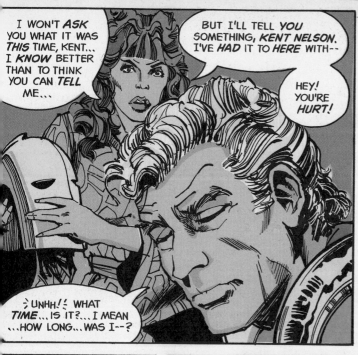

I WON'T ASK YOU WHAT IT WAS THIS TIME, KENT... I KNOW BETTER THAN TO THINK YOU CAN TELL ME...

BUT I'LL TELL YOU SOMETHING, KENT NELSON. I'VE HAD IT TO HERE WITH--

HEY! YOU'RE HURT!

¿UNHH!? WHAT TIME... IS IT?... I MEAN ...HOW LONG... WAS I--?

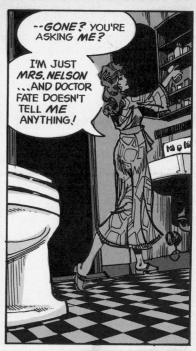

--GONE? YOU'RE ASKING ME?

I'M JUST MRS. NELSON ...AND DOCTOR FATE DOESN'T TELL ME ANYTHING!

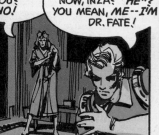

I BANDAGE YOUR WOUNDS ...WAKE YOU FROM YOUR NIGHTMARES...I STAY UP ALL NIGHT WONDERING IF YOU'LL EVER COME HOME...BUT WILL HE TELL ME WHAT HE GOES TO YOU? NO!

DO WE HAVE TO GO THROUGH THIS NOW, INZA? "HE"? YOU MEAN, ME--I'M DR. FATE!

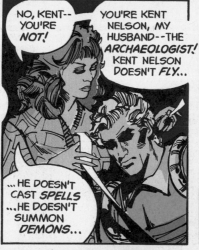

NO, KENT-- YOU'RE NOT!

YOU'RE KENT NELSON, MY HUSBAND--THE ARCHAEOLOGIST! KENT NELSON DOESN'T FLY...

...HE DOESN'T CAST SPELLS ...HE DOESN'T SUMMON DEMONS...

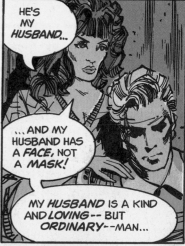

HE'S MY HUSBAND...

...AND MY HUSBAND HAS A FACE, NOT A MASK!

MY HUSBAND IS A KIND AND LOVING -- BUT ORDINARY--MAN...

...AND THAT KIND OF MAN DOESN'T RUN AFTER RIDICULOUS MENACES WHICH DON'T CONCERN HIM...THEN COME HOME HALF-DEAD!

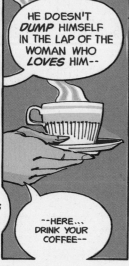

HE DOESN'T DUMP HIMSELF IN THE LAP OF THE WOMAN WHO LOVES HIM--

--HERE... DRINK YOUR COFFEE--

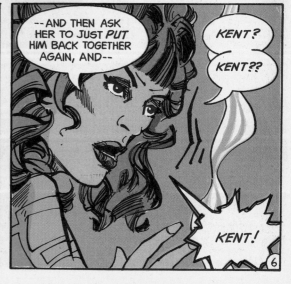

--AND THEN ASK HER TO JUST PUT HIM BACK TOGETHER AGAIN, AND--

KENT?

KENT??

KENT!

6

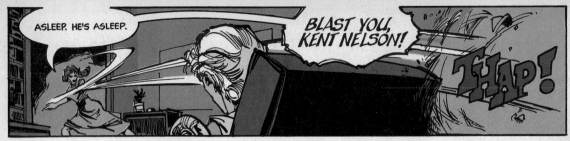

ASLEEP. HE'S ASLEEP.

BLAST YOU, KENT NELSON!

THAP!

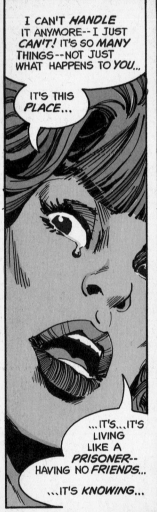

I CAN'T *HANDLE* IT ANYMORE-- I JUST *CAN'T!* IT'S SO *MANY* THINGS--NOT JUST WHAT HAPPENS TO *YOU*...

IT'S THIS *PLACE*...

...IT'S...IT'S LIVING LIKE A *PRISONER*--HAVING NO *FRIENDS*...

...IT'S *KNOWING*...

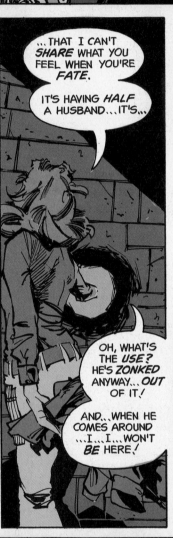

...THAT I CAN'T *SHARE* WHAT YOU FEEL WHEN YOU'RE *FATE*.

IT'S HAVING *HALF* A HUSBAND...IT'S...

OH, WHAT'S THE *USE?* HE'S *ZONKED* ANYWAY...*OUT* OF IT!

AND...WHEN HE COMES AROUND ...I...I...WON'T *BE* HERE!

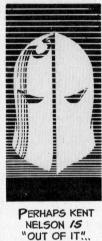

PERHAPS KENT NELSON *IS* "OUT OF IT"...BUT *HALF* OF HIM HAS HEARD HIS WIFE'S TEARFUL WORDS...

...AND *HALF* OF HIM CRIES, *TOO.*

...WHILE THE *OTHER* HALF HEARS BUT *ONE* WORD:

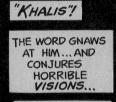

"KHALIS"!

THE WORD GNAWS AT HIM...AND CONJURES HORRIBLE *VISIONS*...

BUT WHAT DOES IT *MEAN?*

HE GOES TO THE ONE PLACE WHERE HE MAY FIND OUT-- A *STUDY* --A CHAMBER ALIVE WITH THE WISDOM OF THE AGES-- *CULLED* BY ARCHAEOLOGIST NELSON FROM COUNTLESS DIGS...

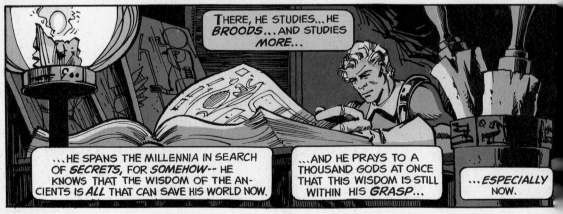

THERE, HE STUDIES...HE *BROODS*...AND STUDIES *MORE*...

...HE SPANS THE MILLENNIA IN SEARCH OF *SECRETS*, FOR *SOMEHOW*-- HE KNOWS THAT THE WISDOM OF THE ANCIENTS IS *ALL* THAT CAN SAVE HIS WORLD NOW.

...AND HE PRAYS TO A THOUSAND GODS AT ONCE THAT THIS WISDOM IS STILL WITHIN HIS *GRASP*...

....*ESPECIALLY* NOW.

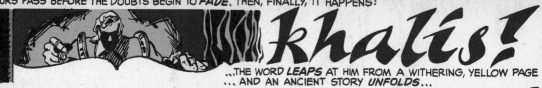

...OURS PASS BEFORE THE DOUBTS BEGIN TO *FADE*. THEN, FINALLY, IT HAPPENS:

khalis!

...THE WORD *LEAPS* AT HIM FROM A WITHERING, YELLOW PAGE
...AND AN ANCIENT STORY *UNFOLDS*...

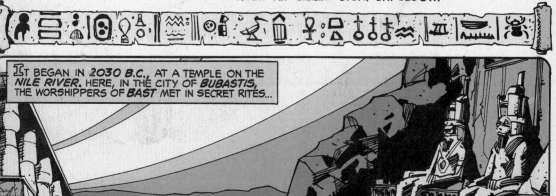

IT BEGAN IN *2030 B.C.*, AT A TEMPLE ON THE *NILE RIVER*. HERE, IN THE CITY OF *BUBASTIS*, THE WORSHIPPERS OF *BAST* MET IN SECRET RITES...

INTO THEIR MIDST CAME A PRIEST NAMED *KHALIS*... A "*MAD PRIEST*"...!

BUBASTIS HAD SEEN *MANY* OF THESE, PREACHING A *GLORIOUS* AFTERLIFE AMONG THE LORDS OF LIFE, *OSIRIS*, AND *AMON-RA*...

BUT THIS KHALIS SERVED A *DIFFERENT* GOD...*VERY DIFFERENT*...

HEAR ME, WORSHIPPERS OF FALSE GODS! I BRING YOU *DEATH* --THE TERRIBLE PUNISHMENT OF *ANUBIS!*

FEEL HIS *STING*--AND KNOW YOUR TRUE MASTER'S *WRATH!*

8

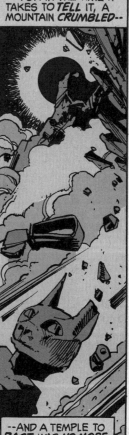

THE RETRIBUTION WAS *INDEED* TERRIBLE --FOR IN THE TIME IT TAKES TO *TELL* IT, A MOUNTAIN *CRUMBLED*--

--AND A TEMPLE TO *BAST* WAS NO MORE.

8

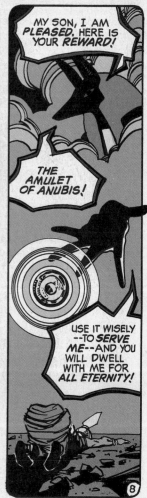

MY SON, I AM *PLEASED*. HERE IS YOUR *REWARD!*

THE *AMULET OF ANUBIS!*

USE IT WISELY --TO *SERVE ME*--AND YOU WILL DWELL WITH ME FOR *ALL ETERNITY!*

A LEGION OF NUBIAN SLAVES LABORED *YEARS* TO BUILD THAT TEMPLE--DRIVEN BY A *POWER* WHICH GRIPPED THEM LIKE THE FIST OF ANGRY ANUBIS *HIMSELF...*

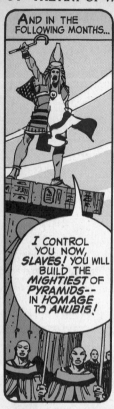

AND IN THE FOLLOWING MONTHS...

I CONTROL YOU NOW, *SLAVES!* YOU WILL BUILD THE *MIGHTIEST* OF PYRAMIDS-- IN *HOMAGE* TO *ANUBIS!*

...UNTIL ONE DAY THERE CAME A *STRANGER* WHO *WOULD NOT* BE BROKEN BY THE TALISMAN'S POWER...

ONLY THE DIVINE *PHARAOH* MAY BE HONORED BY SUCH A TEMPLE!

NO *LONGER* WILL YOU *DEFY* THE *LORDS* OF LIFE, KHALIS!

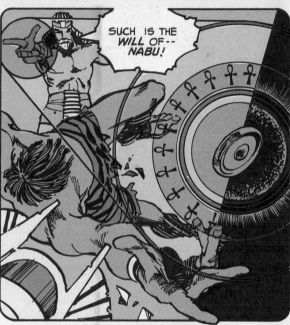

SUCH IS THE *WILL* OF-- *NABU!*

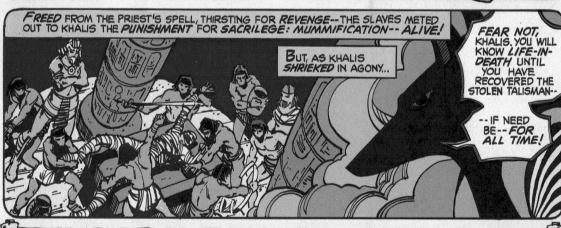

FREED FROM THE PRIEST'S SPELL, THIRSTING FOR *REVENGE*--THE SLAVES METED OUT TO KHALIS THE *PUNISHMENT* FOR *SACRILEGE: MUMMIFICATION--ALIVE!*

BUT, AS KHALIS *SHRIEKED* IN AGONY...

FEAR NOT, KHALIS, YOU WILL KNOW *LIFE-IN-DEATH* UNTIL YOU HAVE RECOVERED THE STOLEN TALISMAN--

--IF NEED BE--*FOR ALL TIME!*

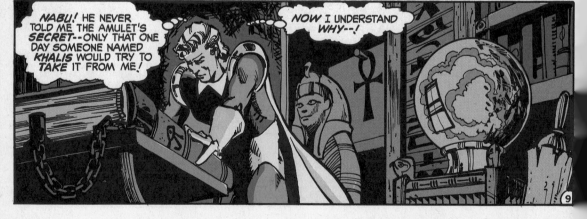

NABU! HE NEVER TOLD ME THE AMULET'S *SECRET*--ONLY THAT ONE DAY SOMEONE NAMED *KHALIS* WOULD TRY TO *TAKE* IT FROM ME!

NOW I UNDERSTAND *WHY--!*

9

TO *SHARE* THAT UNDERSTANDING, WE MUST TURN TIME BACK *5 YEARS* -- TO THE *VALLEY OF UR*...

...WHERE ARCHAEO- GIST *SVEN NELSON* AND HIS 12-YEAR-OLD SON *KENT* EXPLORED THE RUINS OF THE *SUMERIAN CIVILIZATION*... AND FOUND MORE THAN THEY EVER *DREAMED!*

THE *BOY* FOUND A *TURNING- POINT* IN HIS YOUNG LIFE...

...WHEN HE *STUMBLED* UPON AN ANCIENT TOMB...

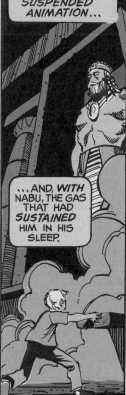

...AND ACCIDENTALLY RELEASED THE WIZARD NAMED *NABU* FROM CENTURIES OF *SUSPENDED ANIMATION*...

...AND, *WITH* NABU, THE GAS THAT HAD *SUSTAINED* HIM IN HIS SLEEP.

FOR SOME REASON THAT GAS PROVED *LETHAL* TO THE BOY'S FATHER...

...AND *SVEN* NELSON *DIED.*

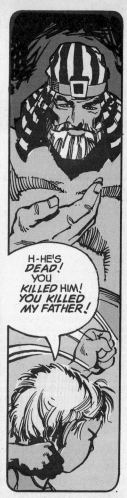

H-HE'S *DEAD!* YOU *KILLED* HIM! *YOU KILLED MY FATHER!*

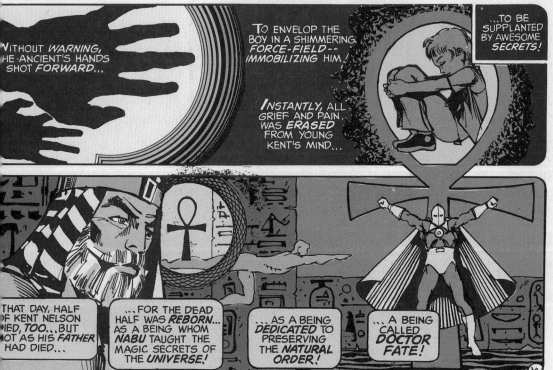

WITHOUT WARNING, THE ANCIENT'S HANDS SHOT *FORWARD*...

TO ENVELOP THE BOY IN A SHIMMERING *FORCE-FIELD* -- IMMOBILIZING HIM!

INSTANTLY, ALL GRIEF AND PAIN WAS *ERASED* FROM YOUNG KENT'S MIND...

...TO BE SUPPLANTED BY AWESOME *SECRETS!*

THAT DAY, HALF OF KENT NELSON *DIED, TOO*...BUT NOT AS HIS *FATHER* HAD DIED...

...FOR THE DEAD HALF WAS *REBORN*... AS A BEING WHOM *NABU* TAUGHT THE MAGIC SECRETS OF THE *UNIVERSE!*

...AS A BEING *DEDICATED* TO PRESERVING THE *NATURAL ORDER!*

...A BEING CALLED *DOCTOR FATE!*

WHEN NABU GAVE ME THE AMULET, HE DARED NOT REVEAL ITS *POWER*-- LEST HE REND THE FABRIC OF *DESTINY!*

NOW THE ULTIMATE *TEST* OF MY ELDRITCH POWER *AWAITS* ME! IT IS ORDAINED BY... *FATE!*

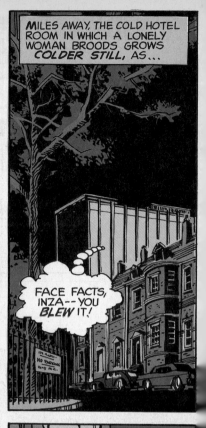

MILES AWAY, THE COLD HOTEL ROOM IN WHICH A LONELY WOMAN BROODS GROWS *COLDER STILL,* AS...

FACE FACTS, INZA-- YOU *BLEW* IT!

YOU'RE JUST WHAT EVERY SLIGHTLY *SCHIZOID* HERO *NEEDS!*

A LOVING WIFE WHO *CUTS OUT* WHEN HE NEEDS HER THE *MOST!*

TUH-*RIFF*IC.

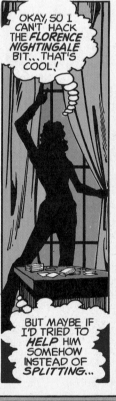

OKAY, SO I CAN'T *HACK* THE *FLORENCE NIGHTINGALE* BIT...THAT'S COOL!

BUT MAYBE IF I'D TRIED TO *HELP* HIM SOMEHOW INSTEAD OF *SPLITTING...*

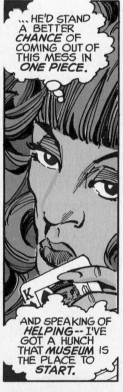

...HE'D STAND A BETTER *CHANCE* OF COMING OUT OF THIS MESS IN *ONE PIECE.*

AND SPEAKING OF *HELPING*-- I'VE GOT A HUNCH THAT *MUSEUM* IS THE PLACE TO *START.*

SLAM

I'LL DRIVE OUT THERE AND *POKE AROUND* -- SEE WHAT I CAN DIG UP!

I DON'T KNOW WHAT I'M *LOOKING* FOR...

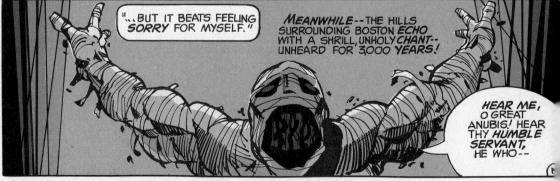

"...BUT IT BEATS FEELING *SORRY* FOR MYSELF."

MEANWHILE--THE HILLS SURROUNDING BOSTON *ECHO* WITH A SHRILL, UNHOLY *CHANT*-- UNHEARD FOR *3,000 YEARS!*

HEAR ME, O GREAT ANUBIS! HEAR THY *HUMBLE* SERVANT, HE WHO--

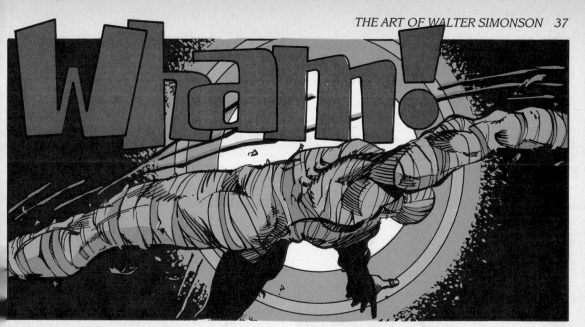

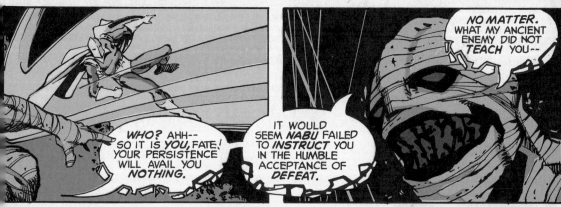

NO MATTER. WHAT MY ANCIENT ENEMY DID NOT *TEACH* YOU--

WHO? AHH-- SO IT IS *YOU*, FATE! YOUR PERSISTENCE WILL AVAIL YOU *NOTHING*.

IT WOULD SEEM *NABU* FAILED TO *INSTRUCT* YOU IN THE HUMBLE ACCEPTANCE OF *DEFEAT*.

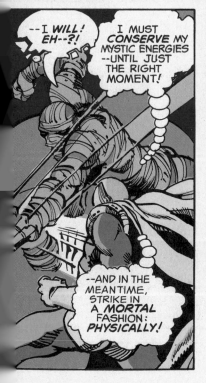

--I *WILL!* EH--?!

I MUST *CONSERVE* MY MYSTIC ENERGIES --UNTIL JUST THE RIGHT MOMENT!

--AND IN THE MEANTIME, STRIKE IN A *MORTAL* FASHION: PHYSICALLY!

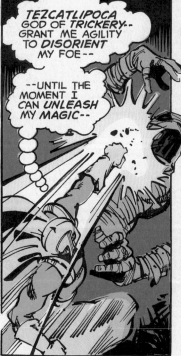

TEZCATLIPOCA GOD OF *TRICKERY*-- GRANT ME AGILITY TO *DISORIENT* MY FOE--

--UNTIL THE MOMENT I CAN *UNLEASH* MY MAGIC--

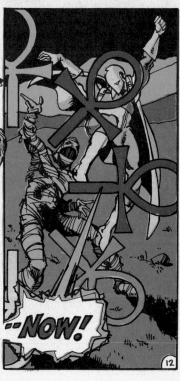

--NOW!

12

INSTANTLY, ALL THE LIGHTS IN THE BOSTON SKYLINE *WINK OUT*, PLUNGING THE GREAT METROPOLIS INTO A DARKNESS DEEPER THAN *SLEEP*...

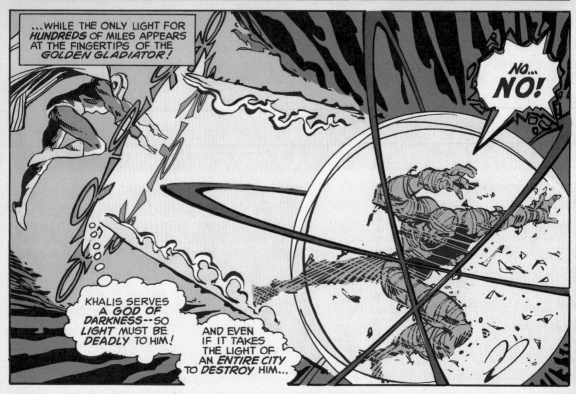

...WHILE THE ONLY LIGHT FOR *HUNDREDS* OF MILES APPEARS AT THE FINGERTIPS OF THE *GOLDEN GLADIATOR!*

NO... NO!

KHALIS SERVES A *GOD OF DARKNESS*--SO *LIGHT* MUST BE *DEADLY* TO HIM!

AND EVEN IF IT TAKES THE LIGHT OF AN *ENTIRE CITY* TO *DESTROY* HIM...

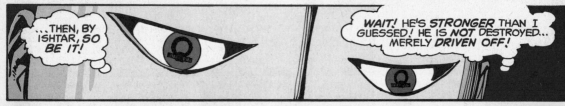

...THEN, BY ISHTAR, *SO BE IT!*

WAIT! HE'S *STRONGER* THAN I GUESSED! HE IS *NOT* DESTROYED... MERELY *DRIVEN OFF!*

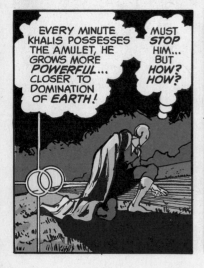

EVERY MINUTE KHALIS POSSESSES THE AMULET, HE GROWS MORE *POWERFUL*... CLOSER TO DOMINATION OF *EARTH!*

MUST *STOP* HIM... BUT *HOW? HOW?*

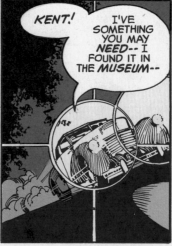

KENT!

I'VE SOMETHING YOU MAY *NEED*-- I FOUND IT IN THE *MUSEUM*--

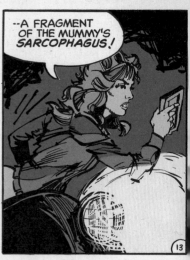

--A FRAGMENT OF THE MUMMY'S *SARCOPHAGUS!*

13

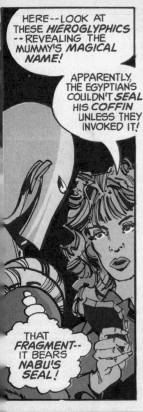

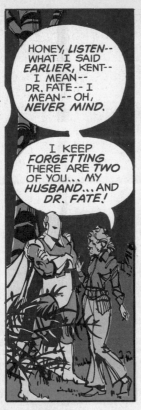

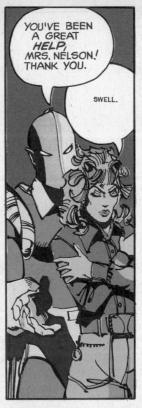

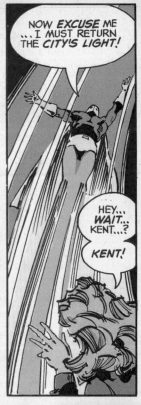

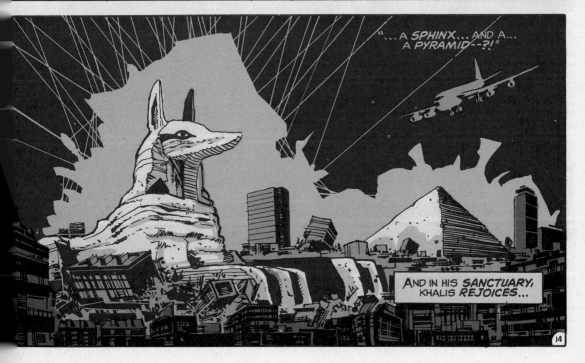

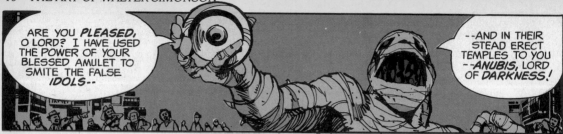

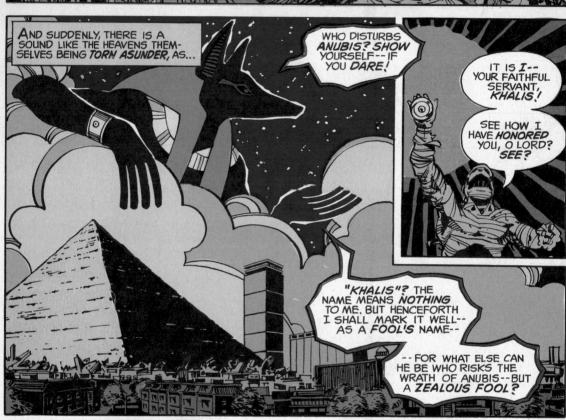

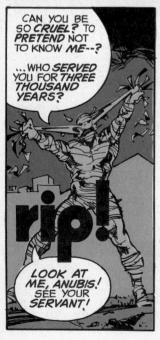

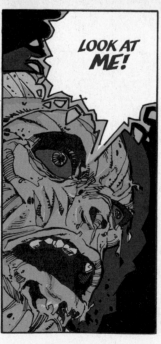

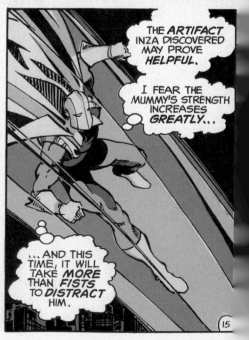

HAH! LOOK AT *YOU*-- WHO ARE NAUGHT BUT ROTTING FLESH AND CRUMBLING BONE?

I COULD SOONER SEE A *MAGGOT'S* SOUL THAN RECOGNIZE *YOU!* HOWEVER...

...I *MAY* CONSIDER YOUR CAUSE... *IF* YOU *DESTROY* THAT ANNOYING *DR. FATE!*

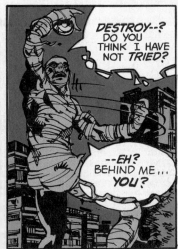

DESTROY--? DO YOU THINK I HAVE NOT *TRIED?*

--EH? BEHIND ME... *YOU?*

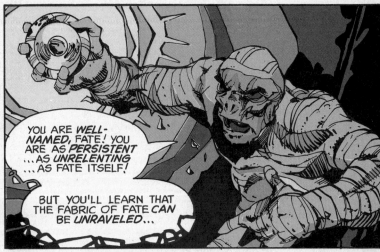

YOU ARE *WELL-NAMED*, FATE! YOU ARE AS *PERSISTENT* ...AS *UNRELENTING* ...AS *FATE* ITSELF!

BUT YOU'LL LEARN THAT THE FABRIC OF FATE *CAN* BE *UNRAVELED*...

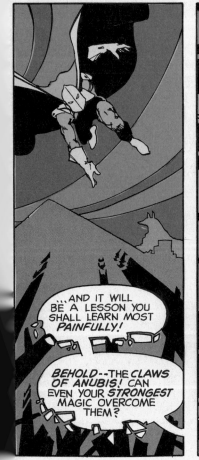

...AND IT WILL BE A LESSON YOU SHALL LEARN MOST *PAINFULLY!*

BEHOLD-- THE CLAWS OF ANUBIS! CAN EVEN YOUR *STRONGEST* MAGIC OVERCOME THEM?

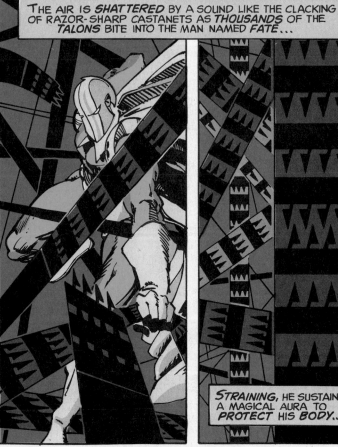

THE AIR IS *SHATTERED* BY A SOUND LIKE THE CLACKING OF RAZOR-SHARP CASTANETS AS *THOUSANDS* OF THE *TALONS* BITE INTO THE MAN NAMED *FATE*...

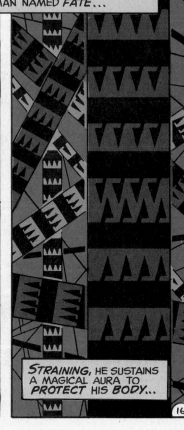

STRAINING, HE SUSTAINS A MAGICAL AURA TO *PROTECT* HIS *BODY*...

16

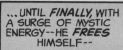

...UNTIL *FINALLY,* WITH A SURGE OF *MYSTIC* ENERGY--HE *FREES* HIMSELF--

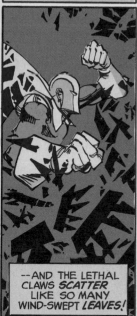

--AND THE LETHAL CLAWS *SCATTER* LIKE SO MANY WIND-SWEPT *LEAVES!*

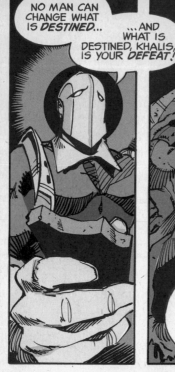

NO MAN CAN CHANGE WHAT IS *DESTINED...*

...AND WHAT IS DESTINED, KHALIS, IS YOUR *DEFEAT!*

THE SEAL--HE HAS THE *SARCOPHAGUS SEAL!*

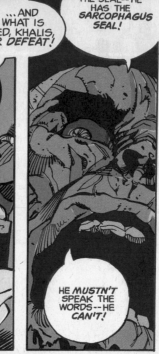

HE *MUSTN'T* SPEAK THE WORDS--HE *CAN'T!*

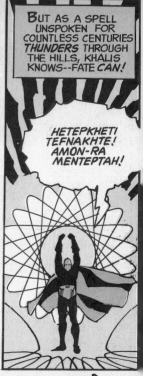

BUT AS A SPELL UNSPOKEN FOR COUNTLESS CENTURIES *THUNDERS* THROUGH THE HILLS, KHALIS KNOWS--FATE *CAN!*

HETEPKHET! TEFNAKHTE! AMON-RA MENTEPTAH!

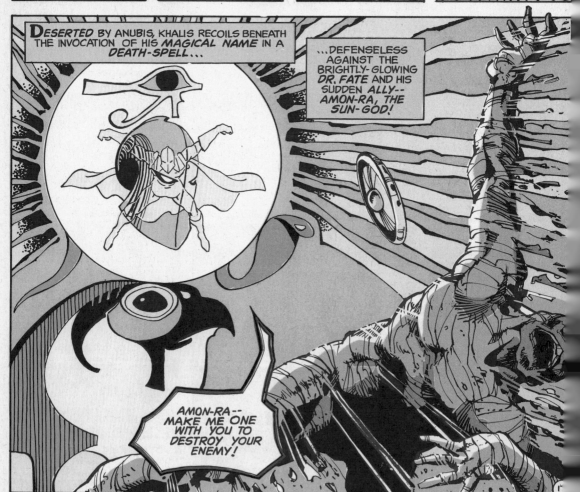

DESERTED BY ANUBIS, KHALIS RECOILS BENEATH THE INVOCATION OF HIS *MAGICAL NAME* IN A *DEATH-SPELL...*

...DEFENSELESS AGAINST THE BRIGHTLY-GLOWING *DR. FATE* AND HIS SUDDEN *ALLY--* AMON-RA, THE *SUN-GOD!*

AMON-RA-- MAKE ME ONE WITH YOU TO DESTROY YOUR ENEMY!

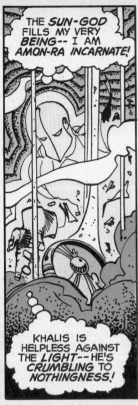

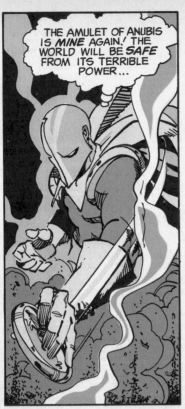

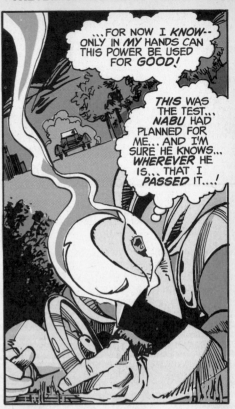

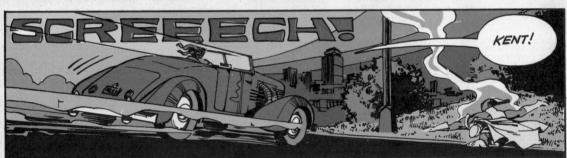

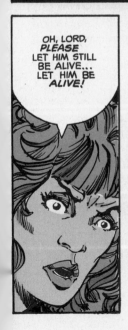

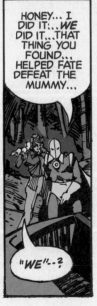

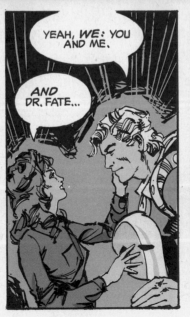

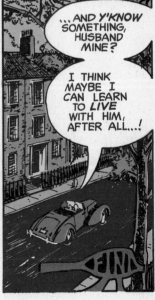

CAPTAIN FEAR

In the early 1970s, DC published several stories starring a pirate named *Captain Fear*. Beautifully drawn by Alex Nino, the stories were an historical rat's nest. The tales were set in the 1850s, more than a hundred years after the heyday of the Caribbean buccaneers, yet featured Spaniards wearing the helmets of conquistadors, unidentifiable but undeniably ancient firearms, and ship types (when they were identifiable) that were hundreds of years out of date!

I have always loved old sailing ships and drawing them in a story had always been one of my ambitions. *Captain Fear* offered the perfect opportunity, and David Michelinie and I fashioned the tale, recasting our hero in the mid-18th century (a mere thirty years after the apex of pirate glory). We sandwiched in full-rigged ships, a ninja warrior, and as much real history as we could inject.

Some three or four years went by before I finally finished the artwork. In that time, though, I must have bought a couple of dozen books on old sailing ships, trying to condense my passion into 18 pages. I used an antique Caslon typeface for the sound effects to suggest a period piece, and generally sweated a lot more over three short episodes than I had ever thought possible. I can still remember Paul Levitz, with a gleam in his eye, showing me the schedules wherein was writ large the latest DC job then under construction—*Captain Fear!* I'd like to think Paul took as much pride in that as I did, but I could be kidding myself.

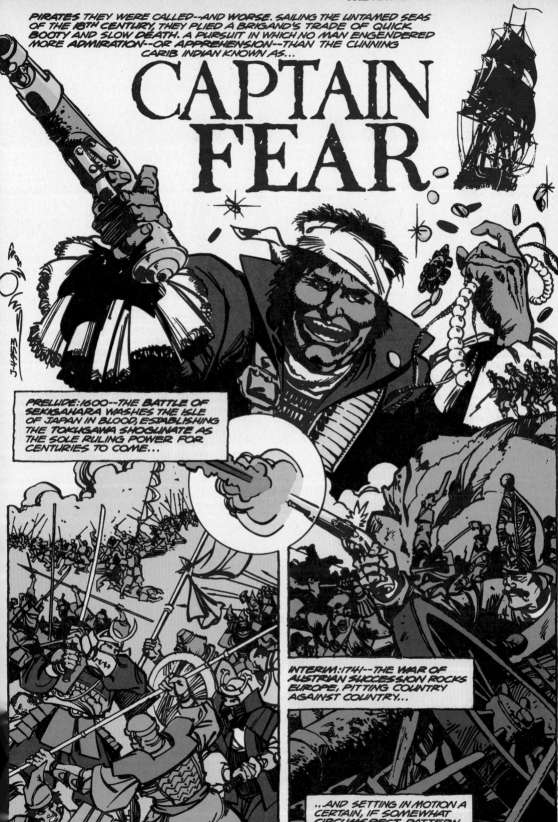

PIRATES THEY WERE CALLED--AND WORSE. SAILING THE UNTAMED SEAS OF THE 18TH CENTURY, THEY PLIED A BRIGAND'S TRADE OF QUICK BOOTY AND SLOW DEATH. A PURSUIT IN WHICH NO MAN ENGENDERED MORE ADMIRATION--OR APPREHENSION--THAN THE CUNNING CARIB INDIAN KNOWN AS...

CAPTAIN FEAR.

PRELUDE: 1600--THE BATTLE OF SEKIGAHARA WASHES THE ISLE OF JAPAN IN BLOOD, ESTABLISHING THE TOKUGAWA SHOGUNATE AS THE SOLE RULING POWER FOR CENTURIES TO COME...

INTERIM: 1741--THE WAR OF AUSTRIAN SUCCESSION ROCKS EUROPE, PITTING COUNTRY AGAINST COUNTRY...

...AND SETTING IN MOTION A CERTAIN, IF SOMEWHAT CIRCUMSPECT, PATTERN FOR--

BY DAVID MICHELINIE / WALTER SIMONSON JOHN WORKMAN / letterer CARL GAFFORD colorist

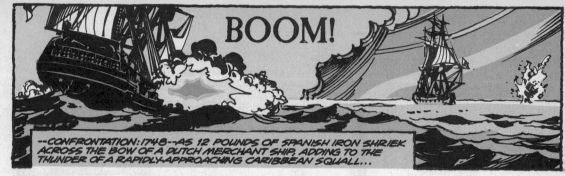

--CONFRONTATION: 1748 --AS 12 POUNDS OF SPANISH IRON SHRIEK ACROSS THE BOW OF A DUTCH MERCHANT SHIP, ADDING TO THE THUNDER OF A RAPIDLY-APPROACHING CARIBBEAN SQUALL...

YOU HAVE BEEN *WARNED*, SEÑOR--*HEAVE TO!* OR TAKE THE *NEXT* VOLLEY AT YOUR *WATER LINE!*

CARAMBA! NO *ANSWER!* VERY WELL, *GUNMASTER*, LET US SEE IF THOSE *PUERCOS* CAN IGNORE A *SECOND--*

SAIL HO, CAPITÁN!

SHIP APPROACHING FAST FROM THE SQUALL LINE!

QUÉ...? BUT WHAT IS ANOTHER *TRADING* VESSEL DOING SO CLOSE TO--

MADRE DE DIOS, CAPITÁN, S-SHE IS NO *MERCHANT!* SHE IS--

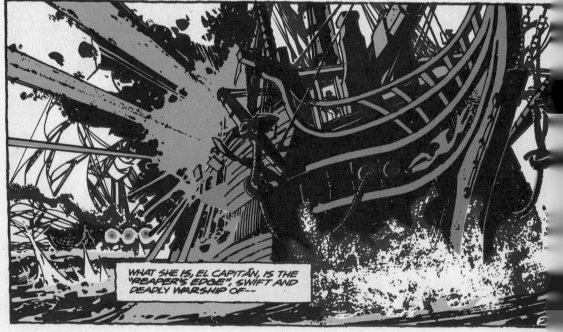

WHAT SHE IS, EL CAPITÁN, IS THE "REAPER'S EDGE", SWIFT AND DEADLY WARSHIP OF--

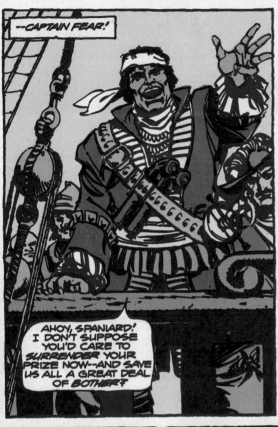

--CAPTAIN FEAR!

AHOY, SPANIARD! I DON'T SUPPOSE YOU'D CARE TO *SURRENDER* YOUR *PRIZE* NOW--AND SAVE US ALL A GREAT DEAL OF *BOTHER?*

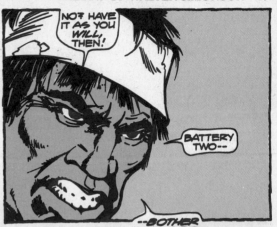

NO? HAVE IT AS YOU *WILL,* THEN!

BATTERY *TWO--*

--BOTHER THEM A BIT *MORE!*

TH-BOOM!

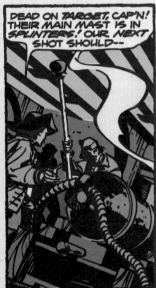

DEAD ON *TARGET,* CAP'N! THEIR MAIN MAST IS IN *SPLINTERS!* OUR *NEXT* SHOT SHOULD--

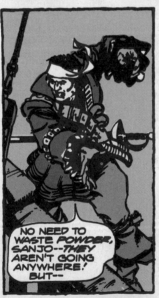

NO NEED TO WASTE *POWDER,* SANJO--*THEY* AREN'T GOING ANYWHERE! BUT--

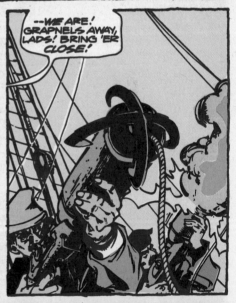

--WE ARE! GRAPNELS AWAY, LADS! BRING 'ER *CLOSE!*

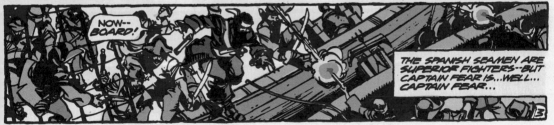

NOW-- *BOARD!*

THE SPANISH SEAMEN ARE *SUPERIOR* FIGHTERS--BUT CAPTAIN FEAR IS...*WELL....* CAPTAIN FEAR...

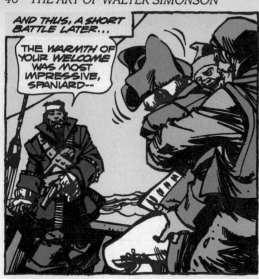

AND THUS, A SHORT BATTLE LATER...

THE WARMTH OF YOUR WELCOME WAS MOST IMPRESSIVE, SPANIARD--

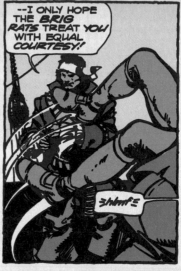

--I ONLY HOPE THE BRIG RATS TREAT YOU WITH EQUAL COURTESY!

SHInK!

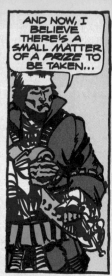

AND NOW, I BELIEVE THERE'S A SMALL MATTER OF A PRIZE TO BE TAKEN...

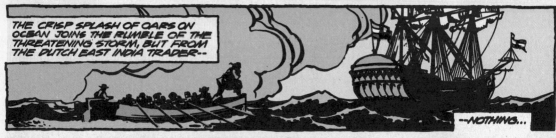

THE CRISP SPLASH OF OARS ON OCEAN JOINS THE RUMBLE OF THE THREATENING STORM, BUT FROM THE DUTCH EAST INDIA TRADER--

--NOTHING...

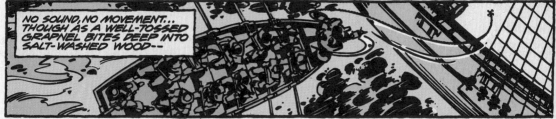

NO SOUND, NO MOVEMENT... THOUGH AS A WELL-TOSSED GRAPNEL BITES DEEP INTO SALT-WASHED WOOD--

--THE REASON FOR THAT SILENCE--

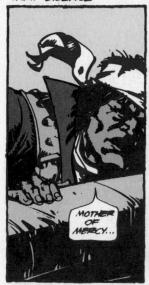

MOTHER OF MERCY...

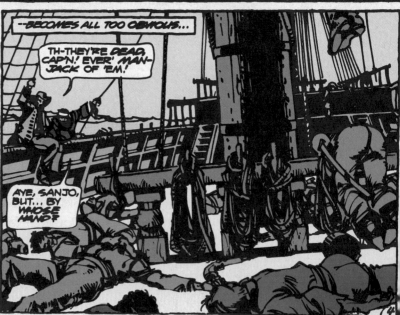

--BECOMES ALL TOO OBVIOUS...

TH-THEY'RE DEAD, CAP'N! EVER' MAN-JACK OF 'EM!

AYE, SANJO, BUT... BY WHOSE HAND?

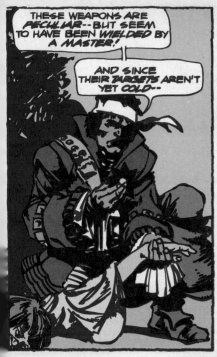

THESE WEAPONS ARE *PECULIAR*--BUT SEEM TO HAVE BEEN *WIELDED* BY A *MASTER!*

AND SINCE THEIR *TARGETS* AREN'T YET *COLD*--

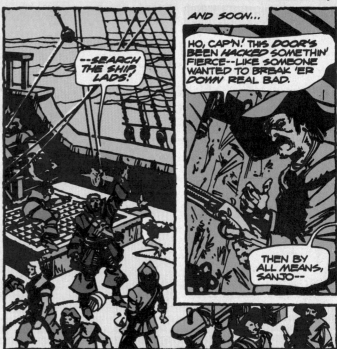

--SEARCH THE SHIP, LADS!

AND SOON...

HO, CAP'N! THIS *DOOR'S* BEEN *HACKED* SOMETHIN' *FIERCE*--LIKE SOMEONE WANTED TO *BREAK 'ER DOWN* REAL BAD.

THEN BY ALL MEANS, SANJO--

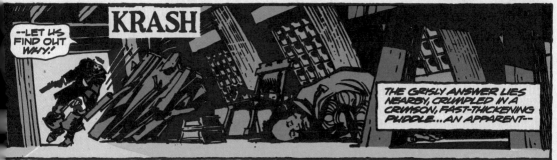

KRASH

--LET US FIND OUT *WHY!*

THE *GRISLY* ANSWER LIES NEARBY, CRUMPLED IN A CRIMSON, FAST-THICKENING PUDDLE...AN APPARENT--

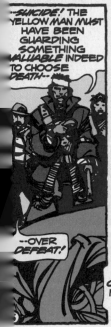

--*SUICIDE!* THE *YELLOW MAN* MUST HAVE BEEN *GUARDING* SOMETHING *VALUABLE* INDEED TO CHOOSE *DEATH*--

--OVER *DEFEAT!*

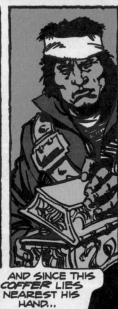

AND SINCE THIS *COFFER* LIES NEAREST HIS HAND...

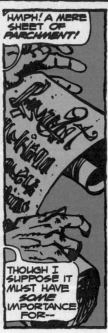

HMPH! A MERE *SHEET* OF *PARCHMENT!*

THOUGH I SUPPOSE IT MUST HAVE *SOME IMPORTANCE* FOR--

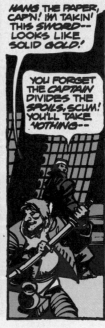

HANG THE *PAPER*, CAP'N! I'M TAKIN' THIS *SWORD*--LOOKS LIKE SOLID *GOLD!*

YOU FORGET THE *CAPTAIN* DIVIDES THE *SPOILS*, SCUM! YOU'LL TAKE *NOTHING*--

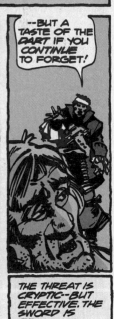

--BUT A TASTE OF THE *DART* IF YOU CONTINUE TO FORGET!

THE THREAT IS *CRYPTIC*--BUT *EFFECTIVE*. THE *SWORD* IS REPLACED...

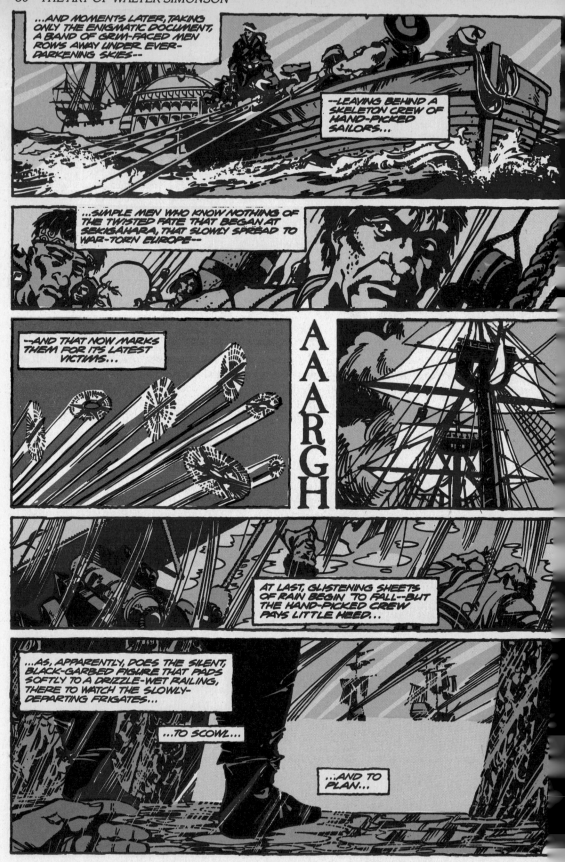

CAPTAIN FEAR

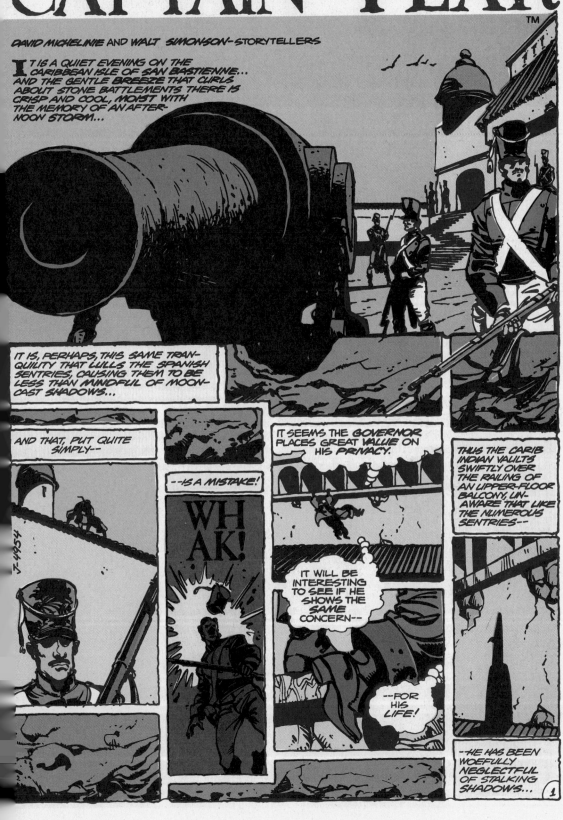

™

DAVID MICHELINIE AND WALT SIMONSON – STORYTELLERS

IT IS A QUIET EVENING ON THE CARIBBEAN ISLE OF SAN BASTIENNE... AND THE GENTLE BREEZE THAT CURLS ABOUT STONE BATTLEMENTS THERE IS CRISP AND COOL, MOIST WITH THE MEMORY OF AN AFTERNOON STORM...

IT IS, PERHAPS, THIS SAME TRANQUILITY THAT LULLS THE SPANISH SENTRIES, CAUSING THEM TO BE LESS THAN MINDFUL OF MOON-CAST SHADOWS...

AND THAT, PUT QUITE SIMPLY—

—IS A MISTAKE!

WH AK!

IT SEEMS THE GOVERNOR PLACES GREAT VALUE ON HIS PRIVACY.

IT WILL BE INTERESTING TO SEE IF HE SHOWS THE SAME CONCERN—

—FOR HIS LIFE!

THUS THE CARIB INDIAN VAULTS SWIFTLY OVER THE RAILING OF AN UPPER-FLOOR BALCONY, UNAWARE THAT LIKE THE NUMEROUS SENTRIES—

—HE HAS BEEN WOEFULLY NEGLECTFUL OF STALKING SHADOWS...

1

SIR, I AM AN *OFFICER* OF THE SPANISH *GOVERNMENT!* AND AS SUCH, MY WORD IS AS GOOD AS--

--*GOLD!* 500 DOUBLOONS! IF YOU WOULD CARE TO *COUNT* IT...?

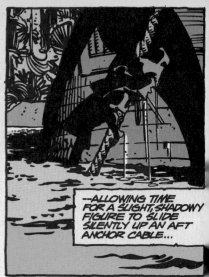

--ALLOWING TIME FOR A SLIGHT, SHADOWY FIGURE TO SLIDE SILENTLY UP AN AFT ANCHOR CABLE...

AND CAPTAIN FEAR DOES JUST THAT--

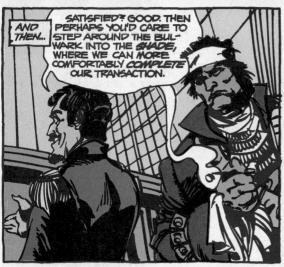

AND THEN...

SATISFIED? GOOD. THEN PERHAPS YOU'D CARE TO STEP AROUND THE BUL-WARK INTO THE *SHADE,* WHERE WE CAN MORE COMFORTABLY *COMPLETE* OUR TRANSACTION.

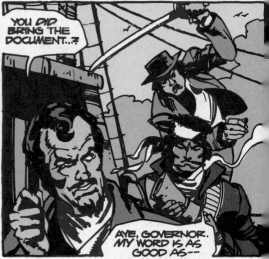

YOU *DID* BRING THE DOCUMENT...?

AYE, GOVERNOR. MY WORD IS AS GOOD AS--

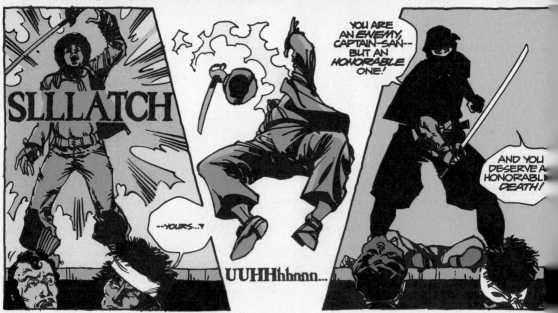

SLLLATCH

--YOURS...?

UUHHhhhoonn...

YOU ARE AN *ENEMY,* CAPTAIN-SAN-- BUT AN *HONORABLE* ONE!

AND YOU DESERVE A HONORABL DEATH!

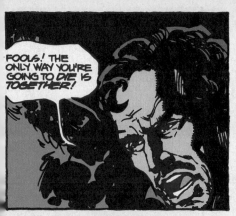

FOOLS! THE ONLY WAY YOU'RE GOING TO *DIE* IS *TOGETHER!*

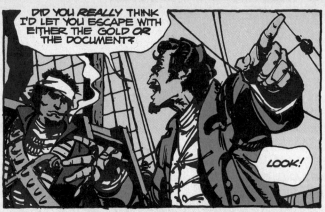

DID YOU *REALLY* THINK I'D LET YOU ESCAPE WITH EITHER THE GOLD OR THE DOCUMENT?

LOOK!

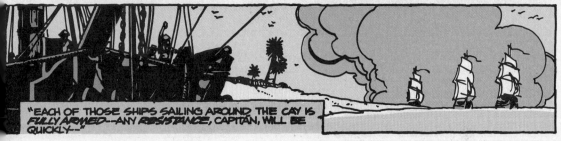

"EACH OF THOSE SHIPS SAILING AROUND THE CAY IS *FULLY ARMED*--ANY *RESISTANCE*, CAPTAIN, WILL BE QUICKLY--"

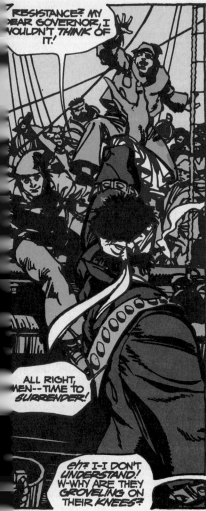

"*RESISTANCE?* MY DEAR GOVERNOR, I WOULDN'T *THINK* OF IT!"

ALL RIGHT, MEN--TIME TO *SURRENDER!*

EH? I-I DON'T *UNDERSTAND!* W-WHY ARE THEY GROVELING ON THEIR *KNEES?*

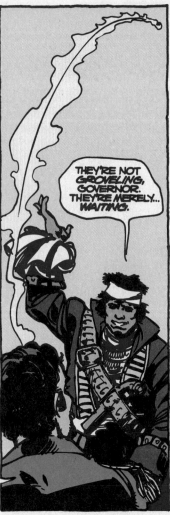

THEY'RE NOT *GROVELING*, GOVERNOR. THEY'RE MERELY... *WAITING.*

BUT AS REALIZATION RE-PLACES PUZZLEMENT IN THE GOVERNOR'S EYES--

--CAPTAIN FEAR'S STILL-LIT CIGAR CONTINUES ITS DESCENDING ARC TOWARDS HIS NOW-ABANDONED FRIGATE--

--THERE TO LAND ON A DECK PREVIOUSLY SPREAD WITH PITCH, AND WASHED IN KEROSENE--

3

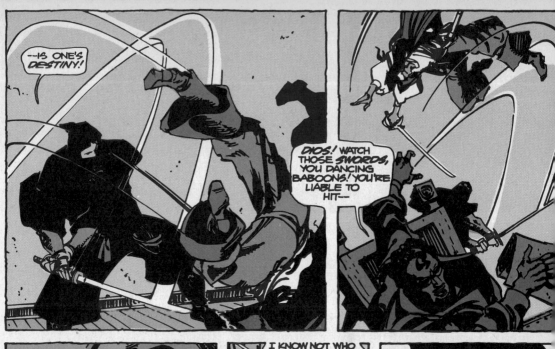

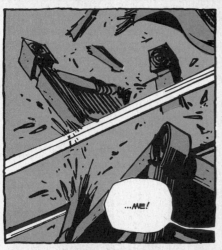

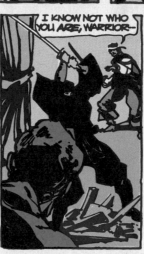

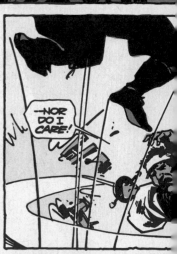

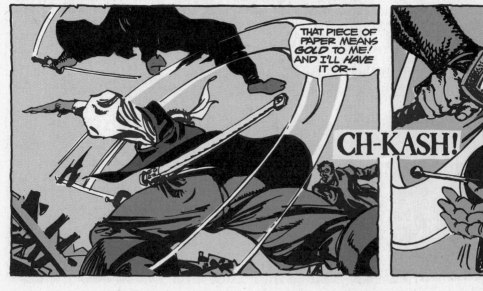

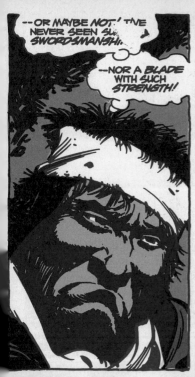

-- OR MAYBE *NOT!* I'VE NEVER SEEN SUCH *SWORDSMANSHIP!*

--NOR A *BLADE* WITH SUCH *STRENGTH!*

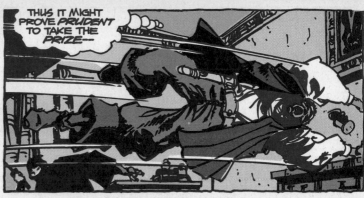

THUS IT MIGHT PROVE *PRUDENT* TO TAKE THE *PRIZE*--

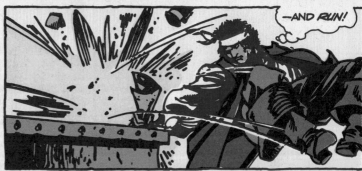

--AND *RUN!*

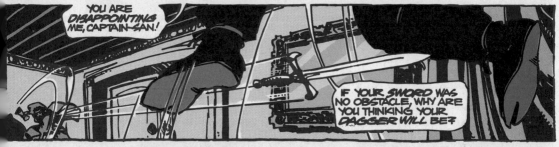

YOU ARE *DISAPPOINTING* ME, CAPTAIN-SAN!

IF YOUR *SWORD* WAS NO OBSTACLE, WHY ARE YOU THINKING YOUR *DAGGER* WILL BE?

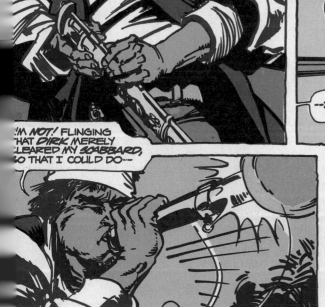

I'M *NOT!* FLINGING THAT *DIRK* MERELY CLEARED MY *SCABBARD,* SO THAT I COULD DO--

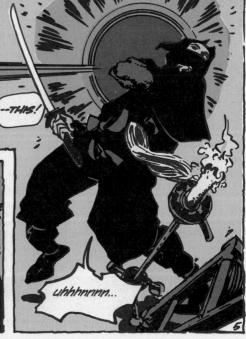

--*THIS!*

uhhhhnnnn...

5

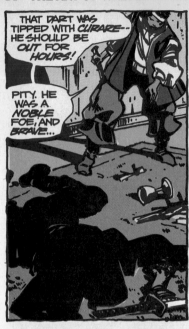
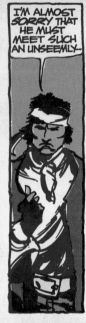
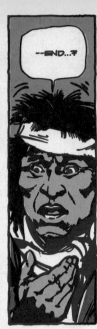
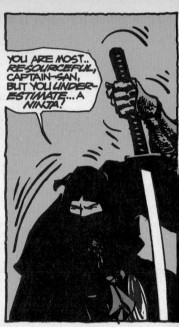
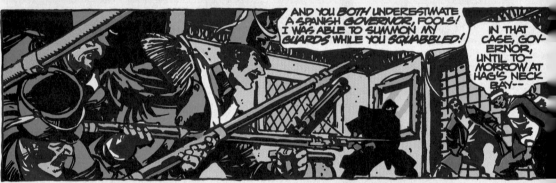

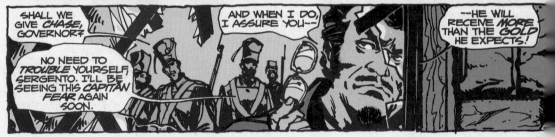

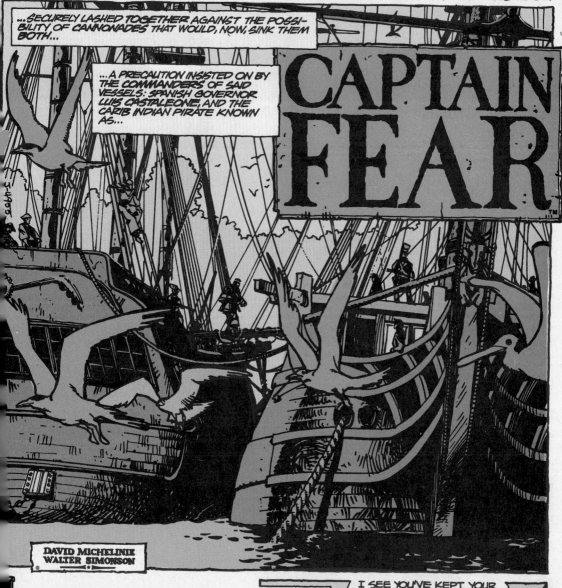

IT IS SPRING, 1748...AND OFF THE LEEWARD SHORE OF A DESERTED CARIBBEAN ISLAND, TWO MIGHTY WARSHIPS CREAK IN UNISON TO THE GENTLE CADENCE OF A SLOWLY-RECEDING TIDE...

...SECURELY LASHED TOGETHER AGAINST THE POSSI-BILITY OF CANNONADES THAT WOULD, NOW, SINK THEM BOTH...

...A PRECAUTION INSISTED ON BY THE COMMANDERS OF SAID VESSELS: SPANISH GOVERNOR LUIS CASTALEONE AND THE CARIB INDIAN PIRATE KNOWN AS...

CAPTAIN FEAR

DAVID MICHELINIE
WALTER SIMONSON

THE REASONS BEHIND THIS CON-FRONTATION ARE COMPLEX, AND BEGAN SOME 24 HOURS EARLIER... WITH THE CAPTURE OF A SECRET DOCUMENT SENT BY JAPANESE DIS-SIDENTS, OFFERING TO FINANCE A WAR IN EUROPE IN EXCHANGE FOR HELP IN OVERTHROWING JAPAN'S RULING SHOGUN. BUT WHILE CAP-TAIN FEAR HAD NEGOTIATED THE SALE OF THAT DOCUMENT TO GOV-ERNOR CASTALEONE, A BLACK-GARBED NINJA HAD APPEARED TO RETRIEVE IT FOR THE SHOGUN. THUS, THE FATE OF THE PRICELESS PAPER HAD BEEN DELAYED--

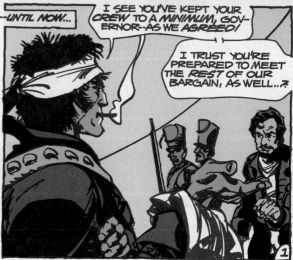

--UNTIL NOW...

I SEE YOU'VE KEPT YOUR CREW TO A MINIMUM, GOV-ERNOR--AS WE AGREED!

I TRUST YOU'RE PREPARED TO MEET THE REST OF OUR BARGAIN, AS WELL...?

1

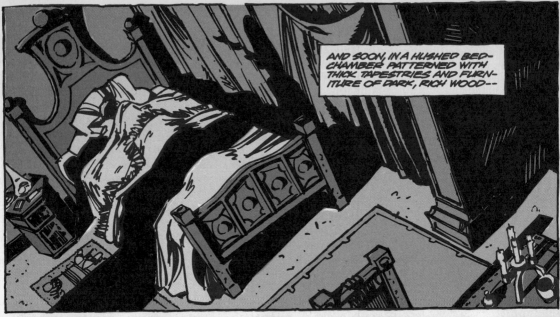

AND SOON, IN A HUSHED BED-CHAMBER PATTERNED WITH THICK TAPESTRIES AND FURNITURE OF DARK, RICH WOOD—

—THE SLUMBER OF GOVERNOR LUIS CASTALEONE—

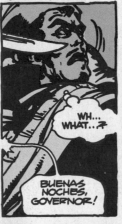

—COMES TO AN ABRUPT END...

WH... WHAT...?

BUENAS NOCHES, GOVERNOR!

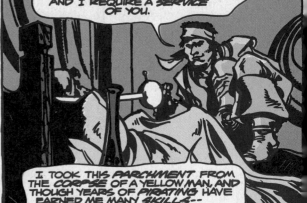

I AM CALLED CAPTAIN FEAR—QUITE JUSTIFIABLY, I MIGHT ADD—AND I REQUIRE A SERVICE OF YOU.

I TOOK THIS PARCHMENT FROM THE CORPSE OF A YELLOW MAN, AND THOUGH YEARS OF PIRATING HAVE EARNED ME MANY SKILLS—

—I'M AFRAID READING ISN'T ONE OF THEM!

YOU WILL OBLIGE ME, GOVERNOR?

HMPH! IT SEEMS MANNERS ARE ANOTHER AREA OF YOUR EDUCATION WHICH IS SORELY LACKING, "CAPITÁN"!

HOWEVER, UNDER THE CIRCUMSTANCES, I—

—EH? TH-THIS IS A SECRET COMMUNIQUÉ BETWEEN DISSIDENT FACTIONS IN JAPAN—AND THE KING OF ENGLAND!

THE JAPANESE ARE OFFERING TO FINANCE ENGLAND'S CURRENT WAR AGAINST AUSTRIA—IN EXCHANGE FOR ENGLAND'S HELP IN OVERTHROWING JAPAN'S RULING SHOGUN!

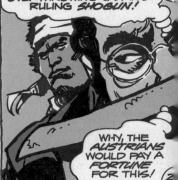

WHY, THE AUSTRIANS WOULD PAY A FORTUNE FOR THIS!

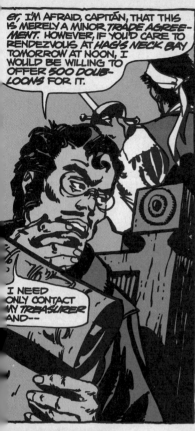

EY, I'M AFRAID, CAPITÁN, THAT THIS IS MERELY A MINOR *TRADE AGREEMENT.* HOWEVER, IF YOU'D CARE TO RENDEZVOUS AT *HAG'S NECK BAY* TOMORROW AT NOON, I WOULD BE WILLING TO OFFER *500 DOUBLOONS* FOR IT.

I NEED ONLY CONTACT MY *TREASURER* AND--

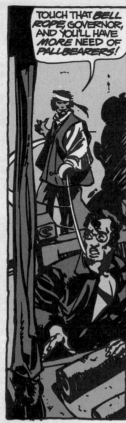

TOUCH THAT *BELL ROPE,* GOVERNOR, AND YOU'LL HAVE MORE NEED OF *PALLBEARERS!*

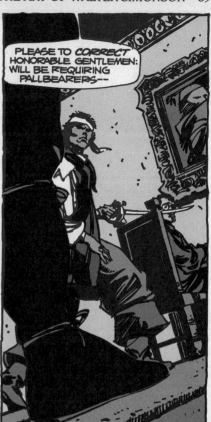

PLEASE TO *CORRECT* HONORABLE GENTLEMEN: WILL BE REQUIRING PALLBEARERS--

--FOR *TWO!*

VOICE IS SOFT, ACCENTED, STRANGELY *MELODIOUS...*

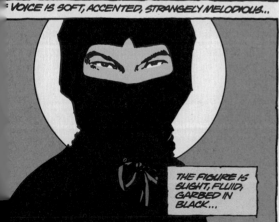

THE FIGURE IS SLIGHT, FLUID, GARBED IN BLACK...

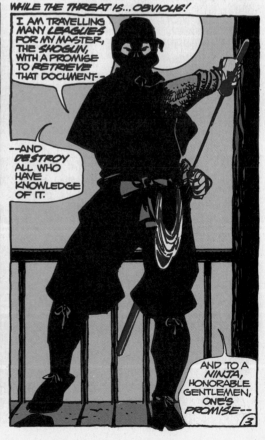

WHILE THE THREAT IS...*OBVIOUS!*

I AM TRAVELLING MANY *LEAGUES* FOR MY MASTER, THE *SHOGUN,* WITH A PROMISE TO *RETRIEVE* THAT DOCUMENT--

--AND *DESTROY* ALL WHO HAVE KNOWLEDGE OF IT.

AND TO A *NINJA,* HONORABLE GENTLEMEN, ONE'S *PROMISE--*

3

--THE *REASONS* FOR WHICH SOON BECOME ALL TOO *CLEAR*...

SHRATCHAFOOM

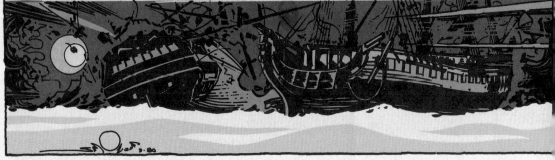

IMMEDIATELY, ACTING ON THE *SIGNAL* OF THE EXPLOSION, A SWIFT *CUTTER* DARTS OUT FROM A HIDDEN TWIST IN THE BAY, CARRYING THE BULK OF CAPTAIN FEAR'S CREW...

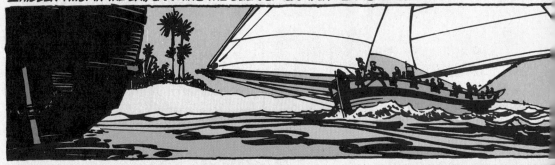

WHILE ABOARD THE FLAMING FRIGATE...

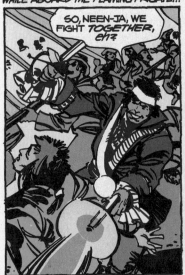

SO, NEEN-JA, WE FIGHT *TOGETHER*, EH?

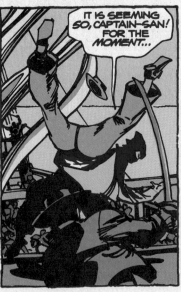

IT IS SEEMING SO, CAPTAIN-SAN! FOR THE MOMENT...

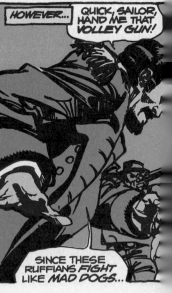

HOWEVER... QUICK, SAILOR, HAND ME THAT VOLLEY GUN!

SINCE THESE RUFFIANS *FIGHT* LIKE *MAD DOGS*...

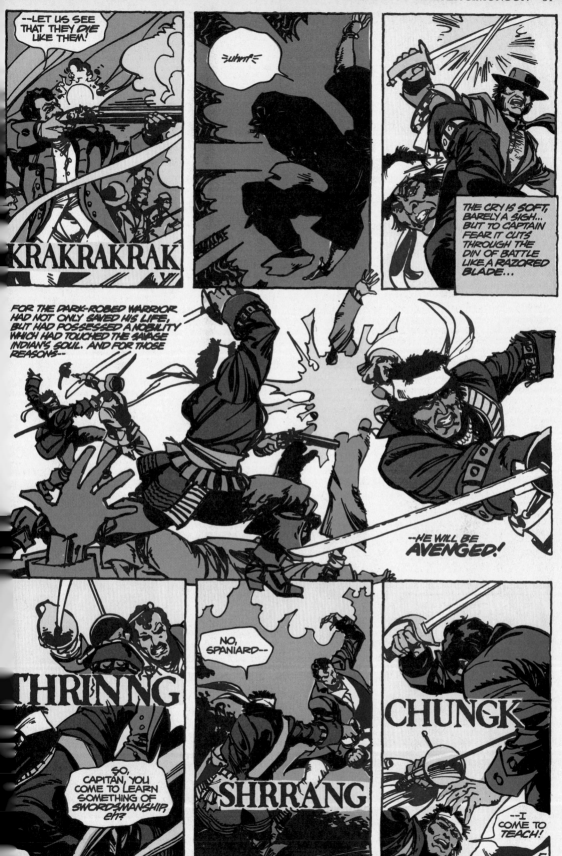

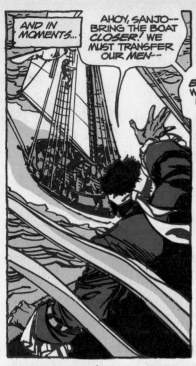

AND IN MOMENTS...

AHOY, SANJO-- BRING THE BOAT CLOSER! WE MUST TRANSFER OUR MEN--

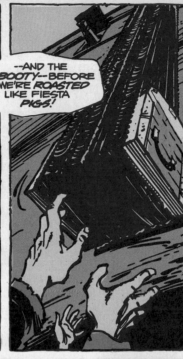

--AND THE BOOTY-- BEFORE WE'RE ROASTED LIKE FIESTA PIGS!

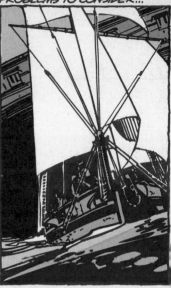

THE PROCESS IS COMPLETED WITHOUT HINDRANCE, FOR THE SPANISH SOLDIERS HAVE OTHER PROBLEMS TO CONSIDER...

AND SOON, THE LOADED CUTTER MOVES SMOOTHLY AWAY FROM THE LISTING DERELICTS...

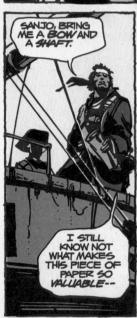

SANJO, BRING ME A BOW AND A SHAFT.

I STILL KNOW NOT WHAT MAKES THIS PIECE OF PAPER SO VALUABLE--

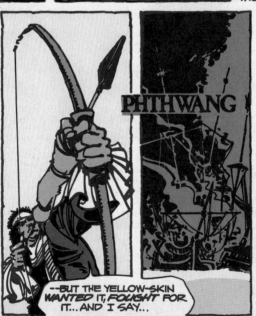

PHTHWANG

--BUT THE YELLOW-SKIN WANTED IT, FOUGHT FOR IT... AND I SAY...

"--EARNED IT!"

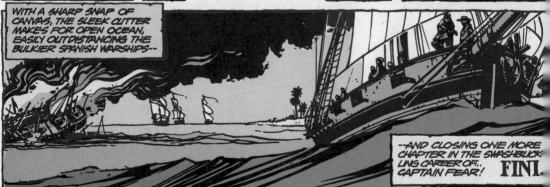

WITH A SHARP SNAP OF CANVAS, THE SLEEK CUTTER MAKES FOR OPEN OCEAN, EASILY OUTDISTANCING THE BULKIER SPANISH WARSHIPS--

--AND CLOSING ONE MORE CHAPTER IN THE SWASHBUCK-LING CAREER OF... CAPTAIN FEAR! FINI.

"U.F.M./RETURN"

"U.F.M." was my second professional job for DC. Gerry Boudreau (who wrote the story) and I had both come to New York City from Rhode Island, where we had been in school in different colleges. Gerry got me my first appointments with a couple of DC editors and we did several stories together. This was the first. Archie Goodwin edited it with a rather tolerant eye and nudged us gently in an effort to get us to learn how to tell a story rather than simply to relate an event. I myself didn't fully appreciate the difference then, but, particularly in retrospect, I can admire Archie's diligent efforts at trying to get the best work out of two fledgling professionals.

"Return" was a direct sequel to "U.F.M." and was my first attempt at coloring my own work. It also marked an early effort on my part to use reference material in the aid of my drawing (instead of inventing it out of my head in the innocence of youthful hubris, as nearly every beginner does). That's why the lead character is a comic-book version of Howard Chaykin, a neighbor at the time and a good friend. The young lady was modeled after Daina Grazunius, another good friend. And both Gray Morrow (from the back) and I appear as spear-carriers.

"Return" may also be the first (or at least one of the earliest) inter-company crossovers. Gerry, who had written both stories, was also writing Star Trek for Gold Key Comics at the time. He penned a sequel to "Return" (unbeknownst to either company, of course; only we shifty freelancers were privy to the secret) and, ultimately, Captain Kirk and his doughty crew also fought the menace of the U.F.M. (under an assumed name, of course).

PROLOGUE

CENTURIES AGO, ON A DISTANT PLANET, THE SCIENTISTS CONSTRUCTED AN *ULTIMATE FIGHTING MACHINE* TO POLICE THE WORLD AND INSURE PEACE AMONG ITS NATIONS...

BUT AS THIS PROJECT NEARED COMPLETION, THE PLANET SUFFERED ATTACK FROM CELESTIAL INVADERS AND THE MACHINE WAS PREMATURELY ACTIVATED...

WHEN THE FIGHTING WAS OVER... ONLY THE MACHINE WAS LEFT...

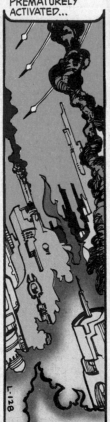

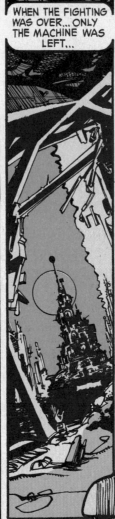

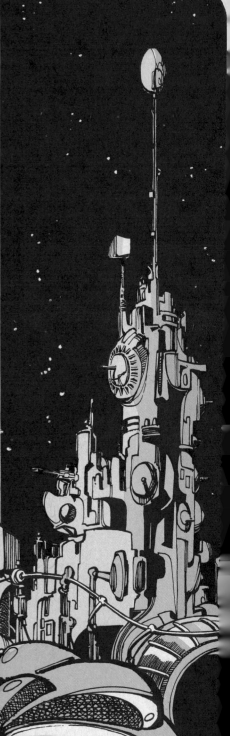

EXPEDITIONARY FORCES FROM NEIGHBORING STAR-SYSTEMS WERE SENT FROM TIME TO TIME TO EXPLORE THE WAR-TORN PLANET. NONE EVER RETURNED. CENTURIES PASSED, AND STILL...ONLY THE MACHINE WAS LEFT.

SCRIPT: GERRY BOUDREAU

THE PLANET WAS DECLARED OFF LIMITS! THE MACHINE AND THE CIVILIZATION IT ONCE REPRESENTED LAY FORGOTTEN AND UNDISTURBED... *UNTIL NOW...*

... WHEN THE BLACKNESS OF SPACE BLAZES WITH NUCLEAR COMBAT, AS TWO EMBITTERED FORCES MEET IN COSMIC WAR, UNKNOWINGLY FORCING CONFRONTATION BETWEEN MAN AND THE...

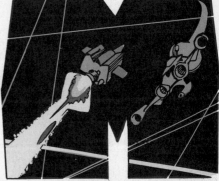

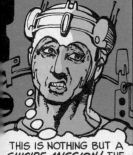

ABOARD THE MILITARY STARSHIP *ARCTURUS*, TECHNICIAN *STACY TAYLOR* COMES TO A GRIM REALIZATION...

THIS IS NOTHING BUT A *SUICIDE MISSION!* THE ALTAIRIANS ARE WIPING US UP LIKE *FOOD STAINS!*

NOT *ME*, BROTHER. WHEN I DIE, IT AIN'T GONNA BE IN SOME *LOST CORNER* OF THE GALAXY...

...FOR SOME CAUSE I DON'T EVEN *CARE* ABOUT...

I'M GETTING MYSELF OUT...

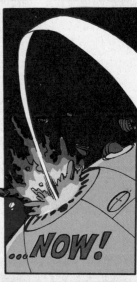

EMERGENCY EXIT

...*NOW!*

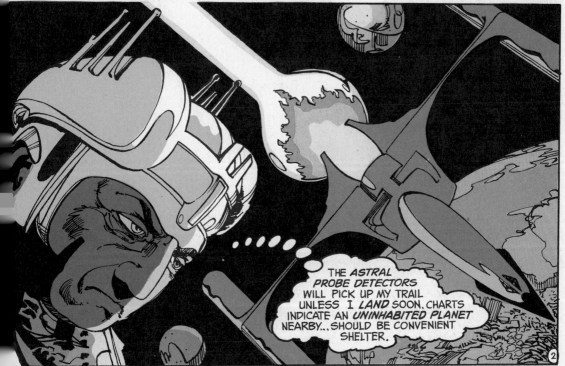

THE *ASTRAL PROBE DETECTORS* WILL PICK UP MY TRAIL UNLESS I *LAND* SOON. CHARTS INDICATE AN *UNINHABITED PLANET* NEARBY...SHOULD BE CONVENIENT SHELTER.

②

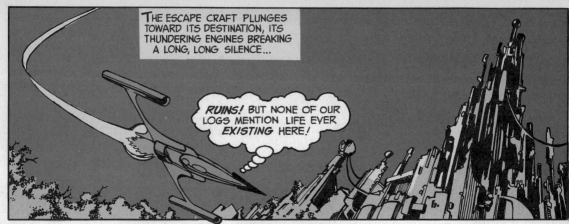

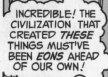

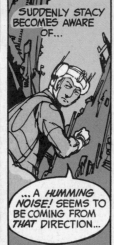

MMMMMMMMMMMMMMMM MMMMMMMM MMMMMM MMMMM MMMM

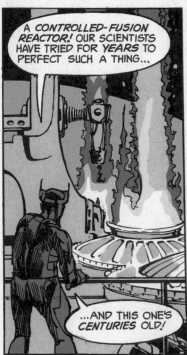

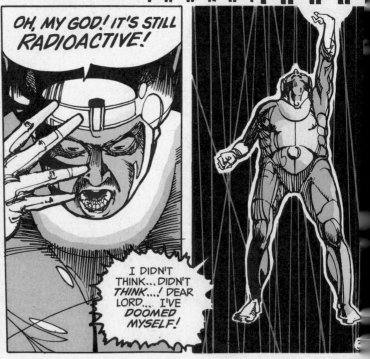

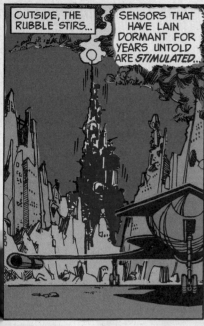

OUTSIDE, THE RUBBLE STIRS...

SENSORS THAT HAVE LAIN DORMANT FOR YEARS UNTOLD ARE *STIMULATED*...

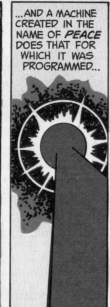

...AND A MACHINE CREATED IN THE NAME OF *PEACE* DOES THAT FOR WHICH IT WAS PROGRAMMED...

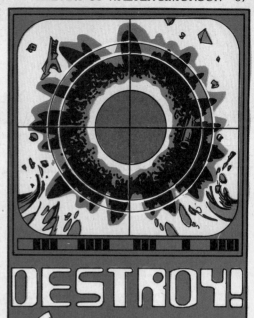

DESTROY!

KA-THOOM!

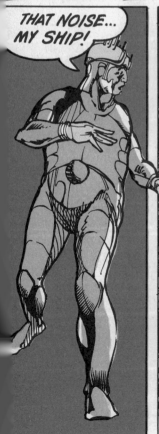

THAT NOISE... MY SHIP!

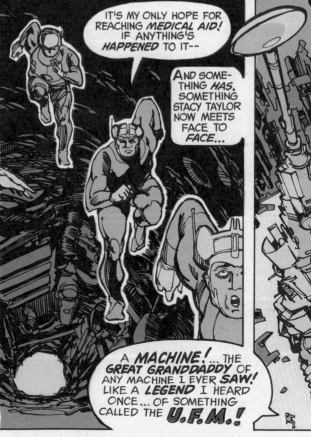

IT'S MY ONLY HOPE FOR REACHING *MEDICAL AID!* IF ANYTHING'S *HAPPENED* TO IT--

AND SOMETHING *HAS.* SOMETHING STACY TAYLOR NOW MEETS FACE TO *FACE*...

A *MACHINE!*... THE *GREAT GRANDDADDY* OF ANY MACHINE I EVER *SAW!* LIKE A *LEGEND* I HEARD ONCE... OF SOMETHING CALLED THE *U.F.M.!*

4

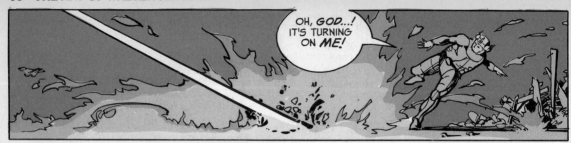

INTRUDER ALERT!

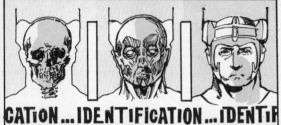

DESTROY!

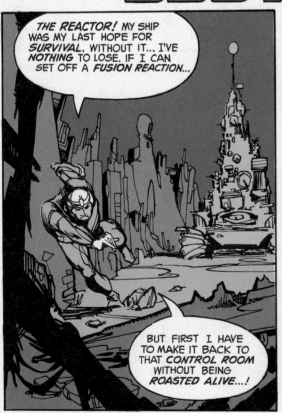

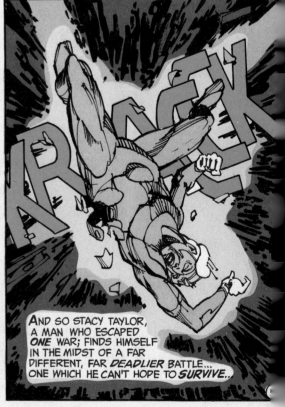

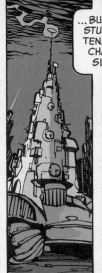

...BUT WHICH, WITH THE STUBBORNNESS, THE TENACITY THAT HAS CHARACTERIZED MAN SINCE PRE-HISTORY...

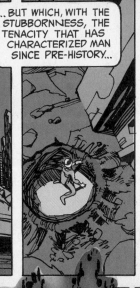

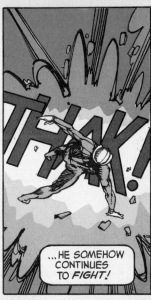

...HE SOMEHOW CONTINUES TO *FIGHT!*

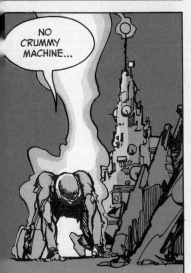

NO CRUMMY MACHINE...

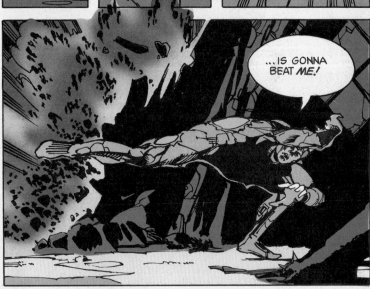

...IS GONNA BEAT *ME!*

NO...

CRUMMY...

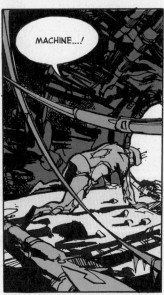

MACHINE....!

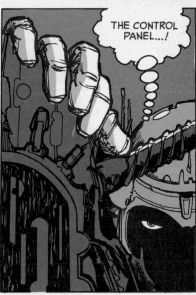

THE CONTROL PANEL...!

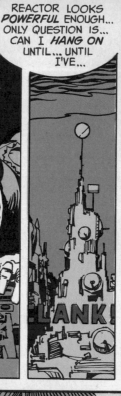

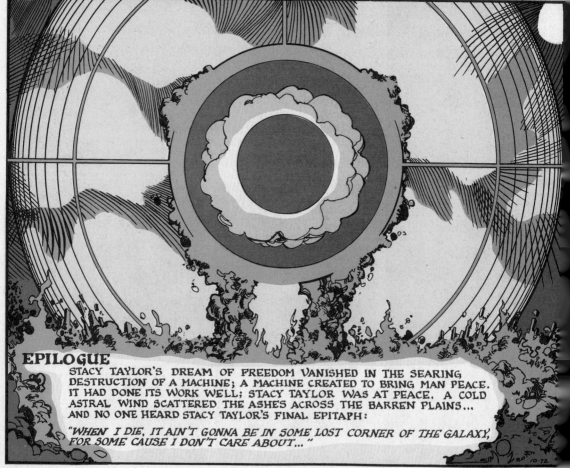

EPILOGUE

STACY TAYLOR'S DREAM OF FREEDOM VANISHED IN THE SEARING DESTRUCTION OF A MACHINE; A MACHINE CREATED TO BRING MAN PEACE. IT HAD DONE ITS WORK WELL; STACY TAYLOR WAS AT PEACE. A COLD ASTRAL WIND SCATTERED THE ASHES ACROSS THE BARREN PLAINS... AND NO ONE HEARD STACY TAYLOR'S FINAL EPITAPH:

"WHEN I DIE, IT AIN'T GONNA BE IN SOME LOST CORNER OF THE GALAXY, FOR SOME CAUSE I DON'T CARE ABOUT..."

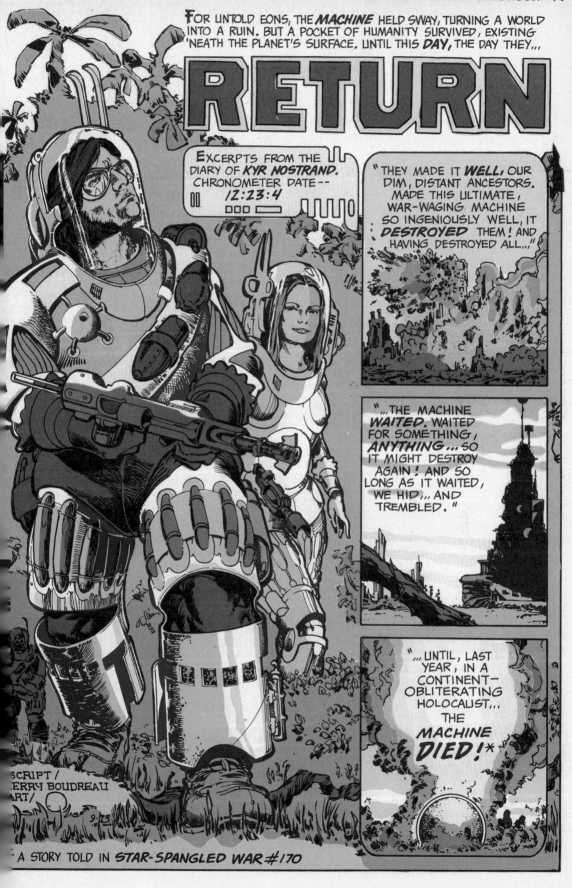

FOR UNTOLD EONS, THE *MACHINE* HELD SWAY, TURNING A WORLD INTO A RUIN. BUT A POCKET OF HUMANITY SURVIVED, EXISTING 'NEATH THE PLANET'S SURFACE. UNTIL THIS *DAY*, THE DAY THEY...

RETURN

EXCERPTS FROM THE DIARY OF *KYR NOSTRAND*. CHRONOMETER DATE -- 12:23:4

"THEY MADE IT *WELL*, OUR DIM, DISTANT ANCESTORS. MADE THIS ULTIMATE, WAR-WAGING MACHINE SO INGENIOUSLY WELL, IT *DESTROYED* THEM! AND HAVING DESTROYED ALL..."

"...THE MACHINE *WAITED*. WAITED FOR SOMETHING, *ANYTHING*...SO IT MIGHT DESTROY AGAIN! AND SO LONG AS IT WAITED, WE HID...AND TREMBLED."

"...UNTIL, LAST YEAR, IN A CONTINENT- OBLITERATING HOLOCAUST... THE *MACHINE DIED!*"

SCRIPT / ERRY BOUDREAU ART /

A STORY TOLD IN *STAR-SPANGLED WAR* #170

NOW, HALF A WORLD FROM THE BLAST SITE, WE **STAND**, BEHOLDING SUNLIGHT FOR THE FIRST TIME...

ALL RIGHT. MOVE OUT! BUT WITH **CAUTION!**

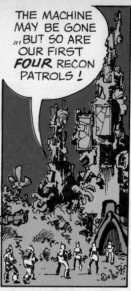

THE MACHINE MAY BE GONE ...BUT SO ARE OUR FIRST **FOUR** RECON PATROLS!

...LET'S NOT MAKE IT **FIVE!**

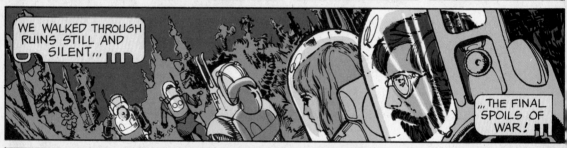

WE WALKED THROUGH RUINS STILL AND SILENT...

...THE FINAL SPOILS OF WAR!

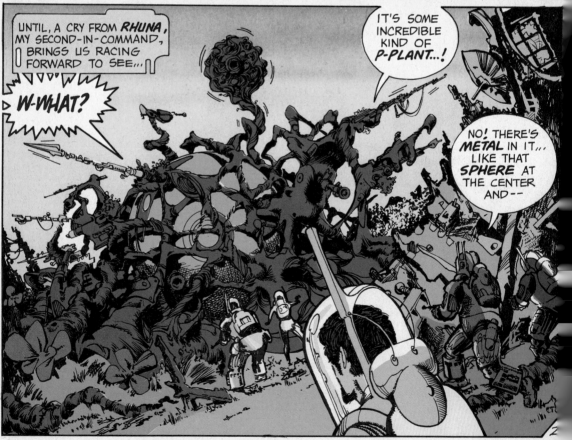

UNTIL, A CRY FROM **RHUNA**, MY SECOND-IN-COMMAND, BRINGS US RACING FORWARD TO SEE...

W-WHAT?

IT'S SOME INCREDIBLE KIND OF **P-PLANT...!**

NO! THERE'S **METAL** IN IT... LIKE THAT **SPHERE** AT THE CENTER AND--

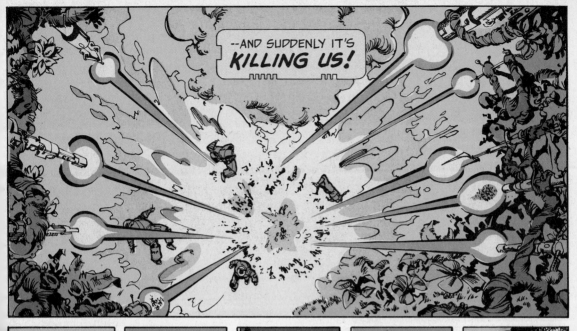

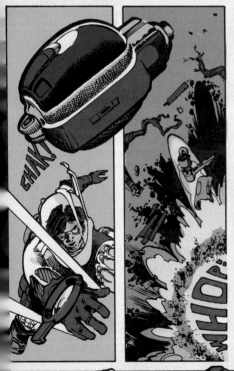

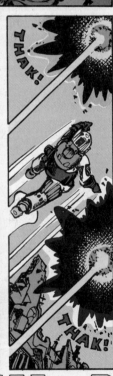

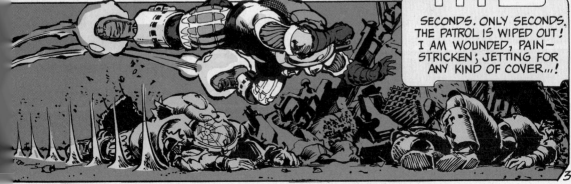

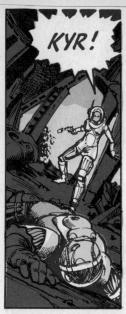

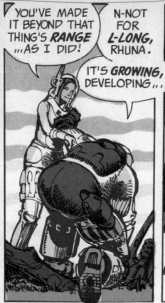

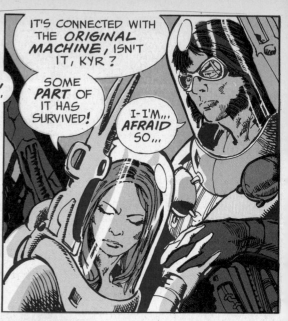

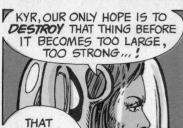

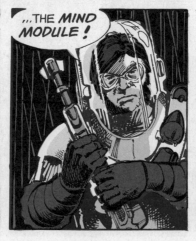

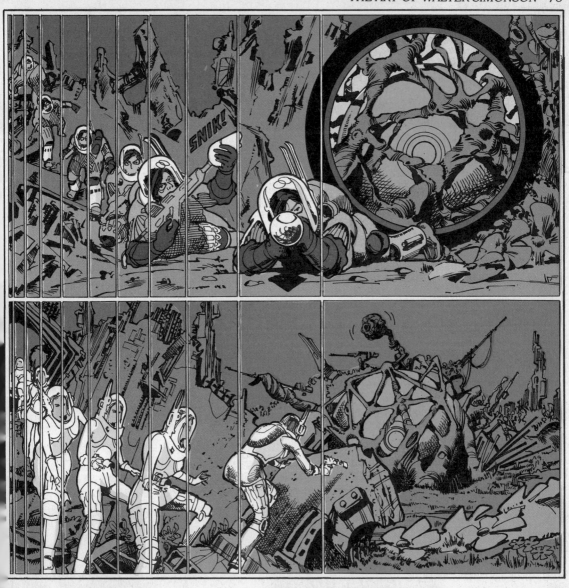

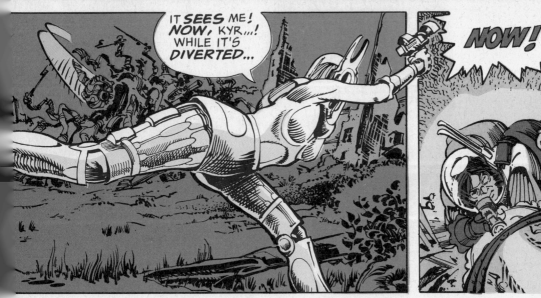

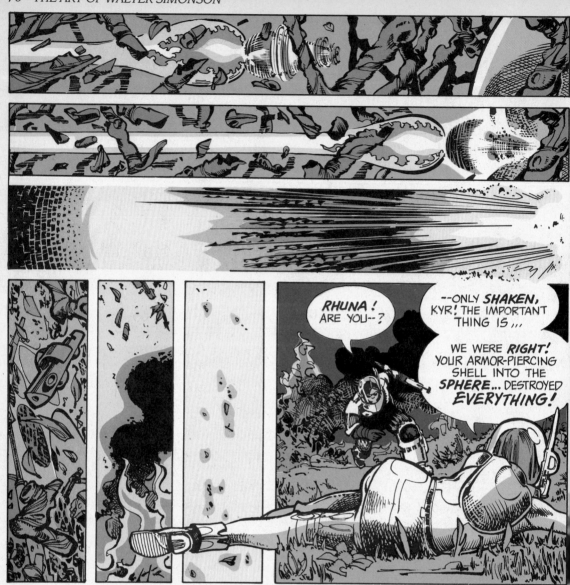

RHUNA! ARE YOU--?

--ONLY SHAKEN, KYR! THE IMPORTANT THING IS...

WE WERE RIGHT! YOUR ARMOR-PIERCING SHELL INTO THE SPHERE... DESTROYED EVERYTHING!

NOW THE SURFACE IS TRULY SAFE FOR OUR PEOPLE'S RETURN.

TO A WORLD WITHOUT WARRING... BY MEN OR MACHINE!

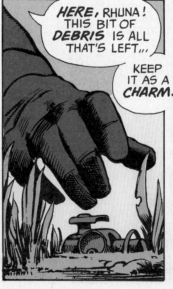

HERE, RHUNA! THIS BIT OF DEBRIS IS ALL THAT'S LEFT...

KEEP IT AS A CHARM.

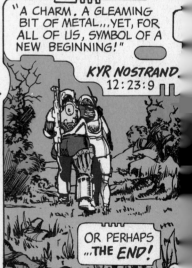

"A CHARM. A GLEAMING BIT OF METAL... YET, FOR ALL OF US, SYMBOL OF A NEW BEGINNING!"

KYR NOSTRAND. 12:23:9

OR PERHAPS ...THE END!

6

HERCULES

HERCULES UNBOUND was the first comic I ever pen-
cilled without inking. I accepted the original assignment
because Wally Wood was doing the finishes, and to any
professional, no more need be said. The chance to work
with Woody, a legendary figure in the business, was too
good a chance to pass up. I've never been sorry.

But Woody left the strip after only a couple of issues, and
it became clear that HERCULES wasn't faring well com-
mercially. Cary Bates and I like the character a lot and
wanted to give him a good send-off, so we spruced up his
costume (not the last time I would curse myself for creating
a complex outfit that would have to be drawn over and over
again!) and created a storyline to explain much about the
character that had been mysterious up to that point.

Our final story, however, required two issues to complete
. . . and we were told that the book was being cancelled
with issue #11, the first issue of our two-part climax. Cary
and I spoke to DC about it and, together, Jenette Kahn, Paul
Levitz, and Joe Orlando gave us permission to go for one
extra issue in order to complete the saga. In a business
where the unfit are ruthlessly weeded out, I have never
forgotten that extra consideration Cary and I were shown,
and I have always been grateful for it.

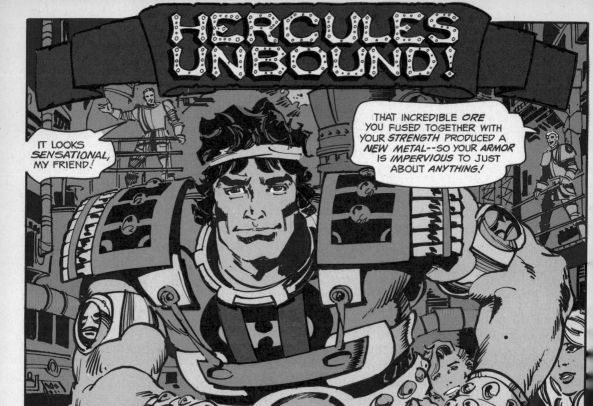

HERCULES UNBOUND!

IT LOOKS *SENSATIONAL*, MY FRIEND!

THAT INCREDIBLE *ORE* YOU FUSED TOGETHER WITH YOUR *STRENGTH* PRODUCED A *NEW* METAL--SO YOUR *ARMOR* IS *IMPERVIOUS* TO JUST ABOUT *ANYTHING!*

UNTIL NOW, ALL THE CAR ASSEMBLY PLANTS IN *DETROIT* HAD BEEN *COLD* AND *DARK*--THE PREVAILING CONDITION IN MOST CITIES SINCE THE OUT-BREAK OF *WORLD WAR THREE* MANY MONTHS AGO! BUT *TODAY* ONE OF THE *SMELTERS* HAS BEEN *REKINDLED*...TO FORGE A *NEW LOOK* FOR THE MIGHTY *HERCULES*-- JUST IN TIME FOR HIM TO CONFRONT...

the DARK SIDE of the GODS

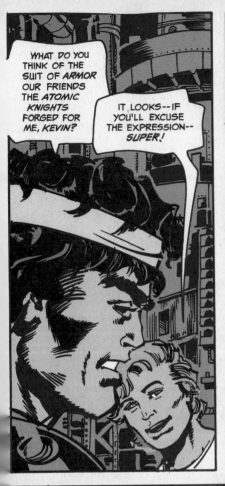

WHAT DO YOU THINK OF THE SUIT OF *ARMOR* OUR FRIENDS THE *ATOMIC KNIGHTS* FORGED FOR ME, *KEVIN?*

IT LOOKS--IF YOU'LL EXCUSE THE EXPRESSION-- *SUPER!*

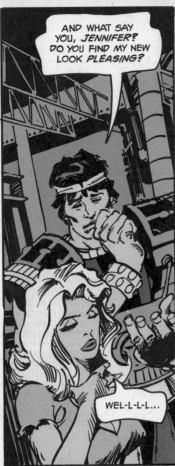

AND WHAT SAY YOU, *JENNIFER?* DO YOU FIND MY NEW LOOK *PLEASING?*

WEL-L-L-L...

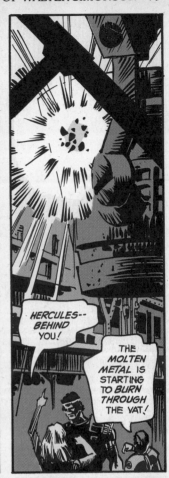

HERCULES-- BEHIND YOU!

THE *MOLTEN METAL* IS STARTING TO *BURN THROUGH* THE VAT!

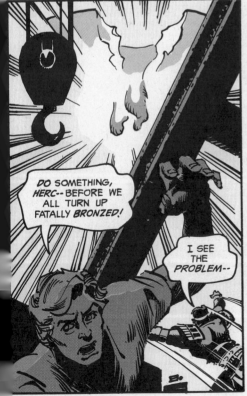

DO SOMETHING, HERC-- BEFORE WE ALL TURN UP FATALLY *BRONZED!*

I SEE THE *PROBLEM*--

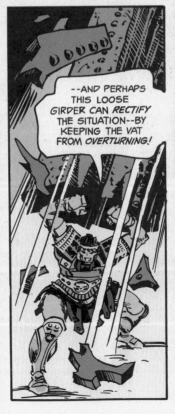

--AND PERHAPS THIS LOOSE GIRDER CAN *RECTIFY* THE SITUATION--BY KEEPING THE VAT FROM *OVERTURNING!*

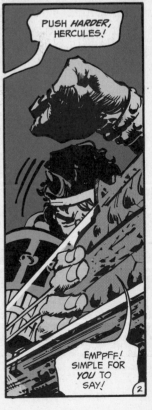

PUSH *HARDER,* HERCULES!

EMPPFF! SIMPLE FOR *YOU* TO SAY!

2

BUT THE *MAN-GOD'S* IRREPRESSIBLE STRENGTH PROVES *TOO MUCH* FOR THE RUSTED AND OVERWROUGHT FOUNDRY-WORKS TO ENDURE...

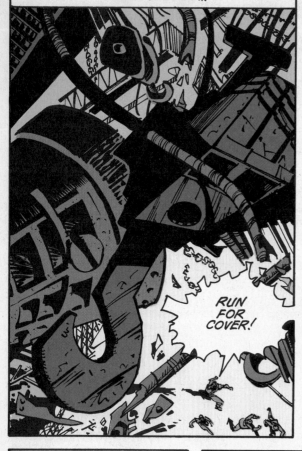

RUN FOR COVER!

AND AS *ATOMIC KNIGHTS GARDNER* AND *DOUGLAS* DO THEIR BEST TO CATCH UP WITH *HERCULES* AND HIS YOUNG FRIENDS...

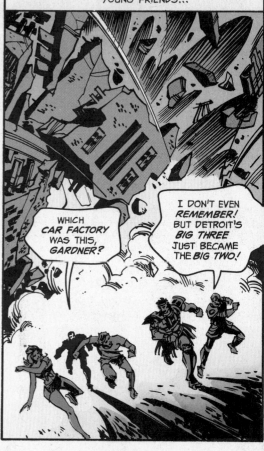

WHICH *CAR FACTORY* WAS THIS, *GARDNER?*

I DON'T EVEN *REMEMBER!* BUT DETROIT'S *BIG THREE* JUST BECAME THE *BIG TWO!*

ONCE OUTSIDE THE RANGE OF THE FIERY DESTRUCTION...

HERCULES, MY FRIEND-- HAS ANYONE EVER REMARKED YOU DON'T EVEN KNOW YOUR OWN *STRENGTH?*

SEVERAL OF MY *FOES* HAVE UTTERED THUS!

NOW SEVERAL OF YOUR *FRIENDS* ARE ITCHING TO GET BACK IN THE *FLYING WING* AND *DITCH* THIS SCENE!

BESIDES, I THINK OUR TWO *ATOMIC KNIGHTS* COULD USE A *LIFT!*

OVER THE RUINS OF THE GREAT METROPOLIS ONCE KNOWN AS *MOTOR CITY*...

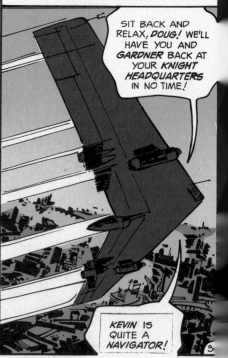

SIT BACK AND RELAX, *DOUG!* WE'LL HAVE YOU AND *GARDNER* BACK AT YOUR *KNIGHT HEADQUARTERS* IN NO TIME!

KEVIN IS QUITE A *NAVIGATOR!*

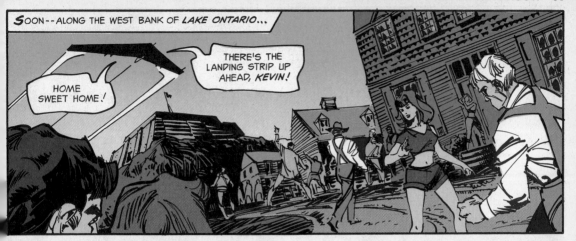

SOON -- ALONG THE WEST BANK OF *LAKE ONTARIO*...

HOME SWEET HOME!

THERE'S THE LANDING STRIP UP AHEAD, *KEVIN!*

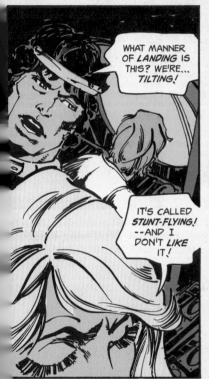

WHAT MANNER OF *LANDING* IS THIS? WE'RE... *TILTING!*

IT'S CALLED *STUNT-FLYING!* --AND I DON'T *LIKE* IT!

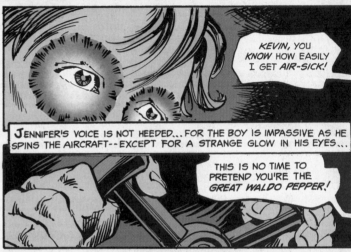

KEVIN, YOU *KNOW* HOW EASILY I GET *AIR-SICK!*

JENNIFER'S VOICE IS NOT HEEDED... FOR THE BOY IS IMPASSIVE AS HE SPINS THE AIRCRAFT--EXCEPT FOR A STRANGE GLOW IN HIS EYES...

THIS IS NO TIME TO PRETEND YOU'RE THE *GREAT WALDO PEPPER!*

KEVIN!

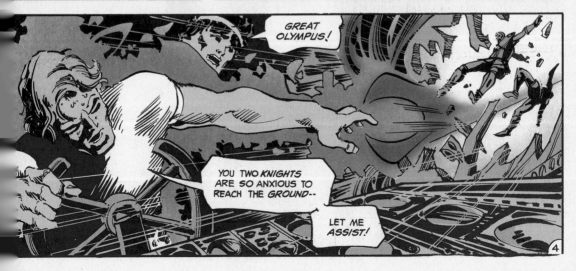

GREAT OLYMPUS!

YOU TWO *KNIGHTS* ARE SO ANXIOUS TO REACH THE *GROUND*--

LET ME *ASSIST!*

4

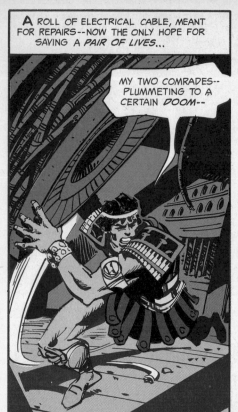

A ROLL OF ELECTRICAL CABLE, MEANT FOR REPAIRS--NOW THE ONLY HOPE FOR SAVING A *PAIR OF LIVES*...

MY TWO COMRADES-- PLUMMETING TO A CERTAIN *DOOM*--

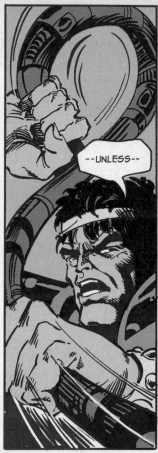

--UNLESS--

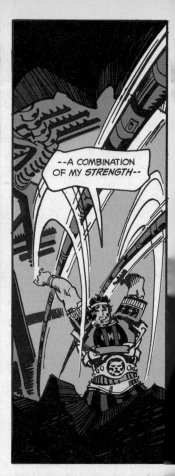

--A COMBINATION OF MY *STRENGTH*--

AND WELL-MEASURED *AIM*--

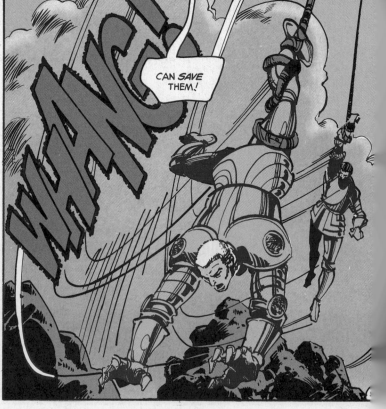

WH-ANG!

CAN *SAVE* THEM!

HIS FEET FIRMLY SECURED TO THE DAMAGED FUSELAGE--*HERCULES* SWINGS HIS MIGHTY ARMS WITH JUST ENOUGH *PRECISION*...

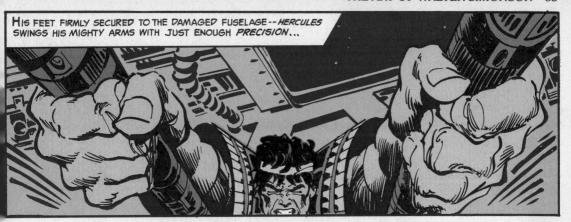

...SO THAT THE *CABLES* SLAM THE PAIR OF *ATOMIC KNIGHTS* INTO THE LIQUID *SAFETY* OF LAKE ONTARIO...

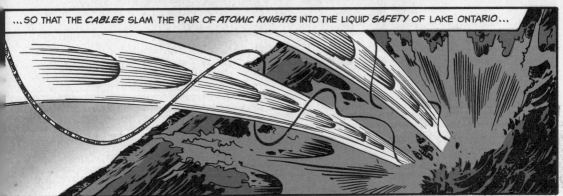

...JUST AS A *SUDDEN UPSWING* IN THE *FLYING WING'S* FLIGHT-PATH CATAPULTS A *THIRD* VICTIM INTO THE TREACHEROUS SKY...

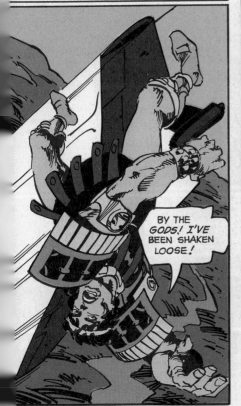

BY THE *GODS!* I'VE BEEN SHAKEN LOOSE!

MEANWHILE, THE SITUATION *INSIDE* THE AIRCRAFT IS NO *LESS* PERILOUS FOR *JENNIFER* AND THE DOG *BASIL*...

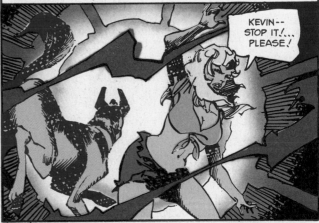

KEVIN-- STOP IT!... PLEASE!

AGAIN, JENNIFER'S PLEA IS IGNORED...FOR THE GOOD-NATURED BLIND BOY KNOWN AS *KEVIN* HAS TAKEN ON THE STATURE OF A NIGHTMARISH *MONSTER!*

6

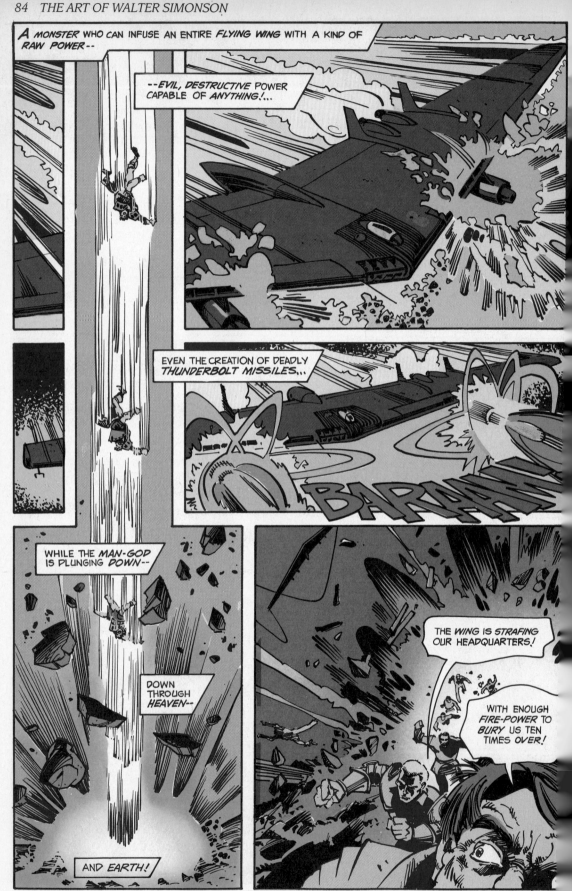

MEANWHILE... WHAT OF THE PLUMMETING *HULK* OF A MAN WHO PLUNGED INTO THE GROUND WITH *CATASTROPHIC* FORCE?

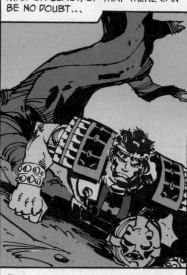

A *CERTAIN DEATH* FOR ANY *OTHER* MAN OR BEAST, OF THAT THERE CAN BE NO DOUBT...

BUT FOR *THIS* OUTRAGEOUSLY *STOUT* FELLOW...

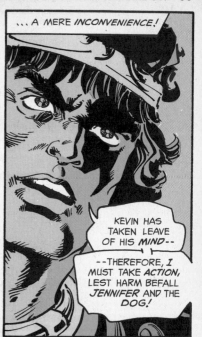

...A MERE *INCONVENIENCE!*

KEVIN HAS TAKEN LEAVE OF HIS *MIND*--

--THEREFORE, *I* MUST TAKE *ACTION,* LEST HARM BEFALL *JENNIFER* AND THE *DOG!*

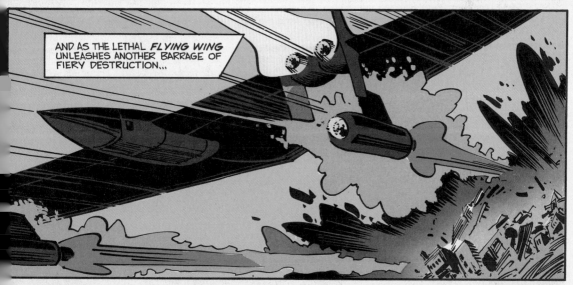

AND AS THE LETHAL *FLYING WING* UNLEASHES ANOTHER BARRAGE OF FIERY DESTRUCTION...

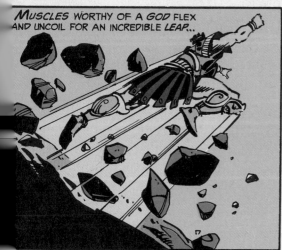

MUSCLES WORTHY OF A *GOD* FLEX AND UNCOIL FOR AN INCREDIBLE *LEAP...*

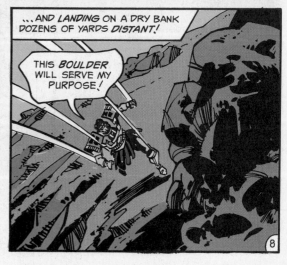

...AND *LANDING* ON A DRY BANK DOZENS OF YARDS *DISTANT!*

THIS *BOULDER* WILL SERVE MY PURPOSE!

8

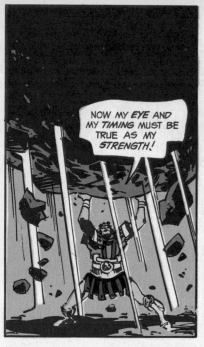

NOW MY *EYE* AND MY *TIMING* MUST BE TRUE AS MY *STRENGTH!*

ABOVE, THE AIRCRAFT CAVORTS LIKE AN INSANE BIRD--

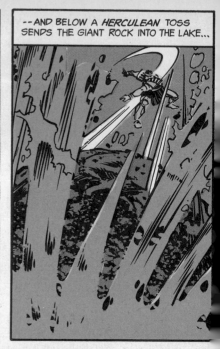

--AND BELOW A *HERCULEAN* TOSS SENDS THE GIANT ROCK INTO THE LAKE...

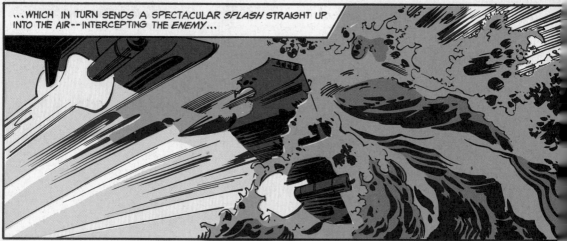

...WHICH IN TURN SENDS A SPECTACULAR *SPLASH* STRAIGHT UP INTO THE AIR--INTERCEPTING THE *ENEMY*...

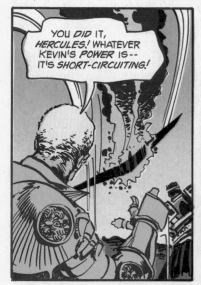

YOU *DID* IT, *HERCULES!* WHATEVER KEVIN'S *POWER* IS-- IT'S *SHORT-CIRCUITING!*

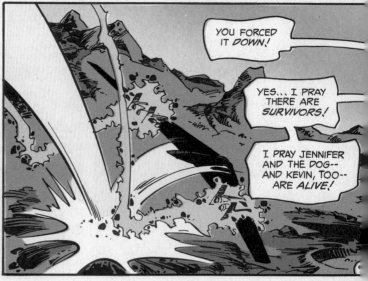

YOU FORCED IT *DOWN!*

YES... I PRAY THERE ARE *SURVIVORS!*

I PRAY JENNIFER AND THE DOG-- AND KEVIN, TOO-- ARE *ALIVE!*

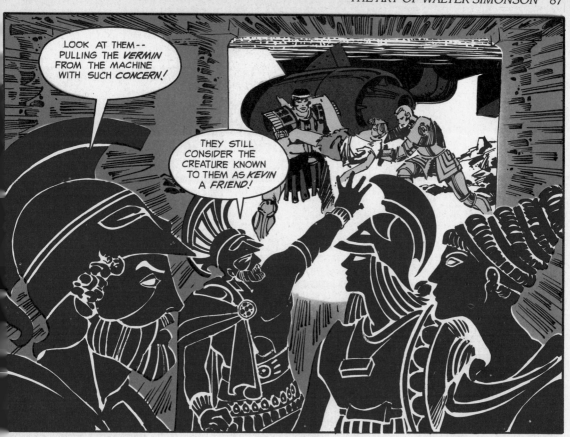

LOOK AT THEM-- PULLING THE *VERMIN* FROM THE MACHINE WITH SUCH *CONCERN!*

THEY STILL CONSIDER THE CREATURE KNOWN TO THEM AS *KEVIN* A *FRIEND!*

YOU ARE NOW ON *MOUNT OLYMPUS*-- IN THE *DIVINE PRESENCE* OF THEY WHO ARE THE *GODS*-- NONE MORE AWESOME THAN THE MIGHTY *ZEUS!*

I HAVE SEEN *ENOUGH*--

ENOUGH TO KNOW THE SITUATION ON EARTH HAS BECOME MOST *GRAVE!*

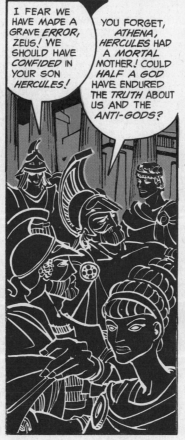

I FEAR WE HAVE MADE A GRAVE *ERROR,* ZEUS! WE SHOULD HAVE *CONFIDED* IN YOUR SON *HERCULES!*

YOU FORGET, *ATHENA, HERCULES* HAD A *MORTAL* MOTHER! COULD *HALF A GOD* HAVE ENDURED THE *TRUTH* ABOUT US AND THE *ANTI-GODS?*

THE TIME HAS *PASSED* FOR RETROSPECTION! THE *ANTI-GODS* GROW *STRONGER* EVEN AS WE *SPEAK!*

YET WE CAN DO PRECIOUS LITTLE ELSE *BUT* SPEAK AMONGST OURSELVES AS LONG AS *MOUNT OLYMPUS* REMAINS TRAPPED IN THIS *TEMPORAL STORM!*

10

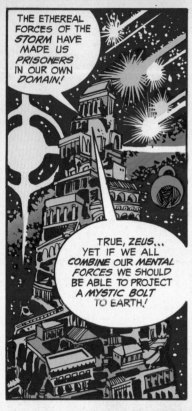

THE ETHEREAL FORCES OF THE *STORM* HAVE MADE US *PRISONERS* IN OUR OWN *DOMAIN!*

TRUE, *ZEUS...* YET IF WE ALL *COMBINE* OUR *MENTAL FORCES* WE SHOULD BE ABLE TO PROJECT A *MYSTIC BOLT* TO EARTH!

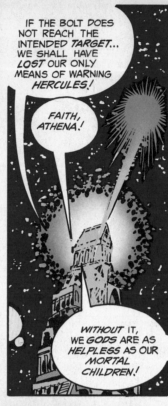

IF THE BOLT DOES NOT REACH THE INTENDED *TARGET...* WE SHALL HAVE *LOST* OUR ONLY MEANS OF WARNING *HERCULES!*

FAITH, *ATHENA!*

WITHOUT IT, WE *GODS* ARE AS *HELPLESS* AS OUR *MORTAL CHILDREN!*

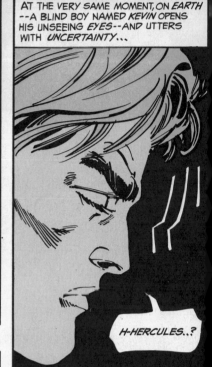

AT THE VERY SAME MOMENT, ON *EARTH* --A BLIND BOY NAMED *KEVIN* OPENS HIS UNSEEING *EYES*--AND UTTERS WITH *UNCERTAINTY...*

H-HERCULES...?

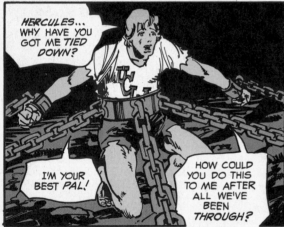

HERCULES... WHY HAVE YOU GOT ME *TIED DOWN?*

I'M YOUR BEST *PAL!*

HOW COULD YOU DO THIS TO ME AFTER ALL WE'VE BEEN *THROUGH?*

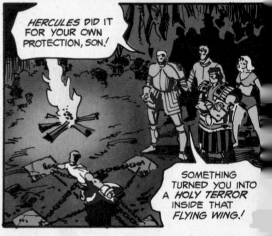

HERCULES DID IT FOR YOUR OWN PROTECTION, SON!

SOMETHING TURNED YOU INTO A *HOLY TERROR* INSIDE THAT *FLYING WING!*

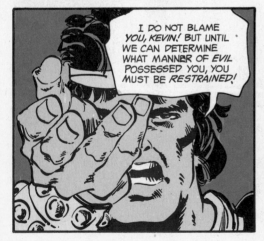

I DO NOT BLAME YOU, *KEVIN!* BUT UNTIL WE CAN DETERMINE WHAT MANNER OF *EVIL* POSSESSED YOU, YOU MUST BE *RESTRAINED!*

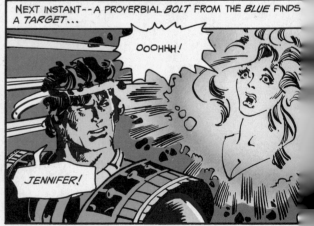

NEXT INSTANT-- A PROVERBIAL *BOLT* FROM THE *BLUE* FINDS A *TARGET...*

OOOHHH!

JENNIFER!

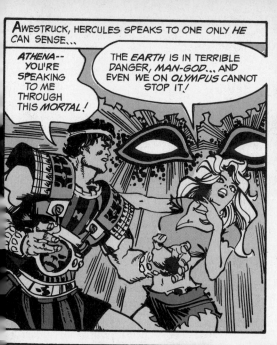

AWESTRUCK, HERCULES SPEAKS TO ONE ONLY *HE* CAN SENSE...

ATHENA-- YOU'RE SPEAKING TO ME THROUGH THIS MORTAL!

THE EARTH IS IN TERRIBLE DANGER, MAN-GOD... AND EVEN WE ON OLYMPUS CANNOT STOP IT!

YOU ARE THE PLANET'S ONLY HOPE! YOU MUST DESTROY THE DEADLY SCOURGE NOW WHILE YOU ARE STILL ABLE!

BUT EVEN AS ATHENA'S WORDS FILL HERCULES' HEARING--THE *CAMPFIRE* SUDDENLY CRACKLES AND SPARKS WITH AN UNEARTHLY *BRILLIANCE*...

...AS IT SEEMS TO TAKE ON A LIFE OF ITS OWN!

WHAT SCOURGE, ATHENA? I DO NOT UNDERSTAND...

YOU MUST DO AS WE SAY! YOU MUST--

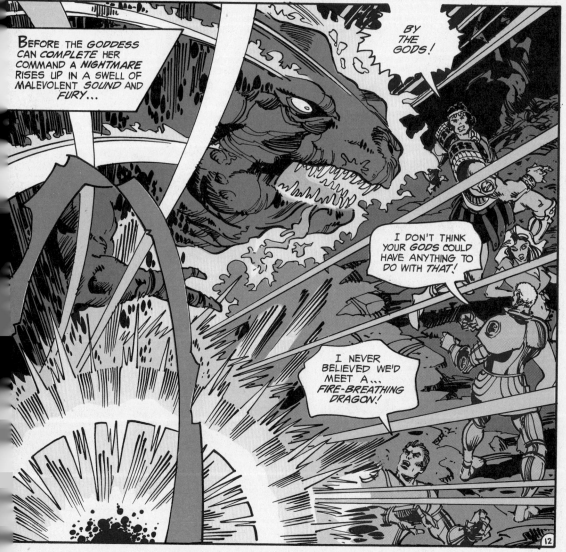

BEFORE THE *GODDESS* CAN *COMPLETE* HER COMMAND A *NIGHTMARE* RISES UP IN A SWELL OF MALEVOLENT *SOUND* AND *FURY*...

BY THE GODS!

I DON'T THINK YOUR GODS COULD HAVE ANYTHING TO DO WITH THAT!

I NEVER BELIEVED WE'D MEET A... FIRE-BREATHING DRAGON!

12

BELIEVE IT OR *NOT, DOUG* -- IT'S *HAPPENING!*

OUR *ARMOR'S* STARTING TO *MELT!*

I WILL PROTECT YOU, *JENNIFER!*

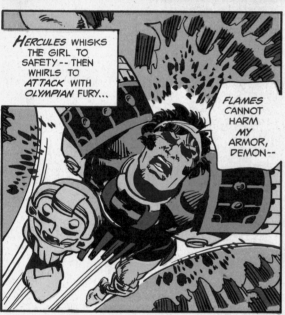

HERCULES WHISKS THE GIRL TO SAFETY -- THEN WHIRLS TO *ATTACK* WITH *OLYMPIAN* FURY...

FLAMES CANNOT HARM *MY* ARMOR, DEMON--

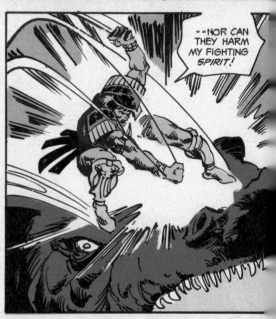

--NOR CAN THEY HARM MY FIGHTING *SPIRIT!*

BUT THE *FLAMING TERROR* ANSWERS BACK WITH A *DEVASTATING* RAGE ALL ITS OWN...

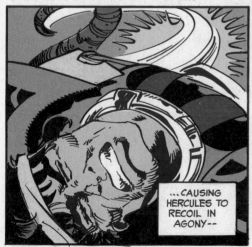

...CAUSING HERCULES TO RECOIL IN AGONY--

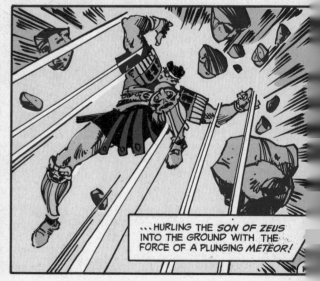

...HURLING THE *SON OF ZEUS* INTO THE GROUND WITH THE FORCE OF A PLUNGING *METEOR!*

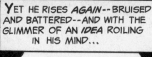

YET HE RISES *AGAIN*--BRUISED AND BATTERED--AND WITH THE GLIMMER OF AN *IDEA* ROILING IN HIS MIND...

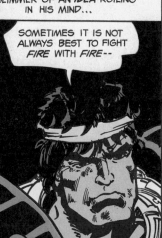

SOMETIMES IT IS NOT ALWAYS BEST TO FIGHT *FIRE* WITH *FIRE*--

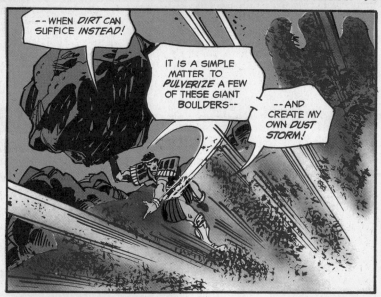

--WHEN *DIRT* CAN SUFFICE *INSTEAD*!

IT IS A SIMPLE MATTER TO *PULVERIZE* A FEW OF THESE GIANT BOULDERS--

--AND CREATE MY OWN *DUST* STORM!

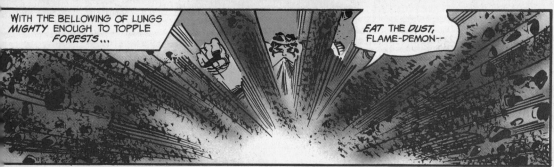

WITH THE BELLOWING OF LUNGS *MIGHTY* ENOUGH TO TOPPLE FORESTS...

EAT THE *DUST*, FLAME-DEMON--

--AND *SMOTHER* IN IT!

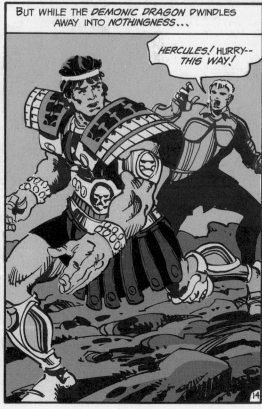

BUT WHILE THE *DEMONIC DRAGON* DWINDLES AWAY INTO *NOTHINGNESS*...

HERCULES! HURRY-- THIS WAY!

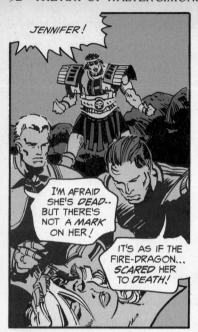

JENNIFER!

I'M AFRAID SHE'S *DEAD*-- BUT THERE'S NOT A *MARK* ON HER!

IT'S AS IF THE *FIRE-DRAGON*... *SCARED* HER TO *DEATH!*

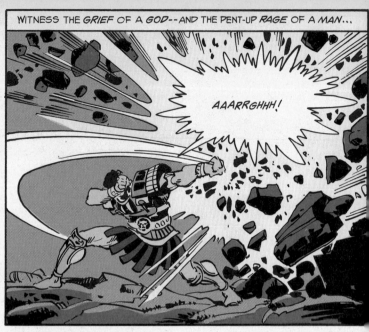

WITNESS THE *GRIEF* OF A *GOD*--AND THE PENT-UP *RAGE* OF A MAN...

AAARRGHHH!

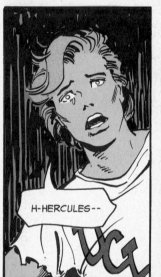

H-HERCULES--

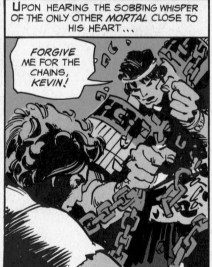

UPON HEARING THE SOBBING WHISPER OF THE ONLY OTHER *MORTAL* CLOSE TO HIS HEART...

FORGIVE ME FOR THE CHAINS, KEVIN!

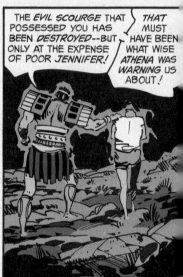

THE *EVIL SCOURGE* THAT POSSESSED YOU HAS BEEN *DESTROYED*--BUT ONLY AT THE EXPENSE OF POOR *JENNIFER!*

THAT MUST HAVE BEEN WHAT WISE *ATHENA* WAS *WARNING* US ABOUT!

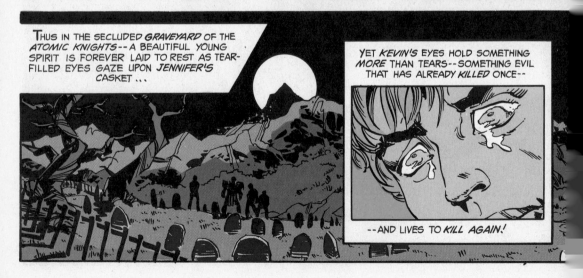

THUS IN THE SECLUDED *GRAVEYARD* OF THE *ATOMIC KNIGHTS*--A BEAUTIFUL YOUNG SPIRIT IS FOREVER LAID TO REST AS TEAR-FILLED EYES GAZE UPON *JENNIFER'S* CASKET...

YET *KEVIN'S* EYES HOLD SOMETHING *MORE* THAN TEARS--SOMETHING EVIL THAT HAS ALREADY *KILLED* ONCE--

--AND LIVES TO *KILL AGAIN!*

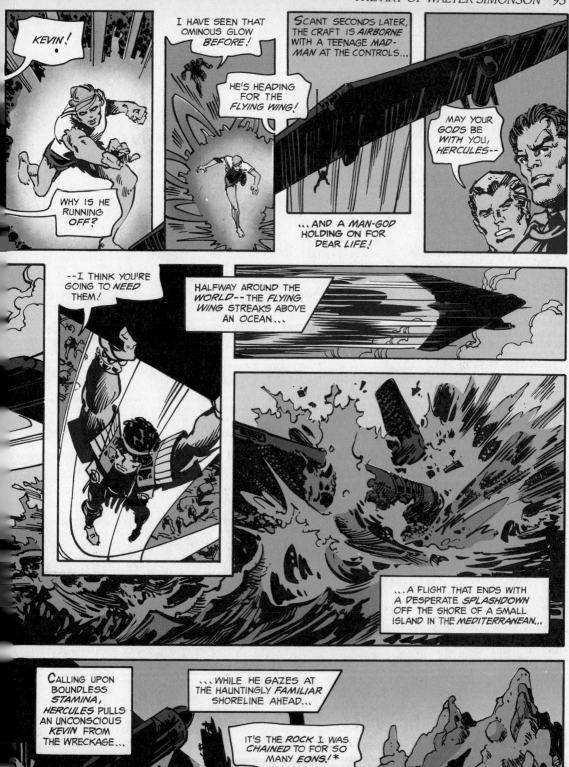

KEVIN!

WHY IS HE RUNNING OFF?

I HAVE SEEN THAT OMINOUS GLOW *BEFORE!*

HE'S HEADING FOR THE *FLYING WING!*

SCANT SECONDS LATER, THE CRAFT IS *AIRBORNE* WITH A TEENAGE *MAD-MAN* AT THE CONTROLS...

...AND A *MAN-GOD* HOLDING ON FOR DEAR *LIFE!*

MAY YOUR *GODS* BE WITH YOU, HERCULES--

--I THINK YOU'RE GOING TO *NEED* THEM!

HALFWAY AROUND THE *WORLD*-- THE *FLYING WING* STREAKS ABOVE AN OCEAN...

...A FLIGHT THAT ENDS WITH A DESPERATE *SPLASHDOWN* OFF THE SHORE OF A SMALL ISLAND IN THE *MEDITERRANEAN*...

CALLING UPON BOUNDLESS *STAMINA,* HERCULES PULLS AN UNCONSCIOUS *KEVIN* FROM THE WRECKAGE...

...WHILE HE GAZES AT THE HAUNTINGLY *FAMILIAR* SHORELINE AHEAD...

IT'S THE *ROCK* I WAS *CHAINED* TO FOR SO MANY *EONS!* *

*NOTE: AS SHOWN IN *HERCULES* #1.

16

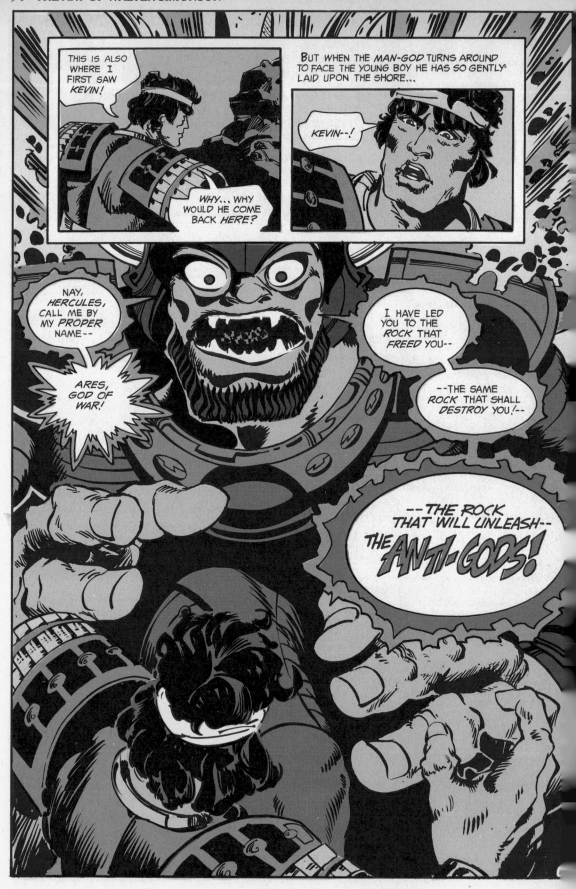

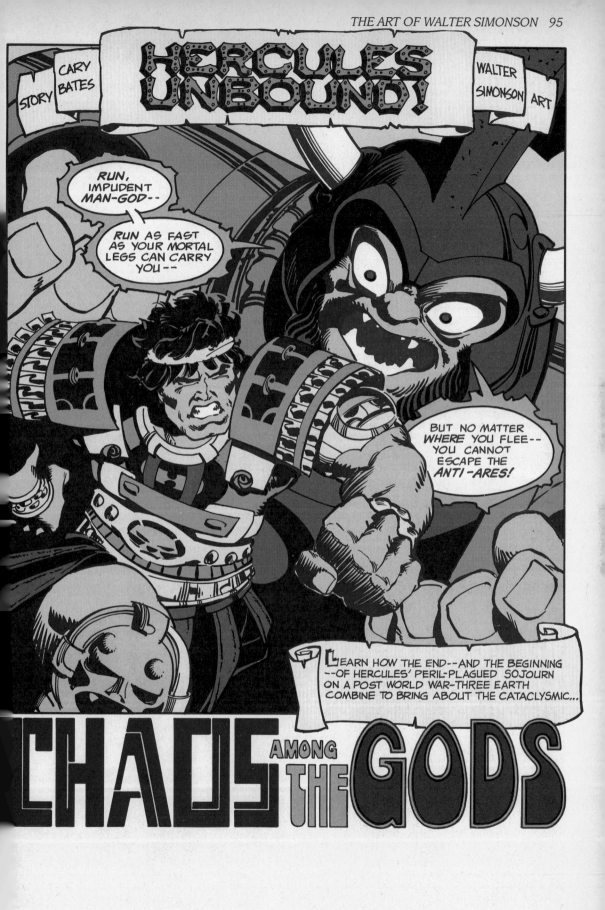

ON A TINY ISLAND IN THE MEDITERRANEAN WHERE ONLY MOMENTS AGO STOOD HERCULES' YOUNG FRIEND KEVIN, THERE NOW STANDS AN AWESOME--

YES... I RUN, DEMONIC ONE! BUT IT'S NOT FEAR WHICH PROPELS ME--!

I WOULD NOT ESCAPE IF I COULD...

...I GO THAT I MAY RETURN--

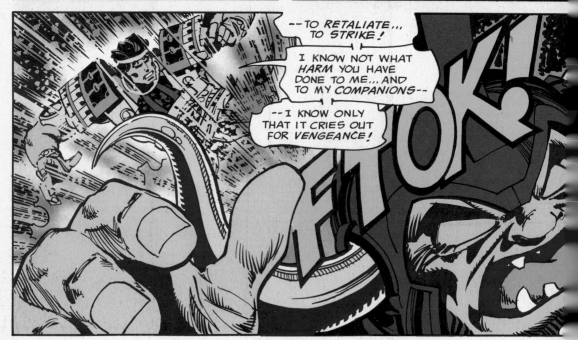

--TO RETALIATE... TO STRIKE!

I KNOW NOT WHAT HARM YOU HAVE DONE TO ME... AND TO MY COMPANIONS--

--I KNOW ONLY THAT IT CRIES OUT FOR VENGEANCE!

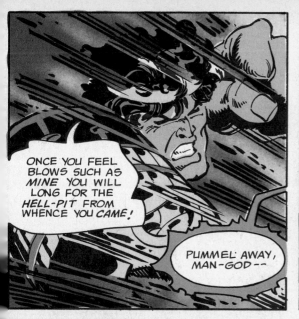

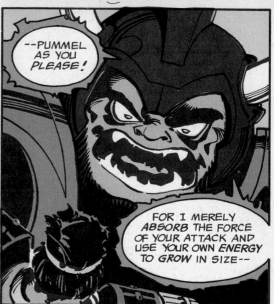

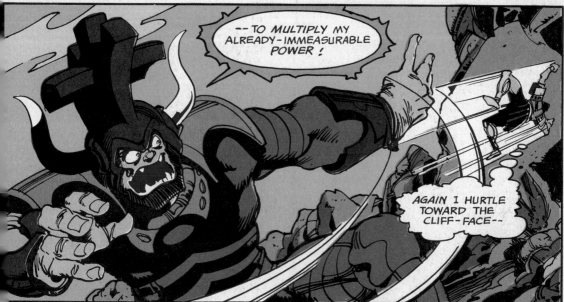

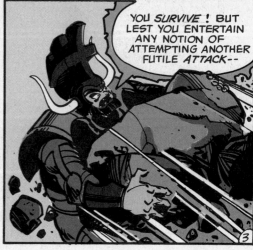

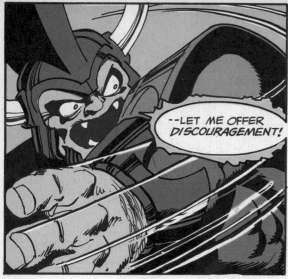

--LET ME OFFER DISCOURAGEMENT!

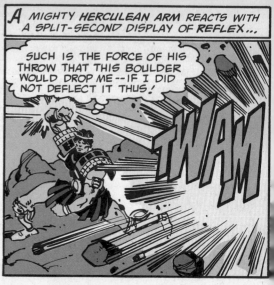

A MIGHTY HERCULEAN ARM REACTS WITH A SPLIT-SECOND DISPLAY OF REFLEX...

SUCH IS THE FORCE OF HIS THROW THAT THIS BOULDER WOULD DROP ME--IF I DID NOT DEFLECT IT THUS!

TWAM

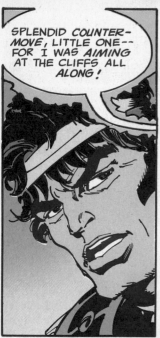

SPLENDID COUNTER-MOVE, LITTLE ONE-- FOR I WAS AIMING AT THE CLIFFS ALL ALONG!

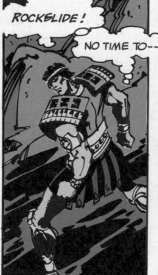

THEN--AN OMINOUS RUMBLING AT HERCULES' BACK BETRAYS THE ANTI-ARES' TRUE INTENT...

ROCKSLIDE!

NO TIME TO--

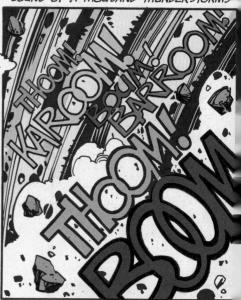

COUNTLESS TONS OF UNYIELDING STONE SPILL DOWNWARD WITH THE SOUND OF A THOUSAND THUNDERSTORMS--

THOOM! KAROOM! BOOM! BARROOM! THOOM! BOOM!

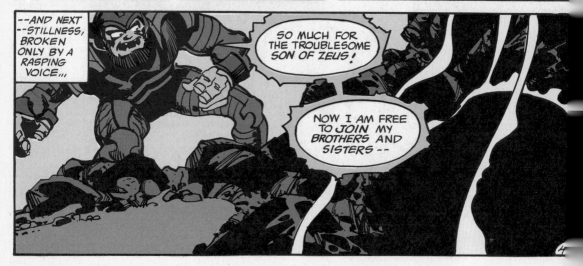

--AND NEXT --STILLNESS, BROKEN ONLY BY A RASPING VOICE...

SO MUCH FOR THE TROUBLESOME SON OF ZEUS!

NOW I AM FREE TO JOIN MY BROTHERS AND SISTERS --

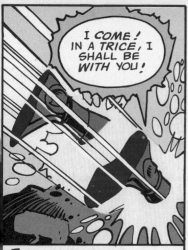

I COME! IN A TRICE, I SHALL BE WITH YOU!

EVEN AS HE SPEAKS, THE FIEND PLUNGES INTO A MASS OF SOLID ROCK--

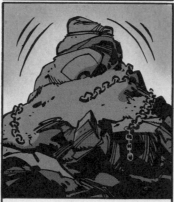

--THE SAME ROCK TO WHICH HERCULES WAS CHAINED FOR UNCOUNTED EONS,...!

NOW, IT BEGINS TO TREMBLE, AS THOUGH SHAKEN BY A GIANT, UNSEEN HAND--

SUDDENLY, THERE IS A SHATTERING--

SHKRAK

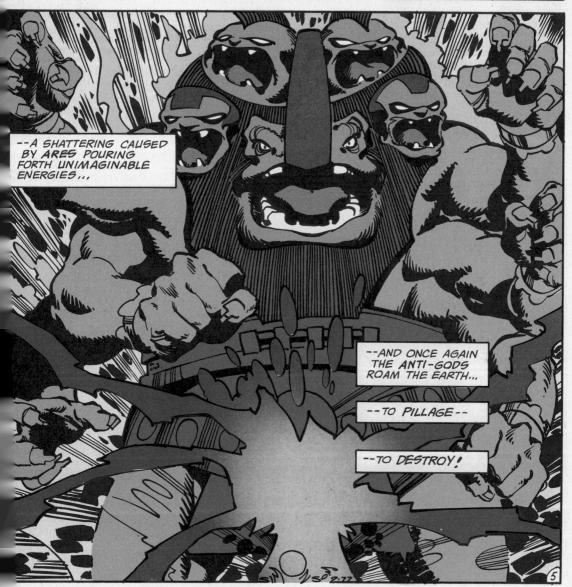

--A SHATTERING CAUSED BY ARES POURING FORTH UNIMAGINABLE ENERGIES...

--AND ONCE AGAIN THE ANTI-GODS ROAM THE EARTH...

--TO PILLAGE--

--TO DESTROY!

5

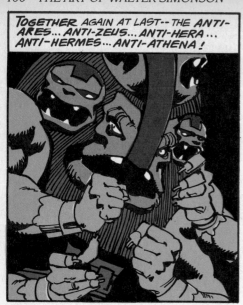

TOGETHER AGAIN AT LAST -- THE ANTI-ARES... ANTI-ZEUS... ANTI-HERA... ANTI-HERMES... ANTI-ATHENA!

THEY PAUSE FOR DEMONIC REFLECTION...

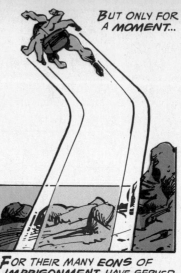

BUT ONLY FOR A MOMENT...

FOR THEIR MANY EONS OF IMPRISONMENT HAVE SERVED ONLY TO FORTIFY THE ONE MALEVOLENT INSTINCT THAT OVERWHELMS THEM...

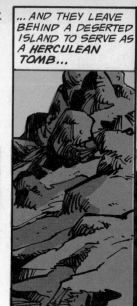

...AND THEY LEAVE BEHIND A DESERTED ISLAND TO SERVE AS A HERCULEAN TOMB...

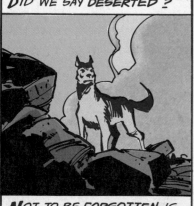

DID WE SAY DESERTED?

NOT TO BE FORGOTTEN IS BASIL...

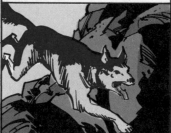

...THE FAITHFUL HOUND THAT HID ABOARD THE FLYING WING WHICH BROUGHT HERCULES TO THIS FOR-SAKEN MEDITERRANEAN ISLE *...

*A FLIGHT WHICH TOOK PLACE LAST ISSUE! -- DENNY!

IT IS NO ACCIDENT THAT HAS BROUGHT BASIL TO THIS PILE OF GEOLOGICAL RUBBLE...

HE HAS SNIFFED OUT THE SCENT OF HIS FRIEND...

WHO, AS IT TURNS OUT...

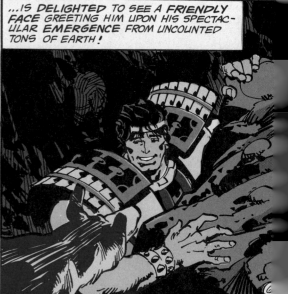

...IS DELIGHTED TO SEE A FRIENDLY FACE GREETING HIM UPON HIS SPECTAC-ULAR EMERGENCE FROM UNCOUNTED TONS OF EARTH!

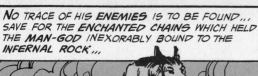

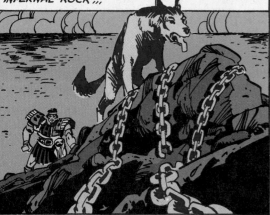

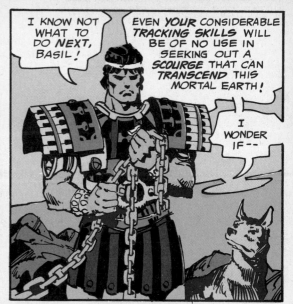

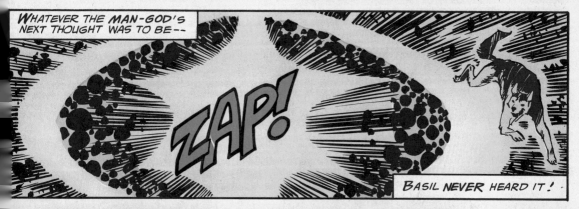

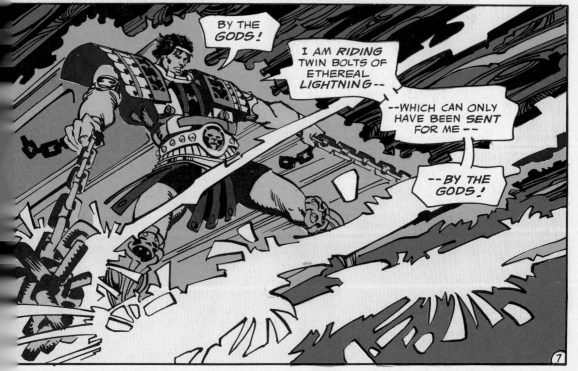

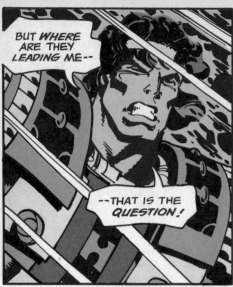

BUT *WHERE* ARE THEY LEADING ME--

--THAT IS THE *QUESTION!*

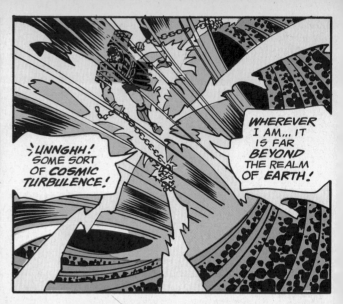

UNNGHH! SOME SORT OF *COSMIC TURBULENCE!*

WHEREVER I AM...IT IS FAR *BEYOND* THE REALM OF *EARTH!*

I DO NOT KNOW HOW MUCH LONGER I CAN *ENDURE* THE RAVAGING *NEXUS* OF THIS HELLISH *STORM!*

I SEEM TO BE *PLUNGING* THROUGH IT--

BUT WILL I *SURVIVE* TO REACH MY *DESTINATION?*

AND AS IF IN ANSWER TO THE *MAN-GOD'S* AGONY AND DOUBTS...THE ETHEREAL FORCES BENEATH HIS BOOTS GIVE WAY TO THE COLD FIRMNESS OF *POLISHED MARBLE!*

FATHER--!

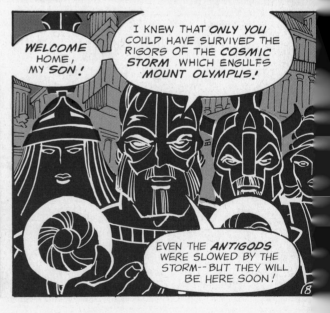

WELCOME HOME, MY SON!

I KNEW THAT *ONLY YOU* COULD HAVE SURVIVED THE RIGORS OF THE *COSMIC STORM* WHICH ENGULFS *MOUNT OLYMPUS!*

EVEN THE *ANTIGODS* WERE SLOWED BY THE STORM--BUT THEY WILL BE HERE SOON!

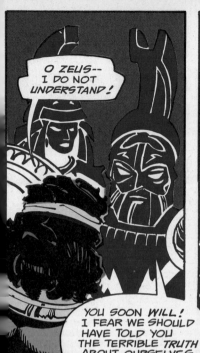

O ZEUS-- I DO NOT UNDERSTAND!

YOU SOON WILL! I FEAR WE SHOULD HAVE TOLD YOU THE TERRIBLE TRUTH ABOUT OURSELVES LONG AGO!

WE GODS ARE IMMORTAL... ALWAYS STRIVING FOR DIVINE PERFECTION! IT WAS THAT ETERNAL QUEST WHICH BROUGHT ON THE IMPENDING CHAOS!

CHAOS, FATHER?

"IT BEGAN MANY EONS AGO, SOON AFTER THE FALL OF ANCIENT GREECE--A TIME WHEN WE BLAMED OURSELVES FOR THE FAILINGS OF OUR MORTAL CHILDREN..."

"WE HAD FORMULATED A PLAN MOST DRASTIC --AND IF SUCCESSFUL, IT WOULD ENABLE US TO ACHIEVE THE ULTIMATE PERFECTION!"

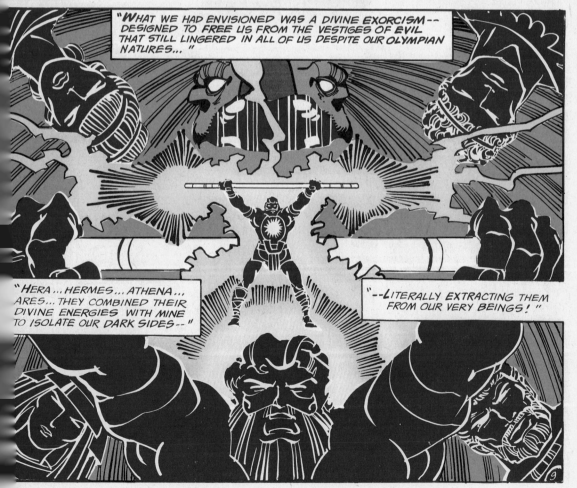

"WHAT WE HAD ENVISIONED WAS A DIVINE EXORCISM-- DESIGNED TO FREE US FROM THE VESTIGES OF EVIL THAT STILL LINGERED IN ALL OF US DESPITE OUR OLYMPIAN NATURES..."

"HERA...HERMES...ATHENA... ARES...THEY COMBINED THEIR DIVINE ENERGIES WITH MINE TO ISOLATE OUR DARK SIDES--

"--LITERALLY EXTRACTING THEM FROM OUR VERY BEINGS!"

"*THUS AN ENTITY OF PURE EVIL WAS SPAWED BY THE EXORCISM --SOMETHING WE HAD NOT FORESEEN...*"

"*...BUT WHICH WE QUICKLY DEALT WITH--STUNNING IT WITH THE POWER OF OLYMPIAN ARMAMENTS FORGED BY ARES!*"

"*ALAS, THAT WAS BUT A TEMPORARY SOLUTION--AND WE REQUIRED A MORE PERMANENT MEANS OF RESTRAINING THE DREAD ANTI-GODS WE HAD CREATED!*"

AFTER DESPERATELY STRIVING FOR ALTERNATIVES ONLY ONE SOLUTION CAME TO MIND...

"*--FOR IT MEANT MOUNTING A CONSPIRACY AGAINST MY BELOVED MAN-GOD SON! YOU WILL RECALL THE GRAND FEAST IN WHICH YOUR USUAL NEMESIS ARES WAS A MOST GRACIOUS HOST...*"

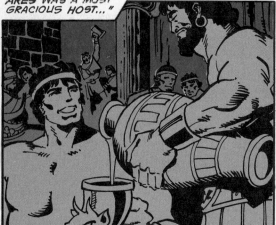

"*AS THE DRUGGED NECTAR YOU CONSUMED WAS SHROUDING YOUR SENSES--YOU MAY RECALL AN ENTIRE UNIT OF OLYMPIAN WAR-RIORS WAS REQUIRED TO STILL YOUR GREAT STRENGTH UNTIL THE DRUG TOOK EFFECT...*"

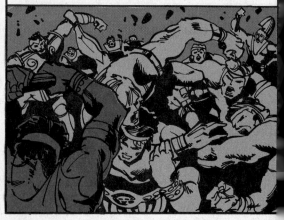

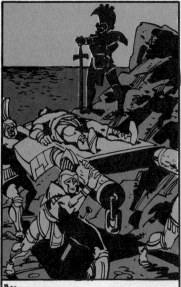

"*UNCONSCIOUS, YOU WERE CARRIED TO A REMOTE MEDITERRANEAN ISLE WE HAD SELECTED...*"

"*WHERE THE ENCHANTED CHAINS YOU WERE TO LOATHE FOR SO LONG WERE FETTERED BY ARES' HAMMER!*"

"*A WORD TO MY BROTHER POSEIDON AND FROM HIS WATERY DOMAIN HE PROVIDED FEARSOME BEHEMOTHS TO STAVE OFF ANY POTENTIAL VISITORS...*"

"*AND FOR THOUSANDS OF YEARS, HERCULES, YOU REMAINED CHAINED --AS NO BEING MORTAL OR OTHER-WISE VENTURED REMOTELY NEAR THE ISLAND!*"

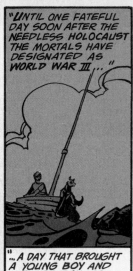

"UNTIL ONE FATEFUL DAY SOON AFTER THE NEEDLESS HOLOCAUST THE MORTALS HAVE DESIGNATED AS WORLD WAR III..."

"...A DAY THAT BROUGHT A YOUNG BOY AND HIS DOG SAILING PERILOUSLY CLOSE TO YOUR SMALL ISLE!"

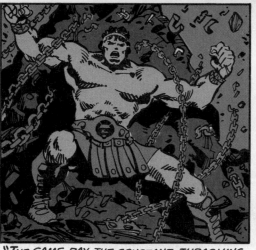

"THE SAME DAY THE CONSTANT THRASHING OF YOUR TITANIC STRENGTH WAS FINALLY ENOUGH TO BREAK OUR ENCHANTED BONDS --AND RELEASE YOU FROM THE ROCK TO WHICH YOU WERE CHAINED!"

"YOU WERE OCCUPIED RESCUING THE LAD FROM THE RAGING BEHEMOTH -- NOT REALIZING THE ROCK YOU LEFT BEHIND WAS THE PRISON WE HAD CREATED TO CONTAIN THE ANTI-GODS!"

"HOW COULD YOU HAVE KNOWN IT WAS YOUR STRENGTH --CHANNELED THROUGH OUR CHAINS -- THAT WAS BINDING THE ROCK AND MAKING IT AN INESCAPABLE CELL!"

"NOR DID YOU REALIZE THE LONG-DORMANT ANTI-GODS HAD AMASSED ENOUGH POWER TO THRUST OUT ONE OF THEIR NUMBER--"

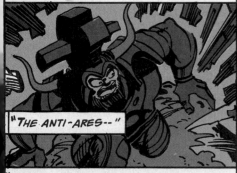

"THE ANTI-ARES--"

"--WHO HASTILY NEEDED A PHYSICAL SHELL IN WHICH HE COULD REST AND SLOWLY STRENGTHEN HIS MALEVOLENT FORCE!"

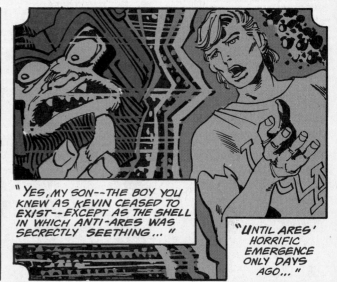

"YES, MY SON--THE BOY YOU KNEW AS KEVIN CEASED TO EXIST--EXCEPT AS THE SHELL IN WHICH ANTI-ARES WAS SECRECTLY SEETHING..."

"UNTIL ARES' HORRIFIC EMERGENCE ONLY DAYS AGO..."

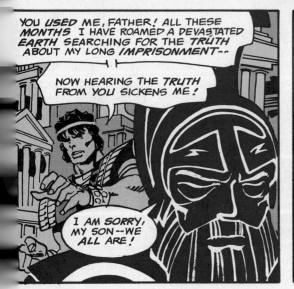

YOU USED ME, FATHER! ALL THESE MONTHS I HAVE ROAMED A DEVASTATED EARTH SEARCHING FOR THE TRUTH ABOUT MY LONG IMPRISONMENT--

NOW HEARING THE TRUTH FROM YOU SICKENS ME!

I AM SORRY, MY SON--WE ALL ARE!

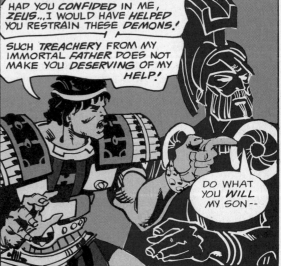

HAD YOU CONFIDED IN ME, ZEUS...I WOULD HAVE HELPED YOU RESTRAIN THESE DEMONS!

SUCH TREACHERY FROM MY IMMORTAL FATHER DOES NOT MAKE YOU DESERVING OF MY HELP!

DO WHAT YOU WILL MY SON--

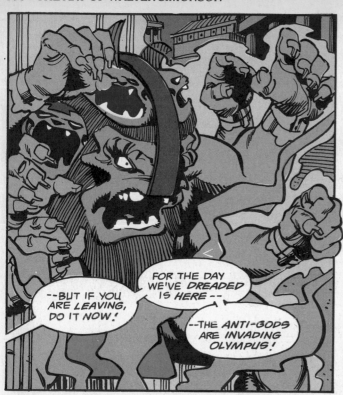

--BUT IF YOU ARE *LEAVING*, DO IT *NOW!*

FOR THE DAY WE'VE *DREADED* IS *HERE* --

--THE *ANTI-GODS* ARE *INVADING OLYMPUS!*

AND RISING IN FORMATION TO MEET THE *HORRENDOUS* THREAT-- A FIGHTING WEDGE OF OLYMPIAN SENTINELS!

'IN THE NAME OF ZEUS--

WE MUST CUT DOWN THE BEAST WHERE IT STANDS!

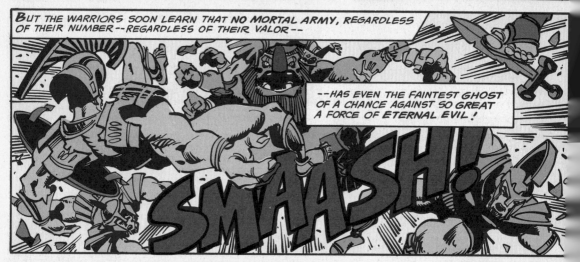

BUT THE WARRIORS SOON LEARN THAT *NO MORTAL ARMY*, REGARDLESS OF THEIR NUMBER--REGARDLESS OF THEIR VALOR--

--HAS EVEN THE FAINTEST GHOST OF A CHANCE AGAINST SO GREAT A FORCE OF *ETERNAL EVIL!*

SMAASH!

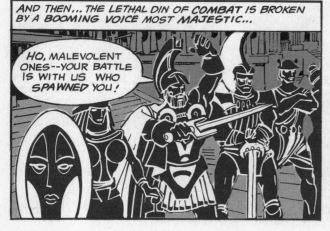

AND THEN,... THE LETHAL DIN OF COMBAT IS BROKEN BY A BOOMING VOICE MOST MAJESTIC...

HO, MALEVOLENT ONES--YOUR BATTLE IS WITH *US* WHO *SPAWNED* YOU!

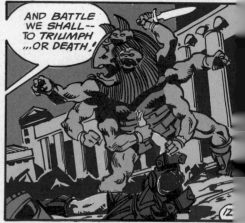

AND BATTLE WE SHALL-- TO *TRIUMPH* ...OR *DEATH!*

12

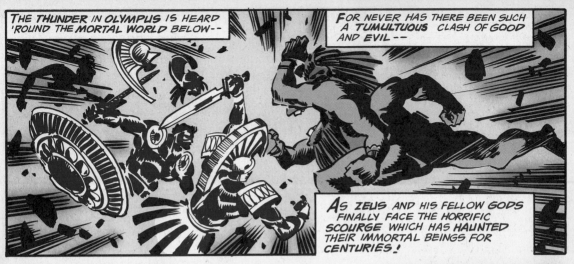

THE THUNDER IN OLYMPUS IS HEARD 'ROUND THE MORTAL WORLD BELOW--

FOR NEVER HAS THERE BEEN SUCH A TUMULTUOUS CLASH OF GOOD AND EVIL --

AS ZEUS AND HIS FELLOW GODS FINALLY FACE THE HORRIFIC SCOURGE WHICH HAS HAUNTED THEIR IMMORTAL BEINGS FOR CENTURIES!

MOUNT OLYMPUS IS SHAKEN THROUGH TO ITS ETHEREAL FOUNDATION AS THE WAR RAGES...

--A WAR WHICH IS WAGED WITHOUT THE MIGHTIEST FIGHTING MACHINE TO EVER WALK THE EARTH--

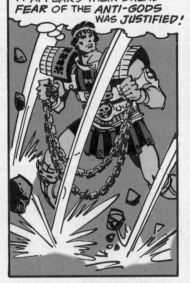

--HERCULES! FATHER AND THE OTHERS DO NOT FARE WELL! IT APPEARS THEIR DREAD FEAR OF THE ANTI-GODS WAS JUSTIFIED!

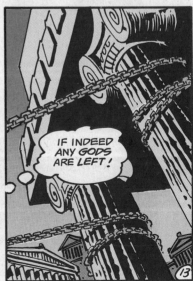

A BRAVE WARRIOR... FALLEN LIKE SO MANY UNDER THOSE MONSTROUS HANDS!

I AM AFRAID THERE CAN BE NO VICTOR IN THIS STRUGGLE--THE SIDES ARE TOO EVENLY MATCHED!

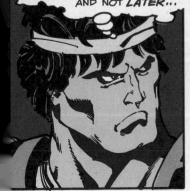

THE GODS AND ANTI-GODS WILL ONLY DESTROY EACH OTHER--OLYMPUS WILL BE LEFT IN RUINS...

BUT WAIT--PERHAPS IF I CAUSE THE INEVITABLE TO HAPPEN NOW AND NOT LATER...

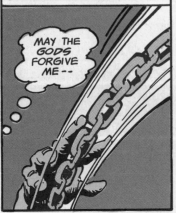

AT ONCE THE MAN-GOD HURTLES THE ENCHANTED CHAINS WHICH ENDURED HIS TORTUROUS JOURNEY THROUGH THE COSMIC STORM RAGING ABOVE...

MAY THE GODS FORGIVE ME--

IF INDEED ANY GODS ARE LEFT!

13

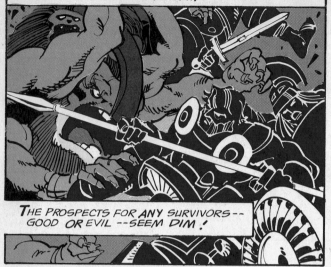

MEANWHILE, THE CATASTROPHIC CLASH HAS INTENSIFIED TO SUCH A DESTRUCTIVE FURY...

THE PROSPECTS FOR ANY SURVIVORS-- GOOD OR EVIL --SEEM DIM!

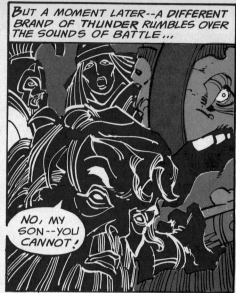

BUT A MOMENT LATER--A DIFFERENT BRAND OF THUNDER RUMBLES OVER THE SOUNDS OF BATTLE...

NO, MY SON--YOU CANNOT!

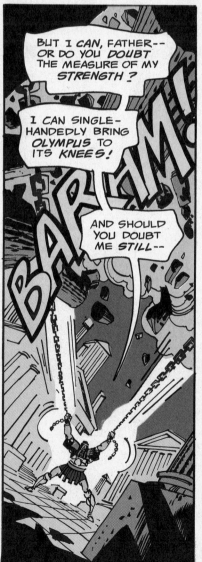

BUT I CAN, FATHER-- OR DO YOU DOUBT THE MEASURE OF MY STRENGTH?

I CAN SINGLE-HANDEDLY BRING OLYMPUS TO ITS KNEES!

AND SHOULD YOU DOUBT ME STILL--

BAR-RAM!!

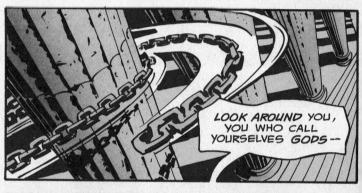

LOOK AROUND YOU, YOU WHO CALL YOURSELVES GODS--

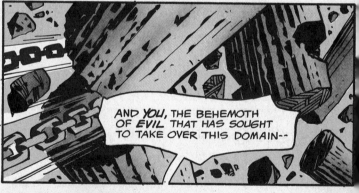

AND YOU, THE BEHEMOTH OF EVIL THAT HAS SOUGHT TO TAKE OVER THIS DOMAIN--

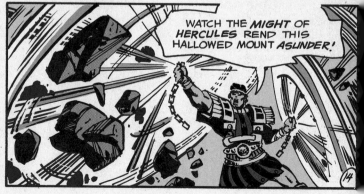

WATCH THE MIGHT OF HERCULES REND THIS HALLOWED MOUNT ASUNDER!

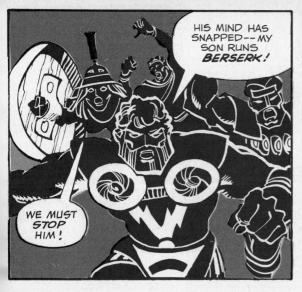

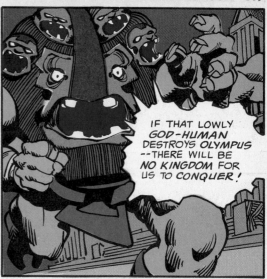

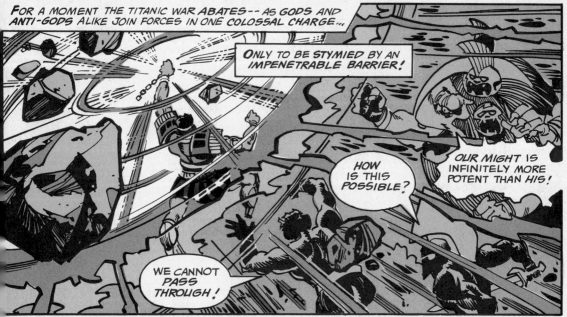

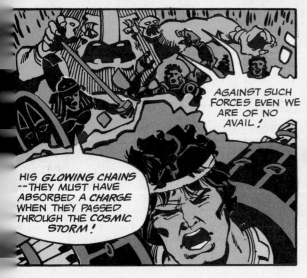

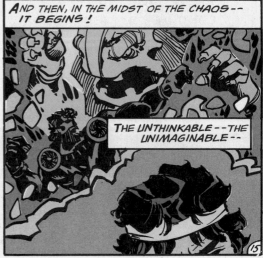

AND THE GRAVE MISDEED THE GODS PERPETRATED IN THE NAME OF *DIVINE PERFECTION* SO LONG AGO IS *RIGHTED* AT LAST...

...THOSE FEARSOME SPECTRES OF EVIL WHICH COMBINED TO FORM THE *ANTI-GODS* ARE CLAIMED BY THOSE WHOSE NAMES ARE *IMMORTAL*--

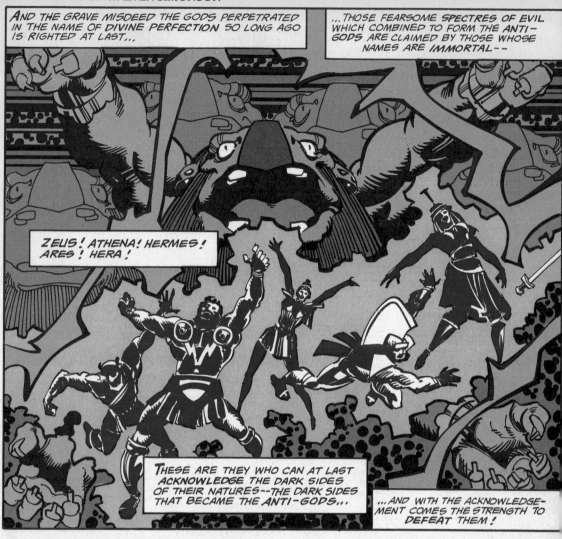

ZEUS! ATHENA! HERMES! ARES! HERA!

THESE ARE THEY WHO CAN AT LAST ACKNOWLEDGE THE DARK SIDES OF THEIR NATURES--THE DARK SIDES THAT BECAME THE *ANTI-GODS*...

...AND WITH THE ACKNOWLEDGE-MENT COMES THE STRENGTH TO DEFEAT THEM!

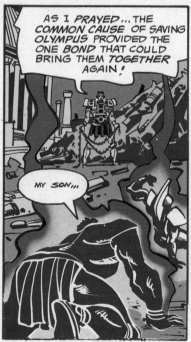

AS I *PRAYED*...THE *COMMON CAUSE* OF SAVING OLYMPUS PROVIDED THE ONE *BOND* THAT COULD BRING THEM *TOGETHER* AGAIN!

MY SON...

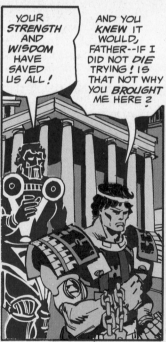

YOUR *STRENGTH* AND *WISDOM* HAVE SAVED US ALL!

AND YOU *KNEW* IT WOULD, FATHER--IF I DID NOT *DIE* TRYING! IS THAT NOT WHY YOU *BROUGHT* ME HERE?

HERCULES... I...

SPARE ME ANY FURTHER GRIEF, ZEUS! IF I MUST *CHOOSE* TO DWELL BETWEEN GODS AND *HUMANS*--

--I BELIEVE YOU *KNOW* WHICH I PREFER!

AND NO SOONER HAS THE MAN-GOD TURNED HIS HEAD--WHEN HE DISCOVERS HIS WISH HAS BEEN GRANTED...

I AM BACK ON EARTH-- MY *TRUE* HOME!

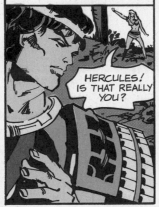

SUDDENLY, A SOFT AND VULNERABLE *VOICE* CALLS OUT--AND THE SON OF ZEUS CANNOT BELIEVE HIS EARS...

HERCULES! IS THAT REALLY YOU?

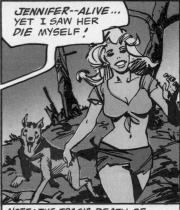

JENNIFER--ALIVE... YET I SAW HER *DIE* MYSELF!

NOTE: THE TRAGIC DEATH OF HERCULES' LONG-TIME COMPANION AT THE HANDS OF THE *ANTI-ARES* WAS CHRONICLED LAST ISSUE! DENNY.

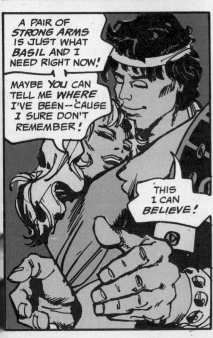

A PAIR OF *STRONG ARMS* IS JUST WHAT *BASIL* AND I NEED RIGHT NOW!

MAYBE *YOU* CAN TELL ME *WHERE* I'VE BEEN--'CAUSE I SURE DON'T REMEMBER!

THIS I CAN *BELIEVE!*

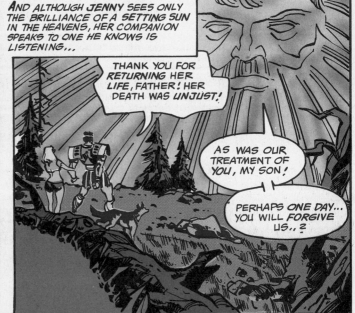

AND ALTHOUGH *JENNY* SEES ONLY THE BRILLIANCE OF A SETTING SUN IN THE HEAVENS, HER COMPANION SPEAKS TO ONE HE KNOWS IS LISTENING...

THANK YOU FOR RETURNING HER LIFE, FATHER! HER DEATH WAS *UNJUST!*

AS WAS OUR TREATMENT OF YOU, MY SON!

PERHAPS *ONE DAY...* YOU WILL *FORGIVE* US...?

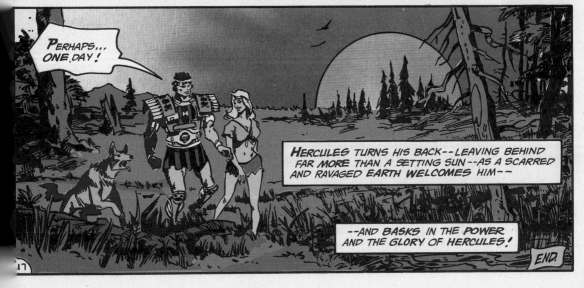

PERHAPS... ONE *DAY!*

HERCULES TURNS HIS BACK--LEAVING BEHIND FAR *MORE* THAN A SETTING SUN--AS A SCARRED AND RAVAGED EARTH WELCOMES HIM--

--AND BASKS IN THE POWER AND THE GLORY OF HERCULES!

END.

METAL MEN

 The Metal Men began for me as a full script written by Steve Gerber. It had been sitting around in a drawer somewhere and was eventually offered to me as a one-shot. After I had finished the job, then-publisher Carmine Infantino liked it enough to commission a couple more stories and, eventually, a series. Steve wasn't available for those, and Gerry Conway took over the writing assignment. We had a good time together, but that winter there was a rough flu going around New York and Gerry was ill three times over the course of a single issue. As I wasn't the world's fastest artist, we fell pretty far behind.

 Eventually, Marty Pasko wrote the last two issues that I drew and, although I had enjoyed the strip overall, I found myself exhausted. Each writer, of course, had a little different idea about where the strip was going; by the end of the fifth issue, the Metal Men were dragging around a couple of supporting characters left over from dangling storylines that were never developed (including a plot in which we had planned to put Tina's brain into a real human body). I was bushed, so I quietly took my leave. But the series had given me a chance to try my hand at a little cartooning, both with the characters and with the display lettering, and METAL MEN remains some of the silliest (and most enjoyable) work I've done.

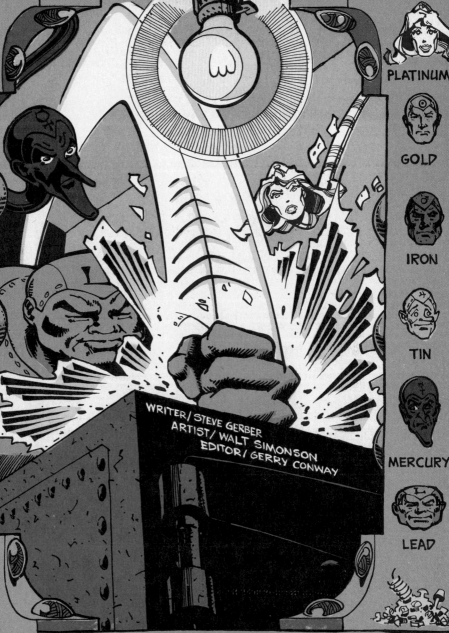

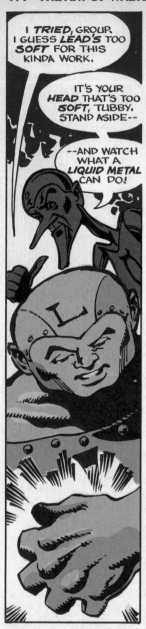

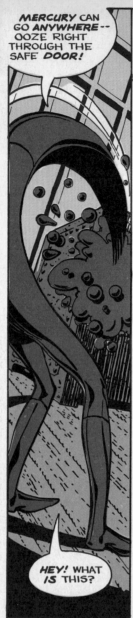

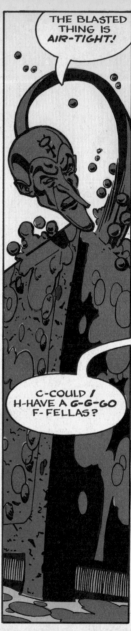

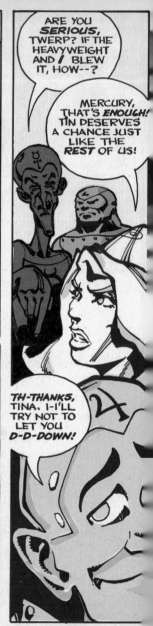

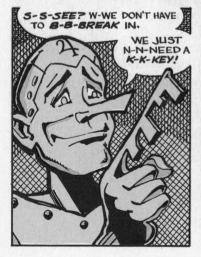

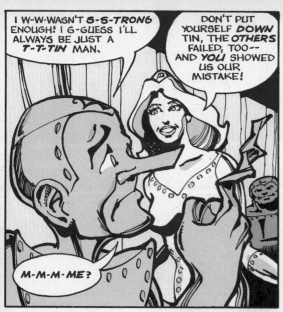

I W-W-WASN'T *S-S-TRONG* ENOUGH! I G-GUESS I'LL ALWAYS BE JUST A *T-T-TIN* MAN.

DON'T PUT YOURSELF *DOWN* TIN, THE *OTHERS* FAILED, TOO-- AND *YOU* SHOWED US OUR MISTAKE!

M-M-M-ME?

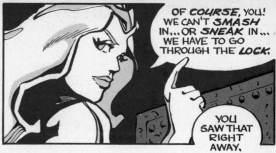

OF *COURSE*, YOU! WE CAN'T *SMASH* IN... OR *SNEAK* IN... WE HAVE TO GO THROUGH THE *LOCK*.

YOU SAW THAT RIGHT AWAY.

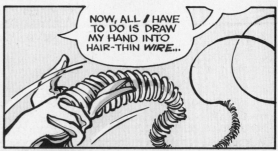

NOW, ALL *I* HAVE TO DO IS DRAW MY HAND INTO HAIR-THIN *WIRE*...

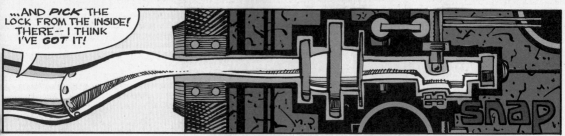

...AND *PICK* THE LOCK FROM THE INSIDE! THERE-- I THINK I'VE *GOT* IT!

snap

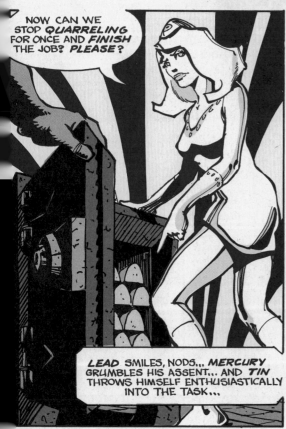

NOW CAN WE STOP *QUARRELING* FOR ONCE AND *FINISH* THE JOB? *PLEASE*?

LEAD SMILES, NODS... *MERCURY* GRUMBLES HIS ASSENT... AND *TIN* THROWS HIMSELF ENTHUSIASTICALLY INTO THE TASK...

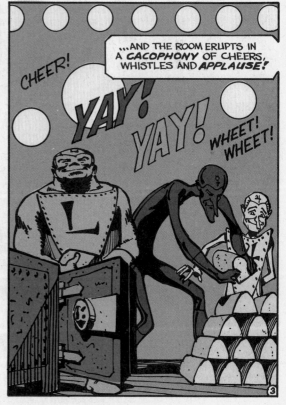

WITHIN MOMENTS, IT IS COMPLETED, AT WHICH POINT A *SPOTLIGHT* FALLS ON THE METAL BAND...

...AND THE ROOM ERUPTS IN A *CACOPHONY* OF CHEERS, WHISTLES AND *APPLAUSE*!

CHEER!

YAY!

YAY!

WHEET! WHEET!

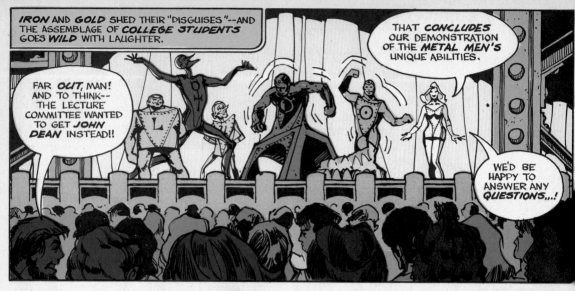

IRON AND GOLD SHED THEIR "DISGUISES"--AND THE ASSEMBLAGE OF COLLEGE STUDENTS GOES WILD WITH LAUGHTER.

THAT CONCLUDES OUR DEMONSTRATION OF THE METAL MEN'S UNIQUE ABILITIES.

FAR OUT, MAN! AND TO THINK-- THE LECTURE COMMITTEE WANTED TO GET JOHN DEAN INSTEAD!!

WE'D BE HAPPY TO ANSWER ANY QUESTIONS...!

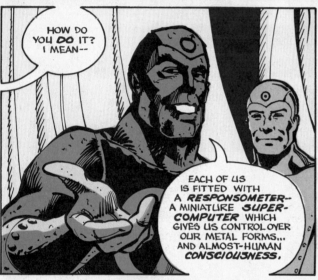

HOW DO YOU DO IT? I MEAN--

EACH OF US IS FITTED WITH A RESPONSOMETER-- A MINIATURE SUPER-COMPUTER WHICH GIVES US CONTROL OVER OUR METAL FORMS... AND ALMOST-HUMAN CONSCIOUSNESS.

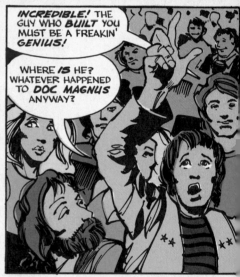

INCREDIBLE! THE GUY WHO BUILT YOU MUST BE A FREAKIN' GENIUS!

WHERE IS HE? WHATEVER HAPPENED TO DOC MAGNUS ANYWAY?

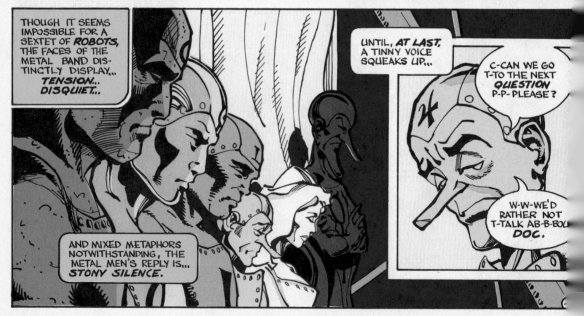

THOUGH IT SEEMS IMPOSSIBLE FOR A SEXTET OF ROBOTS, THE FACES OF THE METAL BAND DISTINCTLY DISPLAY... TENSION... DISQUIET...

UNTIL, AT LAST, A TINNY VOICE SQUEAKS UP...

C-CAN WE GO T-TO THE NEXT QUESTION P-P-PLEASE?

W-W-WE'D RATHER NOT T-TALK AB-B-BOUT DOC.

AND MIXED METAPHORS NOTWITHSTANDING, THE METAL MEN'S REPLY IS... STONY SILENCE.

SMALL *WONDER*, THE LAST TIME THE ROBOTS *SAW* THEIR CREATOR, *DR. WILL MAGNUS*... HE WAS TRYING TO *DESTROY* THEM*!*

BRAINWASHED BY THE DICTATOR OF *KARNIA*, MAGNUS' GENIUS HAS BEEN *TWISTED*... ALL HIS FORMER LOYALTIES *OBLITERA-TED*... INDEED, HIS *MIND ITSELF* LAIN TO RUIN!

THINGS HAVE *CHANGED* A BIT SINCE THEN. THE PRODIGAL CYBERNETICIST HAS COME *HOME* -- AGAINST HIS WILL -- AT THE "SUGGESTION" OF THE *C.I.A.*

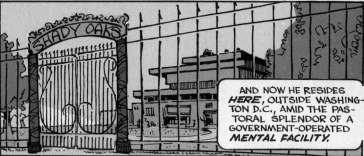

AND NOW HE RESIDES *HERE*, OUTSIDE WASHINGTON D.C., AMID THE PASTORAL SPLENDOR OF A GOVERNMENT-OPERATED *MENTAL FACILITY.*

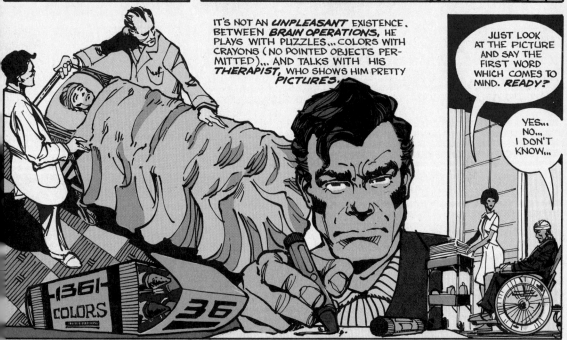

IT'S NOT AN *UNPLEASANT* EXISTENCE. BETWEEN *BRAIN OPERATIONS*, HE PLAYS WITH PUZZLES... COLORS WITH CRAYONS (NO POINTED OBJECTS PERMITTED)... AND TALKS WITH HIS *THERAPIST*, WHO SHOWS HIM PRETTY *PICTURES.*

JUST LOOK AT THE PICTURE AND SAY THE FIRST WORD WHICH COMES TO MIND. *READY?*

YES... NO... I DON'T KNOW...

1361 COLORS

36

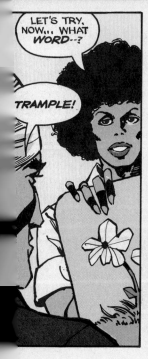

LET'S TRY, NOW... WHAT *WORD*--?

TRAMPLE!

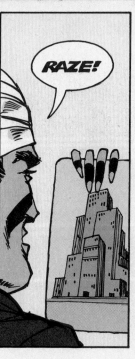

RAZE!

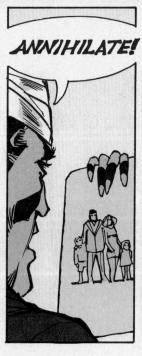

ANNIHILATE!

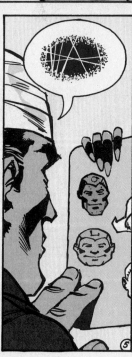

⑤

FOR LONG MOMENTS, THE SCIENTIST *STARES* WITHOUT SPEAKING. HIS FACIAL MUSCLES GO *TAUT.* FIRST HIS HEAD, THEN HIS ENTIRE BODY *QUIVERS*, ATTEMPTING TO CONTAIN THE *VIRULENCE* RISING WITHIN HIMSELF.

HE *FAILS!*

SHRED!

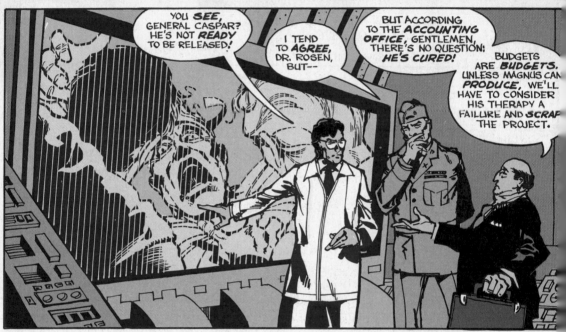

YOU *SEE*, GENERAL CASPAR? HE'S NOT *READY* TO BE RELEASED!

I TEND TO *AGREE*, DR. ROSEN, BUT--

BUT ACCORDING TO THE *ACCOUNTING OFFICE*, GENTLEMEN, THERE'S NO QUESTION: *HE'S CURED!*

BUDGETS ARE *BUDGETS.* UNLESS MAGNUS CAN *PRODUCE*, WE'LL HAVE TO CONSIDER HIS THERAPY A FAILURE AND *SCRAP* THE PROJECT.

YOU'RE TALKING ABOUT A *HUMAN MIND*, WHITTIER--! YOU CAN'T MEASURE HIS PROGRESS IN DOLLARS AND CENTS!

GENTLEMEN, *PLEASE--!*

SURELY WE CAN *COMPROMISE*--ON SOME FORM OF *WORK-THERAPY*, LET'S SAY.

HMMMM, YES, THAT *WOULD* ALLOW HIM TO *PRODUCE...!*

I *STILL* SAY HE'S NOT *READY.* BUT IF THERE'S NO OTHER WAY...!

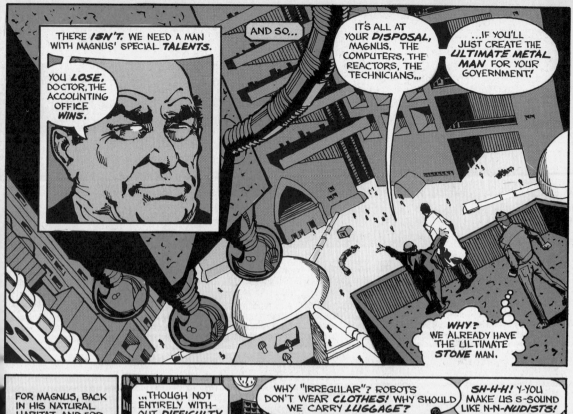

THERE *ISN'T.* WE NEED A MAN WITH MAGNUS' SPECIAL *TALENTS.*

YOU *LOSE,* DOCTOR, THE ACCOUNTING OFFICE *WINS.*

AND SO...

IT'S ALL AT YOUR *DISPOSAL,* MAGNUS, THE COMPUTERS, THE REACTORS, THE TECHNICIANS...

...IF YOU'LL JUST CREATE THE *ULTIMATE METAL MAN* FOR YOUR GOVERNMENT!

WHY? WE ALREADY HAVE THE ULTIMATE *STONE* MAN.

FOR MAGNUS, BACK IN HIS NATURAL HABITAT, AND FOR THE *METAL MEN* ON THEIR LECTURE CIRCUIT, THE ENSUING WEEKS PASS QUICKLY...

...THOUGH NOT ENTIRELY WITH-OUT *DIFFICULTY.*

NO *LUGGAGE?* NO *SURNAMES?* THIS *IS* QUITE IRREGULAR...!

WHY "IRREGULAR"? ROBOTS DON'T WEAR *CLOTHES!* WHY SHOULD WE CARRY *LUGGAGE?*

SH-H-H! Y-YOU MAKE US S-SOUND LIKE N-N-*NUDISTS!*

THIS ISN'T *FUNNY,* TIN, WE'RE VICTIMS OF *DISCRIMINATION.*

WE ARE *NOT* REQUIRED TO ACCOMMODATE *MACHINES,* SIR! YOU'LL HAVE TO SEEK LODGING *ELSEWHERE* IN *WASHINGTON.*

WE-- EH?

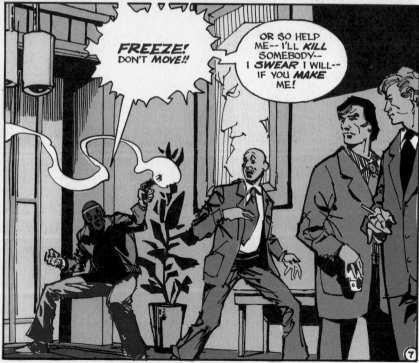

FREEZE! DON'T *MOVE!!*

OR SO HELP ME-- I'LL *KILL* SOMEBODY-- I *SWEAR* I WILL-- IF YOU *MAKE* ME!

BLAM

⑦

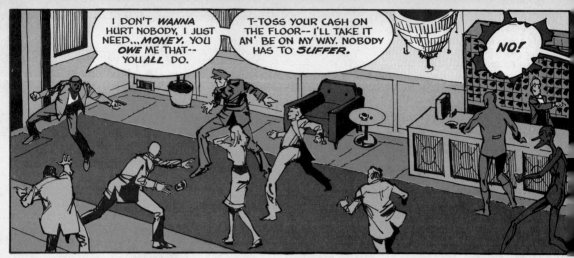

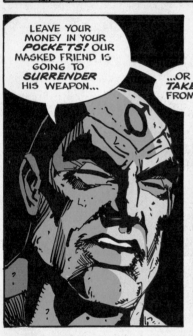

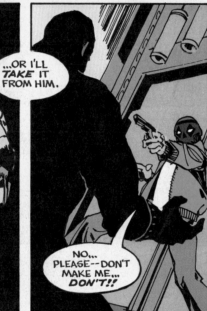

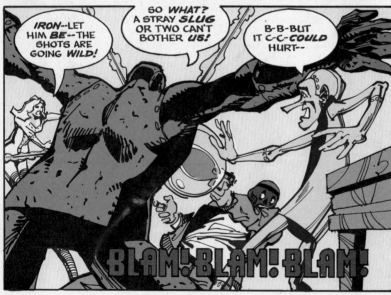

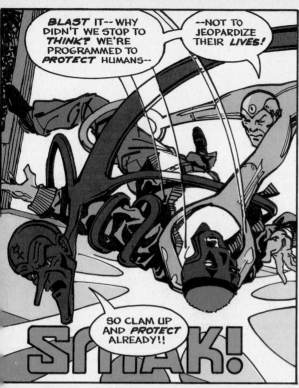

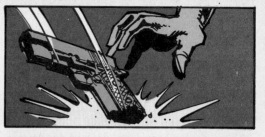

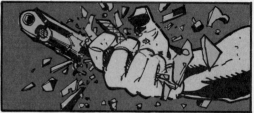

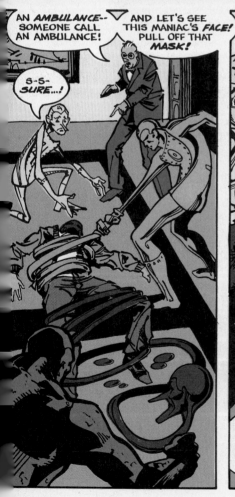

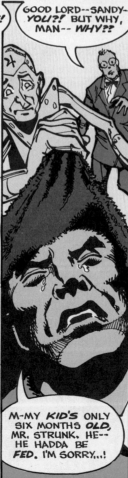

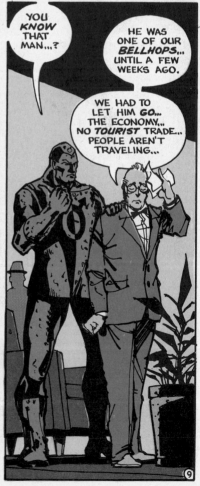

HE'S A *GOOD* BOY...HONEST AS THE DAY IS LONG...HATED TO DO IT TO HIM...

EXCUSE ME, I'D BEST PHONE THE *POLICE.*

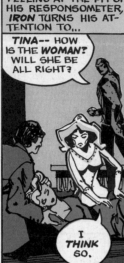

FIGHTING THE *HOLLOW* FEELING AT THE PIT OF HIS RESPONSOMETER, *IRON* TURNS HIS ATTENTION TO...

TINA-- HOW IS THE *WOMAN?* WILL SHE BE ALL RIGHT?

I *THINK* SO.

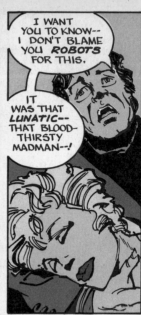

I WANT YOU TO KNOW-- I DON'T BLAME YOU *ROBOTS* FOR THIS.

IT WAS THAT *LUNATIC*-- THAT BLOOD-THIRSTY MADMAN--!

IT LOOKED THAT WAY TO *ME* TOO-- BUT EVEN MY *PHOTO-CELLS* WEREN'T OBJECTIVE ENOUGH OBSERVERS.

SO MANY THINGS... LOOK SO *DIFFERENT*... TO DIFFERENT EYES.

THERE HE IS, CHARLIE, CAREFUL--HE'S *DANGEROUS!*

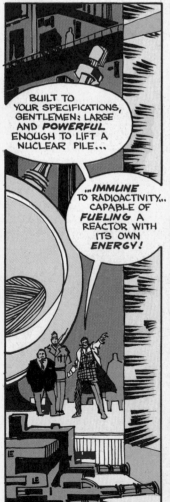

WHILE, JUST A SILVER DOLLAR'S THROW AWAY, ACROSS THE POTOMAC IN *VIRGINIA*...

BUILT TO YOUR SPECIFICATIONS, GENTLEMEN: LARGE AND *POWERFUL* ENOUGH TO LIFT A NUCLEAR PILE...

...*IMMUNE* TO RADIOACTIVITY... CAPABLE OF *FUELING* A REACTOR WITH ITS OWN *ENERGY!*

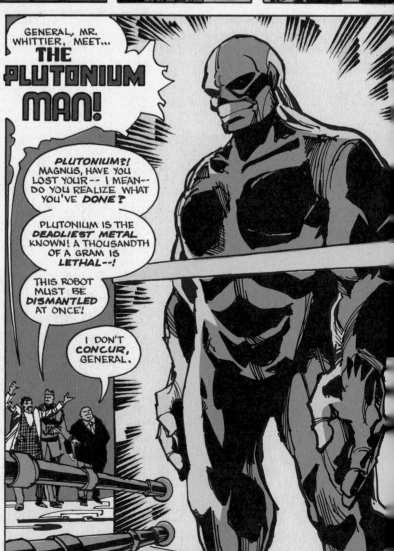

GENERAL, MR. WHITTIER, MEET...

THE PLUTONIUM MAN!

PLUTONIUM?! MAGNUS, HAVE YOU LOST YOUR-- I MEAN-- DO YOU REALIZE WHAT YOU'VE *DONE?*

PLUTONIUM IS THE *DEADLIEST METAL* KNOWN! A THOUSANDTH OF A GRAM IS *LETHAL*--!

THIS ROBOT MUST BE *DISMANTLED* AT ONCE!

I DON'T *CONCUR*, GENERAL.

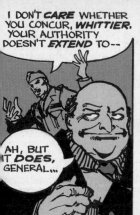

I DON'T *CARE* WHETHER YOU CONCUR, *WHITTIER,* YOUR AUTHORITY DOESN'T *EXTEND* TO--

AH, BUT IT *DOES,* GENERAL...

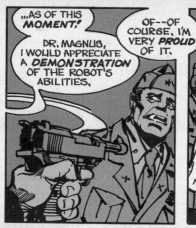

...AS OF THIS *MOMENT!*

DR. MAGNUS, I WOULD APPRECIATE A *DEMONSTRATION* OF THE ROBOT'S ABILITIES.

OF--OF COURSE. I'M VERY *PROUD* OF IT.

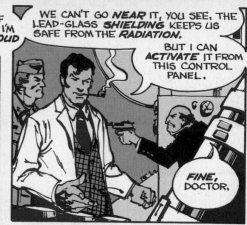

WE CAN'T GO *NEAR* IT, YOU SEE. THE LEAD-GLASS *SHIELDING* KEEPS US SAFE FROM THE *RADIATION.*

BUT I CAN *ACTIVATE* IT FROM THIS CONTROL PANEL.

FINE, DOCTOR.

AT THE TWIST OF A *DIAL*...

...THE ROBOT'S EYES FLASH TO *LIFE.*

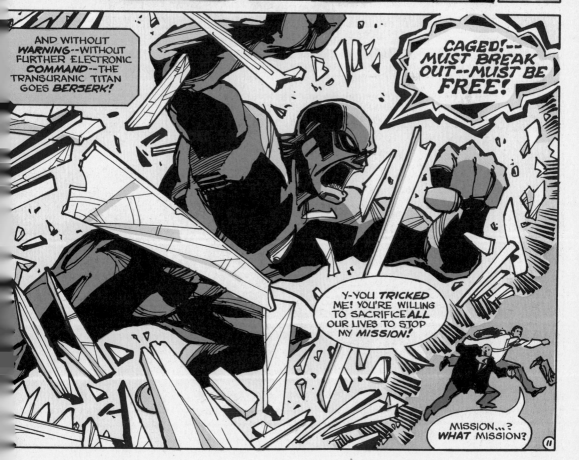

AND WITHOUT *WARNING*--WITHOUT FURTHER ELECTRONIC *COMMAND*--THE TRANSURANIC TITAN GOES *BERSERK!*

CAGED!-- MUST BREAK OUT--MUST BE *FREE!*

Y-YOU *TRICKED* ME! YOU'RE WILLING TO SACRIFICE *ALL* OUR LIVES TO STOP MY *MISSION!*

MISSION...? *WHAT* MISSION?

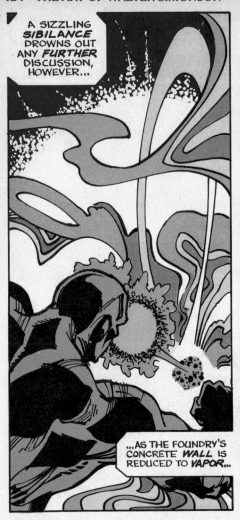

A SIZZLING *SIBILANCE* DROWNS OUT ANY *FURTHER* DISCUSSION, HOWEVER...

...AS THE FOUNDRY'S CONCRETE *WALL* IS REDUCED TO *VAPOR*...

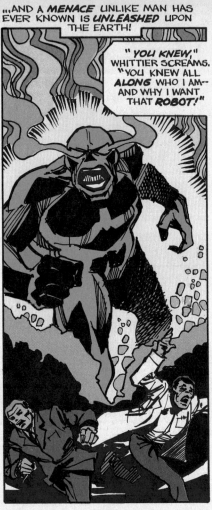

...AND A *MENACE* UNLIKE MAN HAS EVER KNOWN IS *UNLEASHED* UPON THE EARTH!

"*YOU KNEW*," WHITTIER SCREAMS. "YOU KNEW ALL *ALONG* WHO I AM-- AND WHY I WANT THAT *ROBOT!*"

FIVE YEARS I'VE PLAYED THE BUREAUCRAT--RISING THROUGH YOUR RANKS TO *TOP SECURITY CLEARANCE*-- ALL FOR THIS MOMENT!

AND NOW, I'VE *FAILED*--CHEATED MY PEOPLE OF THEIR *REVENGE*--ON *MAGNUS*--AND YOUR LOATHSOME *UNITED STATES!!*

A *SPY*-- WHITTIER-- *YOU?*

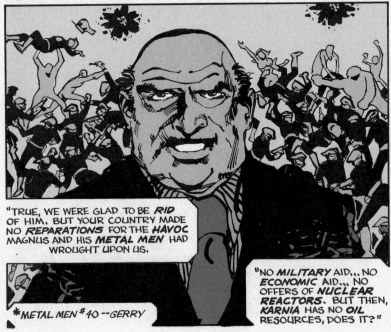

"A *SPY*, GENERAL? *NO*. YOUR NATION HAS NO *SECRETS* WE DESIRE-- ONLY *WEALTH*. I'M AN AGENT OF *KARNIA*, WHOSE DICTATOR *ABDUCTED* DR. MAGNUS--AND *DIED* FOR HIS CRIME.✱

"TRUE, WE WERE GLAD TO BE *RID* OF HIM, BUT YOUR COUNTRY MADE NO *REPARATIONS* FOR THE *HAVOC* MAGNUS AND HIS *METAL MEN* HAD WROUGHT UPON US.

✱*METAL MEN* #40 --GERRY

"NO *MILITARY* AID,... NO *ECONOMIC* AID... NO OFFERS OF *NUCLEAR REACTORS*. BUT THEN, *KARNIA* HAS NO *OIL* RESOURCES, DOES IT?"

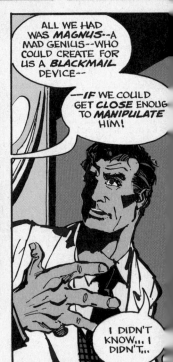

ALL WE HAD WAS *MAGNUS*--A MAD GENIUS--WHO COULD CREATE FOR US A *BLACKMAIL* DEVICE--

--*IF* WE COULD GET *CLOSE* ENOUGH TO *MANIPULATE* HIM!

I DIDN'T KNOW... I DIDN'T...

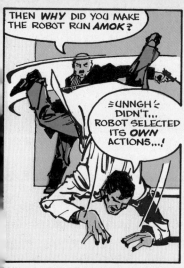
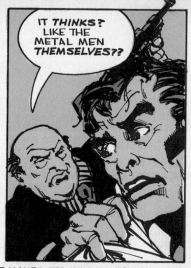
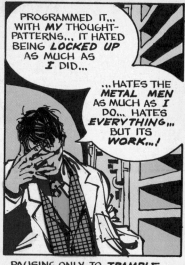

AND SO THE UNSTOPPABLE ELEMENT MAKES ITS WAY TO *WASHINGTON*... PAUSING ONLY TO *TRAMPLE*...
TO *RAZE*...TO *ANNIHILATE*: A *METAL MADMAN*, AS HOPELESSLY INSANE AS ITS CREATOR.

TRAMPLE RAZE ANNIHILATE

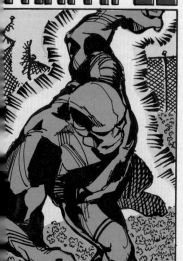
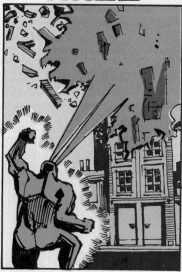
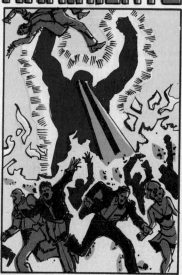

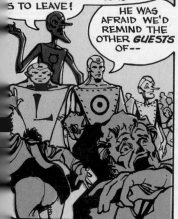
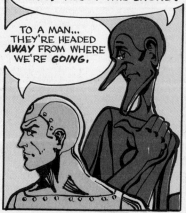
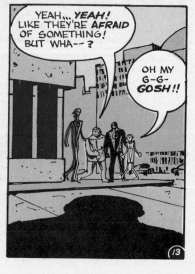

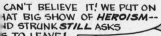
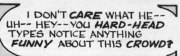

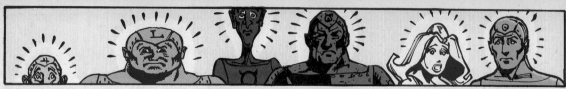

FOR A MOMENT, TIME SEEMS TO *FREEZE*-- ALL MOTION *HALTED*--AS SEVEN *RESPONSOMETERS* ASSESS THE SITUATION! THE METAL MEN SENSE A *FAMILIAR* QUALITY IN THIS APPARENT ADVERSARY,

AND THE *PLUTONIUM MAN* RECOGNIZES *THEM*, AS WELL-- AND CANNOT SUPPRESS HIS PROGRAMMED

HATRED!

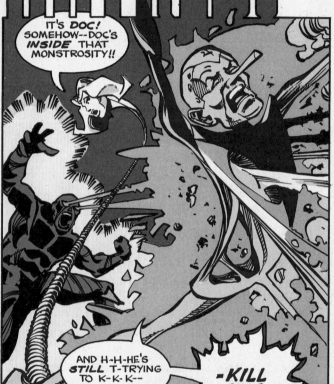

IT'S *DOC!* SOMEHOW--DOC'S *INSIDE* THAT MONSTROSITY!!

AND H-H-HE'S *STILL* T-TRYING TO K-K-K--

-KILL US!

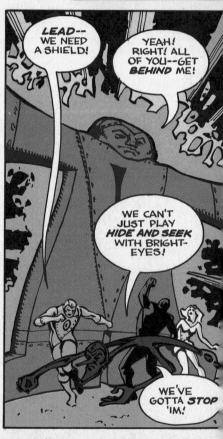

LEAD-- WE NEED A SHIELD!

YEAH! RIGHT! ALL OF YOU--GET *BEHIND* ME!

WE CAN'T JUST PLAY *HIDE* AND *SEEK* WITH BRIGHT-EYES!

WE'VE GOTTA *STOP* 'IM!

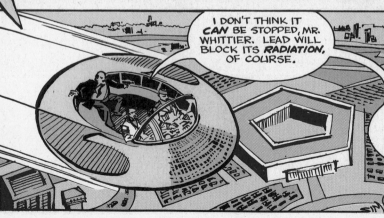

I DON'T THINK IT *CAN* BE STOPPED, MR. WHITTIER. LEAD WILL BLOCK ITS *RADIATION*, OF COURSE.

BUT LEAD *MELTS* AT 327.5 DEGREES CENTIGRADE AND THE *PLUTONIUM MAN* CAN GENERATE THE HEAT OF A *NUCLEAR REACTOR!*

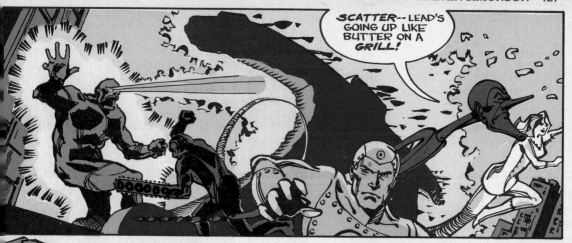

SCATTER-- LEAD'S GOING UP LIKE BUTTER ON A *GRILL!*

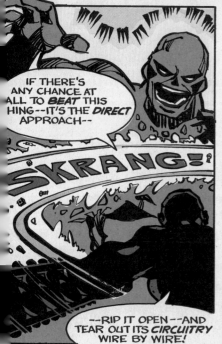

IF THERE'S ANY CHANCE AT ALL TO *BEAT* THIS THING-- IT'S THE *DIRECT* APPROACH--

SKRANG!

--RIP IT OPEN-- AND TEAR OUT ITS *CIRCUITRY* WIRE BY WIRE!

BUT IT *CAN'T* BE TORN APART, GENERAL. OH, POSSIBLY BY *SUPERMAN...* BUT NO ONE ELSE COULD TOLERATE THE *RADIATION LEVEL.*

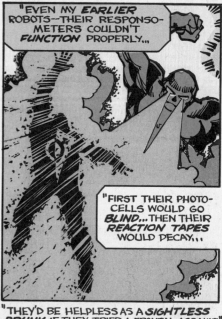

"EVEN MY *EARLIER* ROBOTS-- THEIR RESPONSO- METERS COULDN'T *FUNCTION* PROPERLY...

"FIRST THEIR PHOTO- CELLS WOULD GO *BLIND...* THEN THEIR *REACTION TAPES* WOULD DECAY...

"THEY'D BE HELPLESS AS A *SIGHTLESS DRUNK* IF THEY TRIED A FRONTAL ASSAULT."

BUT IT COULD BE *BOUND* -- IF WE COULD UPSET ITS FOOTING-- AIM ITS BEAMS *UPWARD!*

LEAVE IT TO *ME,* LADY, YOU AND GLAMOR- PANTS GET READY TO DO YOUR *DUCTILITY* ACT!

O SAYING, THE QUID METAL MAN PREADS HIMSELF A THIN SLIPPERY ICKSILVER HEET UPON THE VEMENT... *BUT...*

SKLOOSH!

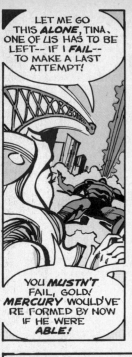

LET ME GO THIS *ALONE*, TINA. ONE OF US HAS TO BE LEFT-- IF I *FAIL*-- TO MAKE A LAST ATTEMPT!

YOU *MUSTN'T* FAIL, GOLD! *MERCURY* WOULD'VE RE-FORMED BY NOW IF HE WERE *ABLE!*

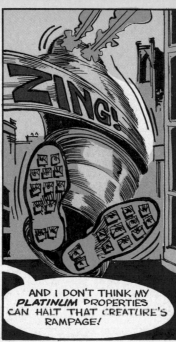

AND I DON'T THINK MY *PLATINUM* PROPERTIES CAN HALT THAT *CREATURE'S* RAMPAGE!

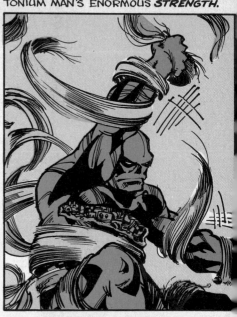

NOR, HOWEVER, ARE *GOLD'S* TALENTS EQUAL TO THE TASK--NOT AGAINST THE PLU-TONIUM MAN'S ENORMOUS *STRENGTH.*

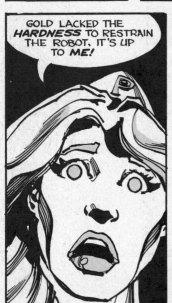

GOLD LACKED THE *HARDNESS* TO RESTRAIN THE ROBOT, IT'S UP TO *ME!*

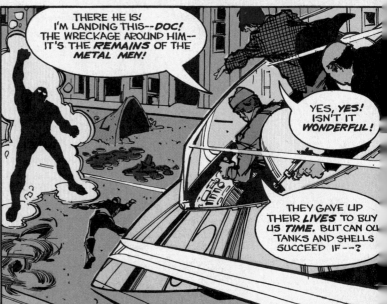

THERE HE IS! I'M LANDING THIS--*DOC!* THE WRECKAGE AROUND HIM-- IT'S THE *REMAINS* OF THE *METAL MEN!*

YES, *YES!* ISN'T IT *WONDERFUL!*

THEY GAVE UP THEIR *LIVES* TO BUY US *TIME.* BUT CAN OUR TANKS AND SHELLS SUCCEED IF--?

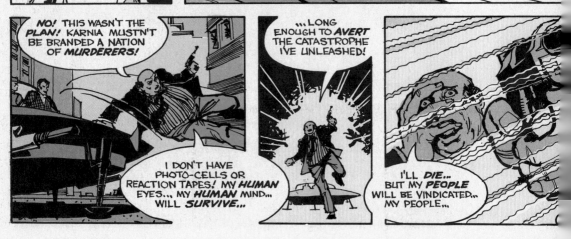

NO! THIS WASN'T THE *PLAN!* KARNIA MUSTN'T BE BRANDED A NATION OF *MURDERERS!*

I DON'T HAVE PHOTO-CELLS OR REACTION TAPES! MY *HUMAN* EYES... MY *HUMAN* MIND... WILL *SURVIVE...*

...LONG ENOUGH TO *AVERT* THE CATASTROPHE I'VE UNLEASHED!

I'LL *DIE...* BUT MY *PEOPLE* WILL BE VINDICATED... MY PEOPLE...

TINY STEEL-JACKETED MISSILES *SLICE* THROUGH THE PLUTONIUM MAN'S METAL *INNARDS*...

...*SUNDERING* ITS *FAIL-SAFE* SYSTEMS... RELEASING ALL THE TERRIBLE *HEAT* IN ITS REACTOR-SPAWNED FORM.

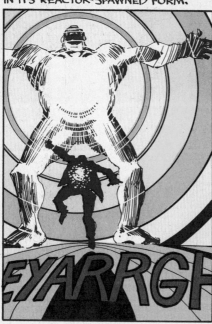

EYARRGH

FIVE METAL MEN *GONE*-- ONE FLESH-MAN *DOOMED*-- DOC *RAVING*--I'M ALL THAT'S *LEFT*--THE CITY'S LAST CHANCE!

AT LEAST... I GOT TO *SEE* DOC ONCE MORE...

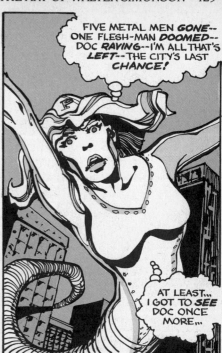

...*BEFORE* I *DIE*!

TINA'S PLATINUM FORM *FUSES* WITH THAT OF THE *PLUTONIUM MAN, TRAPPING* THE AWESOME HEAT *INSIDE* THE GIANT ROBOT!

AND WHEN THE METAL MONSTROSITY REACHES A TEMPERATURE *NO* MAN-MADE OBJECT CAN *CONTAIN*...

DOC... I STILL... *LOVE* YOU!

TINA? IS THAT YOU?

Tina?

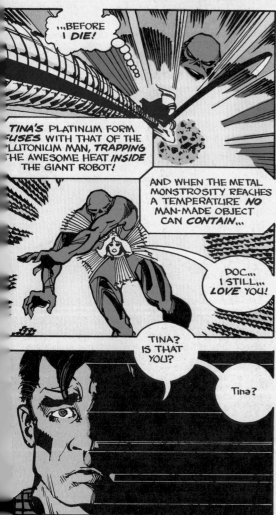

...WHAT SCIENTISTS CALL THE *"CHINA SYNDROME"* TAKES OVER.

THE PLUTONIUM MAN MELTS *THROUGH* PAVEMENT INTO THE *BEDROCK* BELOW...

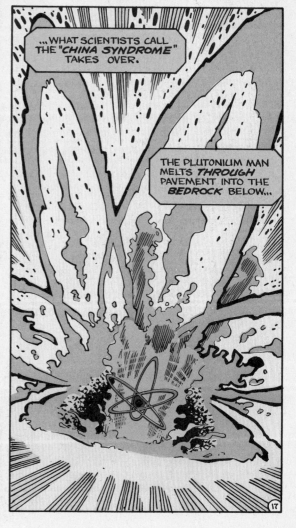

17

KARWHOOM!

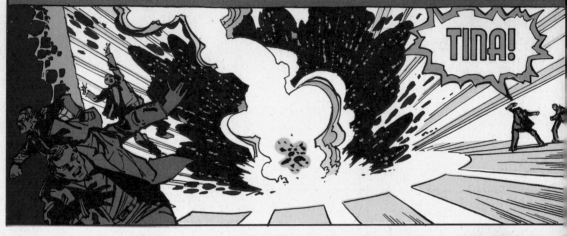

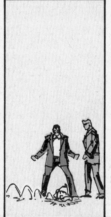
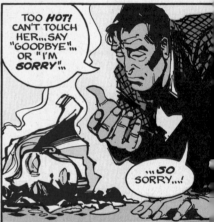

aftermath MASSIVE DECONTAMINATION PROCEDURES CLEANSE THE CAPITAL'S STREETS AND CITIZENS OF RADIATION...MEMORIAL SERVICES ARE HELD AT ARLINGTON CEMETERY FOR A BUREAUCRAT-TURNED-*HERO*...AND A FATEFUL *LIFE-DECISION* IS REACHED:

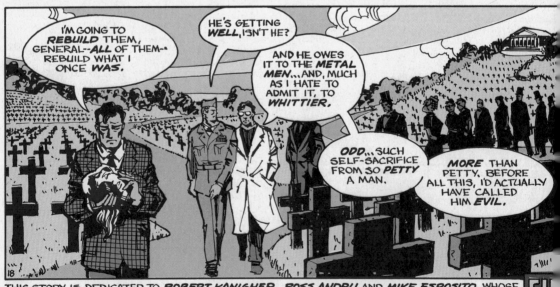

THIS STORY IS DEDICATED TO *ROBERT KANIGHER*, *ROSS ANDRU*, AND *MIKE ESPOSITO*, WHOSE CREATIVE FIRES FIRST FORGED THE *METAL MEN*. -- G.C./S.G./W.S.

THE CITY OF *VENICE* IS BUILT ON AN ARCHIPELAGO OF ISLANDS AND *MUD FLATS* ABOUT FOUR KILOMETERS FROM THE ITALIAN MAINLAND.

FOR THE PAST FOURTEEN HUNDRED YEARS, IT'S SEEN A SUCCESSION OF WARS, ARMIES AND NAVIES, OF KINGS AND QUEENS--

BUT IT'S DOUBTFUL VENICE HAS EVER SEEN ANYTHING *QUITE* LIKE--

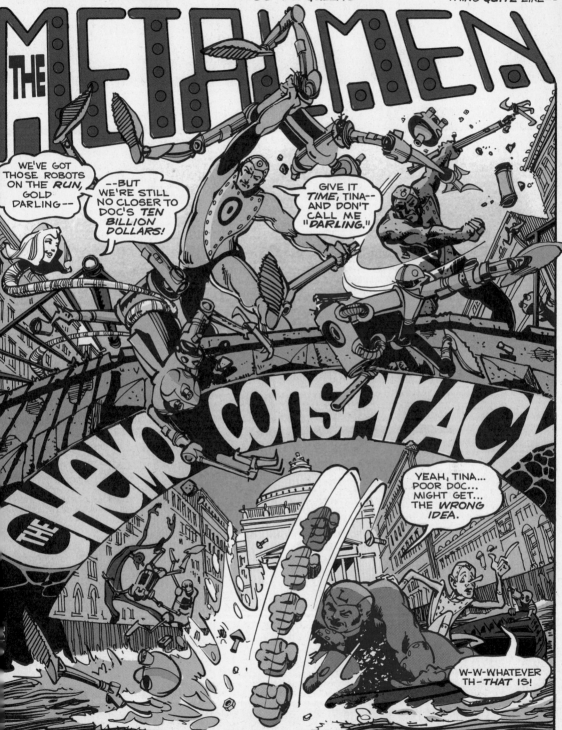

THE METAL MEN

THE HERO CONSPIRACY

WE'VE GOT THOSE ROBOTS ON THE *RUN,* GOLD DARLING--

--BUT WE'RE STILL NO CLOSER TO DOC'S *TEN BILLION* DOLLARS!

GIVE IT *TIME,* TINA-- AND DON'T CALL ME *"DARLING."*

YEAH, TINA... POOR DOC... MIGHT GET... THE *WRONG* IDEA.

W-W-WHATEVER TH-*THAT* IS!

AW, *COME ON*, TIN! YOU KNOW DOC MAGNUS THINKS PLATINUM IS...UM...SWEET ON *HIM*.

BUT PLATINUM'S A R-R-ROBOT, LEAD--LIKE *US*...

...AND D-DOC'S A *PERSON*! HE S-SHOULD BE G-G-GLAD SHE'S AFTER *GOLD*!

"YOU SAID *YOURSELF* TIN... DOC'S A *PERSON*...

"...AND PERSONS HAVE *FEELINGS*.

"REMEMBER...UH... DOC'S BEEN *SICK*...

"...AND HE'S ONLY JUST...UH... GETTING *WELL*. THAT'S WHY WE'RE HERE IN *VENICE* Y'KNOW...

"...TO...UH... HELP DOC GET *BETTER*, BY FINDING ALL THE *MONEY* HE STOLE!"

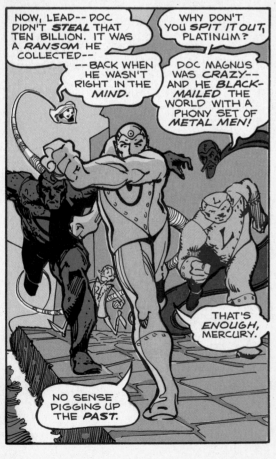

NOW, LEAD-- DOC DIDN'T *STEAL* THAT TEN BILLION. IT WAS A *RANSOM* HE COLLECTED--

--BACK WHEN HE WASN'T RIGHT IN THE *MIND*.

WHY DON'T YOU *SPIT IT OUT*, PLATINUM?

DOC MAGNUS WAS *CRAZY*-- AND HE *BLACK-MAILED* THE WORLD WITH A *PHONY* SET OF *METAL MEN*!

THAT'S *ENOUGH*, MERCURY.

NO SENSE DIGGING UP THE *PAST*.

DOC'S *WELL* NOW, AND HE WANTS TO *RETURN* THE RANSOM.

ACCORDING TO WHAT HE TOLD *US*, IT *SHOULD* BE RIGHT--

--here?

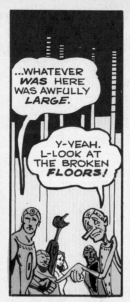

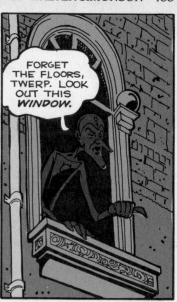

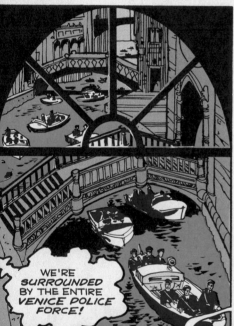

If YOU'VE COME THIS FAR, READER, YOU'RE PROBABLY WONDERING WHAT THE METAL MEN ARE *DOING* IN VENICE--WELL-KNOWN CITY OF *PIAZZAS* AND *CANALS.*

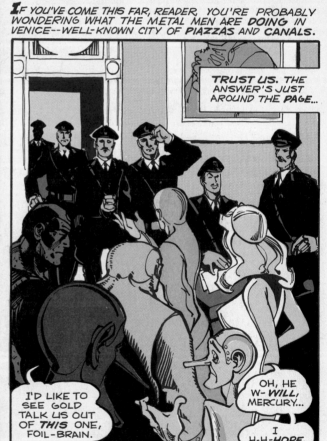

FLASHBACK

ON *THAT* CHEERY NOTE, LET'S BEGIN OUR HANDY DANDY...

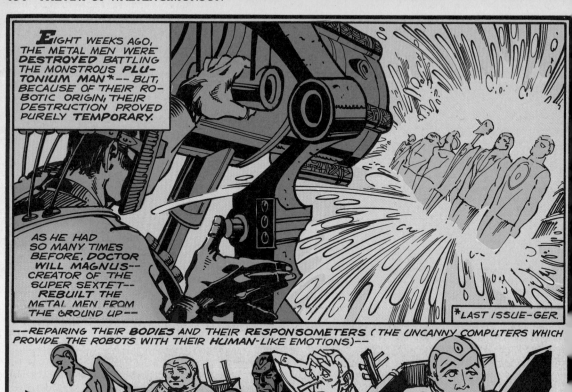

EIGHT WEEKS AGO, THE METAL MEN WERE **DESTROYED** BATTLING THE MONSTROUS **PLUTONIUM MAN** *-- BUT, BECAUSE OF THEIR ROBOTIC ORIGIN, THEIR DESTRUCTION PROVED PURELY **TEMPORARY.**

AS HE HAD SO MANY TIMES BEFORE, DOCTOR **WILL MAGNUS--** CREATOR OF THE **SUPER SEXTET--** REBUILT THE METAL MEN FROM THE GROUND UP--

*LAST ISSUE-GER.

--REPAIRING THEIR **BODIES** AND THEIR **RESPONSOMETERS** (THE UNCANNY COMPUTERS WHICH PROVIDE THE ROBOTS WITH THEIR **HUMAN-LIKE EMOTIONS)--**

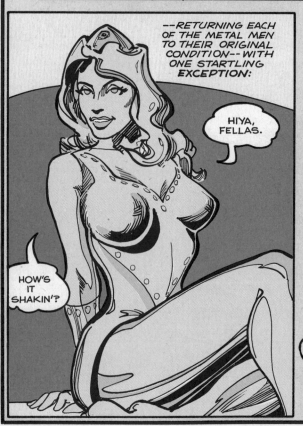

--RETURNING EACH OF THE METAL MEN TO THEIR ORIGINAL CONDITION-- WITH ONE STARTLING **EXCEPTION:**

HIYA, FELLAS.

HOW'S IT SHAKIN'?

PLATINUM... TINA...?

IS SOMETHING **WRONG,** DOCTOR MAGNUS?

ISOBEL... I'VE GOT A FEELING TINA'S CHANGED...

...BUT... INTO WHAT...?

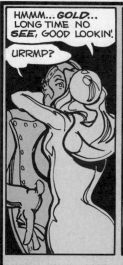

HMMM... *GOLD*... LONG TIME NO *SEE*, GOOD LOOKIN'.

URRMP?

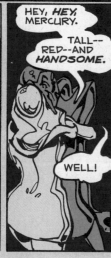

HEY, *HEY*, MERCURY.

TALL-- RED--AND *HANDSOME*.

WELL!

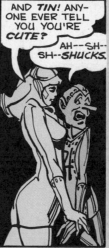

AND *TIN!* ANY-ONE EVER TELL YOU YOU'RE *CUTE?*

AH--SH--SH--SHUCKS.

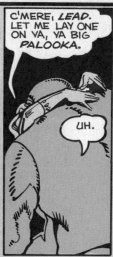

C'MERE, *LEAD*. LET ME LAY ONE ON YA, YA BIG *PALOOKA*.

UH.

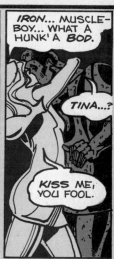

IRON... MUSCLE-BOY... WHAT A *HUNK* A *BOD*.

TINA...?

KISS ME, YOU FOOL.

MAGNUS... I'VE GOT A JOB FOR YOU, M'BOY.

VITAL TO *NATIONAL SECURITY*, AND ALL THAT. NOT TO MENTION NATIONAL *ECONOMY*.

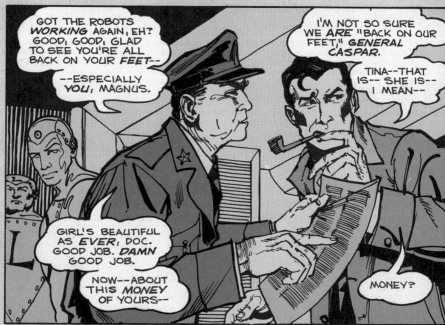

GOT THE ROBOTS *WORKING* AGAIN, EH? GOOD, GOOD, GLAD TO SEE YOU'RE ALL BACK ON YOUR *FEET*--

--ESPECIALLY *YOU*, MAGNUS.

I'M NOT SO SURE WE *ARE* "BACK ON OUR FEET," *GENERAL CASPAR*.

TINA--THAT IS-- SHE IS-- I MEAN--

GIRL'S BEAUTIFUL AS *EVER*, DOC. GOOD JOB. *DAMN* GOOD JOB.

NOW--ABOUT THIS *MONEY* OF YOURS--

MONEY?

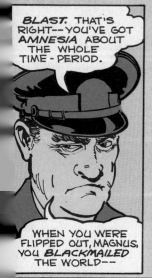

BLAST. THAT'S RIGHT--YOU'VE GOT *AMNESIA* ABOUT THE WHOLE TIME-PERIOD.

WHEN YOU WERE FLIPPED OUT, MAGNUS, YOU *BLACKMAILED* THE WORLD--

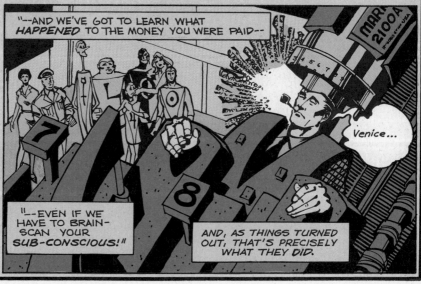

"--AND WE'VE GOT TO LEARN WHAT *HAPPENED* TO THE MONEY YOU WERE PAID--

"--EVEN IF WE HAVE TO *BRAIN-SCAN* YOUR *SUB-CONSCIOUS!*"

Venice...

AND, AS THINGS TURNED OUT, THAT'S PRECISELY WHAT THEY DID.

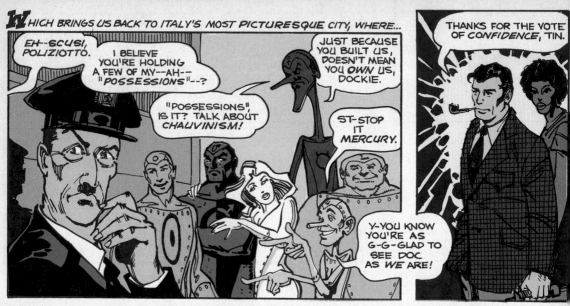

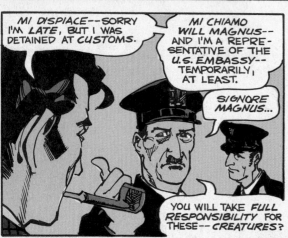

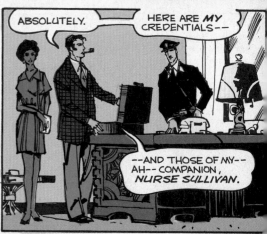

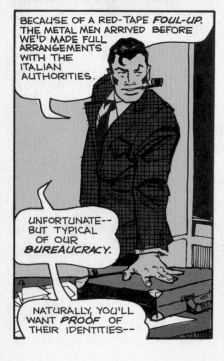

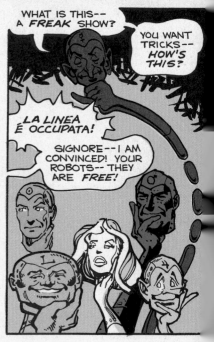

BUT LET'S LOOK ELSEWHERE FOR A SECOND

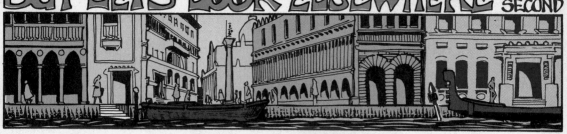

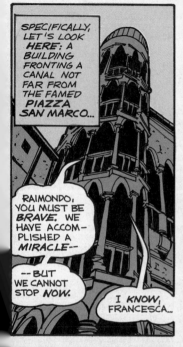

SPECIFICALLY, LET'S LOOK *HERE*: A BUILDING FRONTING A CANAL NOT FAR FROM THE FAMED *PIAZZA SAN MARCO*...

RAIMONDO, YOU MUST BE *BRAVE*. WE HAVE ACCOMPLISHED A *MIRACLE*--

--BUT WE CANNOT STOP *NOW*.

I KNOW, FRANCESCA...

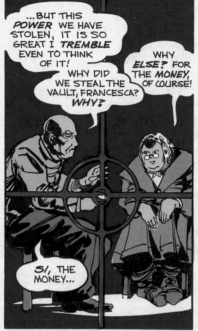

...BUT THIS *POWER* WE HAVE STOLEN, IT IS SO GREAT I *TREMBLE* EVEN TO THINK OF IT!

WHY DID WE STEAL THE VAULT, FRANCESCA? *WHY?*

WHY *ELSE?* FOR THE *MONEY*, OF COURSE!

SI, THE MONEY...

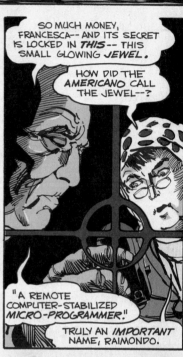

SO MUCH MONEY, FRANCESCA-- AND ITS SECRET IS LOCKED IN *THIS*-- THIS SMALL GLOWING *JEWEL*.

HOW DID THE *AMERICANO* CALL THE JEWEL--?

"A REMOTE COMPUTER-STABILIZED *MICRO-PROGRAMMER*."

TRULY AN *IMPORTANT* NAME, RAIMONDO.

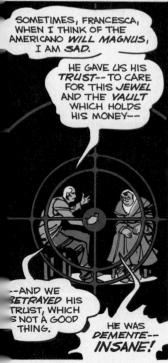

SOMETIMES, FRANCESCA, WHEN I THINK OF THE AMERICANO *WILL MAGNUS*, I AM *SAD*.

HE GAVE US HIS *TRUST*--TO CARE FOR THIS *JEWEL* AND THE *VAULT* WHICH HOLDS HIS MONEY--

--AND WE BETRAYED HIS TRUST, WHICH IS NOT A GOOD THING.

HE WAS *DEMENTE-- INSANE!*

SUCH A MADMAN DESERVES NO *LOYALTY*-- AND BESIDES, MY HUSBAND, WAS NOT HIS MONEY STOLEN--A *RANSOM?*

SI. SI.

STILL--THIS THING *FRIGHTENS* ME, FRANCESCA.

MORE THAN THE MONEY VAULT IS INVOLVED, AFTER ALL...

THERE IS ALSO... *THE GUARD.*

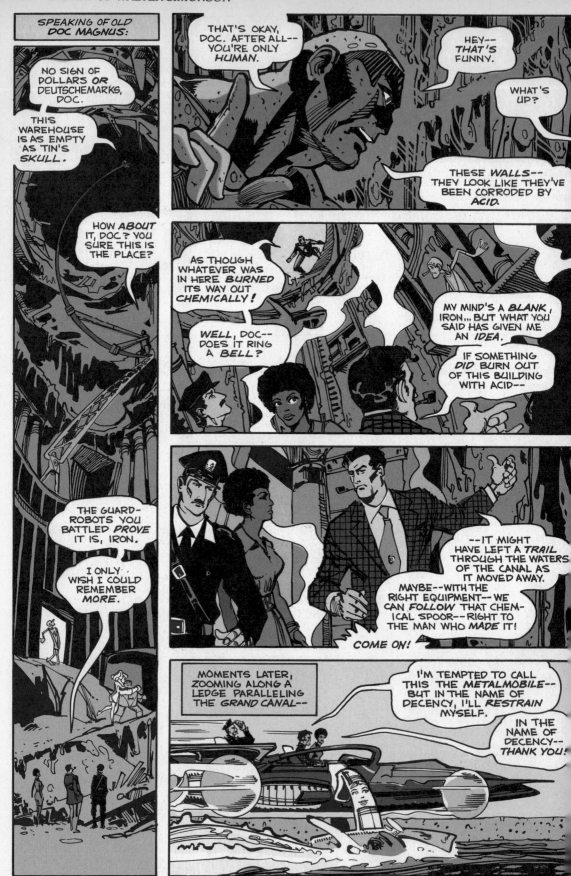

SPEAKING OF OLD DOC MAGNUS:

NO SIGN OF DOLLARS *OR* DEUTSCHEMARKS, DOC.

THIS WAREHOUSE IS AS EMPTY AS TIN'S *SKULL.*

HOW *ABOUT* IT, DOC? YOU *SURE* THIS IS THE PLACE?

THE GUARD-ROBOTS YOU BATTLED *PROVE* IT IS, IRON.

I ONLY WISH I COULD REMEMBER *MORE.*

THAT'S OKAY, DOC. AFTER ALL-- YOU'RE ONLY *HUMAN.*

HEY-- *THAT'S* FUNNY.

WHAT'S UP?

THESE *WALLS*-- THEY LOOK LIKE THEY'VE BEEN CORRODED BY *ACID.*

AS THOUGH WHATEVER WAS IN HERE *BURNED* ITS WAY OUT *CHEMICALLY!*

WELL, DOC-- DOES IT RING A *BELL?*

MY MIND'S A *BLANK,* IRON... BUT WHAT YOU SAID HAS GIVEN ME AN *IDEA.*

IF SOMETHING *DID* BURN OUT OF THIS BUILDING WITH ACID--

--IT MIGHT HAVE LEFT A *TRAIL* THROUGH THE WATERS OF THE CANAL AS IT MOVED AWAY.

MAYBE--WITH THE RIGHT EQUIPMENT-- WE CAN *FOLLOW* THAT CHEM- ICAL SPOOR--RIGHT TO THE MAN WHO *MADE* IT!

COME ON!

MOMENTS LATER, ZOOMING ALONG A LEDGE PARALLELING THE *GRAND CANAL*--

I'M TEMPTED TO CALL THIS THE *METALMOBILE*-- BUT IN THE NAME OF DECENCY, I'LL *RESTRAIN* MYSELF.

IN THE NAME OF DECENCY-- *THANK YOU!*

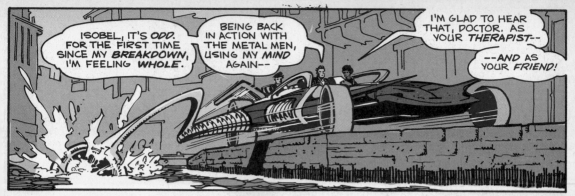

ISOBEL, IT'S *ODD.* FOR THE FIRST TIME SINCE MY *BREAKDOWN,* I'M FEELING *WHOLE.*

BEING BACK IN ACTION WITH THE METAL MEN, USING MY *MIND* AGAIN--

I'M GLAD TO HEAR THAT, DOCTOR. AS YOUR *THERAPIST*--

--AND AS YOUR *FRIEND!*

OUTSIDE THE DARKENED ROOM WHERE FRANCESCA AND RAIMONDO STAND, THERE'S THE SOUND OF AN APPROACHING *VEHICLE;* BUT IT'S A SOUND THEY *IGNORE,* AS...

YOU MUST UNLOCK THE JEWEL'S SECRET, RAIMONDO. *YOU MUST.*

WITHOUT IT, THE VAULT WILL REMAIN CLOSED TO US *FOREVER!*

TAPTAPTAP

I AM *TRYING,* WIFE--

--BUT THE JEWEL IS *STUBBORN.*

PERHAPS IF I *TAP* IT; THE GEM WILL MAKE THE *SOUND* SIGNORE MAGNUS TOLD US WAS NECESSARY TO *OPEN* THE VAULT.

BOPBOP BOPBOP

RAIMONDO-- HAVE PATIENCE!

THE JEWEL, IT WILL--

POUNDPOUNDPOUNDPOUNDPOUNDPOUNDPOUND

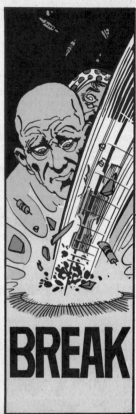

BREAK

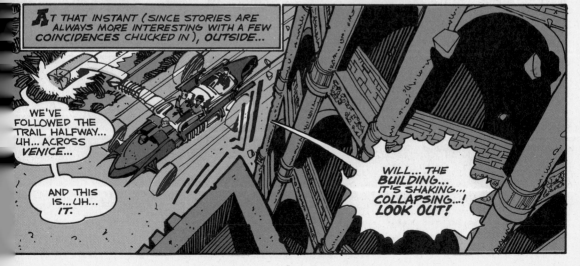

AT THAT INSTANT (SINCE STORIES ARE ALWAYS MORE INTERESTING WITH A FEW COINCIDENCES CHUCKED IN), OUTSIDE...

WE'VE FOLLOWED THE TRAIL HALFWAY... UH... ACROSS VENICE...

AND THIS IS...UH... IT.

WILL... THE BUILDING... IT'S SHAKING... COLLAPSING...! LOOK OUT!

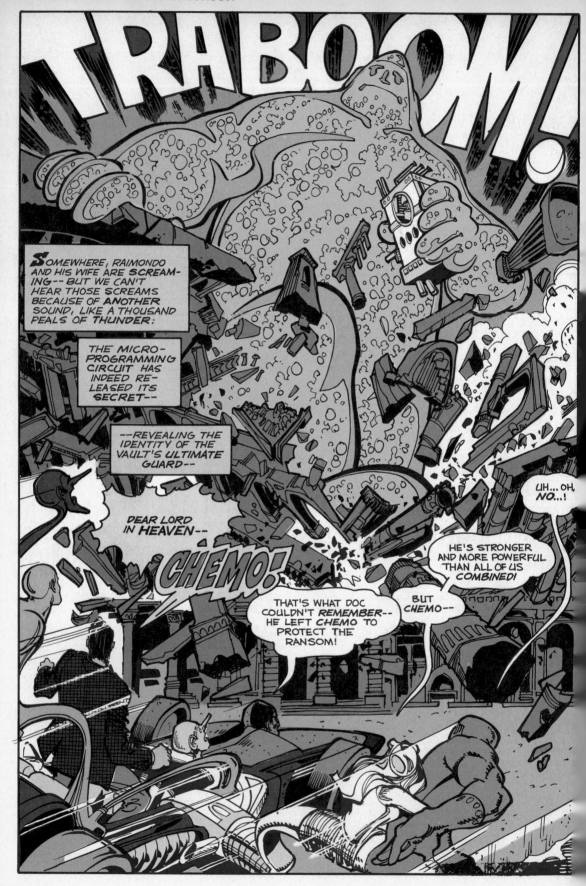

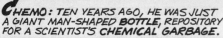

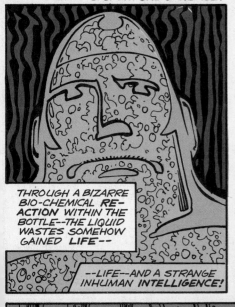

CHEMO: TEN YEARS AGO, HE WAS JUST A GIANT MAN-SHAPED BOTTLE, REPOSITORY FOR A SCIENTIST'S CHEMICAL GARBAGE.

THROUGH A BIZARRE BIO-CHEMICAL RE-ACTION WITHIN THE BOTTLE--THE LIQUID WASTES SOMEHOW GAINED LIFE--

--LIFE--AND A STRANGE INHUMAN INTELLIGENCE!

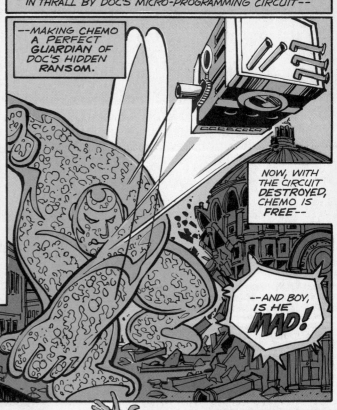

FOR MANY MONTHS, THAT INTELLIGENCE HAS BEEN HELD IN THRALL BY DOC'S MICRO-PROGRAMMING CIRCUIT--

--MAKING CHEMO A PERFECT GUARDIAN OF DOC'S HIDDEN RANSOM.

NOW, WITH THE CIRCUIT DESTROYED, CHEMO IS FREE--

--AND BOY, IS HE MAD!

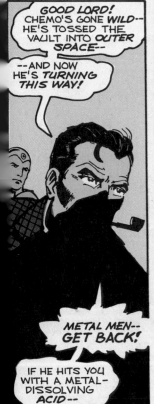

GOOD LORD! CHEMO'S GONE WILD-- HE'S TOSSED THE VAULT INTO OUTER SPACE--

--AND NOW HE'S TURNING THIS WAY!

METAL MEN-- GET BACK!

IF HE HITS YOU WITH A METAL-DISSOLVING ACID--

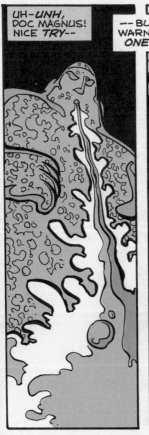

UH-UNH, DOC MAGNUS! NICE TRY--

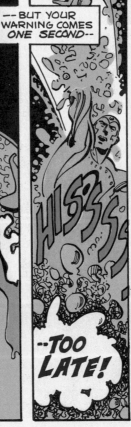

--BUT YOUR WARNING COMES ONE SECOND--

HISSS

--TOO LATE!

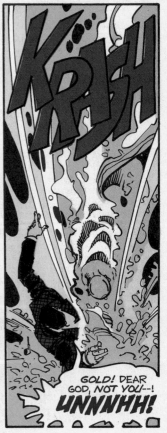

KRASH

GOLD! DEAR GOD, NOT YOU--! UNNNHH!

AND NOW, JUST TO *FRUSTRATE* YOU, DEAR READER— **A PAUSE in the DAY'S OCCUPATION**

BELIEVE IT OR NOT, WHAT YOU'RE ABOUT TO SEE *DOES* RELATE TO OUR STORY—BUT ONLY INDIRECTLY.

THE PLACE IS WASHINGTON D.C., AND THE ACTION IS *SIMULTANEOUS* WITH THE SCENE ON THE PREVIOUS PAGE...

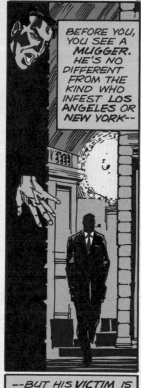

BEFORE YOU, YOU SEE A *MUGGER*. HE'S NO DIFFERENT FROM THE KIND WHO INFEST LOS ANGELES OR NEW YORK—

—BUT HIS *VICTIM* IS SOMETHING *ELSE* AGAIN:

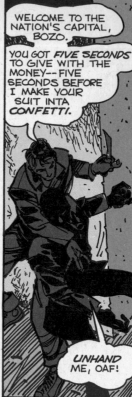

WELCOME TO THE NATION'S CAPITAL, BOZO.

YOU GOT *FIVE SECONDS* TO GIVE WITH THE MONEY—FIVE SECONDS BEFORE I MAKE YOUR SUIT INTA *CONFETTI*.

UNHAND ME, OAF!

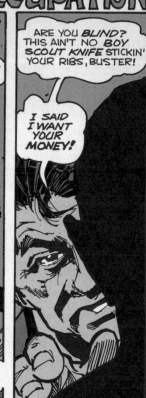

ARE YOU *BLIND*? THIS AIN'T NO *BOY SCOUT KNIFE* STICKIN' YOUR RIBS, BUSTER!

I SAID I WANT *YOUR MONEY!*

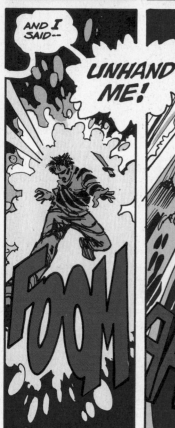

AND *I* SAID—

UNHAND ME!

FOOM

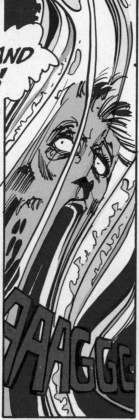

YAAGG

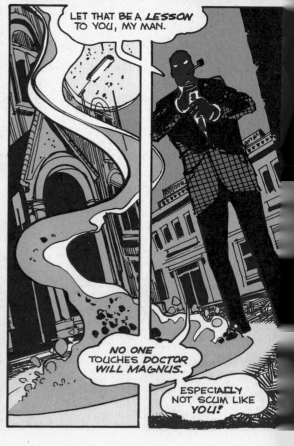

LET THAT BE A *LESSON* TO YOU, MY MAN.

NO ONE TOUCHES DOCTOR WILL MAGNUS.

ESPECIALLY NOT *SCUM* LIKE YOU!

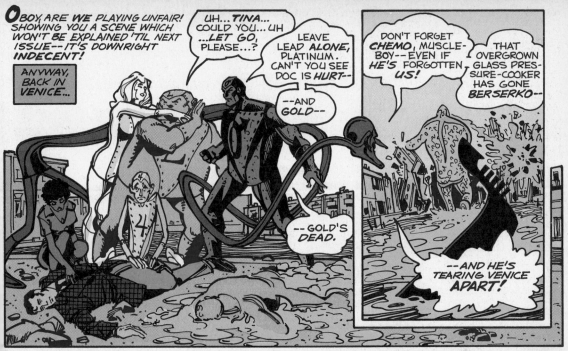

O BOY, ARE WE PLAYING UNFAIR! SHOWING YOU A SCENE WHICH WON'T BE EXPLAINED 'TIL NEXT ISSUE--IT'S DOWNRIGHT INDECENT!

ANYWAY, BACK IN VENICE...

UH...TINA... COULD YOU...UH ...LET GO, PLEASE...?

LEAVE LEAD ALONE, PLATINUM. CAN'T YOU SEE DOC IS HURT--

--AND GOLD--

--GOLD'S DEAD.

DON'T FORGET CHEMO, MUSCLE-BOY--EVEN IF HE'S FORGOTTEN US!

THAT OVERGROWN GLASS PRES-SURE-COOKER HAS GONE BERSERKO--

--AND HE'S TEARING VENICE APART!

I KNOW, MERCURY--BUT SHOULD WE GO AFTER HIM-- OR AFTER THE RANSOM?

GOLD IS OUR LEADER-- HE MAKES THE DECISIONS.

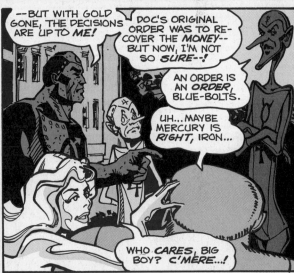

--BUT WITH GOLD GONE, THE DECISIONS ARE UP TO ME!

DOC'S ORIGINAL ORDER WAS TO RE-COVER THE MONEY-- BUT NOW, I'M NOT SO SURE--!

AN ORDER IS AN ORDER, BLUE-BOLTS.

UH...MAYBE MERCURY IS RIGHT, IRON...

WHO CARES, BIG BOY? C'MERE...!

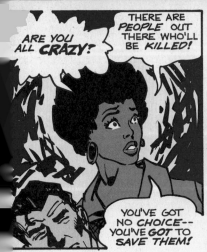

ARE YOU ALL CRAZY!

THERE ARE PEOPLE OUT THERE WHO'LL BE KILLED!

YOU'VE GOT NO CHOICE-- YOU'VE GOT TO SAVE THEM!

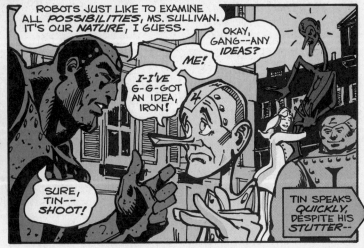

ROBOTS JUST LIKE TO EXAMINE ALL POSSIBILITIES, MS. SULLIVAN. IT'S OUR NATURE, I GUESS.

OKAY, GANG--ANY IDEAS?

ME!

I-I'VE G-G-GOT AN IDEA, IRON!

SURE, TIN-- SHOOT!

TIN SPEAKS QUICKLY, DESPITE HIS STUTTER--

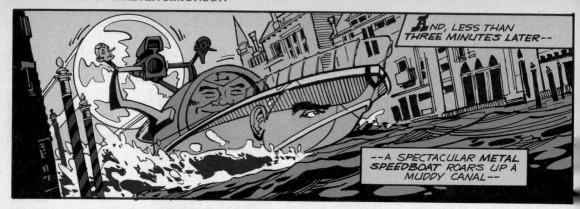

AND, LESS THAN THREE MINUTES LATER--

--A SPECTACULAR METAL SPEEDBOAT ROARS UP A MUDDY CANAL--

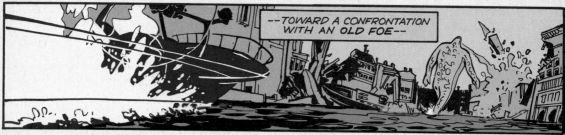

--TOWARD A CONFRONTATION WITH AN OLD FOE--

--AND A HEAD-ON COLLISION WITH (DARE WE SAY IT?)-- DESTINY!

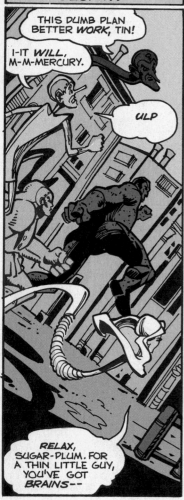

THIS DUMB PLAN BETTER WORK, TIN!

I-IT WILL, M-M-MERCURY.

ULP

RELAX, SUGAR-PLUM. FOR A THIN LITTLE GUY, YOU'VE GOT BRAINS--

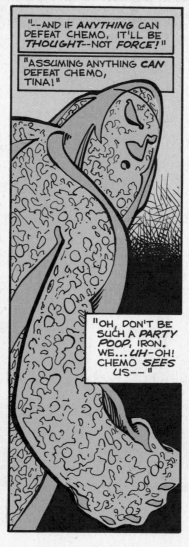

"--AND IF ANYTHING CAN DEFEAT CHEMO, IT'LL BE THOUGHT--NOT FORCE!"

"ASSUMING ANYTHING CAN DEFEAT CHEMO, TINA!"

"OH, DON'T BE SUCH A PARTY POOP, IRON. WE...UH-OH! CHEMO SEES US--"

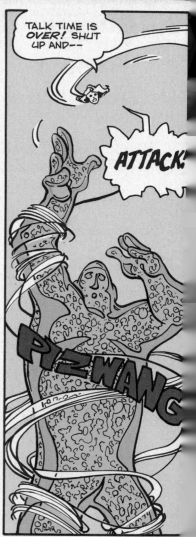

TALK TIME IS OVER! SHUT UP AND--

ATTACK!

PIZWANG

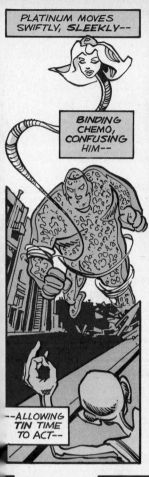

PLATINUM MOVES SWIFTLY, SLEEKLY--

BINDING CHEMO, CONFUSING HIM--

--ALLOWING TIN TIME TO ACT--

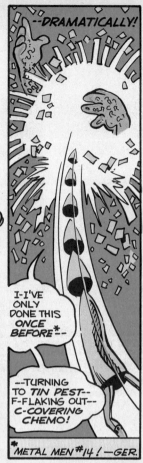

--DRAMATICALLY!

I-I'VE ONLY DONE THIS ONCE BEFORE*--

--TURNING TO TIN PEST-- F-FLAKING OUT-- C-COVERING CHEMO!

*METAL MEN #14! --GER.

UH...TIN'S GIVEN US OUR...UH... CHANCE, IRON.

WE'VE GOTTA...UH... KEEP CHEMO ON THE...UM... DEFENSIVE.

RIGHT, LEAD. AS LONG AS CHEMO'S MOUTH IS SHUT--

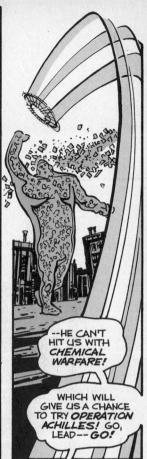

--HE CAN'T HIT US WITH CHEMICAL WARFARE!

WHICH WILL GIVE US A CHANCE TO TRY OPERATION ACHILLES! GO, LEAD--GO!

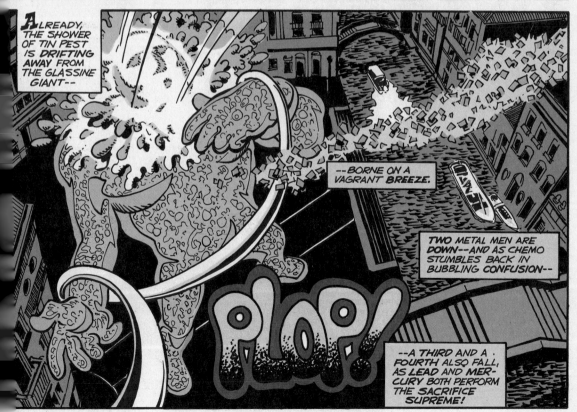

ALREADY, THE SHOWER OF TIN PEST IS DRIFTING AWAY FROM THE GLASSINE GIANT--

--BORNE ON A VAGRANT BREEZE.

TWO METAL MEN ARE DOWN--AND AS CHEMO STUMBLES BACK IN BUBBLING CONFUSION--

PLOP!

--A THIRD AND A FOURTH ALSO FALL, AS LEAD AND MER- CURY BOTH PERFORM THE SACRIFICE SUPREME!

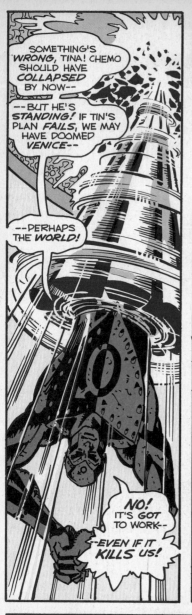

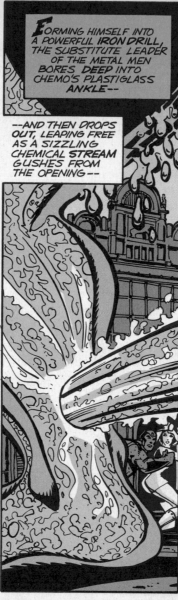

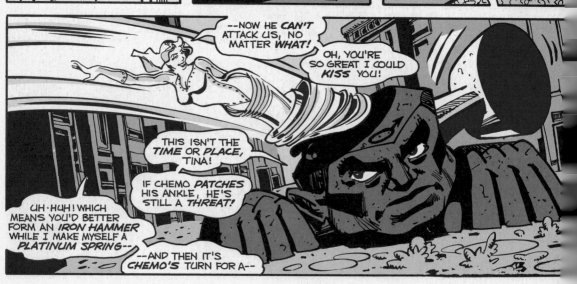

TAKE-OUT!

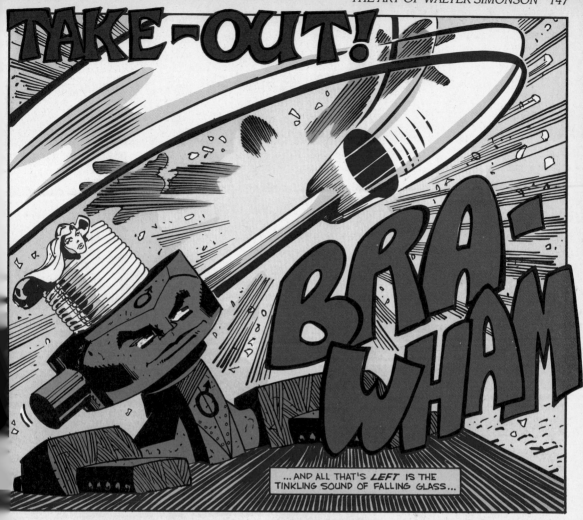

...AND ALL THAT'S *LEFT* IS THE TINKLING SOUND OF FALLING GLASS...

AND BRING DOWN...

YOU *OKAY*, WILL?

FOR A WHILE THERE, YOU HAD ME *WORRIED*...

I HAD *MYSELF* WORRIED, ISOBEL... ...BUT YES, I'M ALL *RIGHT*... I *THINK*.

IT'S ALL *OVER* BUT THE *CLEANING UP*, DOC.

MEANWHILE, THERE'S THIS *PROBLEM*... WITH *TINA*... ER...

WE WANT TO GET *MARRIED*, DOC.

AIN'T HE *CUTE*?

ISOBEL--

--I TAKE IT *BACK*.

I'M *NOT* VERY WELL, *AFTER ALL*...!

GERRY CONWAY / WALTER SIMONSON CO-PRODUCTION! BASED ON CHARACTERS ORIGINALLY
WRITER-EDITOR / ARTIST-CALLIGRAPHER CREATED BY *BOB KANIGHER*

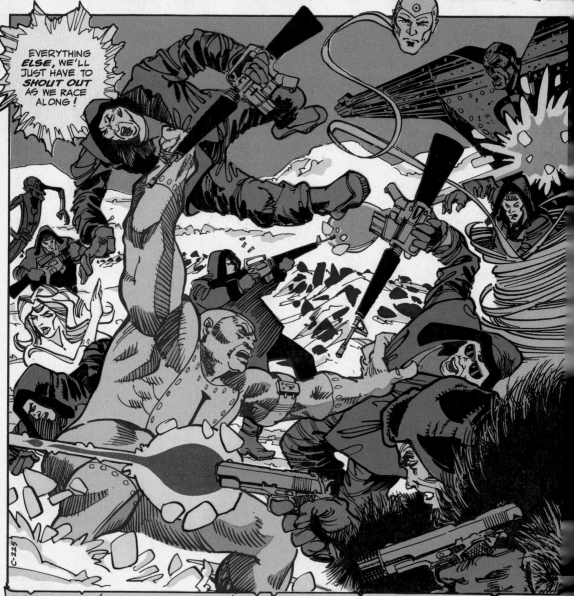

TO MAKE SENSE OF OUR SPECTAC-ULAR SPLASH PAGE, WE'LL HAVE TO *PLUNGE BACK THROUGH TIME*--

--TO McMURDO SOUND ARMY BASE, JUST ABOUT *THREE WEEKS AGO*--

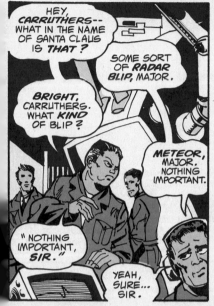

HEY, *CARRUTHERS*-- WHAT IN THE NAME OF SANTA CLAUS IS *THAT*?

SOME SORT OF *RADAR BLIP*, MAJOR.

BRIGHT, CARRUTHERS. WHAT *KIND* OF BLIP?

METEOR, MAJOR, NOTHING IMPORTANT.

"NOTHING IMPORTANT, SIR."

YEAH, SURE... SIR.

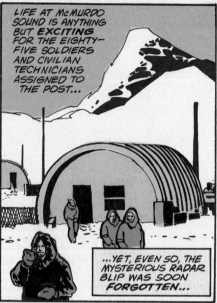

LIFE AT McMURDO SOUND IS ANYTHING BUT *EXCITING* FOR THE EIGHTY-FIVE SOLDIERS AND CIVILIAN TECHNICIANS ASSIGNED TO THE POST...

...YET, EVEN SO, THE MYSTERIOUS RADAR BLIP WAS SOON *FORGOTTEN*...

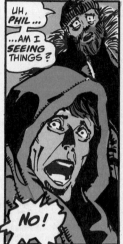

...AND FOR TWO WEEKS, THE DAILY MONOTONY CONTINUED *UNINTER-RUPTED*, UNTIL, ONE "MORNING"...

UH, PHIL... ...AM I *SEEING* THINGS?

NO!

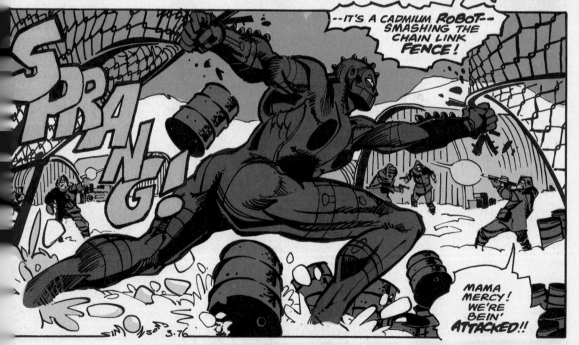

--IT'S A CADMIUM ROBOT-- SMASHING THE CHAIN LINK *FENCE*!

SPRANG!

MAMA MERCY! WE'RE BEIN' *ATTACKED*!!

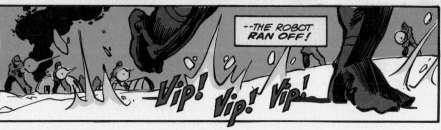

FOR FOURTEEN TERRIFYING MINUTES, THE MEN OF McMURDO BASE FOUGHT A BATTLE FOR THEIR *LIVES*-- AND THEN, AS ABRUPTLY AS HE *APPEARED*--

--THE ROBOT *RAN OFF*!

Vip! Vip! Vip!

BUT THAT (AS THE OLD SAW GOES) WAS ONLY THE *BEGINNING*. OVER THE NEXT SIX DAYS, THE BASE WAS ATTACKED AGAIN AND AGAIN AND AGAIN -- EACH TIME BY A *DIFFERENT ROBOT MENACE*, EACH ROBOT BASED ON A *DIFFERENT ELEMENT* --

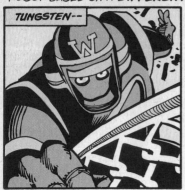

TUNGSTEN--

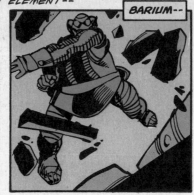

BARIUM--

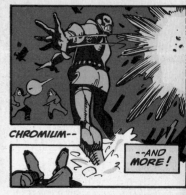

CHROMIUM--

--AND MORE!

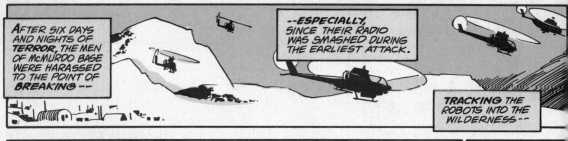

AFTER SIX DAYS AND NIGHTS OF TERROR, THE MEN OF McMURDO BASE WERE HARASSED TO THE POINT OF *BREAKING* --

--ESPECIALLY, SINCE THEIR RADIO WAS SMASHED DURING THE EARLIEST ATTACK.

TRACKING THE ROBOTS INTO THE WILDERNESS --

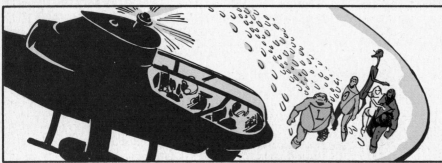

--THEY EVENTUALLY *FOUND* THEIR METALLIC TORMENTORS (OR SO THEY THOUGHT): FIVE SLIGHTLY BEWILDERED *METAL MEN* (HOLD YOUR QUESTIONS TILL LATER)--

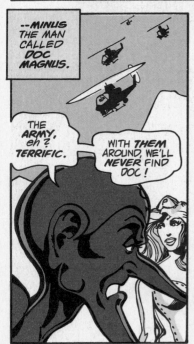

--MINUS THE MAN CALLED *DOC MAGNUS.*

THE ARMY, EH? TERRIFIC.

WITH *THEM* AROUND, WE'LL *NEVER* FIND DOC!

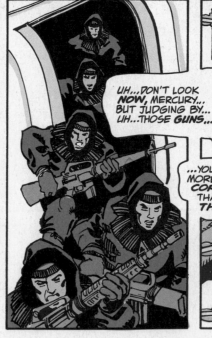

UH...DON'T LOOK *NOW*, MERCURY... BUT JUDGING BY... UH...THOSE *GUNS*...

...YOU MAY BE MORE ...UH... *CORRECT*... THAN YOU *THINK* !

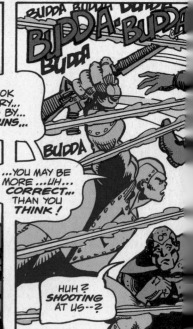

BUDDA BUDDA BUDDA BUDDA

BUDDA

HUH ? SHOOTING AT US--?

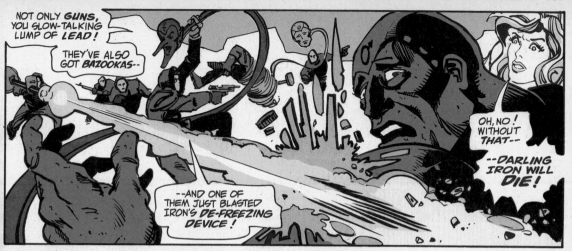

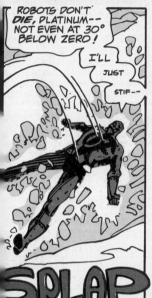

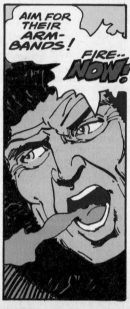

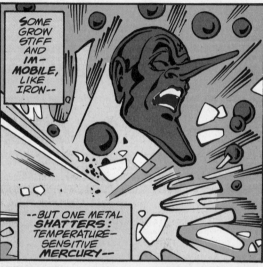

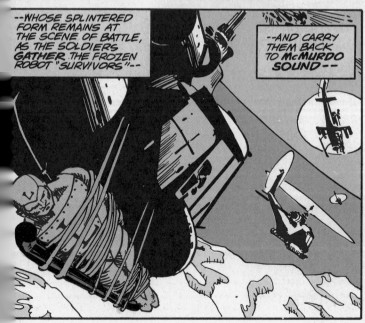

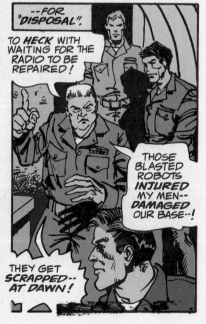

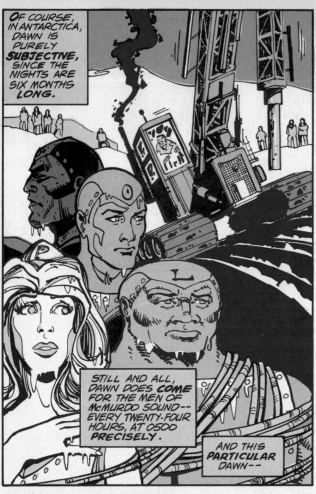

OF COURSE, IN ANTARCTICA, DAWN IS PURELY *SUBJECTIVE*, SINCE THE NIGHTS ARE SIX MONTHS LONG.

STILL AND ALL, DAWN DOES *COME* FOR THE MEN OF McMURDO SOUND-- EVERY TWENTY-FOUR HOURS, AT 0500 *PRECISELY.*

AND THIS *PARTICULAR* DAWN--

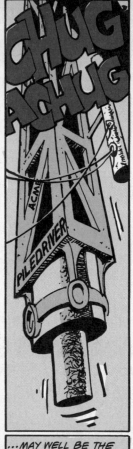

CHUG ACHUG

ACME PILEDRIVER

...MAY WELL BE THE *LAST* DAWN THE METAL MEN WILL EVER *SEE!*

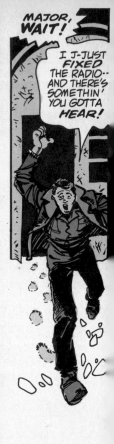

MAJOR, *WAIT!*

I J-JUST *FIXED* THE RADIO-- AND THERE'S SOMETHIN' YOU GOTTA *HEAR!*

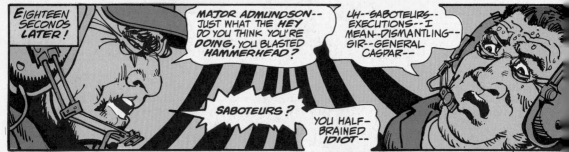

EIGHTEEN SECONDS LATER!

MAJOR ADMUNDSON-- JUST WHAT THE *HEY* DO YOU THINK YOU'RE DOING, YOU BLASTED HAMMERHEAD?

SABOTEURS?

UH--SABOTEURS-- EXECUTIONS--I MEAN--DISMANTLING-- SIR--GENERAL CASPAR--

YOU HALF-BRAINED IDIOT--

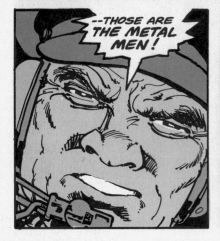

--THOSE ARE THE METAL MEN!

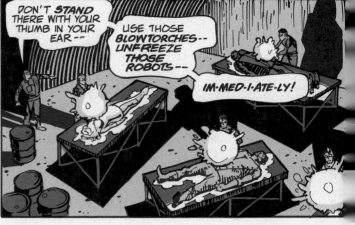

DON'T STAND THERE WITH YOUR THUMB IN YOUR EAR--

USE THOSE BLOWTORCHES-- UNFREEZE THOSE ROBOTS--

IM-MED-I-ATE-LY!

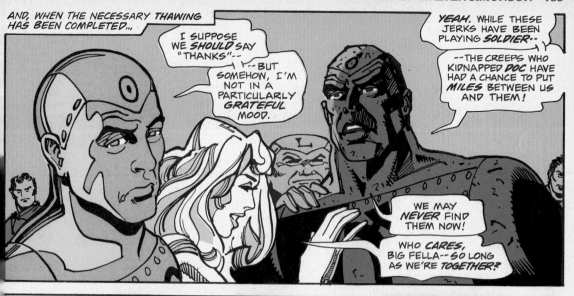

AND, WHEN THE NECESSARY *THAWING* HAS BEEN COMPLETED...

I SUPPOSE WE *SHOULD* SAY "THANKS"--

--BUT SOMEHOW, I'M NOT IN A PARTICULARLY *GRATEFUL* MOOD.

YEAH. WHILE THESE JERKS HAVE BEEN PLAYING *SOLDIER*--

--THE CREEPS WHO KIDNAPPED *DOC* HAVE HAD A CHANCE TO PUT *MILES* BETWEEN US AND THEM!

WE MAY *NEVER* FIND THEM NOW!

WHO *CARES,* BIG FELLA--SO LONG AS WE'RE *TOGETHER?*

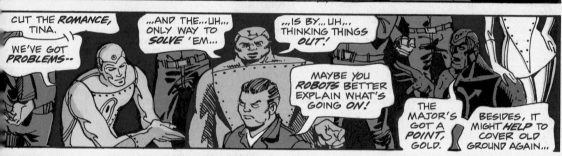

CUT THE *ROMANCE,* TINA.

WE'VE GOT *PROBLEMS*--

...AND THE...UH... ONLY WAY TO *SOLVE* 'EM...

...IS BY...UH... THINKING THINGS *OUT!*

MAYBE YOU *ROBOTS* BETTER EXPLAIN WHAT'S GOING *ON!*

THE MAJOR'S GOT A *POINT,* GOLD.

BESIDES, IT MIGHT *HELP* TO COVER OLD GROUND AGAIN...

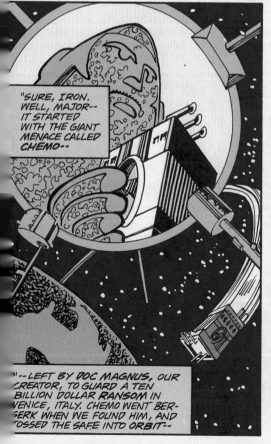

"SURE, IRON, WELL, MAJOR-- IT STARTED WITH THE GIANT MENACE CALLED *CHEMO*--

"--LEFT BY *DOC MAGNUS,* OUR *CREATOR,* TO GUARD A TEN BILLION DOLLAR *RANSOM* IN *VENICE, ITALY.* CHEMO WENT BER- SERK WHEN WE FOUND HIM, AND [T]OSSED THE SAFE INTO ORBIT--

"--AND THEN PROCEEDED TO TEAR VENICE *APART,* UNTIL WE MANAGED TO STOP HIM ONCE AND FOR *ALL.**

"NOW, THIS RANSOM MONEY WAS SOME- THING DOC HAD GOTTEN *ILLEGALLY,* BACK WHEN HE WAS A *LITTLE INSANE*--

*LAST ISSUE. --GER.

"--SO NATURALLY, THE OWNERS WANTED IT *BACK.*

"IN HIS [...]TER THE BA[...] REBU[...]

"--AND AS HIS THERAPIST, *NURSE SULLIVAN*, WAS APT TO POINT OUT, BY REBUILDING US, HE WAS ALSO HELPING TO REBUILD *HIMSELF*.

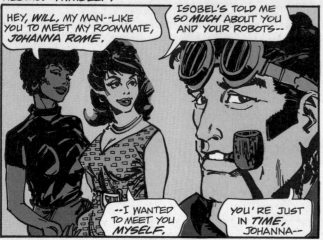

HEY, *WILL*, MY MAN--LIKE YOU TO MEET MY ROOMMATE, *JOHANNA ROME.*

ISOBEL'S TOLD ME SO *MUCH* ABOUT YOU AND YOUR ROBOTS--

--I WANTED TO MEET YOU *MYSELF*.

YOU'RE JUST IN *TIME*, JOHANNA--

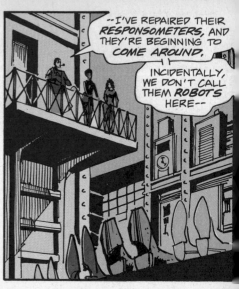

--I'VE REPAIRED THEIR *RESPONSOMETERS*, AND THEY'RE BEGINNING TO *COME AROUND*.

INCIDENTALLY, WE DON'T CALL THEM *ROBOTS* HERE--

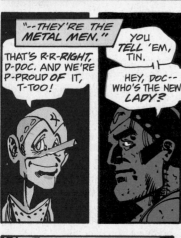

"--THEY'RE THE *METAL MEN*."

THAT'S R-R-*RIGHT*, D-DOC. AND WE'RE P-PROUD *OF* IT, T-TOO!

YOU *TELL* 'EM, TIN.

HEY, DOC-- WHO'S THE NEW *LADY*?

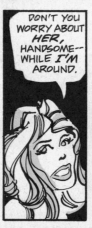

DON'T YOU WORRY ABOUT *HER*, HANDSOME-- WHILE *I'M* AROUND.

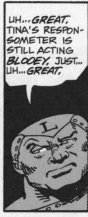

UH...*GREAT*. TINA'S RESPON- SOMETER IS STILL ACTING *BLOOEY*. JUST... UH...*GREAT.*

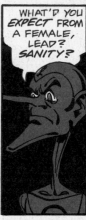

WHAT'D YOU *EXPECT* FROM A FEMALE, LEAD? *SANITY?*

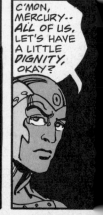

C'MON, MERCURY-- *ALL* OF US. LET'S HAVE A LITTLE *DIGNITY*, OKAY?

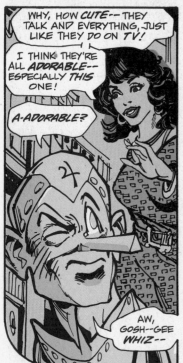

WHY, HOW *CUTE*-- THEY TALK AND EVERYTHING, JUST LIKE THEY DO ON *TV!*

I THINK THEY'RE ALL *ADORABLE*-- ESPECIALLY *THIS* ONE!

A-ADORABLE?

AW, GOSH--GEE *WHIZ*--

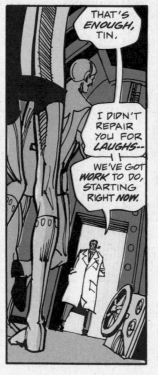

THAT'S *ENOUGH*, TIN.

I DIDN'T REPAIR YOU FOR *LAUGHS*--

WE'VE GOT *WORK* TO DO, STARTING RIGHT *NOW.*

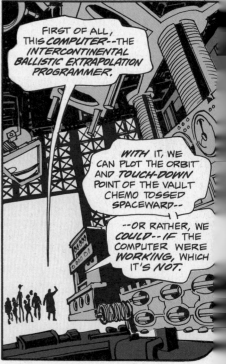

FIRST OF ALL, THIS *COMPUTER*--THE *INTERCONTINENTAL BALLISTIC EXTRAPOLATION PROGRAMMER.*

WITH IT, WE CAN PLOT THE ORBIT AND *TOUCH-DOWN* POINT OF THE VAULT CHEMO TOSSED SPACEWARD--

--OR RATHER, WE *COULD*--IF THE COMPUTER WERE *WORKING*, WHICH IT'S *NOT.*

THE ART OF WALTER SIMONSON 155

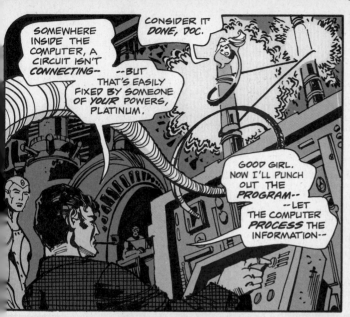

SOMEWHERE INSIDE THE COMPUTER, A CIRCUIT ISN'T *CONNECTING*--

CONSIDER IT *DONE*, DOC.

--BUT THAT'S EASILY FIXED BY SOMEONE OF *YOUR* POWERS, PLATINUM.

GOOD GIRL. NOW I'LL PUNCH OUT THE *PROGRAM*-- --LET THE COMPUTER *PROCESS* THE INFORMATION--

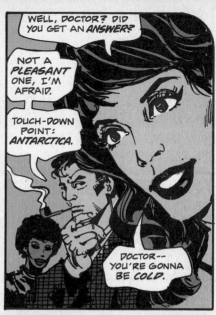

WELL, DOCTOR? DID YOU GET AN *ANSWER*?

NOT A *PLEASANT* ONE, I'M AFRAID.

TOUCH-DOWN POINT: *ANTARCTICA*.

DOCTOR-- YOU'RE GONNA BE *COLD*.

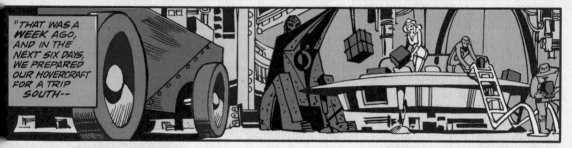

"THAT WAS A *WEEK* AGO, AND IN THE NEXT SIX DAYS, WE PREPARED OUR HOVERCRAFT FOR A TRIP SOUTH--

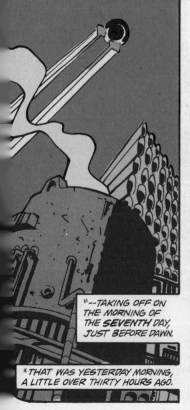

"--TAKING OFF ON THE MORNING OF THE *SEVENTH* DAY, JUST BEFORE DAWN.

"THAT WAS YESTERDAY MORNING, A LITTLE OVER THIRTY HOURS AGO.

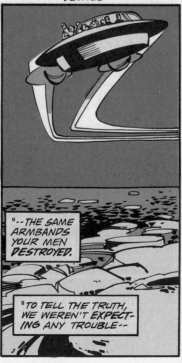

"SINCE THE TEMPERATURE IN ANTARCTICA WAS GOING TO BE *LOWER* THAN OUR AVERAGE *FREEZING POINT*, DOC GAVE US EACH ARMBAND *DE-FREEZING* DEVICES--

"--THE SAME ARMBANDS YOUR MEN *DESTROYED*.

"TO TELL THE TRUTH, WE WEREN'T *EXPECT*-ING ANY TROUBLE--

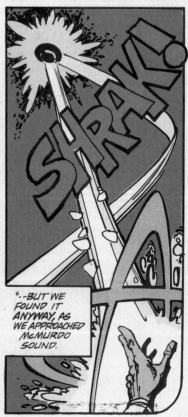

SHRAK!

"--BUT WE FOUND IT *ANYWAY*, AS WE APPROACHED McMURDO SOUND.

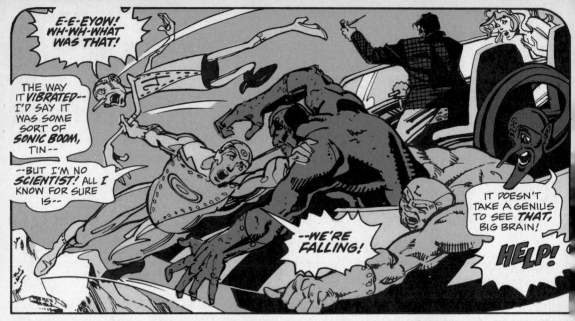

E-E-EYOW! WH-WH-WHAT WAS THAT!

THE WAY IT VIBRATED-- I'D SAY IT WAS SOME SORT OF SONIC BOOM, TIN--

--BUT I'M NO SCIENTIST! ALL I KNOW FOR SURE IS--

--WE'RE FALLING!

IT DOESN'T TAKE A GENIUS TO SEE THAT, BIG BRAIN!

HELP!

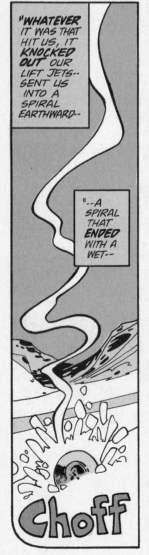

"WHATEVER IT WAS THAT HIT US, IT KNOCKED OUT OUR LIFT JETS-- SENT US INTO A SPIRAL EARTHWARD--

"--A SPIRAL THAT ENDED WITH A WET--

Choff

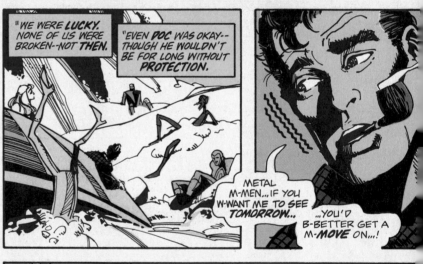

"WE WERE LUCKY. NONE OF US WERE BROKEN--NOT THEN.

"EVEN DOC WAS OKAY-- THOUGH HE WOULDN'T BE FOR LONG WITHOUT PROTECTION.

METAL M-MEN... IF YOU W-WANT ME TO SEE TOMORROW...

...YOU'D B-BETTER GET A M-MOVE ON...!

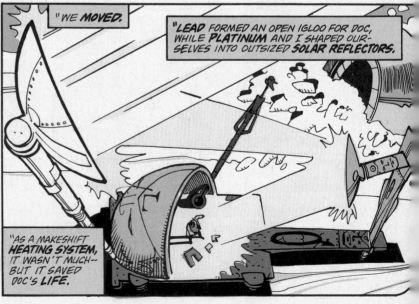

"WE MOVED.

"LEAD FORMED AN OPEN IGLOO FOR DOC, WHILE PLATINUM AND I SHAPED OUR-SELVES INTO OUTSIZED SOLAR REFLECTORS.

"AS A MAKESHIFT HEATING SYSTEM, IT WASN'T MUCH-- BUT IT SAVED DOC'S LIFE.

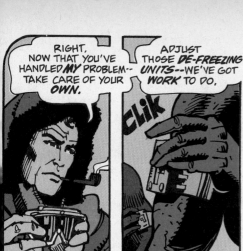

RIGHT, NOW THAT YOU'VE HANDLED *MY* PROBLEM-- TAKE CARE OF YOUR *OWN*.

ADJUST THOSE *DE-FREEZING UNITS*--WE'VE GOT *WORK* TO DO.

Clik

UH...DOC...WE MAY HAVE MORE WORK THAN...UH...WE *FIGURED*.

LOOK... UH... *COMPANY*.

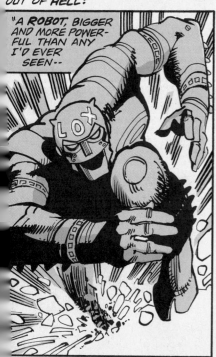

"IT CAME *BARRELING* OUT OF THE SNOW LIKE THE HUMAN PROVERB OF A BAT OUT OF *HELL*:

"*A ROBOT*, BIGGER AND MORE POWER-FUL THAN ANY I'D EVER SEEN--

THAT *INSIGNIA* ON ITS *FOREHEAD*--

L.O.X.-- LIQUID OXYGEN.

FORGET THAT--

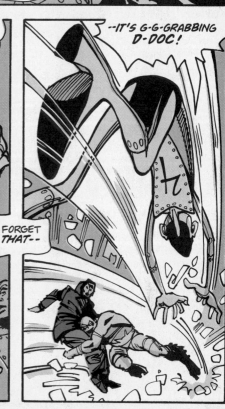

--IT'S G-G-GRABBING D-DOC!

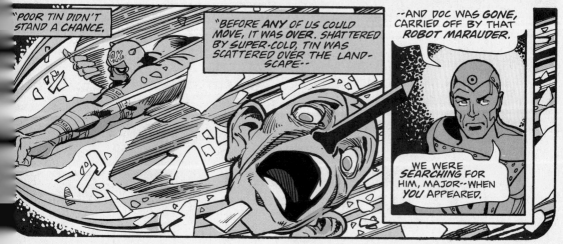

"POOR TIN DIDN'T STAND A CHANCE.

"BEFORE *ANY* OF US COULD MOVE, IT WAS OVER. SHATTERED BY SUPER-COLD, TIN WAS SCATTERED OVER THE LAND-SCAPE--

--AND DOC WAS *GONE*, CARRIED OFF BY THAT *ROBOT MARAUDER*.

WE WERE *SEARCHING* FOR HIM, MAJOR--WHEN *YOU* APPEARED.

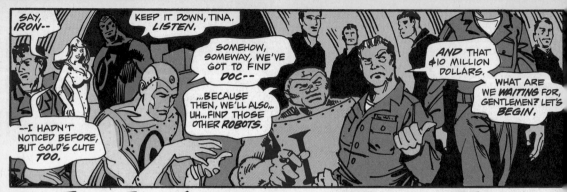

A Little Traveling Music Please!

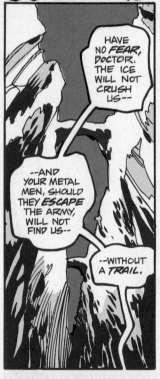

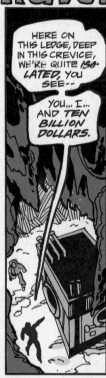

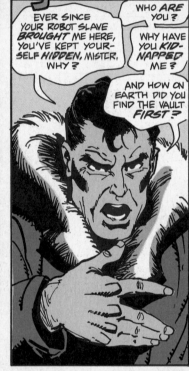

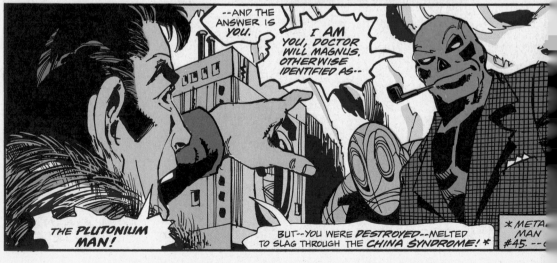

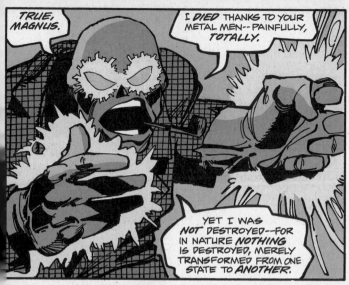

TRUE, MAGNUS.

I *DIED* THANKS TO YOUR METAL MEN-- PAINFULLY, *TOTALLY.*

YET I WAS *NOT* DESTROYED--FOR IN NATURE *NOTHING* IS DESTROYED, MERELY TRANSFORMED FROM ONE STATE TO *ANOTHER.*

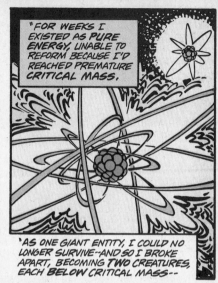

"FOR WEEKS I EXISTED AS *PURE ENERGY*, UNABLE TO REFORM BECAUSE I'D REACHED PREMATURE *CRITICAL MASS.*

"AS ONE GIANT ENTITY, I COULD NO LONGER SURVIVE--AND SO I *BROKE APART*, BECOMING *TWO* CREATURES, EACH *BELOW* CRITICAL MASS--

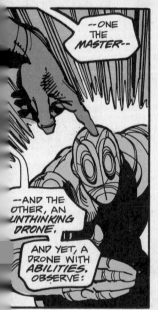

--ONE THE *MASTER*--

--AND THE OTHER, AN *UNTHINKING DRONE.*

AND YET, A DRONE WITH *ABILITIES.* OBSERVE:

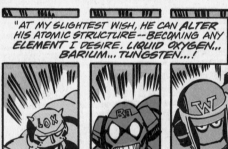

"AT MY SLIGHTEST WISH, HE CAN *ALTER HIS ATOMIC STRUCTURE*--BECOMING ANY ELEMENT I DESIRE. LIQUID OXYGEN... BARIUM... TUNGSTEN...!

"FOR THE PAST WEEK, WE'VE *HARASSED* A NEARBY ARMY BASE--IN PREPARATION FOR YOUR *COMING*--"

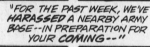

BING BING BING

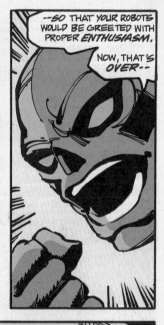

--SO THAT YOUR ROBOTS WOULD BE GREETED WITH PROPER *ENTHUSIASM.*

NOW, THAT'S *OVER*--

--AND THE MOMENT I'VE WAITED FOR HAS *ARRIVED.*

SINCE I *AM* YOU, DOCTOR MAGNUS-- YOUR *CREATION* AND YOUR *DOUBLE*--

--I WANT WHAT *YOU* WANT:

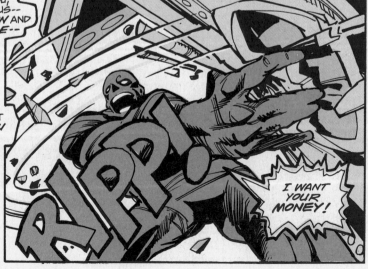

R·I·P·P!

I WANT YOUR *MONEY!*

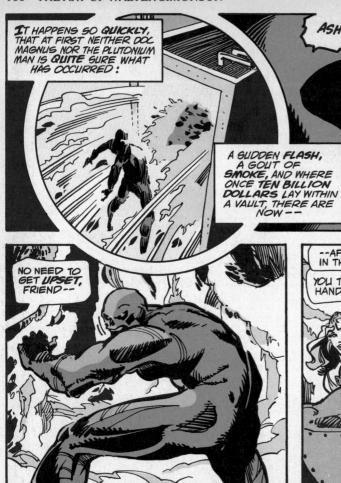

IT HAPPENS SO QUICKLY, THAT AT FIRST NEITHER DOC MAGNUS NOR THE PLUTONIUM MAN IS QUITE SURE WHAT HAS OCCURRED:

A SUDDEN FLASH, A GOUT OF SMOKE, AND WHERE ONCE TEN BILLION DOLLARS LAY WITHIN A VAULT, THERE ARE NOW--

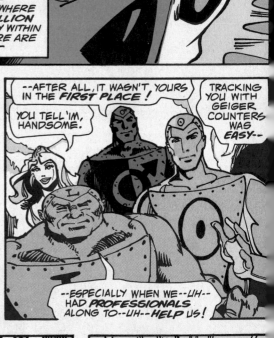

ASHES!

MY BODY-HEAT-- BURNED THE MONEY TO A CRISP!

IT'S GONE! GONE, GONE, GONE!

NO NEED TO GET UPSET, FRIEND--

--AFTER ALL, IT WASN'T YOURS IN THE FIRST PLACE!

YOU TELL 'IM, HANDSOME.

TRACKING YOU WITH GEIGER COUNTERS WAS EASY--

--ESPECIALLY WHEN WE--UH-- HAD PROFESSIONALS ALONG TO--UH--HELP US!

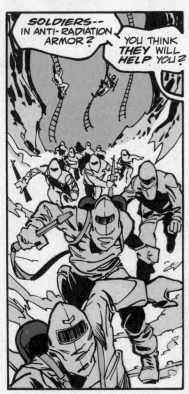

SOLDIERS-- IN ANTI-RADIATION ARMOR?

YOU THINK THEY WILL HELP YOU?

YOU'RE EVEN MORE IMBECILIC THAN I'D THOUGHT!

BRAMM

A SIMPLE SHOCK-WAVE SENDS THEM REELING, AND WHILE THEY FALL--

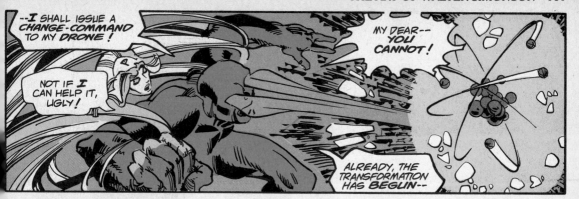

--I SHALL ISSUE A CHANGE-COMMAND TO MY DRONE!

NOT IF I CAN HELP IT, UGLY!

MY DEAR-- YOU CANNOT!

ALREADY, THE TRANSFORMATION HAS BEGUN--

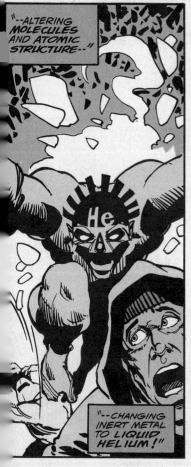

"--ALTERING MOLECULES AND ATOMIC STRUCTURE--"

"--CHANGING INERT METAL TO LIQUID HELIUM!"

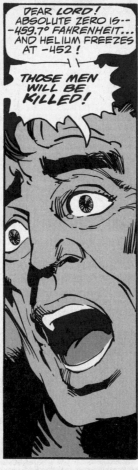

DEAR LORD! ABSOLUTE ZERO IS-- -459.7° FAHRENHEIT... AND HELIUM FREEZES AT -452!

THOSE MEN WILL BE KILLED!

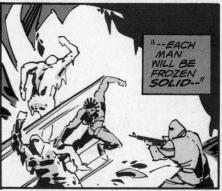

"NO, DOCTOR--NOT KILLED, BUT RATHER, LIKE SOME GIANT-SIZED TELEVISION DINNER--"

"--EACH MAN WILL BE FROZEN SOLID--"

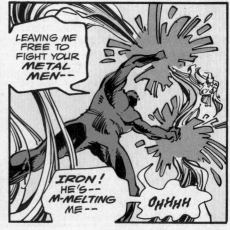

LEAVING ME FREE TO FIGHT YOUR METAL MEN--

IRON! HE'S-- M-MELTING ME--

OHHHH

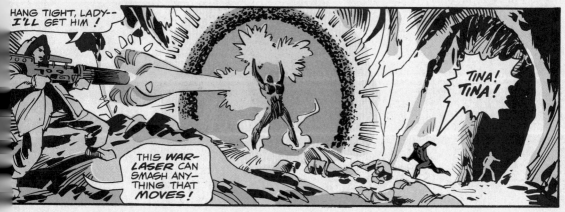

HANG TIGHT, LADY-- I'LL GET HIM!

THIS WAR-LASER CAN SMASH ANY-THING THAT MOVES!

TINA! TINA!

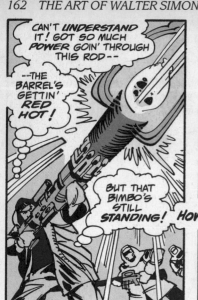

CAN'T *UNDERSTAND* IT! GOT SO MUCH *POWER* GOIN' THROUGH THIS ROD--

--THE BARREL'S GETTIN' *RED HOT!*

BUT THAT *BIMBO'S* STILL *STANDING!* HOW--?

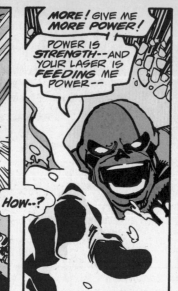

MORE! GIVE ME *MORE POWER!*

POWER IS *STRENGTH*--AND YOUR LASER IS *FEEDING* ME POWER--

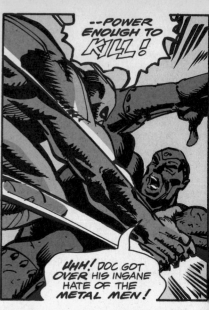

--*POWER* ENOUGH TO *KILL!*

UHH! DOC GOT OVER HIS *INSANE HATE* OF THE *METAL MEN!*

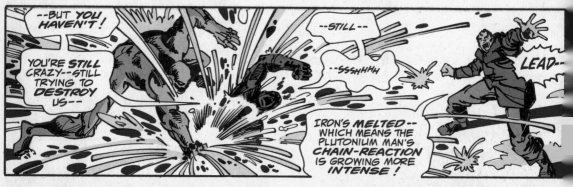

--BUT *YOU* HAVEN'T!

YOU'RE *STILL CRAZY*--STILL TRYING TO *DESTROY* US--

--STILL--

--SSSHHHH

LEAD--

IRON'S *MELTED*-- WHICH MEANS THE *PLUTONIUM MAN'S CHAIN-REACTION* IS GROWING MORE *INTENSE!*

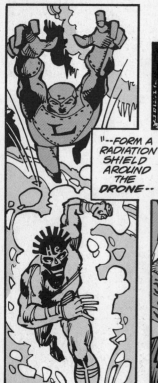

"--YOU'RE THE ONLY ONE WHO CAN SAVE US *NOW!*"

"--FORM A *RADIATION SHIELD* AROUND THE DRONE--

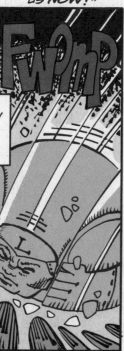

FWOMP

CUT OFF from his master's *controlling energy,* the drone reacts with *blind, unreasoning* TERROR!

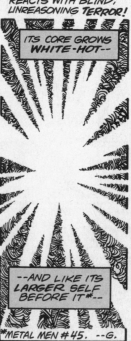

ITS *CORE* GROWS *WHITE-HOT*--

--AND LIKE ITS *LARGER SELF* BEFORE IT*--

*METAL MEN #45. --G.

--THE DRONE FALLS VICTIM TO THE *CHINA SYNDROME!*

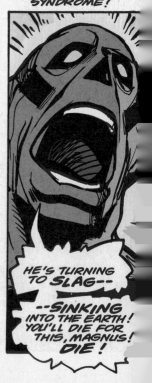

HE'S TURNING TO *SLAG*--

--*SINKING* INTO THE *EARTH!* YOU'LL *DIE* FOR THIS, MAGNUS! *DIE!*

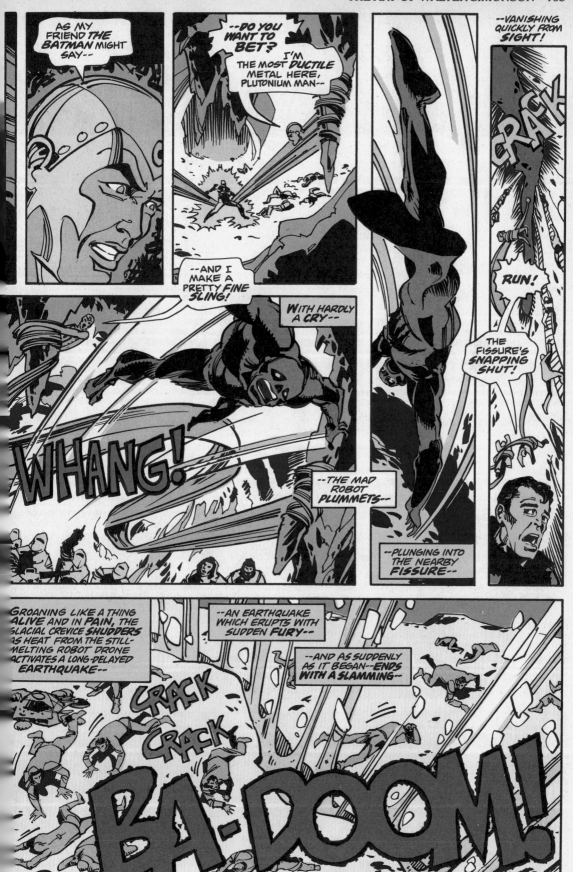

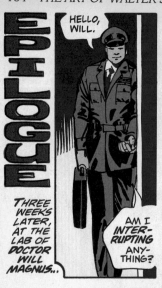

EPILOGUE

THREE WEEKS LATER, AT THE LAB OF DOCTOR WILL MAGNUS...

HELLO, WILL.

AM I INTERRUPTING ANYTHING?

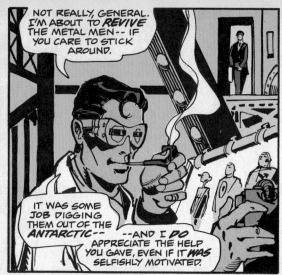

NOT REALLY, GENERAL. I'M ABOUT TO *REVIVE* THE METAL MEN-- IF YOU CARE TO STICK AROUND.

IT WAS SOME JOB DIGGING THEM OUT OF THE *ANTARCTIC*-- --AND I *DO* APPRECIATE THE HELP YOU GAVE, EVEN IF IT *WAS* SELFISHLY MOTIVATED.

OH--YOU MEAN THE *RANSOM MONEY?*

WE HAD HOPED TO FIND *SOME* OF IT--

--BUT IT'S NOT ACTUALLY *IMPORTANT*--

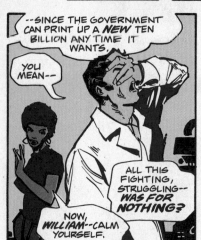

--SINCE THE GOVERNMENT CAN PRINT UP A *NEW* TEN BILLION ANY TIME IT WANTS.

YOU MEAN--

ALL THIS FIGHTING, STRUGGLING-- *WAS FOR NOTHING?*

NOW, WILLIAM--CALM YOURSELF.

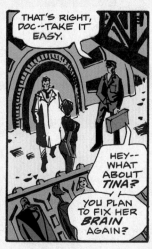

THAT'S RIGHT, DOC--TAKE IT EASY.

HEY-- WHAT ABOUT *TINA?*

YOU PLAN TO FIX HER *BRAIN* AGAIN?

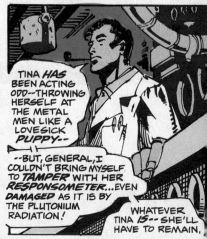

TINA *HAS* BEEN ACTING ODD--THROWING HERSELF AT THE METAL MEN LIKE A LOVESICK *PUPPY*--

--BUT, GENERAL, I COULDN'T BRING MYSELF TO *TAMPER* WITH HER *RESPONSOMETER*...EVEN *DAMAGED* AS IT IS BY THE PLUTONIUM RADIATION!

WHATEVER TINA *IS*-- SHE'LL HAVE TO REMAIN.

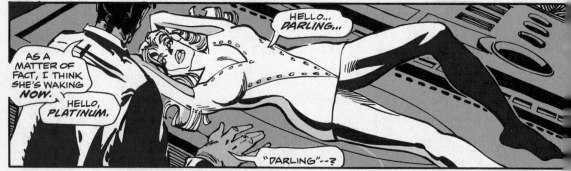

HELLO... *DARLING...*

AS A MATTER OF FACT, I THINK SHE'S WAKING *NOW.*

HELLO, PLATINUM.

"DARLING"--?

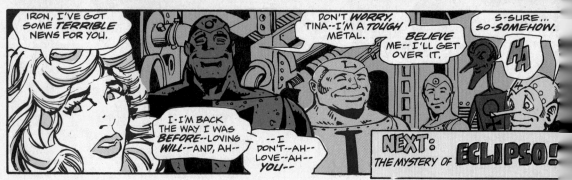

IRON, I'VE GOT SOME *TERRIBLE* NEWS FOR YOU.

DON'T *WORRY,* TINA--I'M A *TOUGH* METAL.

BELIEVE ME-- I'LL GET OVER IT.

S-SURE... SO-SOMEHOW.

I-I'M BACK THE WAY I WAS *BEFORE*--LOVING *WILL*--AND, AH--

--I DON'T--AH-- *LOVE*--AH-- *YOU*--

NEXT: THE MYSTERY OF **ECLIPSO!**

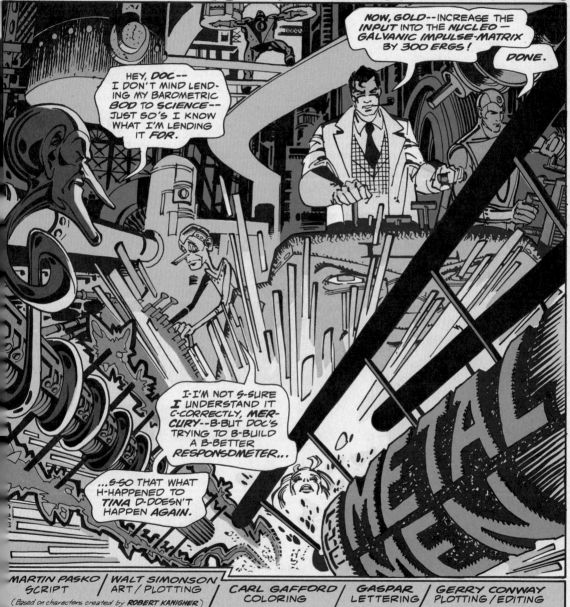

TRYING, TIN--BUT NOT SUCCEEDING!

‡SIGH‡ OKAY, GOLD--YOU MIGHT AS WELL SHUT 'ER DOWN. I DON'T SEEM TO BE GETTING ANYWHERE!

I CAN RE-ASSEMBLE YOU METAL MEN PER-FECTLY--BUT WHEN IT COMES TO THE SUBTLETIES OF YOUR MECHANISMS--!

I DON'T KNOW, BUT MAYBE SINCE MY...ILLNESS, I...I'VE LOST MY TOUCH!

NONSENSE, DARLING! YOU'LL FIND THE ANSWER--JUST GIVE IT TIME!

BUT WHATEVER HAPPENS, YOU'LL STILL HAVE PLATINUM--AND DON'T YOU FORGET IT!

SWELL.

THINGS COULD BE WORSE, DOC.

TINA COULD STILL BE MAKING COW-EYES AT ANYTHING IN RIVETS! *

* AS IN METAL MEN #46 AND #47 -- Gerry.

OH, IRON--I FORGOT ABOUT YOU. YOU CAN COME DOWN FROM THERE NOW--WE'RE FINISHED. I HAVE SOME...OTHER THINGS I WANT TO DO.

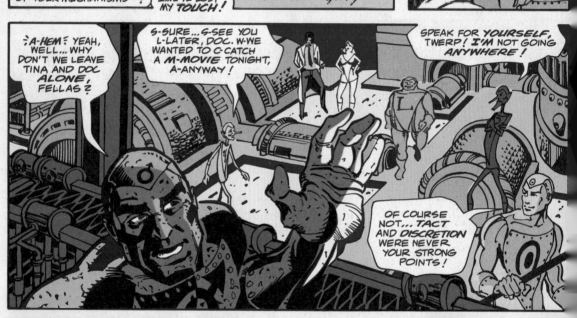

‡A-HEM‡ YEAH, WELL...WHY DON'T WE LEAVE TINA AND DOC ALONE, FELLAS?

S-SURE...S-SEE YOU L-LATER, DOC. W-WE WANTED TO C-CATCH A M-MOVIE TONIGHT, A-ANYWAY!

SPEAK FOR YOURSELF, TWERP! I'M NOT GOING ANYWHERE!

OF COURSE NOT...TACT AND DISCRETION WERE NEVER YOUR STRONG POINTS!

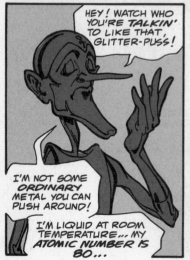

HEY! WATCH WHO YOU'RE TALKIN' TO LIKE THAT, GLITTER-PUSS!

I'M NOT SOME ORDINARY METAL YOU CAN PUSH AROUND!

I'M LIQUID AT ROOM TEMPERATURE...MY ATOMIC NUMBER IS 80...

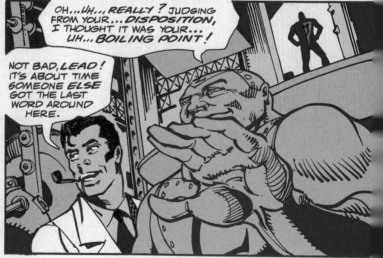

OH,...UH,...REALLY? JUDGING FROM YOUR...DISPOSITION, I THOUGHT IT WAS YOUR...UH...BOILING POINT!

NOT BAD, LEAD! IT'S ABOUT TIME SOMEONE ELSE GOT THE LAST WORD AROUND HERE.

SUDDENLY...

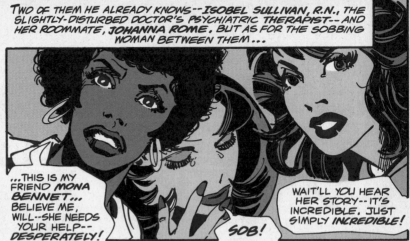

TWO OF THEM HE ALREADY KNOWS--ISOBEL SULLIVAN, R.N., THE SLIGHTLY-DISTURBED DOCTOR'S PSYCHIATRIC THERAPIST--AND HER ROOMMATE, JOHANNA ROME. BUT AS FOR THE SOBBING WOMAN BETWEEN THEM...

WILL-- WILL! IT'S ISOBEL-- --COME HERE-- QUICK!

...THIS IS MY FRIEND MONA BENNET... BELIEVE ME, WILL--SHE NEEDS YOUR HELP-- DESPERATELY!

SOB!

WAIT'LL YOU HEAR HER STORY--IT'S INCREDIBLE. JUST SIMPLY INCREDIBLE!

MAGNUS APPEARS...AND THREE WOMEN GREET HIM WITH A FEVERISH RUSH OF WORDS...

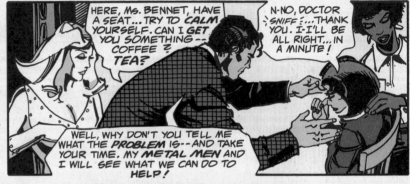

HERE, Ms. BENNET, HAVE A SEAT...TRY TO CALM YOURSELF. CAN I GET YOU SOMETHING-- COFFEE? TEA?

N-NO, DOCTOR ~SNIFF?~...THANK YOU. I-I'LL BE ALL RIGHT...IN A MINUTE!

WELL, WHY DON'T YOU TELL ME WHAT THE PROBLEM IS--AND TAKE YOUR TIME. MY METAL MEN AND I WILL SEE WHAT WE CAN DO TO HELP!

THAT MIGHT NOT BE SO EASY, DR. MAGNUS. IT'S MY FIANCE-- HE'S A PHYSICIST NAMED BRUCE GORDON.

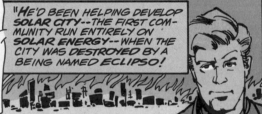

"HE'D BEEN HELPING DEVELOP SOLAR CITY--THE FIRST COMMUNITY RUN ENTIRELY ON SOLAR ENERGY--WHEN THE CITY WAS DESTROYED BY A BEING NAMED ECLIPSO!"

"WEEKS LATER, I DISCOVERED BRUCE IS ECLIPSO--THAT A WOUND CAUSED BY A CUT FROM A BLACK DIAMOND HAD ALTERED HIS BODY CHEMISTRY SOMEHOW...

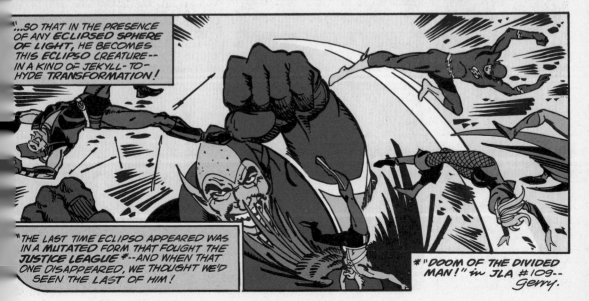

"...SO THAT IN THE PRESENCE OF ANY ECLIPSED SPHERE OF LIGHT, HE BECOMES THIS ECLIPSO CREATURE-- IN A KIND OF JEKYLL-TO-HYDE TRANSFORMATION!

"THE LAST TIME ECLIPSO APPEARED WAS IN A MUTATED FORM THAT FOUGHT THE JUSTICE LEAGUE *--AND WHEN THAT ONE DISAPPEARED, WE THOUGHT WE'D SEEN THE LAST OF HIM!

* "DOOM OF THE DIVIDED MAN!" in JLA #109-- Gerry.

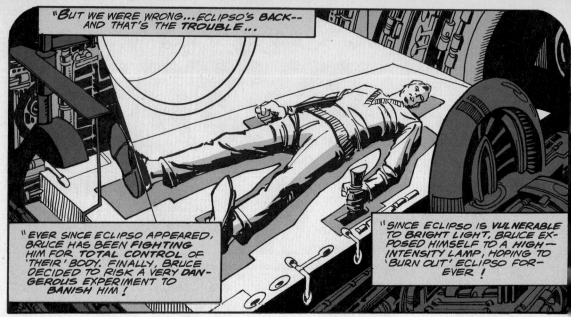

"BUT WE WERE WRONG...ECLIPSO'S BACK-- AND THAT'S THE TROUBLE..."

"EVER SINCE ECLIPSO APPEARED, BRUCE HAS BEEN FIGHTING HIM FOR TOTAL CONTROL OF 'THEIR' BODY. FINALLY, BRUCE DECIDED TO RISK A VERY DANGEROUS EXPERIMENT TO BANISH HIM!"

"SINCE ECLIPSO IS VULNERABLE TO BRIGHT LIGHT, BRUCE EXPOSED HIMSELF TO A HIGH-INTENSITY LAMP, HOPING TO 'BURN OUT' ECLIPSO FOR-EVER!"

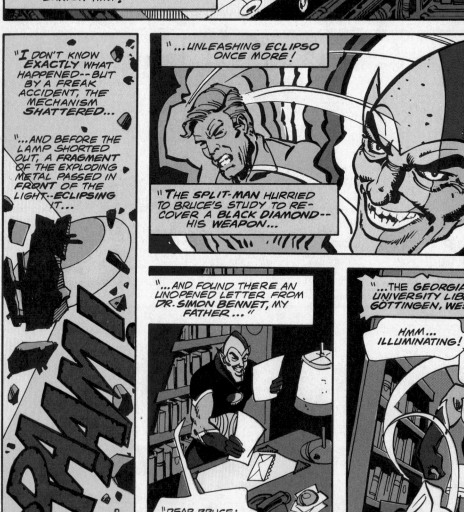

"I DON'T KNOW EXACTLY WHAT HAPPENED--BUT BY A FREAK ACCIDENT, THE MECHANISM SHATTERED...

"...AND BEFORE THE LAMP SHORTED OUT, A FRAGMENT OF THE EXPLODING METAL PASSED IN FRONT OF THE LIGHT--ECLIPSING IT...

"...UNLEASHING ECLIPSO ONCE MORE!"

"THE SPLIT-MAN HURRIED TO BRUCE'S STUDY TO RECOVER A BLACK DIAMOND-- HIS WEAPON...

BRAAM!

"...AND FOUND THERE AN UNOPENED LETTER FROM DR. SIMON BENNET, MY FATHER..."

"DEAR BRUCE: THE DATA YOU NEED CAN ONLY BE FOUND IN..."

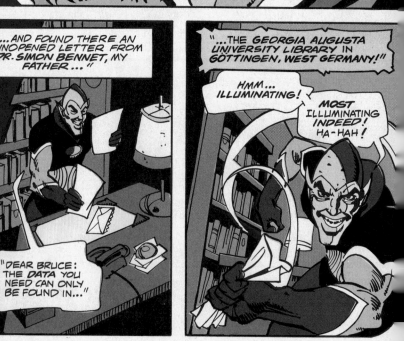

"...THE GEORGIA AUGUSTA UNIVERSITY LIBRARY IN GÖTTINGEN, WEST GERMANY!"

HMM... ILLUMINATING!

MOST ILLUMINATING INDEED! HA-HAH!

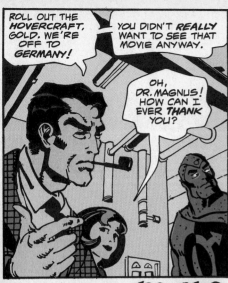

ROLL OUT THE *HOVERCRAFT*, GOLD. WE'RE OFF TO GERMANY!

YOU DIDN'T *REALLY* WANT TO SEE THAT MOVIE ANYWAY.

OH, *DR. MAGNUS!* HOW CAN I EVER *THANK* YOU?

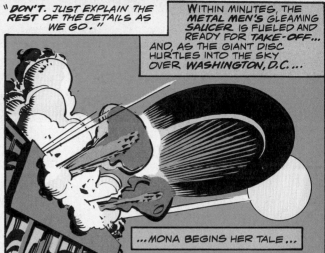

"DON'T. JUST EXPLAIN THE REST OF THE DETAILS AS WE GO."

WITHIN MINUTES, THE *METAL MEN'S* GLEAMING *SAUCER* IS FUELED AND READY FOR *TAKE-OFF*... AND, AS THE GIANT DISC HURTLES INTO THE SKY OVER *WASHINGTON, D.C.*...

...MONA BEGINS HER TALE...

...A TALE FULL OF *UNEXPECTED TWISTS* AND *DARKLING MYSTERIES*--SINCE... **no one expects** **THE SPANISH INQUISITION**

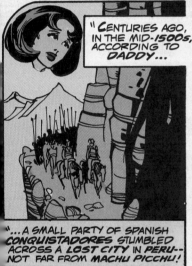

"*CENTURIES* AGO, IN THE MID-*1500s*, ACCORDING TO *DADDY*...

"...A SMALL PARTY OF SPANISH *CONQUISTADORES* STUMBLED ACROSS A *LOST CITY* IN PERU-- NOT FAR FROM *MACHU PICCHU!*

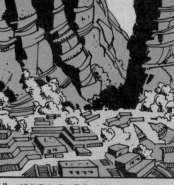

"THEY FOUND THE RUINS OF A CITY OF *PRIMITIVE ARCHITECTURE*...

"...WHICH BORE *NO RESEM-BLANCE* TO THAT OF THE INCAS, SURPRISINGLY ENOUGH.

"ONLY ONE OF THE SPANIARDS GOT OUT OF THERE *ALIVE!* HE WAS FOUND, SCREAMING IN *AGONY,* BY A PAIR OF *MISSIONARY PRIESTS*...

"NONE COULD GUESS WHAT HIS COLLEAGUES HAD FOUND-- OR WHAT *KILLED* THEM!

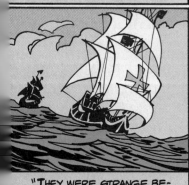

"ONLY A SERIES OF *PARCH-MENTS* BEARING STRANGE *WRITING* SURVIVED THE EXPEDITION--CARRIED BY SPANISH SEAMEN BACK TO THE *OLD WORLD*...

"THEY WERE STRANGE BE-CAUSE THE INCAS *HAD* NO WRITING!

"THEY WERE BURNED AS *HERETICAL DOCUMENTS* BY THE *SPANISH INQUISITION!*

"BUT NOT BEFORE *ONE* OF THE PARCHMENTS COULD BE *STOLEN* BY A REBELLIOUS MONK WHO FLED FROM SPAIN TO ESCAPE RELIGIOUS PERSECUTION..."

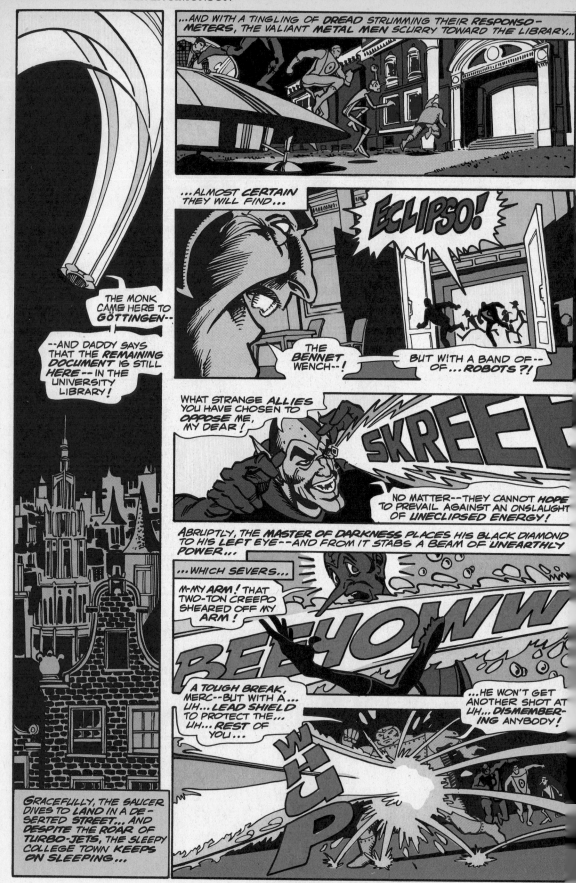

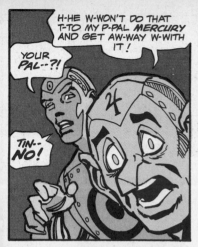

H-HE W-WON'T DO THAT T-TO MY P-PAL MERCURY AND GET AW-WAY W-WITH IT!

YOUR PAL--?!

TIN-- NO!

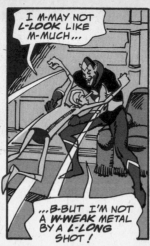

I M-MAY NOT L-LOOK LIKE M-MUCH...

...B-BUT I'M NOT A W-WEAK METAL BY A L-LONG SHOT!

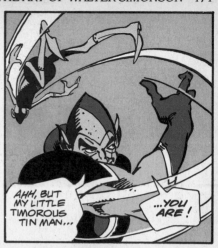

AHH, BUT MY LITTLE TIMOROUS TIN MAN...

...YOU ARE!

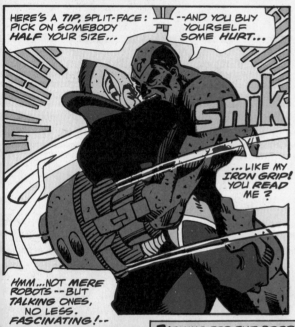

HERE'S A TIP, SPLIT-FACE: PICK ON SOMEBODY HALF YOUR SIZE...

--AND YOU BUY YOURSELF SOME HURT...

Shik

...LIKE MY IRON GRIP! YOU READ ME?

HMM...NOT MERE ROBOTS -- BUT TALKING ONES, NO LESS. FASCINATING!--

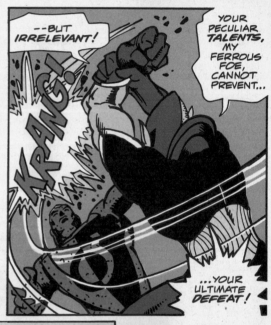

--BUT IRRELEVANT!

KRANG!

YOUR PECULIAR TALENTS, MY FERROUS FOE, CANNOT PREVENT...

...YOUR ULTIMATE DEFEAT!

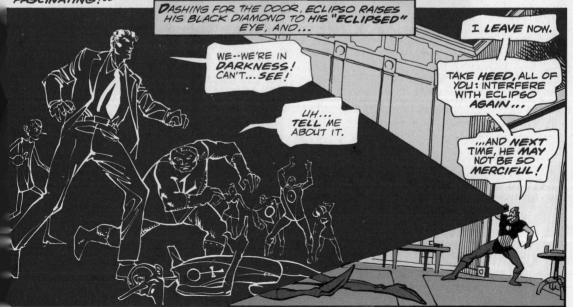

DASHING FOR THE DOOR, ECLIPSO RAISES HIS BLACK DIAMOND TO HIS "ECLIPSED" EYE, AND...

WE--WE'RE IN DARKNESS! CAN'T...SEE!

UH... TELL ME ABOUT IT.

I LEAVE NOW.

TAKE HEED, ALL OF YOU: INTERFERE WITH ECLIPSO AGAIN...

...AND NEXT TIME, HE MAY NOT BE SO MERCIFUL!

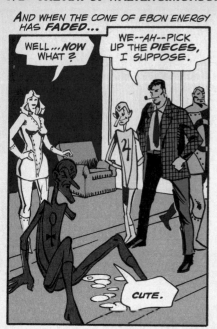

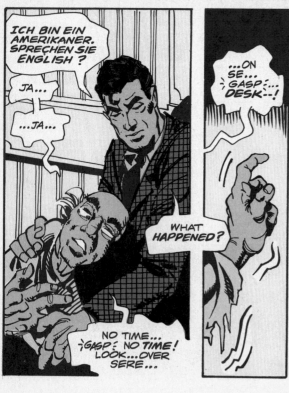

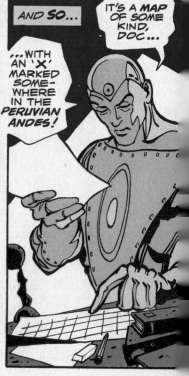

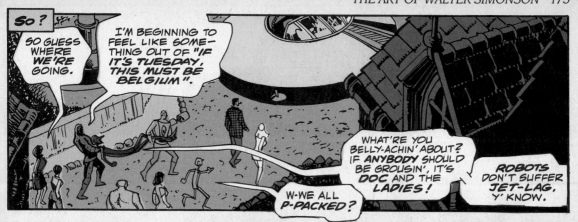

SO?

SO GUESS WHERE WE'RE GOING.

I'M BEGINNING TO FEEL LIKE SOMETHING OUT OF "IF IT'S TUESDAY, THIS MUST BE BELGIUM".

WHAT'RE YOU BELLY-ACHIN' ABOUT? IF ANYBODY SHOULD BE GROUSIN', IT'S DOC AND THE LADIES!

W-WE ALL P-PACKED?

ROBOTS DON'T SUFFER JET-LAG, Y' KNOW.

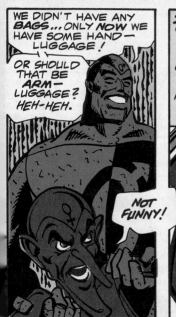

WE DIDN'T HAVE ANY BAGS...ONLY NOW WE HAVE SOME HAND-LUGGAGE!

OR SHOULD THAT BE ARM-LUGGAGE? HEH-HEH.

NOT FUNNY!

DOOM

IT'S BEEN ONLY FIVE HOURS SINCE MONA BENNET FIRST WALKED INTO OUR HEROES' LIVES.

AND IN THAT TIME, THEY'VE CROSSED AN ENTIRE HEMISPHERE, BATTLED A FEARSOME OPPONENT, AND NOW...THEY'RE GOING BACK AGAIN!

SO IF YOU'RE A BIT OUT OF BREATH RIGHT NOW, DEAR, DIZZY READER...THINK HOW THEY MUST FEEL!

FOR NOW...ONE MORE TIME... OFF WE GO INTO THE WILD BLUE YONDER...

TIME TO DO A LITTLE PATCH-UP JOB ON MERCURY. TAKE THE WHEEL, GOLD.

MY PLEASURE.

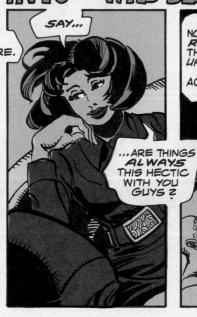

SAY...

...ARE THINGS ALWAYS THIS HECTIC WITH YOU GUYS?

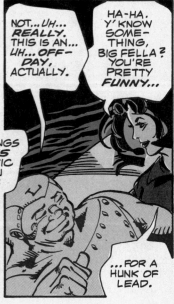

NOT...UH... REALLY. THIS IS AN... UH...OFF-DAY, ACTUALLY.

HA-HA. Y' KNOW SOMETHING, BIG FELLA? YOU'RE PRETTY FUNNY...

...FOR A HUNK OF LEAD.

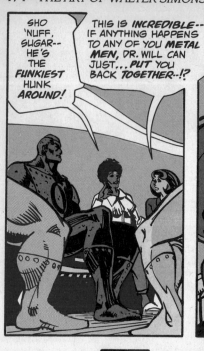

SHO 'NUFF, SUGAR-- HE'S THE *FUNKIEST* HUNK AROUND!

THIS IS *INCREDIBLE*-- IF ANYTHING HAPPENS TO ANY OF YOU *METAL MEN*, DR. WILL CAN JUST... *PUT* YOU BACK *TOGETHER*--!?

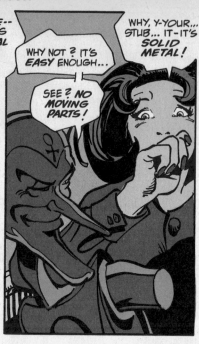

WHY NOT? IT'S *EASY* ENOUGH...

SEE? *NO MOVING PARTS!*

WHY, Y-YOUR... STUB... IT-IT'S *SOLID METAL!*

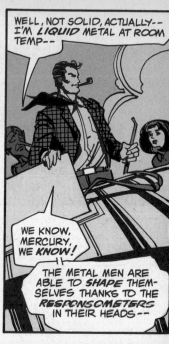

WELL, NOT SOLID, ACTUALLY-- I'M *LIQUID* METAL AT ROOM TEMP--

WE KNOW, MERCURY, WE *KNOW!*

THE METAL MEN ARE ABLE TO *SHAPE* THEM- SELVES THANKS TO THE *RESPONSOMETERS* IN THEIR HEADS--

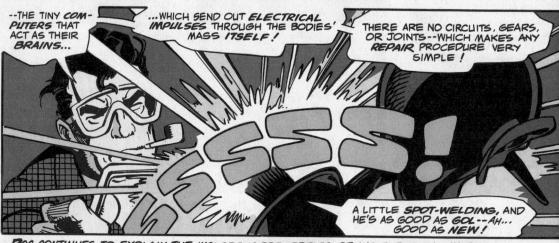

--THE TINY *COM- PUTERS* THAT ACT AS THEIR *BRAINS*...

...WHICH SEND OUT *ELECTRICAL IMPULSES* THROUGH THE BODIES' MASS *ITSELF!*

THERE ARE NO CIRCUITS, GEARS, OR JOINTS--WHICH MAKES ANY *REPAIR* PROCEDURE VERY SIMPLE!

SSSSS!

A LITTLE *SPOT-WELDING*, AND HE'S AS GOOD AS GOL--AH... GOOD AS *NEW!*

DOC CONTINUES TO EXPLAIN THE WONDROUS PROPERTIES OF HIS ELEMENTAL INVENTIONS... AND IN THIS FASHION, THE TIME PASSES QUICKLY--UNTIL THE LANDSCAPE BENEATH THE SKITTERING GOLDEN PLATTER BECOMES THE RUGGED TERRAIN OF THE PERUVIAN ANDES...

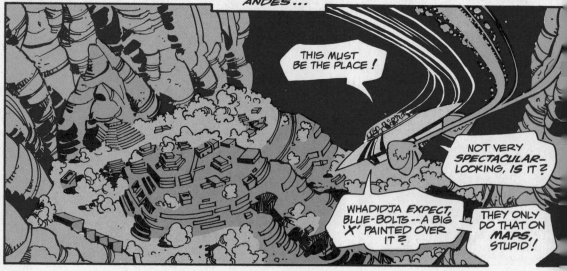

THIS MUST BE THE PLACE!

NOT VERY *SPECTACULAR-* LOOKING, IS IT?

WHADIDJA *EXPECT,* BLUE-BOLTS--A BIG 'X' PAINTED OVER IT?

THEY ONLY DO THAT ON *MAPS,* STUPID!

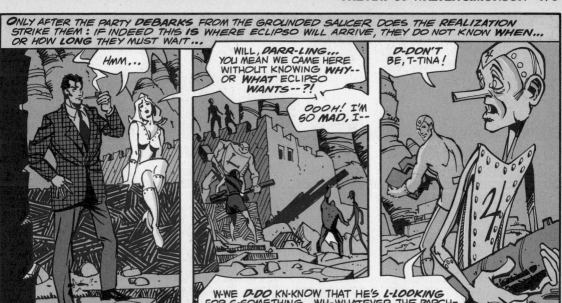

ONLY AFTER THE PARTY *DEBARKS* FROM THE GROUNDED SAUCER DOES THE REALIZATION STRIKE THEM : IF INDEED THIS *IS* WHERE ECLIPSO WILL ARRIVE, THEY DO NOT KNOW *WHEN*... OR HOW *LONG* THEY MUST WAIT...

HMM...

WILL, *DARR-LING*... YOU MEAN WE CAME HERE WITHOUT KNOWING *WHY*-- OR *WHAT* ECLIPSO WANTS--?!

OOOH! I'M *SO* MAD, I--

D-DON'T BE, T-TINA!

W-WE *D-DO* KN-KNOW THAT HE'S *L-LOOKING* FOR S-SOMETHING...WH-WHATEVER THE PARCH-MENT HE S-SWIPED FROM G-GÖTTINGEN TOLD HIM AB-ABOUT!

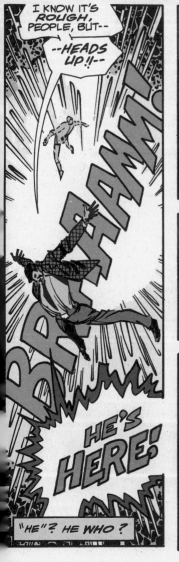

I KNOW IT'S *ROUGH*, PEOPLE, BUT--

--HEADS *UP*!!--

BRRRAAMM!

HE'S *HERE!*

"HE"? HE WHO?

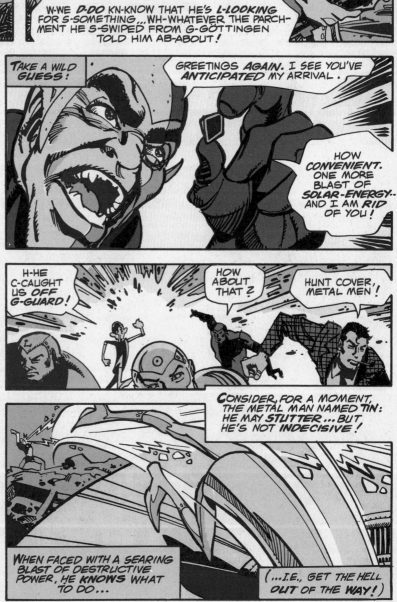

TAKE A WILD GUESS:

GREETINGS *AGAIN*. I SEE YOU'VE *ANTICIPATED* MY ARRIVAL.

HOW *CONVENIENT*. ONE MORE BLAST OF *SOLAR-ENERGY*-- AND I AM *RID* OF YOU!

H-HE C-CAUGHT US OFF G-GUARD!

HOW ABOUT THAT?

HUNT COVER, METAL MEN!

CONSIDER, FOR A MOMENT, THE METAL MAN NAMED *TIN*: HE MAY *STUTTER*...BUT HE'S NOT *INDECISIVE*!

WHEN FACED WITH A SEARING BLAST OF DESTRUCTIVE POWER, HE *KNOWS* WHAT TO DO...

(...*I.E.*, GET THE HELL OUT OF THE *WAY*!)

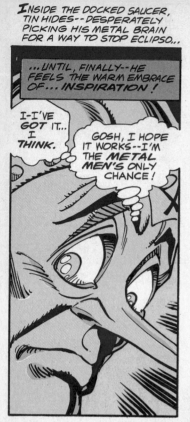

INSIDE THE DOCKED SAUCER, TIN HIDES--DESPERATELY PICKING HIS METAL BRAIN FOR A WAY TO STOP ECLIPSO...

...UNTIL, FINALLY--HE FEELS THE WARM EMBRACE OF... INSPIRATION!

I-I'VE GOT IT... I THINK.

GOSH, I HOPE IT WORKS--I'M THE METAL MEN'S ONLY CHANCE!

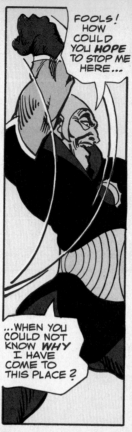

FOOLS! HOW COULD YOU HOPE TO STOP ME HERE...

...WHEN YOU COULD NOT KNOW WHY I HAVE COME TO THIS PLACE?

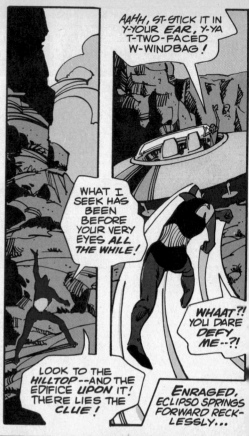

AAHH, ST-STICK IT IN Y-YOUR EAR, Y-YA T-TWO-FACED W-WINDBAG!

WHAT I SEEK HAS BEEN BEFORE YOUR VERY EYES ALL THE WHILE!

WHAAT?! YOU DARE DEFY ME--?!

LOOK TO THE HILLTOP--AND THE EDIFICE UPON IT! THERE LIES THE CLUE!

ENRAGED, ECLIPSO SPRINGS FORWARD RECKLESSLY...

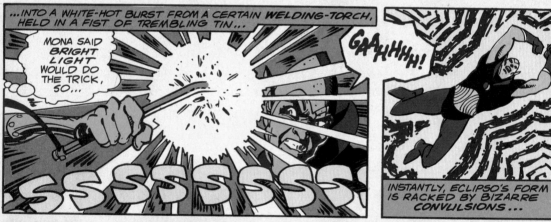

...INTO A WHITE-HOT BURST FROM A CERTAIN WELDING-TORCH, HELD IN A FIST OF TREMBLING TIN...

MONA SAID BRIGHT LIGHT WOULD DO THE TRICK, SO...

SSSSSSSSS

GAAHHHH!

INSTANTLY, ECLIPSO'S FORM IS RACKED BY BIZARRE CONVULSIONS...

UNTIL...

BRUCE!

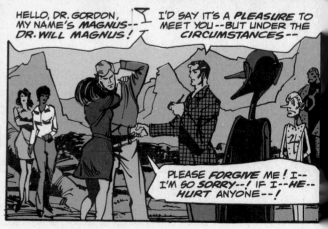

HELLO, DR. GORDON, MY NAME'S MAGNUS-- DR. WILL MAGNUS!

I'D SAY IT'S A PLEASURE TO MEET YOU--BUT UNDER THE CIRCUMSTANCES--

PLEASE FORGIVE ME! I-- I'M SO SORRY--! IF I--HE-- HURT ANYONE--!

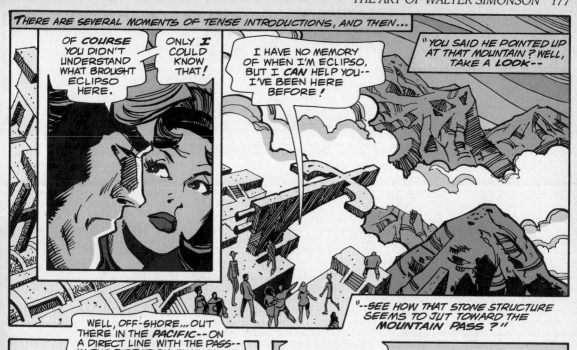

THERE ARE SEVERAL MOMENTS OF TENSE INTRODUCTIONS, AND THEN...

OF *COURSE* YOU DIDN'T UNDERSTAND WHAT BROUGHT ECLIPSO HERE.

ONLY *I* COULD KNOW THAT!

I HAVE NO MEMORY OF WHEN I'M ECLIPSO, BUT I *CAN* HELP YOU-- I'VE BEEN HERE BEFORE!

"*YOU* SAID HE POINTED UP AT THAT MOUNTAIN? WELL, TAKE A *LOOK*--

"--SEE HOW THAT STONE STRUCTURE SEEMS TO JUT TOWARD THE *MOUNTAIN PASS*?"

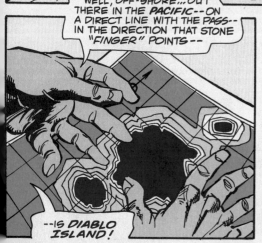

WELL, OFF-SHORE...OUT THERE IN THE *PACIFIC*--ON A DIRECT LINE WITH THE PASS-- IN THE DIRECTION THAT STONE "*FINGER*" POINTS--

--IS *DIABLO ISLAND!*

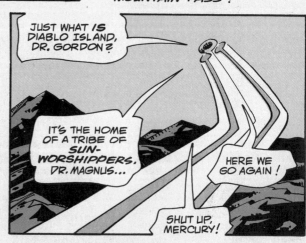

JUST WHAT *IS* DIABLO ISLAND, DR. GORDON?

IT'S THE HOME OF A TRIBE OF *SUN-WORSHIPPERS*, DR. MAGNUS...

HERE WE GO AGAIN!

SHUT UP, MERCURY!

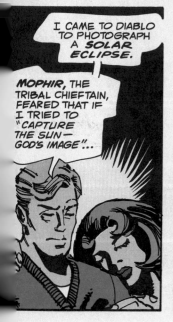

I CAME TO DIABLO TO PHOTOGRAPH A *SOLAR ECLIPSE.*

MOPHIR, THE TRIBAL CHIEFTAIN, FEARED THAT IF I TRIED TO "*CAPTURE THE SUN—GOD'S IMAGE*"...

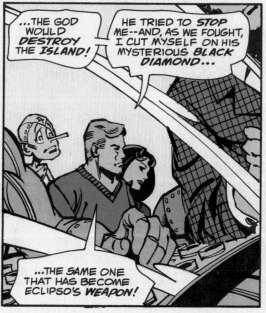

...THE GOD WOULD *DESTROY* THE *ISLAND!*

HE TRIED TO *STOP* ME--AND, AS WE FOUGHT, I CUT MYSELF ON HIS MYSTERIOUS *BLACK DIAMOND*...

...THE SAME ONE THAT HAS BECOME ECLIPSO'S *WEAPON!*

THE UGLY *REST* OF IT YOU *KNOW.*

HANG ON, EVERY-ONE--WE'RE BANKING IN!

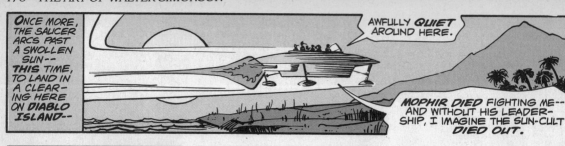

ONCE MORE, THE SAUCER ARCS PAST A SWOLLEN SUN-- THIS TIME, TO LAND IN A CLEARING HERE ON DIABLO ISLAND--

AWFULLY *QUIET* AROUND HERE.

MOPHIR *DIED* FIGHTING ME-- AND WITHOUT HIS LEADERSHIP, I IMAGINE THE SUN-CULT *DIED* OUT.

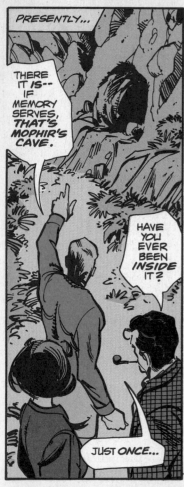

PRESENTLY...

THERE IT *IS*-- IF MEMORY SERVES, THAT'S MOPHIR'S CAVE.

HAVE YOU EVER BEEN *INSIDE* IT?

JUST *ONCE*...

...ONLY *BRIEFLY**-- I DON'T REALLY *REMEMBER* MUCH ABOUT IT.

COME ON, PEOPLE-- A LITTLE LESS *GAB* AND A BIT MORE *HUSTLE*, IF YOU PLEASE--!

THEY PRESS *ONWARD*--AND THE EQUATORIAL HEAT GIVES WAY TO AN OPPRESSION OF A *DIFFERENT* KIND--DANK AND BONE-CHILLING--AS THE GLOOM SETTLES ABOUT THEIR SHOULDERS...

*HOUSE OF SECRETS #67--Ger.

WHEN THEIR EYES *ADJUST*, IT IS AS IF *ANOTHER WORLD* HAD OPENED UP TO THEM! THEY ARE SURROUNDED BY THE REMNANTS OF DIM DAYS... A LEGACY OF AWESOME *ANTIQUITY!*...

A CATHEDRAL-LIKE *HUSH* FALLS OVER THE ASSEMBLAGE...

...AND IN THE SILENCE, THE METAL MEN CAN HEAR THEIR OWN RESPONSOMETERS TICKING--UNTIL...

HEY, *FELLAS!*

OVER *HERE*... A TABLET... INSCRIBED WITH AN *ECLIPSED SUN!*

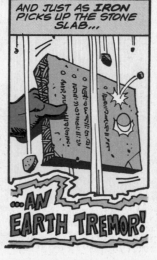

AND JUST AS IRON PICKS UP THE STONE SLAB...

...AN *EARTH TREMOR!*

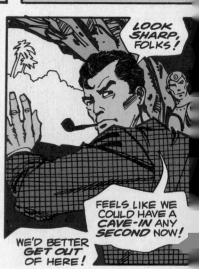

LOOK *SHARP*, FOLKS!

FEELS LIKE WE COULD HAVE A *CAVE-IN* ANY SECOND NOW!

WE'D BETTER *GET OUT* OF HERE!

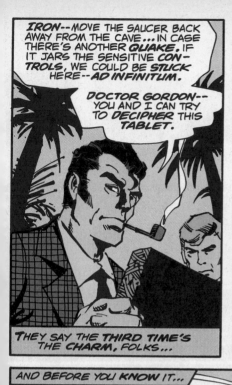

IRON--MOVE THE SAUCER BACK AWAY FROM THE CAVE...IN CASE THERE'S ANOTHER *QUAKE*. IF IT JARS THE SENSITIVE *CONTROLS*, WE COULD BE *STUCK* HERE--*AD INFINITUM.*

DOCTOR GORDON-- YOU AND I CAN TRY TO *DECIPHER* THIS TABLET.

THEY SAY THE *THIRD* TIME'S THE *CHARM*, FOLKS...

...BUT WHETHER OR NOT WHAT'S ABOUT TO HAPPEN IS *CHARMING* DEPENDS, WE SUPPOSE, UPON YOUR POINT OF VIEW.

FOR YET A *THIRD* TIME, THE SAUCER TRAVERSES THE SUN'S GOLDEN ORB...

BUT FOR THE *FIRST* TIME, DR. *BRUCE GORDON* IS *BENEATH* IT! AS A HEMI-SPHERE OF SUNLIGHT IS *OBSCURED* BY THE HOVER-CRAFT'S *HULL*--A SHADOW FALLS UPON HIM...

AND *THAT*--IN A *WAY*--IS WHAT YOU CALL YOUR BASIC *SOLAR ECLIPSE.*

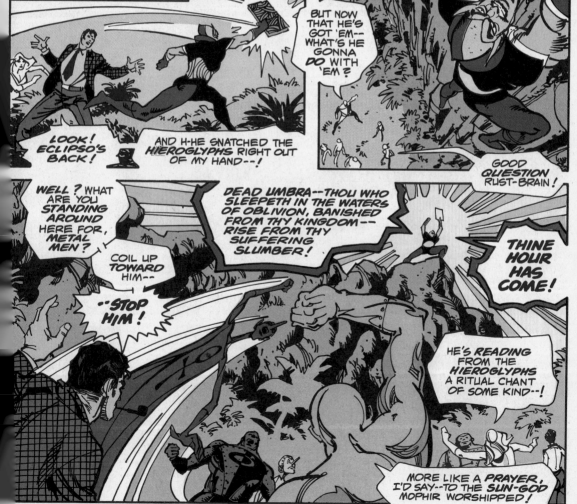

AND BEFORE YOU KNOW IT...

LOOK! *ECLIPSO'S* BACK!

AND H-HE SNATCHED THE *HIEROGLYPHS* RIGHT OUT OF MY HAND--!

BUT NOW THAT HE'S GOT 'EM-- WHAT'S HE GONNA *DO* WITH 'EM?

GOOD QUESTION RUST-BRAIN!

WELL? WHAT ARE YOU *STANDING AROUND* HERE FOR, *METAL MEN?*

COIL UP TOWARD HIM--

--*STOP HIM!*

DEAD UMBRA--THOU WHO SLEEPETH IN THE WATERS OF OBLIVION, BANISHED FROM THY KINGDOM-- RISE FROM THY SUFFERING SLUMBER!

THINE HOUR HAS COME!

HE'S *READING* FROM THE *HIEROGLYPHS* A RITUAL CHANT OF SOME KIND--!

MORE LIKE A *PRAYER*, I'D SAY--TO THE *SUN-GOD MOPHIR* WORSHIPPED!

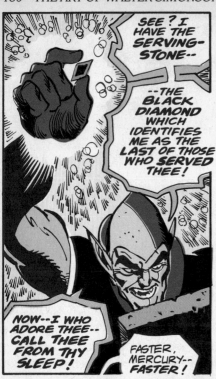

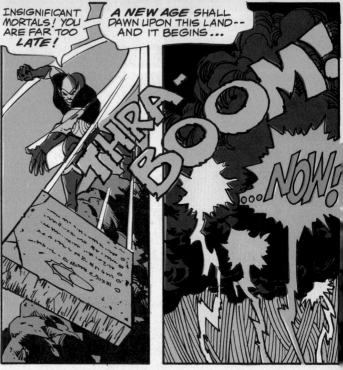

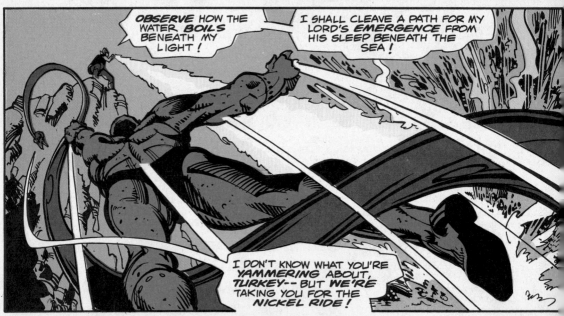

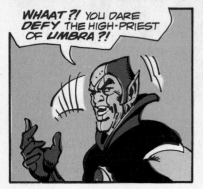

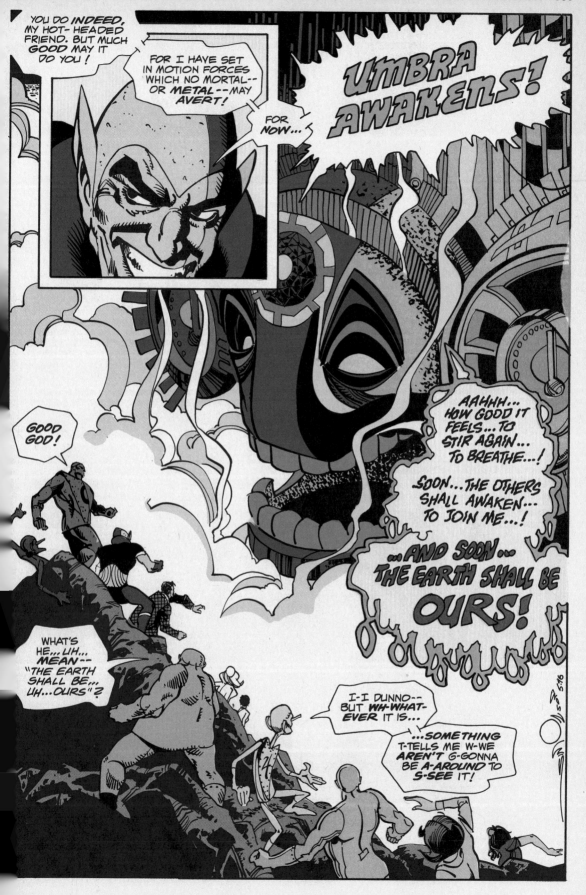

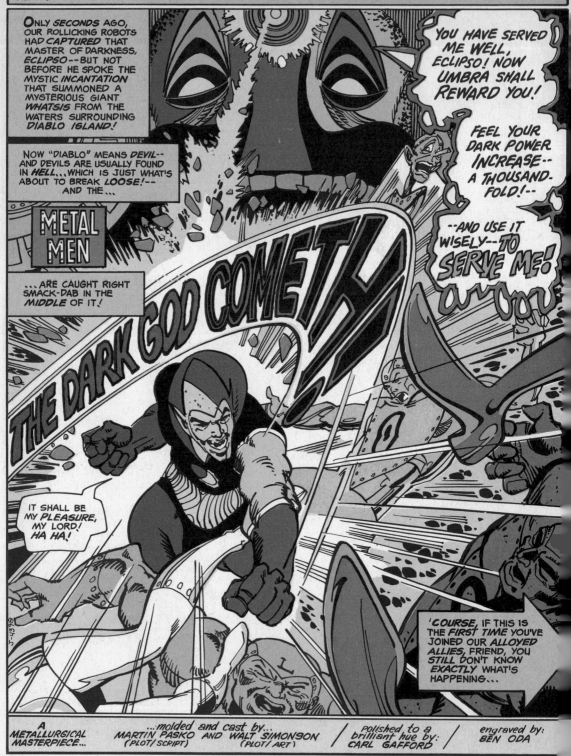

(Based on characters created by ROBERT KANIGHER)

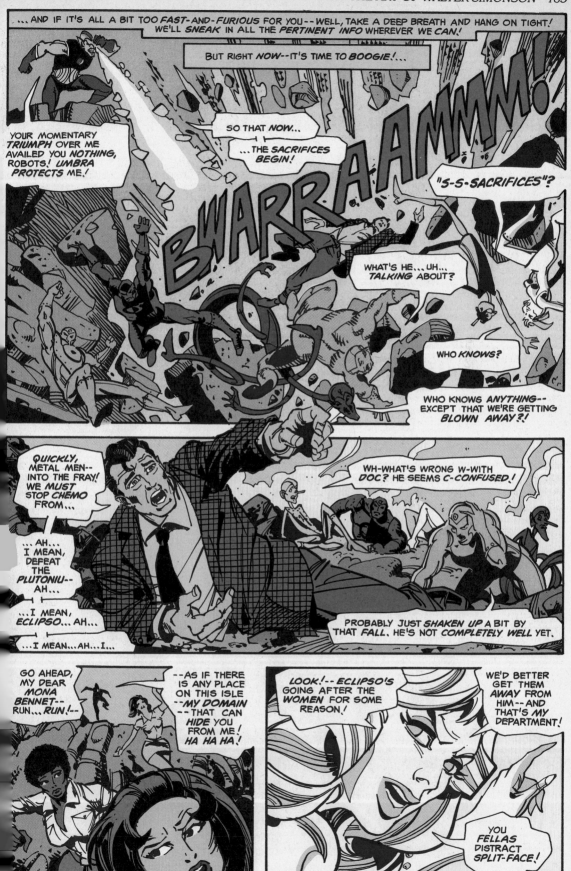

SPROINGG!!

I DON'T KNOW WHO *DIED* AND LEFT *YOU* IN CHARGE, *PLATINUM*--

BUT JUST THIS *ONCE*, I'LL GO *ALONG* WITH YOU!

INSTANTLY, *GOLD* SENDS HIS DUCTILE PROPERTIES INTO ACTION, *STRETCHING* HIMSELF...

...INTO A SLENDER SAFFRON CABLE...

ZING!

DEFTLY, THE MALLEABLE METAL MAN *COILS* AROUND THE SCURRYING ECLIPSO'S *ANKLE*...

...AND THEN *STIFFENS* WITH A *SNAP*--

--SENDING THE *DIVIDED MAN* TO THE VERY FIRM TERRA FIRMA WITH A *LOUD*...

CRASH!

BUT *THEN*--WITH A *SURENESS* BORN OF REPEATED *PRACTICE*, THE *DEMON* OF DARKNESS RAISES HIS DEADLY *BLACK DIAMOND* TO HIS *UNECLIPSED* EYE...

...TO HURL A SEARING BLAST OF INTENSE *ENERGY* INTO THE GLITTERING RIBBON WHICH BINDS HIM!

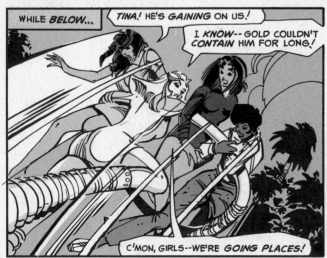

WHILE *BELOW*...

TINA! HE'S *GAINING* ON US!

I *KNOW*-- GOLD COULDN'T *CONTAIN* HIM FOR LONG!

C'MON, GIRLS--WE'RE *GOING PLACES!*

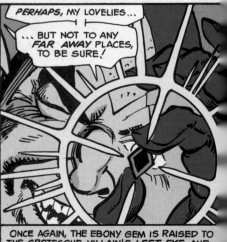

PERHAPS, MY LOVELIES...

... BUT NOT TO ANY *FAR AWAY* PLACES, TO BE SURE!

ONCE AGAIN, THE EBONY GEM IS RAISED TO THE GROTESQUE VILLAIN'S *LEFT EYE*, AND...

...THEN...TIMM-BERR!

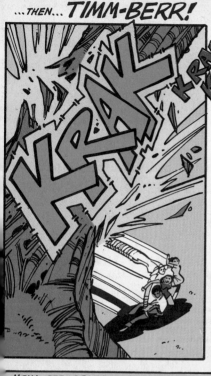

KRAK!
KRAK! KRAK! KRAK! KRAK!

BOOM

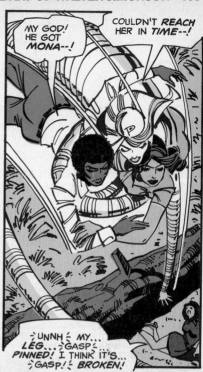

MY GOD! HE GOT MONA--!

COULDN'T *REACH* HER IN *TIME*--!

UNNH-- MY... LEG... -GASP- PINNED! I THINK IT'S... -GASP!- -GASP!- *BROKEN!*

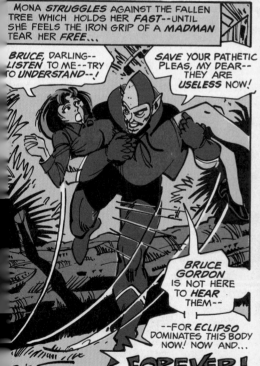

MONA *STRUGGLES* AGAINST THE FALLEN TREE WHICH HOLDS HER *FAST*--UNTIL SHE FEELS THE IRON GRIP OF A *MADMAN* TEAR HER *FREE*...

BRUCE, DARLING-- *LISTEN* TO ME--TRY TO *UNDERSTAND*--!

SAVE YOUR PATHETIC *PLEAS*, MY DEAR-- THEY ARE *USELESS* NOW!

BRUCE GORDON IS NOT HERE TO *HEAR* THEM--

--FOR *ECLIPSO* DOMINATES THIS BODY NOW! NOW AND...

FOREVER!

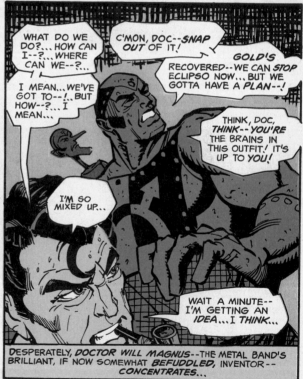

WHAT DO WE DO?... HOW CAN I--?... WHERE CAN WE--?...

I MEAN...WE'VE GOT TO--!, BUT HOW--?... I MEAN...

I'M SO MIXED UP...

C'MON, DOC--*SNAP OUT* OF IT!

GOLD'S RECOVERED--WE CAN *STOP* ECLIPSO NOW... BUT WE GOTTA HAVE A *PLAN*--!

THINK, DOC, *THINK*--YOU'RE THE BRAINS IN THIS OUTFIT! IT'S UP TO *YOU!*

WAIT A MINUTE-- I'M GETTING AN *IDEA*....I THINK...

DESPERATELY, *DOCTOR WILL MAGNUS*--THE METAL BAND'S BRILLIANT, IF NOW SOMEWHAT *BEFUDDLED*, INVENTOR-- CONCENTRATES...

...IN AN EFFORT TO *FOCUS* HIS *REELING BRAIN!* FINALLY, FEVERISH SECONDS *LATER*-- FOLLOWING A HASTILY- STAMMERED *PLAN*--A METAL MEN-BRAND *CABLE CAR* SPEEDS INTO THE BREACH...

ZIP!

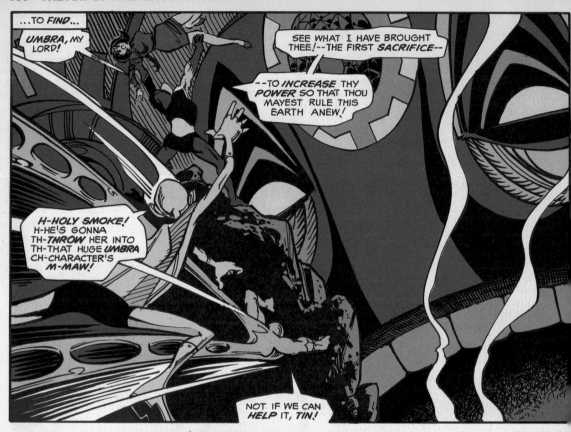

...TO FIND...

UMBRA, MY LORD!

SEE WHAT I HAVE BROUGHT THEE!--THE FIRST *SACRIFICE*--

--TO *INCREASE* THY *POWER* SO THAT THOU MAYEST RULE THIS EARTH ANEW!

H-HOLY SMOKE! H-HE'S GONNA TH-*THROW* HER INTO TH-THAT HUGE *UMBRA* CH-CHARACTER'S M-*MAW*!

NOT IF WE CAN *HELP* IT, TIN!

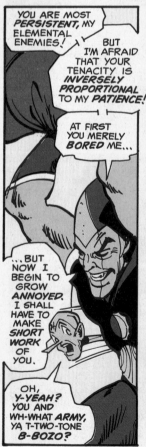

YOU ARE MOST *PERSISTENT*, MY ELEMENTAL ENEMIES!

BUT I'M AFRAID THAT YOUR TENACITY IS *INVERSELY PROPORTIONAL* TO MY *PATIENCE*!

AT FIRST YOU MERELY *BORED* ME...

...BUT NOW I BEGIN TO GROW *ANNOYED*. I SHALL HAVE TO MAKE *SHORT WORK* OF YOU.

OH, Y-YEAH? YOU AND WH-WHAT *ARMY*, YA T-TWO-TONE B-BOZO?

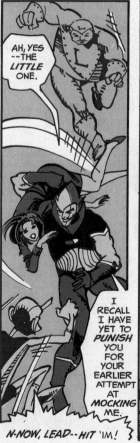

AH, YES --THE *LITTLE* ONE.

I RECALL I HAVE YET TO *PUNISH* YOU FOR YOUR EARLIER ATTEMPT AT *MOCKING* ME.

N-NOW, LEAD--HIT 'IM!

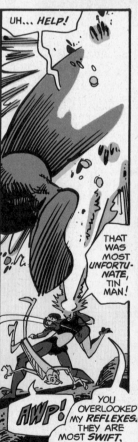

UH... *HELP*!

THAT WAS MOST *UNFORTU-NATE*, TIN MAN!

AWP!

YOU OVERLOOKED MY *REFLEXES*. THEY ARE MOST *SWIFT*.

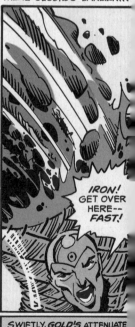

AND BEFORE THE *SOUND* OF THE DEVASTATING BLAST HAS *FADED*, A TORRENT OF *MOLTEN LEAD* GUSHES FROM THE POINT WHERE A VALIANT METAL HAD STOOD MERE SECONDS EARLIER...

IRON! GET OVER HERE-- *FAST!*

SWIFTLY, *GOLD'S* ATTENUATE FORM WEAVES ITSELF INTO A *FUNNEL* TO CATCH THE REMAINS OF HIS STRICKEN COMRADE ...

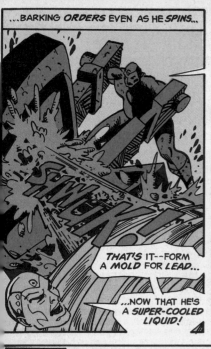

...BARKING *ORDERS* EVEN AS HE *SPINS*...

THAT'S IT--FORM A *MOLD* FOR *LEAD*...

...NOW THAT HE'S A *SUPER-COOLED* LIQUID!

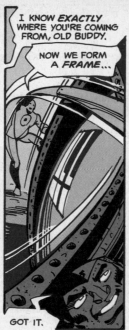

I KNOW *EXACTLY* WHERE YOU'RE COMING FROM, OLD BUDDY.

NOW WE FORM A *FRAME*...

GOT IT.

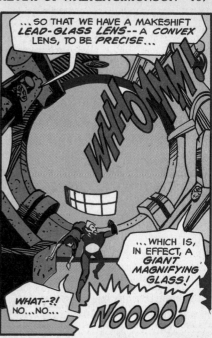

...SO THAT WE HAVE A MAKESHIFT *LEAD-GLASS LENS*-- A *CONVEX* LENS, TO BE *PRECISE*...

...WHICH IS, IN EFFECT, A *GIANT MAGNIFYING GLASS!*

WHAT--?! NO...NO...

WHOMM!!

NOOOO!

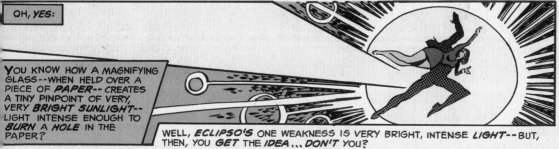

OH, *YES:*

YOU KNOW HOW A MAGNIFYING GLASS--WHEN HELD OVER A PIECE OF *PAPER*-- CREATES A TINY PINPOINT OF VERY, VERY *BRIGHT* SUNLIGHT-- LIGHT INTENSE ENOUGH TO *BURN* A *HOLE* IN THE PAPER?

WELL, *ECLIPSO'S* ONE WEAKNESS IS VERY BRIGHT, INTENSE *LIGHT*-- BUT, THEN, YOU *GET* THE *IDEA...DON'T* YOU?

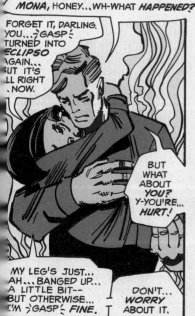

THUS, THE UNSPEAKABLY *EVIL* SPLIT-MAN IS INSTANTLY *TRANSFORMED* INTO HIS *GOOD* ALTER-EGO, PHYSICIST *BRUCE GORDON*...

MONA, HONEY...WH-WHAT *HAPPENED?*

FORGET IT, DARLING YOU...-;GASP;-- TURNED INTO *ECLIPSO* AGAIN... BUT IT'S ALL RIGHT NOW.

BUT WHAT ABOUT *YOU?* Y-YOU'RE... *HURT!*

MY LEG'S JUST... AH...BANGED UP... A LITTLE BIT-- BUT OTHERWISE... I'M -;GASP;-. *FINE.*

DON'T... *WORRY* ABOUT IT.

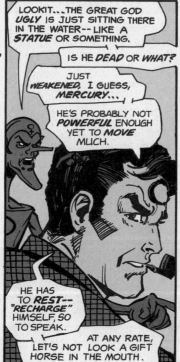

LOOKIT...THE GREAT GOD *UGLY* IS JUST SITTING THERE IN THE WATER-- LIKE A *STATUE* OR SOMETHING.

IS HE *DEAD* OR *WHAT?*

JUST *WEAKENED*, I GUESS, *MERCURY*...

HE'S PROBABLY NOT *POWERFUL* ENOUGH YET TO *MOVE* MUCH.

HE HAS TO *REST*-- "RECHARGE" HIMSELF, SO TO SPEAK.

AT ANY RATE, LET'S NOT LOOK A GIFT HORSE IN THE MOUTH.

"I SUGGEST WE GET AS FAR *AWAY* FROM HERE AS POSSIBLE --WHILE WE STILL *CAN!*"

WELL, IT BEATS SUCKING DOUGHNUTS AND WHISTLING.

ARE YOU *COMFORTABLE*, MONA?

I'M FINE, TINA--AND *THANK* YOU.

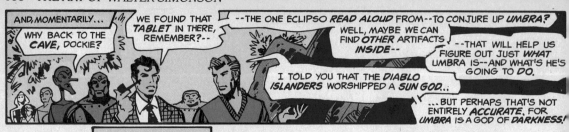

AND, MOMENTARILY...

WHY BACK TO THE *CAVE*, DOCKIE?

WE FOUND THAT *TABLET* IN THERE, REMEMBER?--

--THE ONE ECLIPSO *READ ALOUD* FROM--TO CONJURE UP *UMBRA*?

WELL, MAYBE WE CAN FIND *OTHER* ARTIFACTS *INSIDE*--

--THAT WILL HELP US FIGURE OUT JUST *WHAT* UMBRA IS--AND WHAT'S HE'S GOING TO *DO*.

I TOLD YOU THAT THE *DIABLO ISLANDERS* WORSHIPPED A *SUN GOD*...

...BUT PERHAPS THAT'S NOT ENTIRELY *ACCURATE*, FOR *UMBRA* IS A GOD OF *DARKNESS!*

WITH THAT, GORDON BEGINS A *FASCINATING* TALE! SO HERE WE GO, FOLKS--ON...

A BRIEF JOURNEY THRU THE PAST

" THE NATIVES BELIEVED THAT WHEN THE *EARTH* WAS IN ITS *INFANCY*--UNCOUNTED AEONS AGO--STRANGE AND HORRIBLE *CREATURES* FROM OUT OF THE DEPTHS OF *SPACE* DESCENDED UPON IT...

"BECAUSE OF THEIR AWESOME APPEARANCE AND *POWERS*, THEY CAME TO BE REGARDED AS *GODS* BY EARLIEST MAN. THEY ESTAB-LISHED *CULTS* TO *WORSHIP* THEM --ONE OF WHICH WAS *UMBRA'S*, HERE ON *DIABLO*.

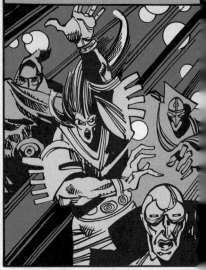

"THESE '*GODS*' *CONTROLLED* THE EARTH--UNTIL THE ANCIENT LEARNED *SEERS* DROVE THE GODS INTO *EXILE*--VIA *WHITE MAGIC*.

"BUT THE HIGH PRIESTS OF *UMBRA* POSSESSED A GIFT FROM THEIR GOD --A *BLACK DIAMOND* --A FRAGMENT OF THE JEWEL WE SAW ON UMBRA'S '*FOREHEAD*'!

"THIS '*SERVING-STONE*' WAS HANDED DOWN AMONG THE WIZARD PRIESTS FROM GENER-ATION TO GENERATION...

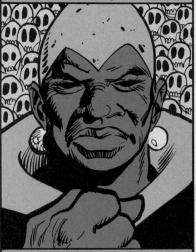

"...AND USED AS A *WEAPON* TO *ENFORCE* THE PRIEST'S RULE OVER THE CULT. THROUGH THE MILLENNIA, UMBRA'S *WORSHIPPERS* DETERMINED TO ONE DAY BRING HIM BACK FROM *OBLIVION*.

"THE LAST IN THE LONG LINE OF PRIESTS WAS *MOPHIR*...

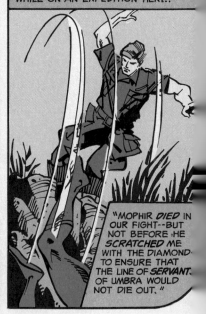

"...WHO FOUGHT ME WHEN I INADVERT-ENTLY CHALLENGED HIS AUTHORITY WHILE ON AN EXPEDITION HERE..

"MOPHIR *DIED* IN OUR FIGHT--BUT NOT BEFORE HE *SCRATCHED* ME WITH THE DIAMOND--TO ENSURE THAT THE LINE OF *SERVANT* OF UMBRA WOULD NOT DIE OUT."

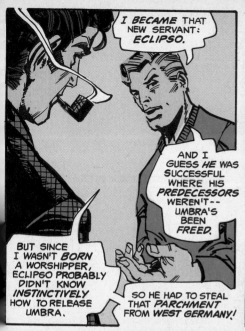

I BECAME THAT NEW SERVANT: ECLIPSO.

AND I GUESS *HE* WAS SUCCESSFUL WHERE HIS *PREDECESSORS* WEREN'T-- UMBRA'S BEEN *FREED.*

BUT SINCE I WASN'T *BORN* A WORSHIPPER, ECLIPSO PROBABLY DIDN'T KNOW *INSTINCTIVELY* HOW TO RELEASE UMBRA.

SO HE HAD TO STEAL THAT PARCHMENT FROM *WEST GERMANY!*

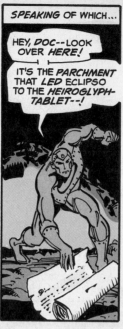

SPEAKING OF WHICH...

HEY, *DOC*--LOOK OVER *HERE!*

IT'S THE *PARCHMENT* THAT *LED* ECLIPSO TO THE *HIEROGLYPH-TABLET--!*

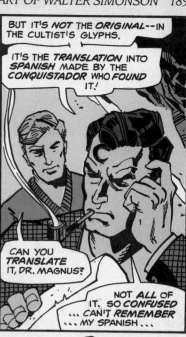

BUT IT'S *NOT* THE *ORIGINAL*--IN THE CULTIST'S GLYPHS.

IT'S THE *TRANSLATION* INTO *SPANISH* MADE BY THE *CONQUISTADOR* WHO *FOUND* IT!

CAN YOU *TRANSLATE* IT, DR. MAGNUS?

NOT *ALL* OF IT. SO CONFUSED CAN'T REMEMBER MY SPANISH ...

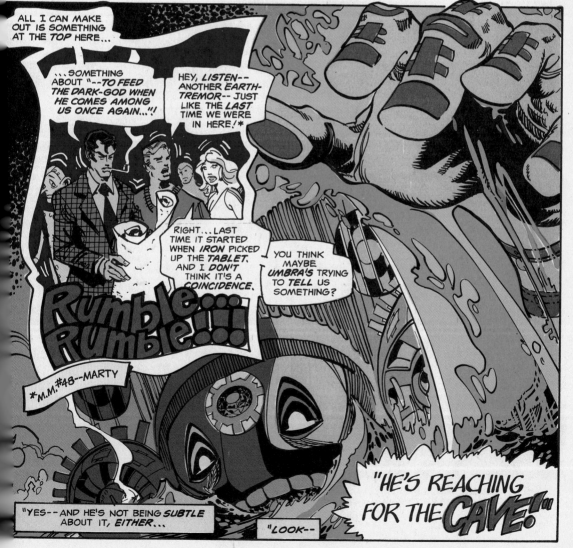

ALL I CAN MAKE OUT IS SOMETHING AT THE *TOP* HERE...

...SOMETHING ABOUT "--*TO FEED THE DARK-GOD WHEN HE COMES AMONG US ONCE AGAIN...*"!

HEY, *LISTEN*-- ANOTHER *EARTH-TREMOR*-- JUST LIKE THE *LAST* TIME WE WERE IN HERE!*

RIGHT... LAST TIME IT STARTED WHEN *IRON* PICKED UP THE *TABLET*, AND I *DON'T* THINK IT'S A *COINCIDENCE.*

YOU THINK MAYBE *UMBRA'S* TRYING TO *TELL* US SOMETHING?

Rumble.... Rumble!!!

*M.M. #48--MARTY

"YES--AND HE'S NOT BEING *SUBTLE* ABOUT IT, *EITHER*..."

"LOOK--

"HE'S REACHING FOR THE *CAVE!*"

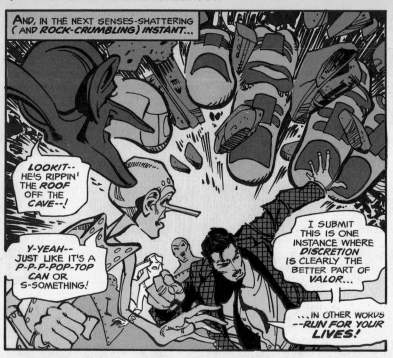

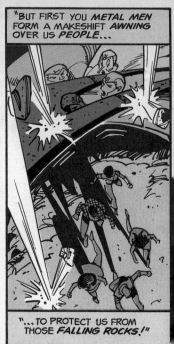

NEAT, HUNH? MERELY A *MODEST* EFFORT FOR OUR MARVELOUS METALS... BUT VERY *IMPRESSIVE* TO A DEMON WHO'S BEEN BAGGING Z'S UNDER THE *SEAWEED* FOR A MILLENNIUM OR THREE! AND TO FIND OUT JUST *HOW MUCH* SO, LET US *SHARE* FOR A MOMENT THE *RUMINATIONS* GOING DOWN BEHIND THOSE INTENSE, GEMLIKE EYES...

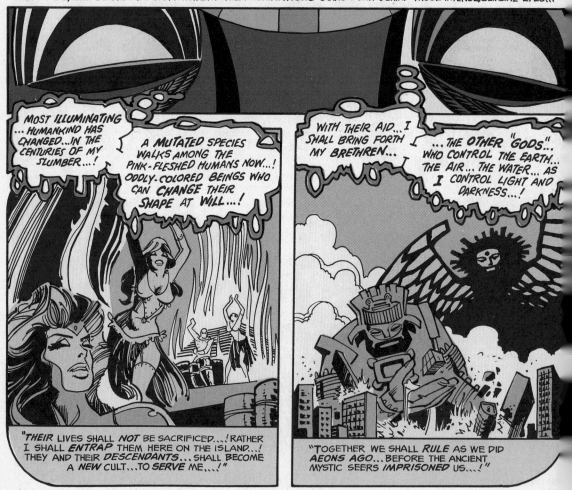

FOR THE TIME BEING, HOWEVER, *UMBRA* CANNOT *MOVE* FROM THE WATER IN WHICH HIS BULKY *BULK* RESIDES...

BUT SURELY THIS "GOD'S" *REACH* CAN EXCEED HIS *GRASP*...

I SHALL SEND FORTH FIVE *KILLING-BEAMS*...

...EACH ATTUNED SPECIFICALLY TO ONE OF THE FIVE PINK-FLESHED HUMANS...!

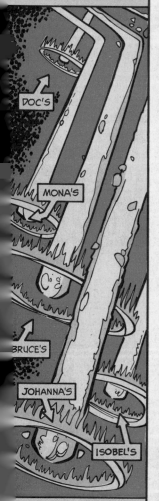

INSTANTLY THEY *APPEAR*-- FIERY BOLTS OF CERTAIN *DEATH* THAT SEEK OUT THEIR DESIGNATED TARGETS LIKE *GUIDED MISSILES*...

DOC'S

MONA'S

BRUCE'S

JOHANNA'S

ISOBEL'S

RELENTLESSLY, THEY BEAR DOWN ON THE FRANTIC HUMANS WHO *FLEE* IN ERRATIC PATTERNS! BUT THE BLAZING BULLETS CANNOT BE DODGED...

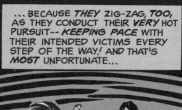

...BECAUSE *THEY* ZIG-ZAG, *TOO*, AS THEY CONDUCT THEIR *VERY* HOT PURSUIT-- *KEEPING PACE* WITH THEIR INTENDED VICTIMS EVERY STEP OF THE WAY! AND THAT'S *MOST* UNFORTUNATE...

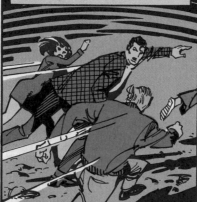

...BECAUSE, YOU SEE, IN CROSSING ONE ANOTHER'S PATHS, THEY *ECLIPSE EACH OTHER*-- AND JUST BEFORE THEY *HIT*, BRUCE GORDON BECOMES *ECLIPSO* ONCE MORE...

NOT THAT IT REALLY *MATTERS* MUCH...

...BECAUSE, IN THE NEXT *SPLIT-INSTANT*...

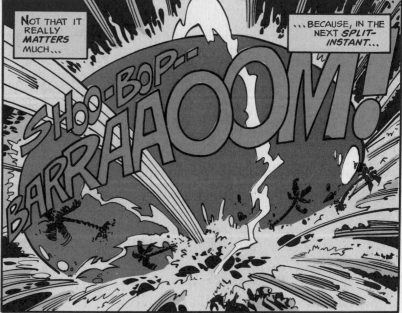

SHOO-BOP-- BARRAAOOM!

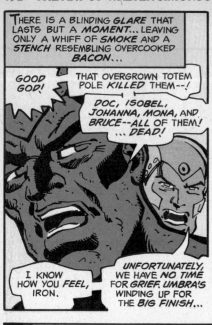

THERE IS A BLINDING *GLARE* THAT LASTS BUT A *MOMENT...* LEAVING ONLY A WHIFF OF *SMOKE* AND A *STENCH* RESEMBLING OVERCOOKED *BACON...*

GOOD GOD!

THAT OVERGROWN TOTEM POLE *KILLED* THEM--!

DOC, ISOBEL, JOHANNA, MONA, AND BRUCE--ALL OF THEM! ...*DEAD!*

I KNOW HOW YOU *FEEL*, IRON.

UNFORTUNATELY, WE HAVE *NO TIME* FOR *GRIEF.* UMBRA'S WINDING UP FOR THE *BIG FINISH...*

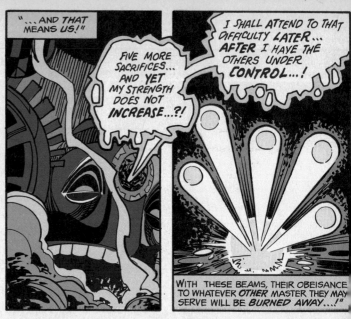

"...AND *THAT* MEANS US!"

FIVE MORE *SACRIFICES...* AND *YET* MY STRENGTH DOES NOT *INCREASE...?!*

I SHALL ATTEND TO THAT DIFFICULTY *LATER...* *AFTER* I HAVE THE OTHERS UNDER *CONTROL...!*

WITH THESE BEAMS, THEIR OBEISANCE TO WHATEVER *OTHER* MASTER THEY MAY SERVE WILL BE *BURNED AWAY...!*"

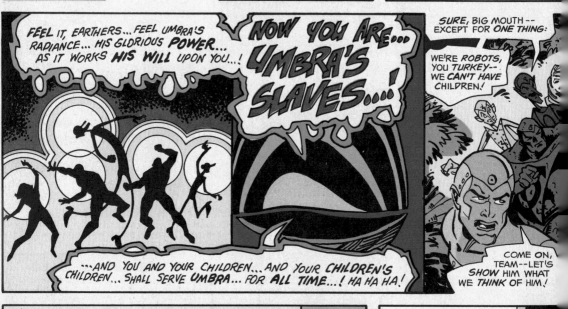

FEEL IT, EARTHERS... *FEEL* UMBRA'S *RADIANCE...* HIS GLORIOUS *POWER...* AS IT WORKS *HIS WILL* UPON YOU...!

NOW YOU ARE... UMBRA'S SLAVES....!

...AND YOU AND YOUR CHILDREN... AND YOUR *CHILDREN'S* CHILDREN... SHALL SERVE *UMBRA...* FOR *ALL TIME...!* HA HA HA!

SURE, BIG MOUTH-- EXCEPT FOR *ONE* THING:

WE'RE ROBOTS, YOU TURKEY-- WE *CAN'T* HAVE CHILDREN!

COME ON, TEAM--LET'S SHOW HIM WHAT WE *THINK* OF HIM!

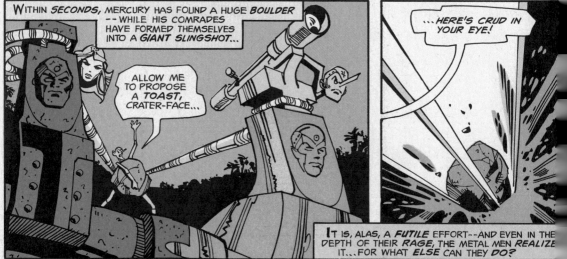

WITHIN *SECONDS,* MERCURY HAS FOUND A HUGE *BOULDER* --WHILE HIS COMRADES HAVE FORMED THEMSELVES INTO A *GIANT SLINGSHOT...*

ALLOW ME TO PROPOSE A *TOAST,* CRATER-FACE...

...HERE'S CRUD IN YOUR EYE!

IT IS, ALAS, A *FUTILE* EFFORT--AND EVEN IN THE DEPTH OF THEIR *RAGE,* THE METAL MEN *REALIZE* IT...FOR WHAT *ELSE* CAN THEY *DO?*

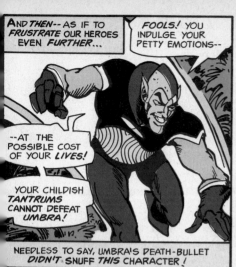

AND *THEN*-- AS IF TO *FRUSTRATE* OUR HEROES EVEN *FURTHER*...

FOOLS! YOU INDULGE YOUR PETTY EMOTIONS--

--AT THE POSSIBLE COST OF YOUR *LIVES!*

YOUR CHILDISH *TANTRUMS* CANNOT DEFEAT *UMBRA!*

NEEDLESS TO SAY, UMBRA'S DEATH-BULLET *DIDN'T* SNUFF *THIS* CHARACTER!

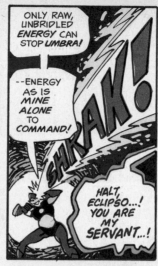

ONLY RAW, UNBRIDLED *ENERGY* CAN STOP *UMBRA!*

--ENERGY AS IS *MINE ALONE* TO COMMAND!

SHRAK!

HALT, ECLIPSO...! YOU ARE MY *SERVANT*...!

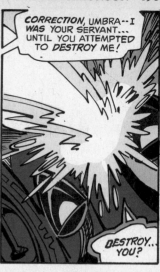

CORRECTION, UMBRA--I WAS YOUR SERVANT... UNTIL YOU ATTEMPTED TO *DESTROY* ME!

DESTROY... YOU?

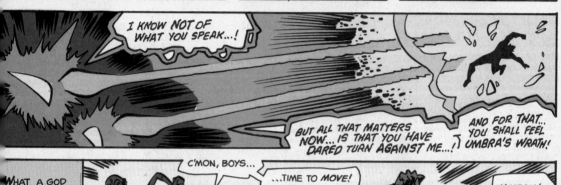

I KNOW *NOT* OF WHAT YOU SPEAK...!

BUT ALL THAT MATTERS NOW... IS THAT YOU HAVE *DARED* TURN AGAINST ME....!

AND FOR THAT... YOU SHALL FEEL *UMBRA'S WRATH!*

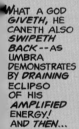

WHAT A GOD *GIVETH*, HE CANETH ALSO *SWIPETH BACK*-- AS UMBRA DEMONSTRATES BY *DRAINING* ECLIPSO OF HIS *AMPLIFIED ENERGY!* AND THEN...

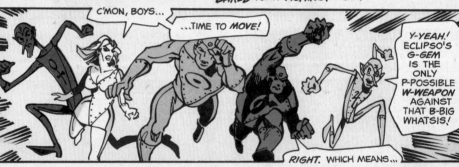

C'MON, BOYS...

...TIME TO MOVE!

Y-YEAH! ECLIPSO'S G-GEM IS THE ONLY P-POSSIBLE W-WEAPON AGAINST THAT B-BIG WHATSIS!

RIGHT. WHICH MEANS...

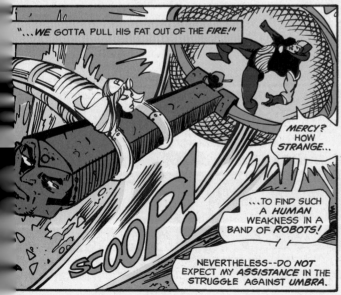

"...WE GOTTA PULL HIS FAT OUT OF THE *FIRE!*"

SCOOP!

MERCY? HOW *STRANGE*...

...TO FIND SUCH A *HUMAN* WEAKNESS IN A BAND OF *ROBOTS!*

NEVERTHELESS--DO *NOT* EXPECT MY *ASSISTANCE* IN THE STRUGGLE AGAINST *UMBRA.*

ECLIPSO FIGHTS ON HIS *OWN* BEHALF ONLY!

I'D *RECONSIDER* THAT IF I WERE YOU.

WHAT--?!

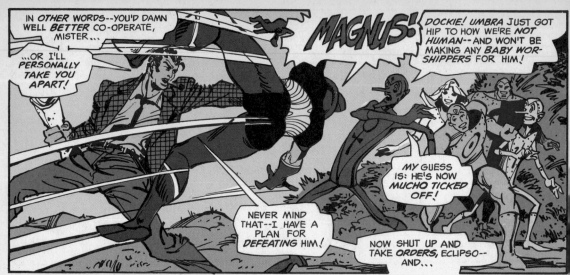

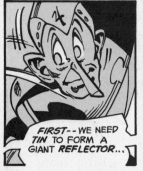

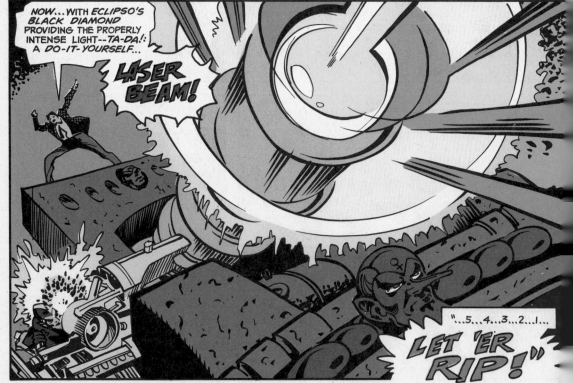

AT *DOC'S* COMMAND, A BATTERY OF *COHERENT LIGHT WAVES* PUMMEL THE PULSING JEWEL THAT GLARES BALEFULLY FROM *UMBRA'S* FOREHEAD LIKE A MALIGN THIRD EYE! BRIGHTER AND *BRIGHTER* GLOWS THE GEM-- UNTIL, WITH A SOFT SOUND OF *SURRENDER*, IT ABRUPTLY TURNS *BLACK*... AMPLE *EVIDENCE* THAT ITS MYSTERIOUS *COSMIC ENERGY* HAS BEEN *TAPPED OUT*...

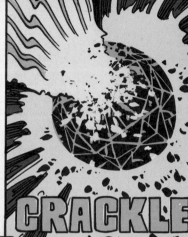

UMBRA'S BODY SHIMMERS AND SHIFTS...HE BEGINS TO *MELT!* HIS EYES ROLL UP IN HIS HEAD...HE HEAVES A BILLION-YEAR-OLD-SIGH... AND GENERALLY GIVES UP ON HIS PLANS FOR A *COMEBACK*...

THIS IS THE *SECOND* BLINDING FLASH WHOSE HEAT HAS SEARED THE *METAL MEN'S* BODIES THIS DAY... BUT *THIS* TIME, THE AIR IS REDOLENT WITH A PUNGENT, *SULPHUROUS* ODOR...

AT THAT MOMENT, *ECLIPSO* REALIZES ONCE MORE THAT HE IS AS MUCH A *SLAVE* TO LIGHT AND DARKNESS AS HE IS THEIR *MASTER*...

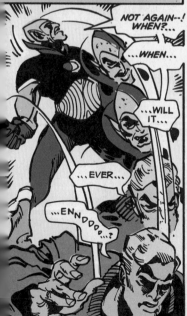

NOT AGAIN--! WHEN?...

...WHEN...

...WILL IT...

...EVER...

...ENNDDDD...?

PERHAPS IT ALREADY *HAS.*

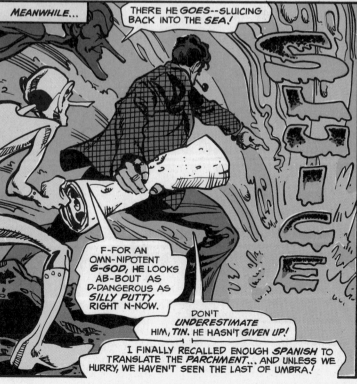

MEANWHILE...

THERE HE *GOES*--SLUICING BACK INTO THE *SEA!*

F-FOR AN OMN-NIPOTENT G-GOD, HE LOOKS AB-BOUT AS D-DANGEROUS AS *SILLY PUTTY* RIGHT N-NOW.

DON'T *UNDERESTIMATE* HIM, *TIN.* HE HASN'T *GIVEN UP!*

I FINALLY RECALLED ENOUGH *SPANISH* TO TRANSLATE THE *PARCHMENT*... AND UNLESS WE HURRY, WE HAVEN'T SEEN THE LAST OF UMBRA!

IN MERE *MINUTES*, THE *METAL MEN* FORM A *SUBMARINE*-- OF *SORTS*...

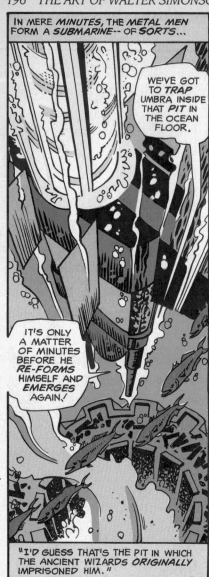

WE'VE GOT TO *TRAP* UMBRA INSIDE THAT *PIT* IN THE OCEAN FLOOR.

IT'S ONLY A MATTER OF MINUTES BEFORE HE *RE-FORMS* HIMSELF AND *EMERGES* AGAIN!

"I'D GUESS THAT'S THE PIT IN WHICH THE ANCIENT WIZARDS *ORIGINALLY* IMPRISONED HIM."

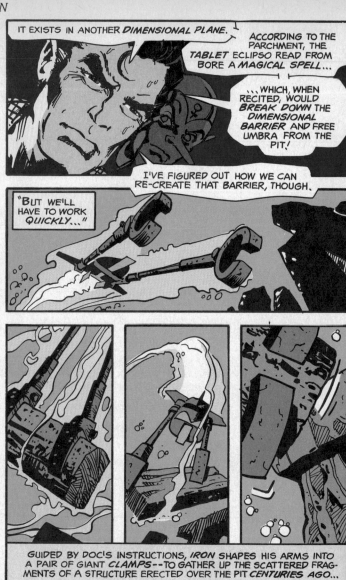

IT EXISTS IN ANOTHER *DIMENSIONAL PLANE.*

ACCORDING TO THE *PARCHMENT,* THE *TABLET* ECLIPSO READ FROM BORE A *MAGICAL SPELL*...

...WHICH, WHEN RECITED, WOULD *BREAK DOWN* THE *DIMENSIONAL BARRIER* AND FREE UMBRA FROM THE *PIT!*

I'VE FIGURED OUT HOW WE CAN RE-CREATE THAT BARRIER, THOUGH.

"BUT WE'LL HAVE TO WORK *QUICKLY*..."

GUIDED BY DOC'S INSTRUCTIONS, *IRON* SHAPES HIS ARMS INTO A PAIR OF GIANT *CLAMPS*--TO GATHER UP THE SCATTERED FRAGMENTS OF A STRUCTURE ERECTED OVER THE PIT *CENTURIES AGO*...

HURRY, IRON-- UMBRA'S *JEWEL* HAS *RE-CHARGED* ITSELF!

HE COULD *COALESCE* ANY MINUTE NOW!

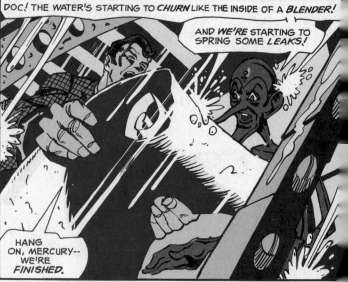

DOC! THE WATER'S STARTING TO *CHURN* LIKE THE INSIDE OF A *BLENDER!*

AND *WE'RE* STARTING TO SPRING SOME *LEAKS!*

HANG ON, MERCURY-- WE'RE *FINISHED.*

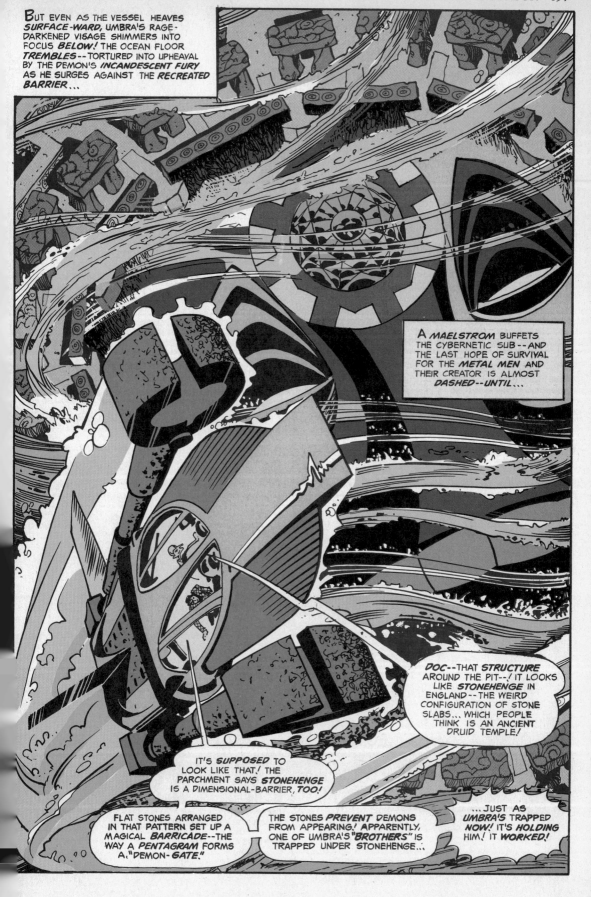

BUT EVEN AS THE VESSEL HEAVES SURFACE-WARD, UMBRA'S RAGE-DARKENED VISAGE SHIMMERS INTO FOCUS BELOW! THE OCEAN FLOOR TREMBLES--TORTURED INTO UPHEAVAL BY THE DEMON'S INCANDESCENT FURY AS HE SURGES AGAINST THE RECREATED BARRIER...

A MAELSTROM BUFFETS THE CYBERNETIC SUB--AND THE LAST HOPE OF SURVIVAL FOR THE METAL MEN AND THEIR CREATOR IS ALMOST DASHED--UNTIL...

DOC--THAT STRUCTURE AROUND THE PIT--! IT LOOKS LIKE STONEHENGE IN ENGLAND--THE WEIRD CONFIGURATION OF STONE SLABS... WHICH PEOPLE THINK IS AN ANCIENT DRUID TEMPLE!

IT'S SUPPOSED TO LOOK LIKE THAT! THE PARCHMENT SAYS STONEHENGE IS A DIMENSIONAL-BARRIER, TOO!

FLAT STONES ARRANGED IN THAT PATTERN SET UP A MAGICAL BARRICADE--THE WAY A PENTAGRAM FORMS A "DEMON-GATE."

THE STONES PREVENT DEMONS FROM APPEARING! APPARENTLY, ONE OF UMBRA'S "BROTHERS" IS TRAPPED UNDER STONEHENGE...

...JUST AS UMBRA'S TRAPPED NOW! IT'S HOLDING HIM! IT WORKED!

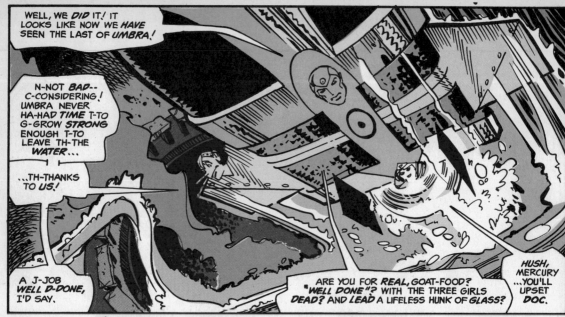

ALL'S WELL THAT ENDS WELL:

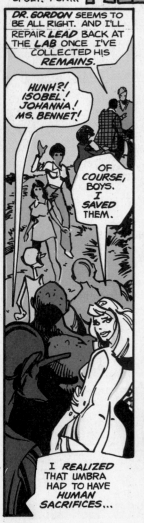

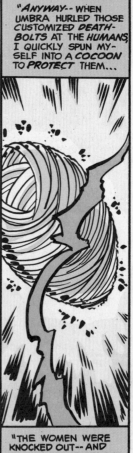

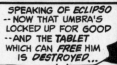

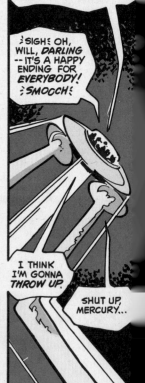

PORTFOLIO

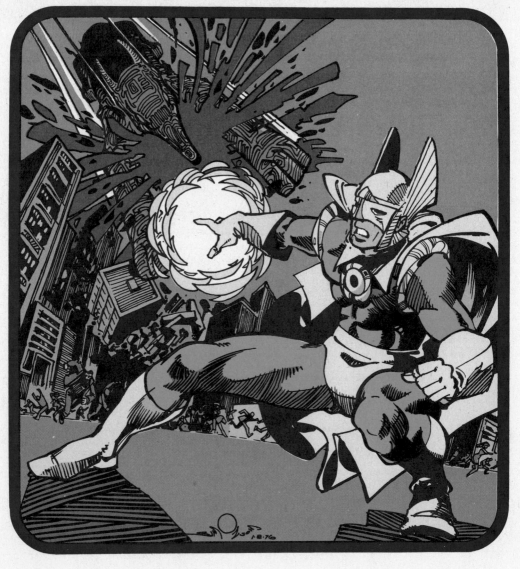

*A proposed alternate look for DC's
Master of Mysticism, Dr. Fate.*

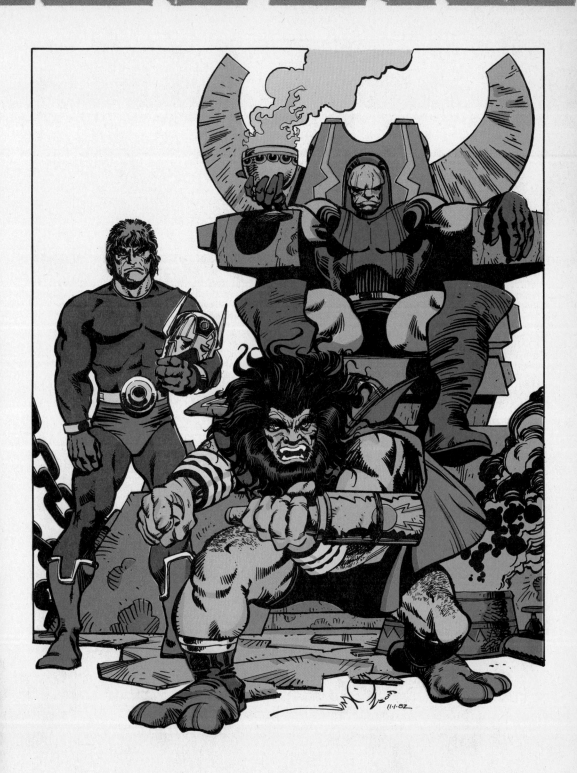

Darkseid and sons.

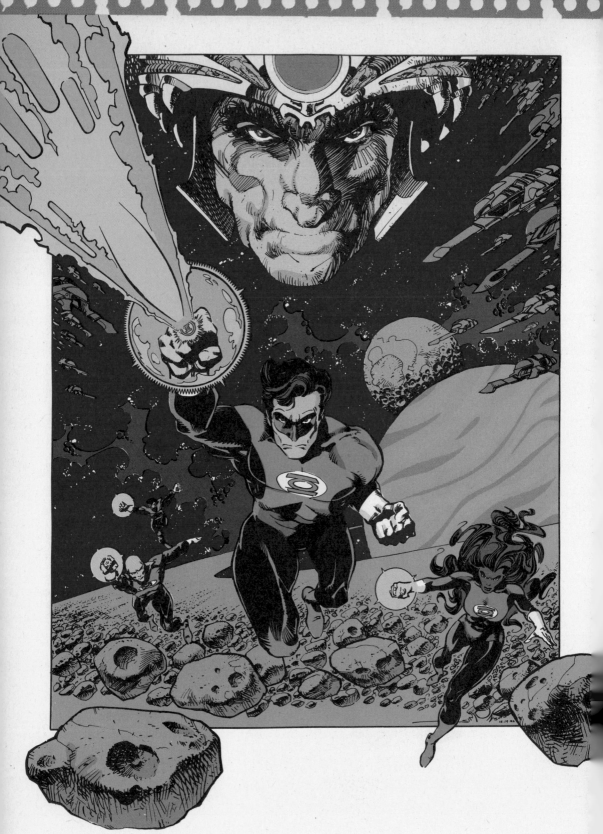

Green Lantern, the Emerald Gladiator.

These two pieces were originally part of a presentation for a proposed GREEN LANTERN movie.

Originally commissioned by former DC editor Jack C. Harris: The Batman's arch-nemesis Two-Face.

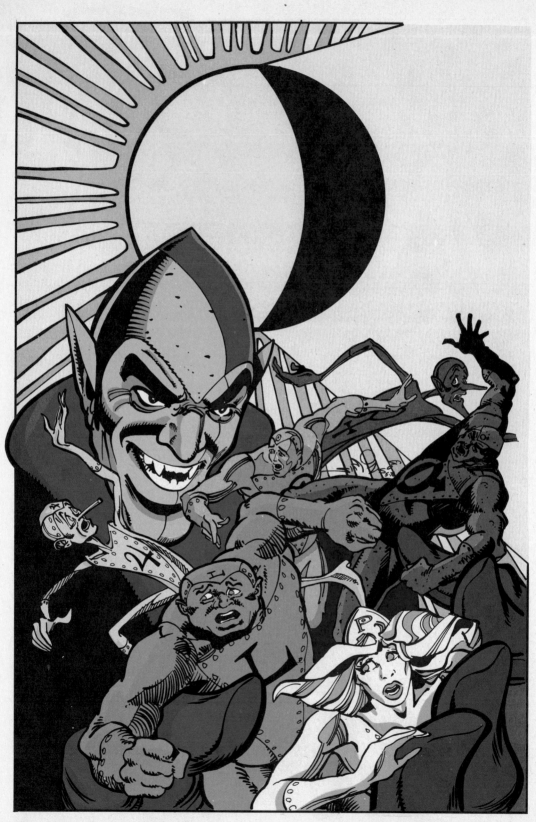

The cover to METAL MEN #48.

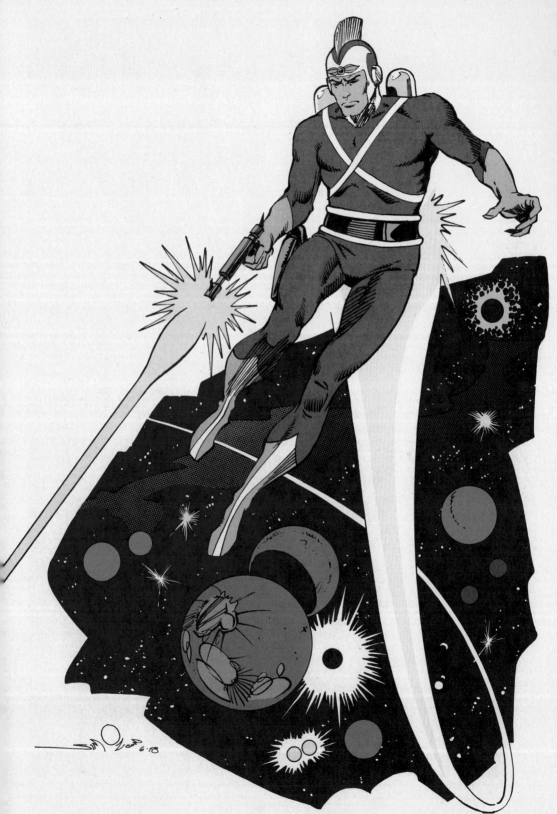

Adam Strange, DC's super-hero of the spaceways.

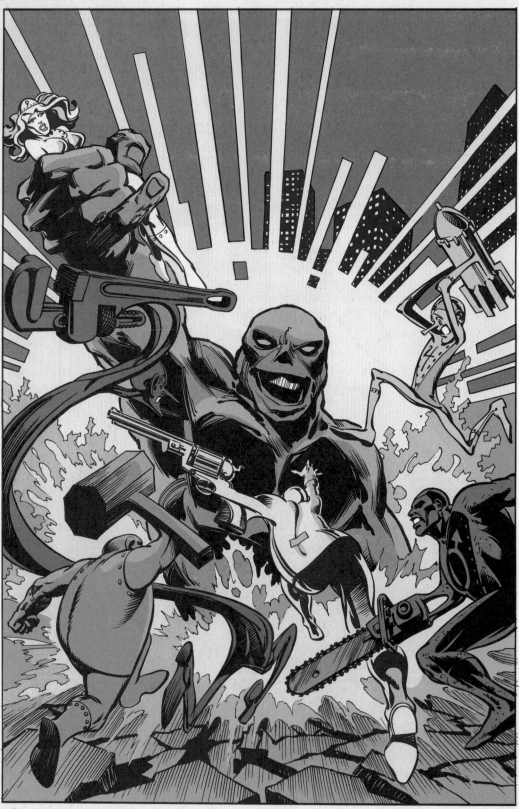

*The original, unused cover to
METAL MEN #45.*

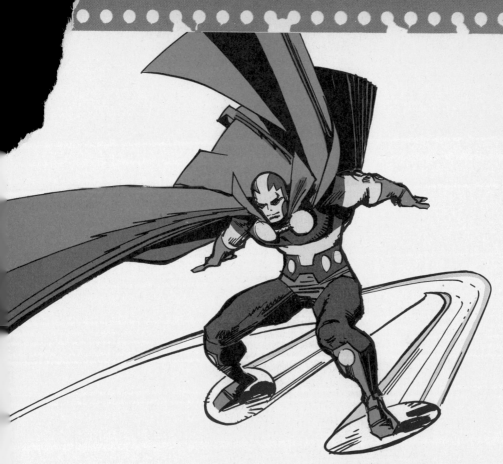

Mr. Miracle, Super-Escape Artist, as depicted by Simonson.

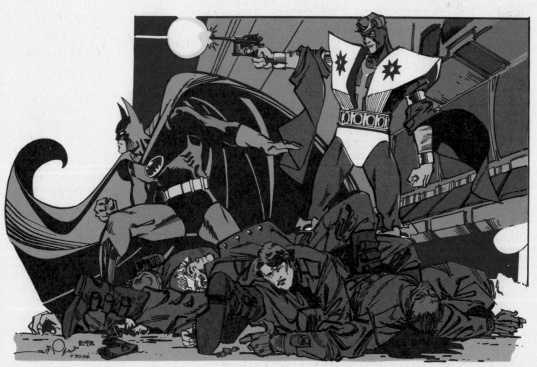

A sketch from 1984 commemorating **Manhunter,** *the award-winning DC strip by Simonson and writer Archie Goodwin.*

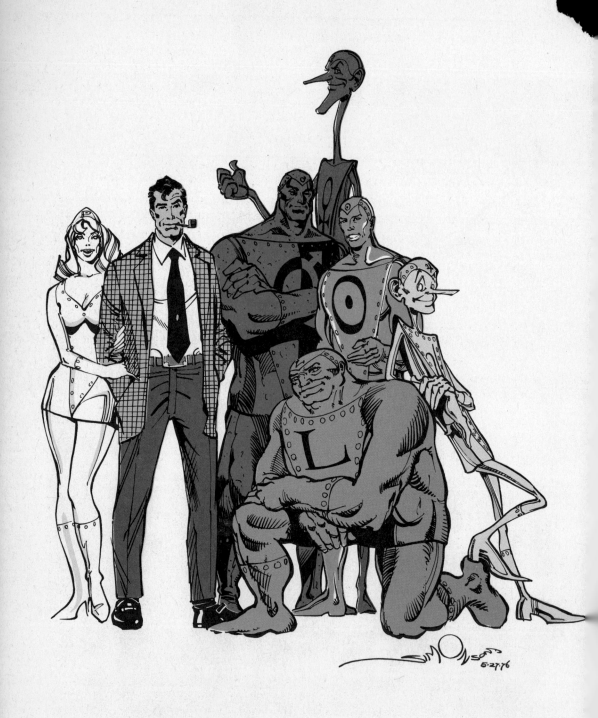

*From 1976: The Metal Men relax
with their creator, Dr. Will Magnus.*